Traditional Crafts
of
Saudi Arabia

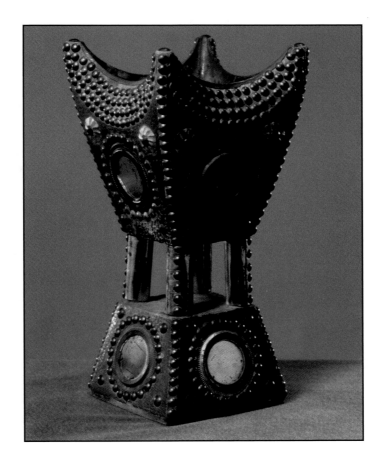

Most of the collection made by John
Topham has been acquired by the Haifa
Faisal Collection, which plans to use
them as a base for a Folk Art Museum
in Riyadh, in combination with other
collections they have acquired.

Supreme Commission | الهيئة العليا
for Tourism | للسياحة

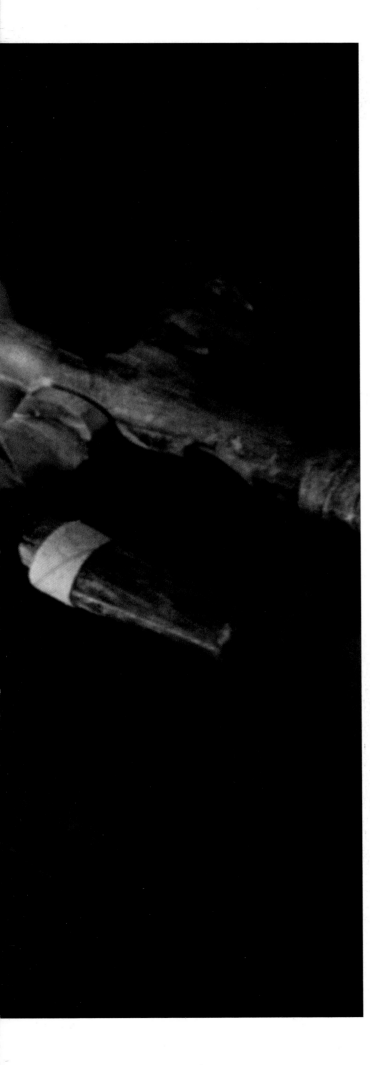

TRADITIONAL CRAFTS
of
SAUDI ARABIA

Weaving ~ Jewellery ~ Costume ~ Leatherwork
Basketry ~ Woodwork ~ Pottery ~ Metalwork

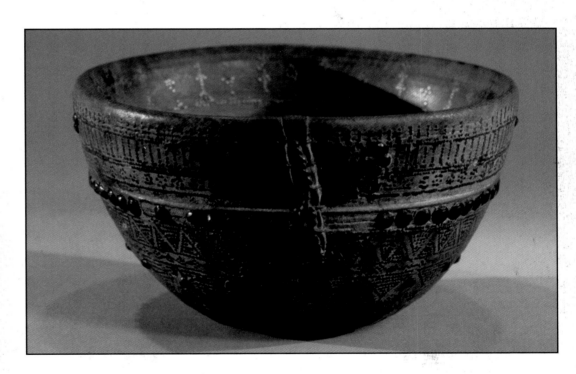

John Topham

with Anthony Landreau and
William E. Mulligan

Foreword by HRH Princess Haifa Al-Faisal

AL-TURATH / STACEY INTERNATIONAL

Traditional Crafts of Saudi Arabia

First published by Stacey International 1982
Revised edition published 2005 by

Stacey International
128 Kensington Church Street
London W8 4BH
Tel: +44 (0)207 221 7166; Fax: +44 (0)207 792 9288
E-mail: marketing@stacey-international.co.uk
Website: www.stacey-international.co.uk

in association with

Al-Turath
PO Box 68200
Riyadh 11527
E-mail: al-turath@al.turath.com
Website: www.al-turath.com

© 2005 John M Topham

ISBN 1 900988 720

First edition
Editor: Charlotte Parry-Crooke
Editorial Team: Charlotte Breese, Sue Hamon Watt, Venetia Porter, Aline Vane-Tempest
Designer: Keith Savage
Maps: Ian Stephen

Revised edition
Editor: Caroline Singer
Designers: Kitty Carruthers, Graham Edwards

Printed and Bound by Times Offset (M) Sdn.Bhd.

Publisher's Note
The objects and pictures in this book were selected from approximately 500 illustrations. Information on date and place of acquisition of objects is given when available; the owners are listed on this page. Measurements of the larger objects are given in feet and inches, those of smaller items are in inches. All dates used in the book are AD.

Half-title photograph:
Classic Incense Burner. *The wooden body is decorated in brass tacks and mirrors and the columns covered with gilded sheet metal. It was probably made in the Eastern Province before 1950, and given to W.E. Tewell. This type of manufacture no longer exists; the same conformation is used but most contemporary incense burners are imported and often have plastic decoration.*

Title page photographs:
A weaver from Hofuf working at a pit loom, which has two harnesses. (Photograph by Joy May Hilden)

Camel Milk Bowl. A rare example of a decorated bowl. Small metal slugs are pounded into drilled holes in the wood to create this particularly elaborate decoration.

The Contributors

J.T. John Topham, a Virginian now living in New York, was educated at St Andrews School, Roanoke College and Duke University. He is a construction consultant and manager who spent several years working in Saudi Arabia, where he became interested in the weavings and other crafts of the Bedouin and villagers and built the collection on which this book is based.

A.L. Anthony Landreau, a leading authority on nomadic weaving, is a former Executive Director of The Textile Museum, Washington DC and Research Curator for the Museum of Art, Carnegie Institute, Pittsburgh. He is well known as a lecturer and consultant on Oriental rugs.

W.E.M. William E. Mulligan spent over thirty years in Saudi Arabia as an Arabian-American Oil Company executive, where his government relations activities included historical and field research into Bedouin and traditional Arab culture. He contributed to *Aramco World, The Encyclopedia of Islam* and other publications. He died in 1994.

Acknowledgements to the First Edition

Interest in the project has been forthcoming from many sources; the author wishes to thank particularly the following for their kind and valuable assistance:

Dr Abdullah H. Masry, Assistant Deputy Minister of Education for Cultural Affairs, Saudi Arabia for his support of the exhibition and the book; Dr Muhammed Bakalla of the King Saud University for his enthusiasm and encouragement; Prince Sultan al-Sudairi of al-Jawf who lent magnificent weavings from his area, and who, with his father, is to be praised for his support of this craft; Colin Paddock, their assistant, especially for his help in obtaining a complete tent.
 Bret Waller, Director of the Memorial Art Gallery of the University of Rochester (and Bruce Chambers, Acting Director 1979-1980) who took the lead in planning the exhibition and who have provided outside technical consultancy and support; W.E. Tewell who spent many years in Arabia and assisted in locating other collections; W.E. Mulligan for contributing the historical introduction, based on his years of study of Arabia; the late Professor Bayly Winder, Director of the Kevorkian Center for Near Eastern Studies, New York University, for his interest, advice and corrections; the Smithsonian Institution Travelling Exhibition Service for arranging the tour of the Rochester exhibition to other museums.
 Muhammed Al-Kabli of Dammam for his assistance in obtaining a tent; Abdullah and Ali al-Zahrani of Jiddah for their interest and assistance in obtaining fine examples of costume and jewellery.
 Dr F.S. Vidal, anthropologist, of the University of Texas, Dallas, for his critical attention to some identifications; A. Landreau who made technical examinations of the weavings, assessed their relationships to other textiles and wrote the Weaving essay; Y.K. Stillman who reviewed the costume and jewellery technically and historically; Louise Mackie of the Textile Museum for her early enthusiasm for the project.
 Celia Wright for editing, rewriting, technical analysis and research; Mary Van Keuren for helping to prepare the catalogue; Judith Emming for helping with the costume descriptions; Don Bujnowski and Katerina Weslein, Rochester Institute of Technology, for assistance on the weaving; Pat Bujnowski for the illustration on page 13; Abdul Aziz al-Sheikh of Riyadh and Aisha Almana of al-Khobar for their help and identifications; Reviera Wilcove and Carol Mattison for typing and general assistance; Joy May Hilden of Berkeley, California, and Dhahran, Saudi Arabia, for her pictures and for revising and expanding the weaving chapter; Jane Stevens of Pittsford, New York, for early assistance on photography; Virginia Heaven, Curator Haifa Faisal Collection, for advice; David Mayor for communications help.
 Most items shown in this book belong to John Topham. Others who generously lent artefacts and photographs are: the Al-Nahda Philanthropic Society; Kimberley Ayers; Grace Burkholder; William Mulligan; Bonnie Ray; Anne Rhea; Folklore Museum, University of Riyadh; Mary Ellen Taylor; Frederick Taylor; Bedj and W.E.Tewell. The author is particularly grateful to Barbara Hawke for her help in Saudi Arabia and especially for acquiring the outstanding tent wall whon on page 30, as well as other items later acquired from her.
 The author also wishes to thank those who took the photographs for the book: John Topham Collection: Tim Callahan assisted by Drew Hardy; Grace Burkholder and Tim Callahan; Anne Rhea Collection: Mark Hodgson; Mary Ellen Taylor Collection: Sharon White; Folklore Museum, University of Riyadh photographs supplied by M. Bakalla; page 14 and page 25 (top) by Wilhelm Büttiker. Other *in situ* photographs are by John Topham, Grace Burkholder, Earl Kage, Museographics, Rochester and 'Ilo the pirate'.
 Thanks are also due to Tom Stacey for his interest almost from the beginning; the staff of Stacey International, London, for their splendid hard work and professionalism; Bill and Joan Ryan; and to my wife, Dorothy Emory Topham, for her patience with this undertaking.

Acknowledgements to this Edition

The publishers would like express their grateful thanks to the Al-Nahda Philanthropic Society in Riyadh for their help and support in the preparation of this revised edition.

Contents

Foreword

Throughout history, society has been peopled with adventurers, those uncommon individuals whose curiosity pushes them beyond the familiar to explore, discover and understand peoples and places as yet unknown. Their dramatic stories continue to populate our histories and capture our imagination.

But we fail, sometimes, to celebrate the quiet adventurers who recognize something precious and treasurable in what, to others, is commonplace, or simply old. It is to them that we owe a special debt, for as societies lay aside traditional customs, styles, and materials to make way for the modern, it is often these adventurers who gather them up and hold them in trust for the future. Such an individual is John Topham who, during his years in Saudi Arabia, listened to the echoes of Arabia that still reverberated in the everyday weavings, utensils, and clothing that were being relegated to its past.

I established a collection of Saudi material culture in 1986 for the principal purpose of providing future generations a window on the traditions and traditional life of Saudi Arabia. The foundation for it was the acquisitions of the collection of Mr Topham, which is represented here, and that of another "quiet" adventurer, Heather Colyer Ross. Since then, numerous small collections and individual objects have been acquired from individuals and auction houses in Saudi Arabia, Europe and the United States. In 2002, the collection was merged with the holdings of the Al-Nahda Charitable Society in Riyadh to form the SANA Collection. Today, SANA has more than 6,000 material artifacts and a research library, including maps and photographs, which provide a unique opportunity to research, study and share with others the material culture of Saudi Arabia and its people.

T. S. Eliot once referred to the material artifacts of a civilization as its "emissaries". My personal thanks to all the adventurers, and particularly to John Topham, who have helped keep the emissaries of Saudi Arabia safe for future generations.

Haifa Al-Faisal
July 2004

4. Percussion cap rifle. *Made in about 1850, this European gun has been modified and decorated in Saudi Arabia. The metal pins hammered in geometric patterns are typical of older Bedouin decoration. The stock has been altered by the addition of a protruding butt piece which keeps it from slipping from under the arm.*

Acquired in the Najd, 1970.

Preface

The Topham Collection was first exhibited in Rochester in 1982, under the same title as the book, *Traditional Crafts of Saudi Arabia*. It then circulated to eight museums under the auspices of the Smithsonian Institution, and to six more museums by direct arrangements between Mr Topham and the museums. This makes a total of fifteen museums over a period of almost ten years.

It attracted a considerable amount of favourable attention everywhere it went, with, according to the museums, higher than usual attendance for travelling exhibitions. It was the first significant exposure of the crafts and culture of the Bedouin and villagers of Saudi Arabia in the United States, and stimulated many other associated lectures and other programmes. Dillon Ripley, the Secretary of the Smithsonian Institution, spoke of the exhibition as a real 'eye-opener' for the West. Mr Topham also lent material to many smaller exhibitions in other institutions.

Major museums where the Topham Collection has been exhibited:

(*Under the auspices of the Smithsonian Institution)

Memorial Art Gallery, University of Rochester, Rochester, New York, 1982
Colorado Springs Fine Arts Center, Colorado Springs, Colorado 1982*
Boston Museum of Science, Boston, Massachusetts, 1983*
The Textile Museum, Washington, D.C., 1983*
Science Museum, Dallas, Texas, 1983*
San José Museum of Art, San José, California, 1983*
Royal Ontario Museum, Toronto, Canada, 1984*
Hanson Memorial Museum, Logan, Kansas, 1984*
The University Museum, University of Pennsylvania, Philadelphia, 1985-87
Metropolitan Museum and Art Center, Coral Gables, Florida, 1987-88
The Field Museum of Natural History, Chicago, Illinois, 1989
Museum of Man, San Diego, California, 1989
Maxwell Museum of Anthropolgy, University of New Mexico, Albuquerque, 1990
Texas Memorial Museum, University of Texas, Austin, Texas, 1991
High Museum, Atlanta, Georgia, 1991

Objects were also lent to a number of other venues including the Seattle World's Fair and the *Palms and Pomegranates* travelling exhibition.

The exhibition at the Field Museum of Natural History, Chicago, Illinois, 1989.

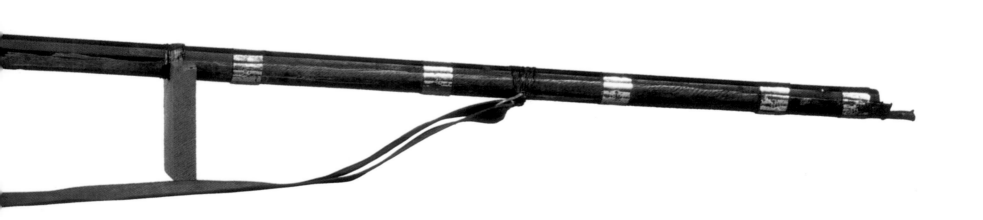

Introduction

My purpose in writing this book is to record the arts and crafts both of the Bedouin and of the villagers of Saudi Arabia before new practical and cheap materials, like plastic, aluminium and nylon, replaced the hand-crafted ornamental accessories of a traditional way of life. Very little research or identification has been attempted in this field, and, while this record, originally compiled for publication in 1982, is comprehensive, it is not complete. My hope is that it may serve as a stimulus for those trying to complete documentation of these fascinating arts and crafts.

Saudi Arabia occupies most of the Arabian peninsula, is about three-quarters of the size of India, and about one-third of the size of the old 48 United States. It is hot, dry and barren except in oases and in some mountainous

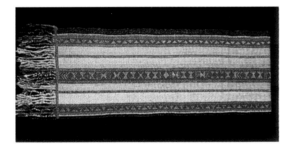

5. Strip rug. *From western Arabia (probably Juhaynah tribe), this geometrically patterned rug consists of warp-faced plain weave stripes alternating with panels of warp-faced complementary warp-pattern weave. It has a striped band of twining at one end and a braided warp fringe. The wool is a combination of camel hair and chemically dyed wools and the edges are goat hair. Made in about 1960, it is 9ft by 2ft 4in. Yarns are 2 x spun, plied s. A detail is shown below.*

Acquired in Rabigh, 1979.

areas. Its people have faced drought, famine and pestilence, but have overcome them, for the Arabs are a resourceful and hardy people. I spent most of the time from the spring of 1977 through to the summer of 1979 working in Saudi Arabia. The collecting and identifying of crafts, especially weavings, became my primary interest. These were the middle or late years of the great change from a dispersed and nomadic culture to an urbanized, semi-industrial and commercial way of life. Great numbers of people had moved to the cities and old tribal associations had become obscure. Although a pride in traditional values persisted, identification of the older material objects associated with them was no longer considered important. It was difficult to find people – even older people – who had an interest in or knowledge of any objects, beyond those with

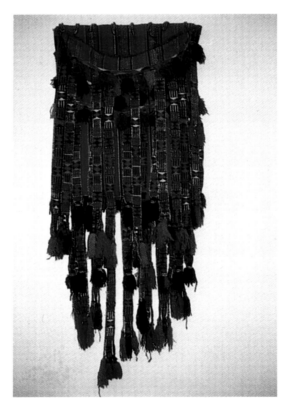

Several Western companies in Saudi Arabia use Bedouin crafts to decorate their offices and houses. This example is a fine camel saddle bag; it hangs with other items in Bechtel's guest house in Al Khobar.

which they themselves had been familiar since childhood.

Although I spent nearly all of my leisure time with dealers and with anyone who could offer information about my subject, and even though I took every possible opportunity to travel – to Ta'if, the Asir, Yanbu, al-Kharj, Dilam, Hofuf, Qatif, al-Jawf and Tabuk – I did not learn in proportion to my efforts. I carried photographs of Saudi-made objects everywhere and showed them to anyone who had the patience to look through them, noting identifications offered and other pertinent comments.

As I assembled the information, I found extensive contradictions. I have made decisions about varying identifications where no consensus could be achieved; these I based on the most reliable information available. Regional identification is generally sound, but I have had to use the words 'probably' and 'possibly' for tribal attributions more often than I would have wished.

It may seem curious that most dates which appear in the book only represent a fifty-year span. It must be understood that drastic change has occurred since the late 1940s, accelerating incredibly since 1970, so that dates related to items have a real significance to those knowledgeable about this subject. Most objects were made in the same way and with the same materials for many generations before the Second World War.

Imported materials were certainly present earlier, but their use has accelerated too, so that now almost the only indigenous materials and work are to be found in weaving, pottery, leather work, basketry and perhaps embroidery, which also increasingly incorporate modern dyes, plastics and machine work. The other element which makes exact dating problematical is that the hard nomadic life and harsh environment ruin and distort many materials. The Bedouin did not want to be cluttered by possessions. He valued the few he had and repaired where he could, but when something became useless, it was discarded or incorporated into a new object.

The reader will find adequate examples of crafts which are illustrated in sufficient variety to serve as a basis for determining the origins of those objects for which I give no certain provenance. The details between these covers represents an honest interpretation of my present knowledge.

Collecting the traditional crafts of Saudi Arabia: a few experiences.

I became interested in Saudi Arabian crafts on my first visit to the Kingdom in 1977. I worked in the Dhahran area, and on Fridays would visit the market in Dammam to buy fruit and vegetables. There, I saw village and Bedouin women selling handwoven rugs of current manufacture on the sidewalk at the gold suq. Here I bought my first Bedouin rug. It was striped in bright colours and had several bands of camel hair. On return trips to Dammam and on visits to Qatif, I was able to acquire about twenty variations on the striped theme.

At this time I also went to Hofuf, in the al-Hasa oasis. On the first trip I was immediately greeted by a man who said, 'Antiques, follow me.' I did so, down a number of alleys to a place where there was an assortment of tent and camel gear, coffee pots and oddments, all exceptionally highly priced. The people were not inclined to bargain so I bought a few pieces of camel gear and left for the main *suq*. In a small corner shop, among stacks of folded factory-made rugs, I found an old twill weaving and bought it. I managed to convey to the shop-keeper that would be interested in more of this type and left him to search while I wandered through the *suq*. I returned to find that the shopkeeper had located three weavings which I also bought. He said one had come from the Najd, the others from al-Hasa.

Interested in learning something of the background of these rugs, I tried to find out where they were being woven and hoped that I could photograph the loom, if not the weavers. But I progressed slowly. Later, in the USA when I tried to research weavings and other crafts of the peninsula, I was frustrated by the lack of any information of consequence, for not only were there no books on the subject but no museums had any samples of the

material. I returned to Arabia, determined to collect a variety of native rugs and to learn what I could of their designs and technical variations.

Jeddah. I spent most of 1978 in Jeddah and soon found the 'rug *suq*', about fifteen small shops opening onto a large square, which was a pilgrim trading center. In the early days of airplanes carrying in pilgrims to Makkah the air terminal was on the other side of this square. The merchants depended a good deal on the pilgrims bringing rugs and other artifacts with them from Pakistan, Persia, Afghanistan, Iraq, Turkey, Egypt and even Nigeria and Indonesia. They brought them to sell in Arabia to finance their trips, but this is now, generally, a thing of the past.

Among these shops I found a few older Persian rugs, but the rug dealers primarily handled great bales of new rugs from Pakistan and Iran. The most commonly found

handwoven rugs were from Pakistan, frequently copies of Bokhara type patterns in different colours. Other handwoven rugs commonly brought in, woven in Iraq, Afghanistan and parts of Iran, were coarse pile rugs in Qashqai pattern, and long pile, with heavily corded edges, often called 'Arab'.

Although I had searched mainly for textiles, picking up only a few other items, I soon realized that the indigenous jewellery was also disappearing. I elected to collect jewellery, with an eye to variety of design motifs and tried to obtain jewellery made in Saudi Arabia as opposed to that brought in from the Yemen and Oman.

There were two shops in the old airport *suq* owned by Abdullah al-Zahrani and his six sons. They had more Bedouin jewellery than any of the other shops, but this, in the year spent in Jeddah, was reduced to a small stock with few remaining choice Saudi pieces. It became my habit in the evenings to go to the

Abdullah al-Zahrani in his shop in Jeddah.

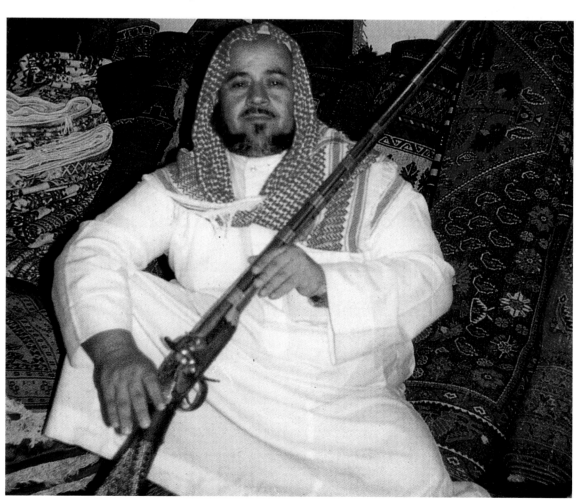

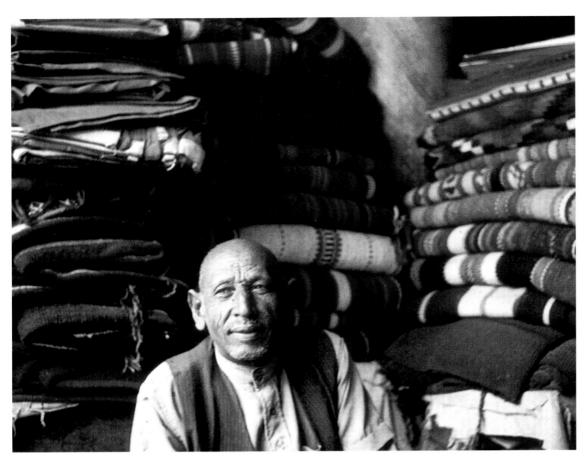

A dealer in Ta'if, one of the few who deals entirely in equipment for the Bedouin, a sweet mannered man, now deceased.

al-Zahranis' shop to sit and talk with them. They and the 11 other shopkeepers were hospitable and very tolerant, and appreciated my interest in old Bedouin things.

Despite the wide variety of rugs available I did not see during my time in Jeddah more than 20 Arabian-made weavings in the entire *suq* except for the occasional modern novelty piece. There were a few embroidered coffee bean bags and some pieces of costume; the traditional Hijaz face masks were sought by Westerners and cost 600 riyals or more. I also bought there a few pieces of costume from the Hijaz, the best of which were older items identified as Bani Salim. Their work was characterized by careful embroidery on the dresses and head shawls and the use of a lot of soft metal beads. I also found intricate woven leatherwork which was also credited to the Bani Salim. The al-Zahranis had in their house some older costumes which they occasionally brought to show me. I bought most of the finer pieces. When they knew I was leaving Jeddah they gave me an exceptionally fine headdress (illustration 133, p.104).

One evening the al-Zahranis told me they

were negotiating for a collection of jewellery, the property of a woman who had died. I was told it was very superior but that they would have to break up the group in order to sell it, which they did not like to do. They suggested I buy it from the estate instead, in order to keep it intact, which I did. It was better silverwork than any other indigenous pieces I had seen, and was believed to have been made by the silversmiths of Najran, whose work has a particular cachet among the dealers.

On another occasion the man who owned the shop next door had an old and worn little round wooden vessel for spice or coffee beans (with a conical top, hinged and decorated with metal tacks), which he had just brought from his home at Yanbu al-Nakhl, which I bought (illustration 245 p.175). The only other example I saw was in the Folklore Museum at Riyadh.

I also obtained several pieces of Makkah-made copper. I was told that copper work has not been carried out in Makkah for many years and that most trays and other metal work now sold there was brought in from Damascus, Baghdad and Pakistan.

Ta'if. On Fridays I would go from Jeddah to Ta'if, a town about 6,000 feet up in the mountains. It is a large town in which many old houses and the old *suq* area survive. There are about thirty shops specializing in rugs in the *suq*. Of these, only one large shop and two or three small shops deal in Arab-made things. The largest, which belonged to two brothers, was the one place in Arabia I found primarily in the business of selling traditional goat hair tents and tent parts. They also had a wide variety of locally-made flat weave Bedouin rugs – plain examples with a great variety of coloured stripes and braided ends. It was also in Ta'if that I found my best example of a tent wall – ending in a profusion of sashes – and an old camel feed bag decorated with beads and cowrie shells. I was friendly with the rug dealers, but when I tried to arrange to photograph someone weaving, or at least the loom, I was told 'We don't know where they come from, the men just bring the rugs in.'

In Ta'if some of the women would sit along the street, trying to sell water skins, which are now a thing of the past. Some would spin as they sat, and bought both sheep wool and goat hair yarn from them, in naturally dyed colours as well as undyed. In the *suq* was a man selling ghee, and a variety of Bedouin-made leather items. I bought several pouches and a sling. In a spice shop I obtained a brightly coloured modern coffee bean bag.

Yanbu. Yanbu is an old sea port. Most old buildings have been destroyed, but there is still a row of shops with the old shutters which retains much of the atmosphere of a hundred years ago. In one small shop was a very old man who sold Bedouin jewellery, neatly displayed, of which he was very proud. He bargained slowly and ceremoniously.

On the road from Yanbu to Jeddah is a town called Rabigh where I found a small old *suq*. Here I found a fine pair of simple camel bags in natural colours with well-made wrapped tassels. A local Arab guided me to an inland semi-settled area to find a long narrow

Inset right: *Weaving a pile rug on a ground loom in Sakaka, al-Jawf.*

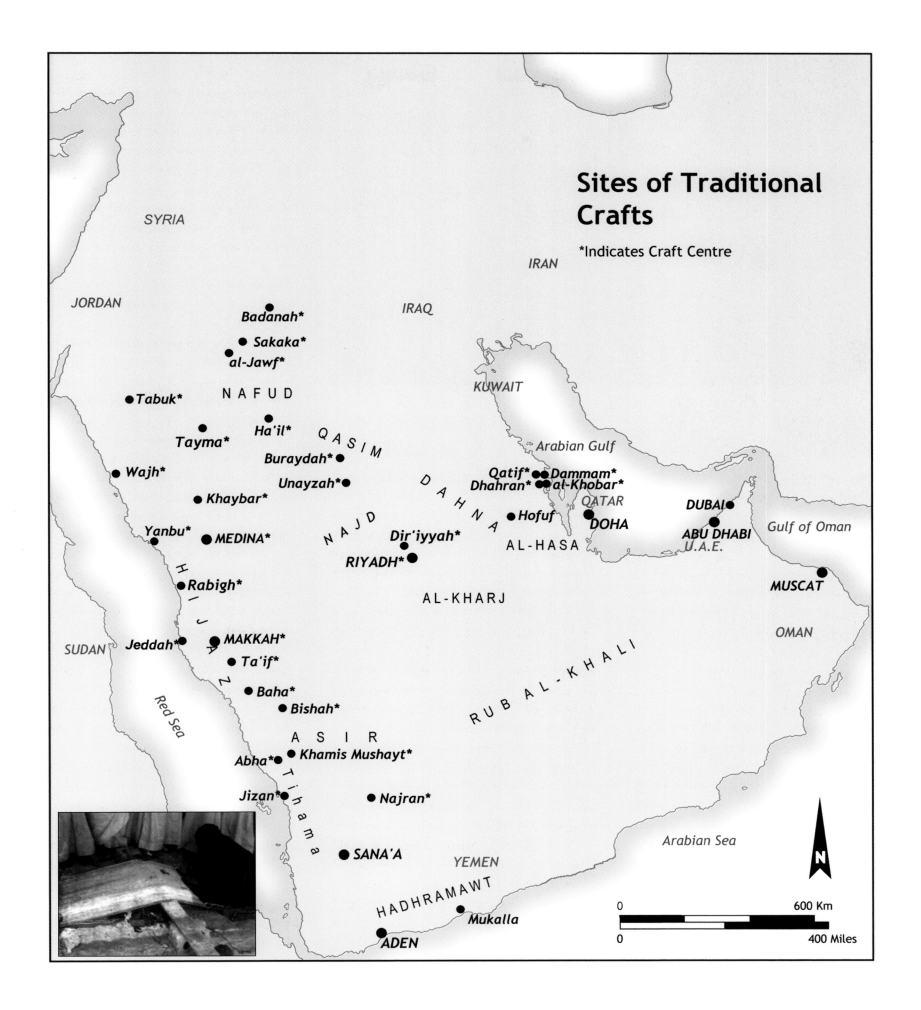

Sites of Traditional Crafts

*Indicates Craft Centre

SYRIA

JORDAN

IRAQ

IRAN

KUWAIT

Badanah*

Sakaka*

al-Jawf*

N A F U D

Tabuk*

Ha'il*

Tayma*

Q A S I M

Buraydah*

Wajh*

Unayzah*

D A H N A

Qatif* Dammam*

Dhahran* al-Khobar*

Arabian Gulf

Khaybar*

QATAR

DUBAI

Yanbu* MEDINA*

N A J D

Dir'iyyah*

Hofuf

DOHA

ABU DHABI

Gulf of Oman

RIYADH*

AL-HASA

U.A.E.

Rabigh*

AL-KHARJ

MUSCAT

H I J A Z

Jeddah* MAKKAH*

OMAN

Ta'if*

R U B A L - K H A L I

Baha*

Red Sea

Bishah*

A S I R

Abha* Khamis Mushayt*

T i h a m a

Jizan* Najran*

Arabian Sea

SANA'A YEMEN

N

HADHRAMAWT

Mukalla

0 600 Km

ADEN

0 400 Miles

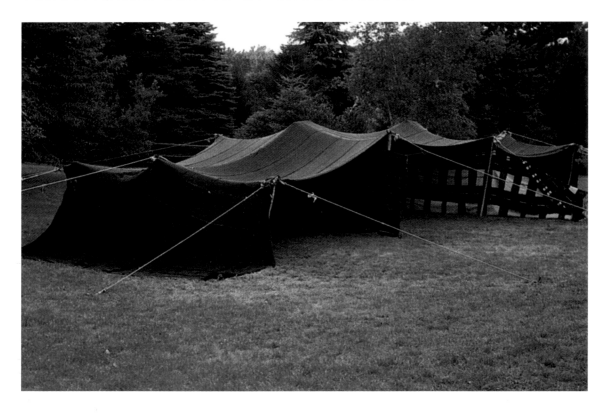

A typical Ruwala tent set up in Pittsford, New York. The large and elaborate tent wall in the background is from the Shararat tribe.

rug with two bands of camel hair through the middle and bands of geometric patterns. Here I also saw a woman wearing a magnificent face mask and an apron covered with gold coins, which I was not able to buy. I managed to purchase another mask there, however, although it was clear from its appearance and the time that it took for my Arab guide to fetch it from a house, that the owner had removed some of the baubles from it before she would let it be sold.

Riyadh. I left Jeddah in early 1979, but returned to Riyadh shortly after, mainly to pursue my interest in rugs and crafts in central Arabia. Near the main mosque in Riyadh were three or four shops known as 'antique shops'. The most important was run by a man called Suliman, whose shop was piled high with objects of all kinds. He had a great variety of guns, some leatherwork, bags, and Middle Eastern novelties. I bought from him a very old *dallah* (coffee pot) said to have been made in Unayzah.

I visited Suliman often and one afternoon he led me to a building which turned out to be his warehouse. Here were two floors of copper and brassware, mostly newly brought in from Damascus, Baghdad and Pakistan, along with some older Arab pieces including four very good camel bags. Another time he led me to his large old adobe house. In one courtyard and piled on its balconies were over a hundred Makkah, Medina and Kuwaiti chests. Another courtyard was piled high with enormous cooking vessels. To the side of it was a caged room, about eight feet wide by twenty feet long, with four foot high rows of coffee pots, *dallahs* mostly of older Arab manufacture. On the upper level around one of the courtyards were three old camel litters. There was also an old bent wood and leather basin for watering camels. He even had a partially destroyed but fine *miraka*, which he said once belonged to Ibn Saud, which he allowed an Arab friend to pre-empt me on buying so that the piece should stay in Arabia.

A well-known source of jewellery is the women's *suq* near downtown Riyadh. Arab women, both intermittent and regular shopkeepers, bring jewellery and various other objects there to sell. They lay out the items before them in trays on the ground, with some of the better things in lidded cans (especially Danish butter cookie cans). I have on occasion seen cans of pearls there. I made friends with

the personable Umm Abdullah, the doyenne of this *suq*, which relationship did little to mitigate the high prices. When she would reluctantly make a small concession she would say, with sadness, 'Oh, *sadiq*' (Oh, friend). There were women's garments for sale in this *suq*, though I never saw any headdresses. It was also the only place in which I found the sought-after oval, gilt forehead piece (illustration 76). Umm Abdullah told me they were made in Unayzah, and worn primarily in the al-Dawasir area.

The Southwest. From Ta'if a friend and I made a five-day trip through the southern Hijaz, Baha and the Asir, almost to Najran. In the Baha villages I obtained two rugs and in Abha I found local grass baskets and clay incense burners. Khamis Mushayt has a Thursday market, where I found two large upper arm bracelets said to be made in Najran. I suspect they were meant for trade in the Hadhramawt where some men wear bands on their upper arms, as some Bedouin in Arabia long ago used to do.

On the way to Najran, we stopped at a roadside stand where I showed the owner pictures of rugs to see if he knew of weavings in the area. An Arab who came by invited us to follow him to his house where there might be things of interest. This was many miles across rough country. I found there an unusual very old *mubarrad* (coffee bean tray) with a lid, the only lidded *mabarrad* I have seen. There were also several good pieces of jewellery, but no good or unusual weavings. We were treated to an excellent lunch including superb mutton broth and *leban*, which took such a long but enjoyable time to consume that we abandoned our plan of going into Najran.

Al-Kharj. In the town of Salamiyah in al-Kharj there is a women's *suq*, a large covered structure with many passages. Mostly the trading was among local people and I found an excellent solid red rug finely woven with broad end bands. I bought some camel decorations from an old woman, a joker, who in good humour tossed the end of a dusty tent wall over my head when I had my back to her while examining the other end of it.

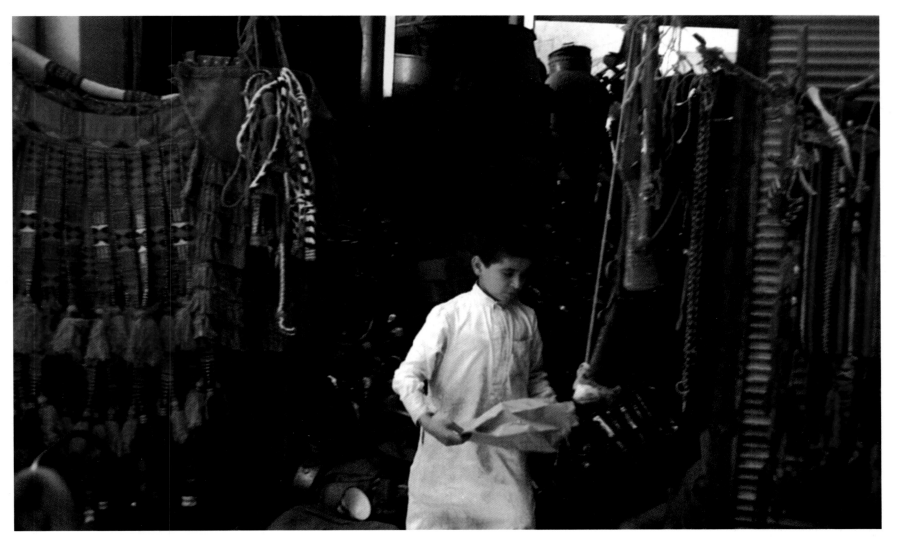

Suliman's son, then aged 10, in his father's antique shop in Riyadh.

The Bedouin and village people who can possibly afford it are now buying gold jewellery. Most of the gold work sold in the gold *suqs* in Arabia is manufactured in Italy. The Yemeni, Omani and other silversmiths once found in all consequential towns have since gone elsewhere or changed businesses. In Riyadh, the so-called Yemeni *suq* used to have twelve or more Yemeni silversmiths. In 1979 I found only three or four remaining and others have been replaced by the gold-selling shops. In Jeddah I did not find a single silversmith making jewellery; those I found did only minor repair work. In Ta'if there were four or five shops repairing and dealing in jewellery, but several shops still make or repair silver casings for daggers and swords and make souvenir daggers. One shop soaked Bedouin jewellery in acid, removing all the patina and leaving the pieces a most unattractive white colour, hoping to lure Bedouin and villagers who could not afford gold. This is common in

a number of places, and many good old pieces have been ruined.

Leather vessels are being replaced with buckets and containers made from old tires and I saw several camels with inner tubes full of water draped around their humps. Most weavings of current manufacture are loosely

woven; the geometric motifs when used are not well defined, the dyes are chemical and the colours often harsh. Little work in any craft today is as well done as that of even ten years ago.

J.T.

The Bedouin and Settled People of Saudi Arabia

. . . a large party of the Qubabina on the march from the watering of Ba'aija farther north to Ghail appeared over the sky-line of the ridge which forms the left bank of the valley, and advanced towards us. A Badawin tribe on the march is always a splendid sight, and these were no exception to the rule, the party consisting of some thirty men heading the procession on gaily caparisoned Dhaluls and perhaps a hundred or more women and children riding in their weird carriages or on the loads of the baggage animals with half-a-dozen watch-dogs in attendance. The women were all clad in red smocks with black veils about their heads, but otherwise seemed to enjoy complete liberty of movement among the men and had, of course, to bear the lion's share of the work that ensued upon the arrival of the party at the wells – the pitching of tents, the sorting of the luggage, and tasks of that nature – while the men disposed themselves in comfortable circles, making coffee and conversing until such time as the watering should be at their disposal.

The tent-dwelling nomad of the Arabian desert, so evocatively described above by the great early 20th-century traveller, St John Philby, in *The Heart of Arabia*, is known as a 'Bedouin', from the Arabic word Badawi, meaning 'tent-dweller'. Townsmen use the term; the Bedouin is most likely to refer to himself simply as 'an Arab'. Those who no longer live the nomadic life still point with pride to their Bedouin ancestry and to the purity of race this implies. The ruling family of Saudi Arabia, for example, which long ago became land owners and town dwellers, traces its descent from the great Bedouin tribe of northern Arabia, the Anazah. Ancient historians and genealogists of Arabia believed that all true Arabs could trace their ancestors either to Qahtan, who has been identified with the Biblical Joktan, or to Ishmael, the son of Abraham and Hagar.

Certain small Bedouin tribes, such as al-Sulabah and al-Awazim, however, are not thought of as pure Arabs by the rest of the Bedouin. Considered descendants of neither Qahtan or Ishmael, their origins are obscure; legends hold al-Sulabah to be descendants of medieval crusaders (there is a similarity between the Arabic word for cross, *salib*, and the name of the tribe). The men of al-Sulabah are trappers, tinkers and musicians. The al-Awazim, among the earliest supporters of King Abdul Aziz ibn Saud, have a preference for raising sheep rather than camels. No Bedouin of lineage will intermarry with members of these tribes, despite the fact that the women of al-Sulabah are regarded as among the most beautiful of the desert.

The Bedouin tribe is an extended family, rather like a Scottish clan, and its members are all related. Tribal law meant that a Bedouin could give loyalty to no authority other than his tribe. The leader of the tribe, the *shaykh* or *emir*, was usually chosen from a few specific branches of the tribe, but his authority came by consent of the tribesmen, rather than by right of lineage. A member of the tribe was always protected and assisted by his tribal brethren. His actions were the responsibility of the tribe; his debts were the debts of the tribe. Property

was, in contrast, not shared; each animal and tent, and most of the wells, belonged to an individual or family.

Over the centuries the lifestyle of the Bedouin has become perfectly adapted to the rigors of life in a harsh environment. Traditionally, his principal occupation is the raising of camels and sheep; because of the climate he is constantly on the move in search of grazing and water for his flocks and herds. All but the sand deserts provide grazing, but vegetation is sparsely spread. Water, too, is scarce. During the hard summer months the Bedouin pitch their tents around the wells owned by the tribe, but with the first rains, they strike out for the desert, heading for the rock pools, wadis, and areas of shallow wells which the rain has filled, moving on so as not to overgraze.

The camel, once the principal form of transport in Arabia, is today largely raised for its meat and milk. Much prestige is still attached to the ownership of camels, but the economic justification for raising them has now diminished. Unlike the tribes which raised camels, which can survive many days without water, the sheep breeders used to be restricted in their movements to a relatively small range

Bedouin women starting to erect a tent.

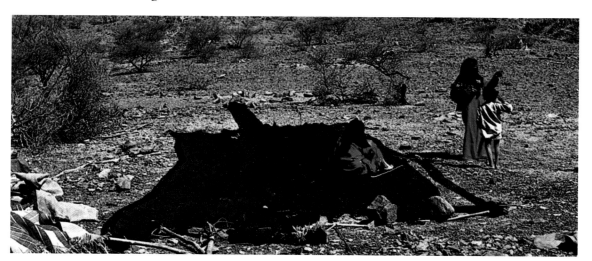

around permanent water. Today, with pick-ups and trucks widely in use, sheep raising practices have been revolutionized.

Traditionally, every Bedouin tribe has principal or prior rights to a large area called a *dirah*, the extent of which can cover thousands of square miles. These rights are still acknowledged, not only by other tribes but also by the different governrnents of the Arabian peninsula. The boundaries of these tribal ranges often appear to overlap, but war, custom, tribal confederations and alliances have resulted in generally recognized limits. In the past the Bedouin seldom took their flocks and herds outside their tribal ranges, although when rain was scarce they were forced to look for other pastures, preferably those of their allies. Their only other recourse was to graze by stealth or force in enemy lands.

Since the Government of Saudi Arabia has removed the threat of inter-tribal raiding and wars, the tribes are less confined by the boundaries of their own dirah, and today tribesmen from the edge of the Rub al-Khali in the South can be found grazing their animals near the borders of Kuwait and Iraq, while Bedouin from the steppes of the Hijaz in the West might wander near the oil installations of eastern Arabia. As one Bedouin has said, indicating an incipient sense of nationalism: 'Now the whole desert is the *dirah* of King Abdul Aziz.'

The Bedouin are thought to speak 'pure' Arabic, a language close to classical Arabic, uncontaminated by the foreign elements prevalent in the towns. The Holy Prophet Muhammad was sent as a boy to live among the Bedouin, and he claimed as an adult to speak the pure tongue of the desert. As well as for purity of speech, the Bedouin are renowned for bravery, chivalry, hospitality and generosity. Material possessions matter less than the obligation to a passing stranger. A Bedouin will slaughter his last goat, or even camel, the milk of which is his staple diet, to provide a good meal for a guest; one of the greatest insults he can suffer is to be called miserly. A man can die so easily of hunger, thirst and lack of shelter in the desert that it is unthinkable not to help a fellow human. Even an enemy is guaranteed three days' hospitality and protection in a Bedouin tent.

Bedouin society, however informal it might appear, is structured, democratic, and effective – the logical development of centuries of adaptation to some of the world's most severe living conditions. The process of settlement has accelerated, and the number of those living the nomadic life exclusively has declined dramatically, so that there are few still living in tents and tending animals.

In the days before King Abdul Aziz put an end to raiding among the tribes, a young man often started his own herd by successful raids on the camels of his tribal enemies. Raids were also made by whole Bedouin tribes, who had lost herds to drought or disease, on more fortunate tribes. Thus was a rough and ready economic balance maintained. A Bedouin would ride his camel to the vicinity of his enemy, then use his horse for the attack. He was by nature a hunter rather than a farmer, who found delight in the art of falconry, the training of salukis and the breeding of the beautiful Arab horse. His husbandry was usually limited to harvesting his date palms.

Nowadays this warlike heritage might draw him into the armies and police forces of the Arabian peninsula. The National Guard of Saudi Arabia, for instance, not only comprises preponderantly Bedouin soldiers, but many of its units are organized along tribal lines with appropriate tribal leaders in command.

Many Bedouin, particularly those of the al-Murrah tribe from the northeastern perimeters of the Empty Quarter, are today employed in their traditional role as trackers, at police stations. Of necessity, they know a great deal about nature. They guide themselves by the stars, and are conversant with the properties of plants as food and medicine. They are masterful trackers and will wander miles on the trail of strays. Dickson, Philby, Thesiger and other travellers relate many stories of the ability of the desert dwellers to read the tracks of men and animals left in the sands. The al-Murrah trackers' testimony in court bears much the same weight as that of fingerprint experts.

The life of a Bedouin woman is still one of continuous work and attention to the animals, especially if her tribe are sheep-herders. Her duties include bringing up the children, cooking, weaving, embroidery, pitching, striking and loading the tent, and occasionally herding. In the past some wives and daughters of wealthy Bedouin on the move rode in a gaily decorated camel litter called a *dhalla*, or in a simpler *ginn* or *maksar* which was covered for protection from the sun. Before the introduction of firearms, young women frequently accompanied their menfolk to battle and cheered them on from specially constructed and decorated litters on camel back. The Ruwala tribal and battle standard was a large frame decorated with ostrich feathers carried on a camel, called *abu adh-Dhur* or *al-Markab*, and it was large enough to hold a girl exhorting them to fight. Musil photographed it before 1908; his photograph is illustrated overleaf.

The Bedouin tent is made of long strips of black and brown cloth woven from goat's hair, sometimes with a mixture of sheep's wool. These strips are sewn together to form the roof and the sides of the tent. One side, away from the prevailing wind, remains open. The hearth is a prominent feature of the tent, its position varying according to the weather. In the case of the wealthier Bedouin, it is generally surrounded by richly woven rugs and cushions, and coffee pots, kettles and other equipment. The hearth is situated in or near the men's quarters where guests are entertained. The tent also includes a kitchen area, and a family or sleeping area.

A Bedouin in the Eastern Province holding a falcon. The falcon stand is in the foreground.

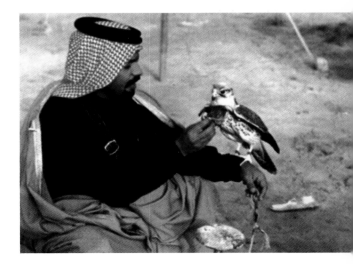

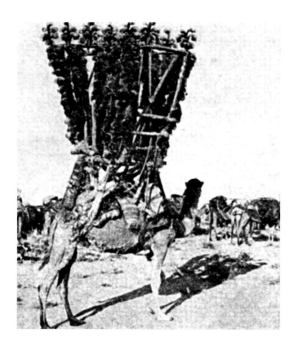

*The Ruwala tribal and battle standard, decorated with ostrich feathers (*abu adh-Dhur*), as photographed by Musil before 1908.*

A sketch of a typical Bedouin tent from Musil's Manners and Customs of the Rwala Bedouin.

Bottom: *An exceptionally fine tent curtain from Sakaka in al-Jawf (possibly from the Shararat tribe).*

The main tribes of Saudi Arabia

The pre-eminent tribe of northern Arabia is the Anazah. This group fills the northernmost part of Saudi Arabia and extends far into present day Jordan and Syria. The Ruwala section of the Anazah, one of the tribes said to be descended from Ishmael, is larger and more powerful than many of the tribes further south, and is regularly to be seen in the vicinity of the Trans-Arabian Pipeline Company's stations of Turaif and Badanah. Tribesmen of al-Sulabah also frequently camp near Badanah.

The Shammar bound the Anazah on the southeastern side, and branch into northern Iraq. Ha'il and Rafha are in the range of the Shammar, and in general it may be said that the Sinjarah and al-Tuman sections of Shammar lie west and north of Rafha, while al-Aslam and Abdah are to the south and east.

Hutaym, Harb and Mutayr form a band, more or less from west to east, between Anazah and Shammar to the north, with the large tribe of Utaybah to the south. The tribe of al-Dhafir ranges between Iraq an Saudi Arabia to the west of Kuwait. In Kuwait itself are the al-Rashayidah with, to the south of them, the al-Awazim.

Bani Khalid, Bani Hajir, al-Ujman and al-Murrah roam throughout the Eastern Province of Saudi Arabia, with the al-Murrah extending south into the sands of the Rub al-Khali. The Utaybah are the most numerous tribesmen of the Najd; the Subay, Qahtan, al-Suhul and al-Dawasir also have their ranges in the Najd, with al-Dawasir centered on the wadi to which they have given their name. An ancient tribe that is spread throughout the central Najd is the Bani Tamim. They have now primarily become townspeople, but many of them retain their older customs and dress.

Billi, Harb and al-Buqum are usually to be found on the western fringes of the Najd, where the high steppe meets the mountains of the Hijaz; Juhaynah is the principal tribe of northern Hijaz. In the highlands south of Ta'if are the Ghamid and the Zahran, who spill down into the Asir. Here the other major groups are Bani Malik, Shahran and Yam. The ancient tribe of Yam have many sub and associated groups and wander across the western third of the Empty Quarter.

Along the southern edge of the Rub al-Khali, are the Dahm, Abidah, al-Say'ar, al-Mahrah and al-Harasis; the Nu'aym, Bani Yas and al-Manasir have traditionally ranged between Qatar and Oman, but now are sometimes found grazing as far north as the border between Saudi Arabia and Iraq.

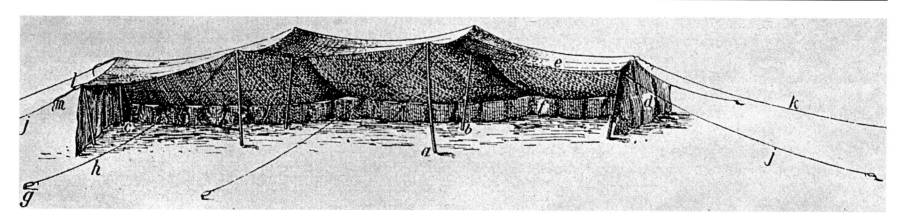

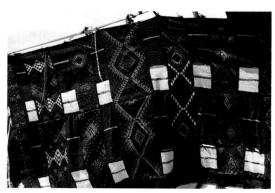

Coffee drinking was unknown in the days of Muhammad, but for centuries the preparation and drinking of coffee has been a ritual. The arrival of a guest precipitates the making of coffee; the sound of the pestle in the mortar and the smell of roasted coffee beans is a signal to others in the vicinity that they are welcome. 'He pounds coffee from morn till night' is the Bedouin way of saying that a man is a generous host.

In contrast to the Bedouin, the settled folk of Arabia have never really attracted the romantic attention of writers and travellers. They have tended their date palms, raised the white donkeys of eastern Arabia, ministered to the social and religious needs of their neighbours, organized camel caravans, and conducted the maritime activities of the coastal regions. They have bought and sold, traded and

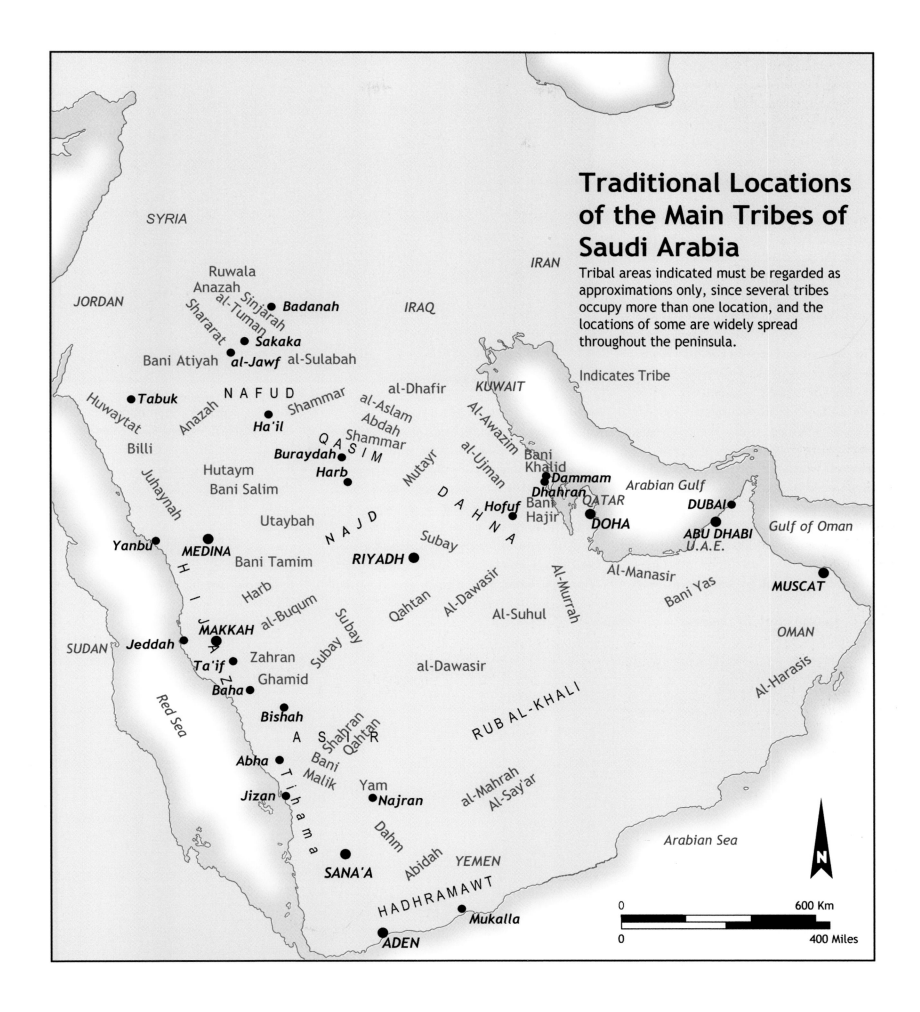

Traditional Locations of the Main Tribes of Saudi Arabia

Tribal areas indicated must be regarded as approximations only, since several tribes occupy more than one location, and the locations of some are widely spread throughout the peninsula.

● Indicates Tribe

SYRIA

JORDAN

IRAQ

IRAN

KUWAIT

Ruwala
Anazah
Sinjarah
al-Tuman ● **Badanah**
Shararat
Bani Atiyah ● **Sakaka**
● **al-Jawf** al-Sulabah

● **Tabuk**
Huwaytat
Billi
Anazah
N A F U D
Shammar al-Aslam
al-Dhafir
Ha'il Abdah
Shammar
Q A S I M
Buraydah ●
Hutaym **Harb** ●
Bani Salim
Mutayr
al-Ujman
Al-Awazim
Bani
Khalid ● **Dammam**
Dhahran
Arabian Gulf
Utaybah
N A J D
D A H N A
Hofuf ●
Bani
Hajir
QATAR
● **DOHA**
DUBAI ●
ABU DHABI ●
U.A.E.
Gulf of Oman

Juhaynah
● **Yanbu**
● **MEDINA**
Bani Tamim
Subay
● **RIYADH**
Al-Manasir
Bani Yas
● **MUSCAT**

H I J
Harb
al-Buqum
Subay
Qahtan
al-Dawasir
Al-Murrah
OMAN

SUDAN
● **Jeddah** ● **MAKKAH**
Z
Ta'if ●
Zahran
Ghamid
Subay
al-Dawasir
Al-Suhul
Al-Harasis

● **Baha**
● **Bishah**
A S R
Shabran
Qahtan
R U B A L - K H A L I

Red Sea
● **Abha**
Bani
Malik
Yam
● **Najran**
al-Mahrah
Al-Say'ar

T i h a m a
● **Jizan**
Dahm
Abidah
YEMEN
Arabian Sea

● **SANA'A**
HADHRAMAWT
● **Mukalla**

● **ADEN**

| 0 | | | 600 Km |
| 0 | | | 400 Miles |

N

cultivated the oases and other sufficiently watered areas.

In central Arabia the settled folk traditionally live in one or two storied sun-baked houses, though here, as elsewhere in Arabia, concrete is being increasingly used. Mud bricks are the traditional building material in this area; they are also used in the West with coral from the sea. In the East similar buildings are augmented by palm leaf shelters known as *barastis*. The palm fronds and leaves are lashed together with palm fibre cord, and the interiors sometimes finished off with an inner coating of gypsum on the walls. These structures are cheap, use local materials, are easily replaced, and remain relatively cool in summer.

The agricultural people of the towns, villages and farms of the Hijaz and Asir still often live in walled compounds. These contain three to five storied towers, originally used for surveillance, which serve as living quarters. Most buildings in the Asir are constructed wholly or in part from stone. Here, too, mud is used as a building material, protected by rows of projecting stones to stop rain from washing away the surface. In Jizan and other settlements with populations mostly of African descent, dwellings are often constructed from mud or palm fronds, with

palm frond 'beehive' roofs.

In these communities agriculture continues to be an established activity and dates the principal crop and staple diet. Many varieties, differing widely in quality, are grown, with the *khulas* of al-Hasa considered the finest. The space between the palms is also cultivated – with alfalfa used for animal fodder; in a good year it can produce up to ten cuttings. Other crops, including most types of grain, rice and

cotton, have also been grown at different times. Vegetables too, have been raised, but only recently in any quantity. Poultry and dairy products are usually kept for consumption by the owners of the animals; cattle, usually of Asian stock, are rare, except in major oases and the Asir, where they are used for work as well as for their milk, beef and leather. Complicated irrigation systems have been developed over the years in the

Below: an adobe village in Yamama, south of Riyadh.

Above: the oasis of Dir'iyyah

Above: A date palm grove near Dilam in al-Kharj.

Below: Terraces and farmhouses in the Asir.

oases while near wadis fields are planned to take adantage of flooding; in both cases animals are still used as a source of natural fertilizer.

Before the coming of oil, there was little industry in Arabia. There were, however, the thriving crafts of boat-building, tanning, weaving and the metalwork for the manufacture of brass coffee pots, cooking utensils, and ornamental daggers. Trading these objects would bring Bedouin and villager together. The townsmen or villagers own and operate the shops in the market (*suq*) where the Bedouin trades. He in turn brings his animals, wool, hides and clarified butter (*samn*) to sell or barter for the dates, rice, coffee, tea and condiments he requires, as well as the clothing he and his family wear. Here also he buys his ammunition, guns, and other items such as daggers, cartridge belts, sandals, incense and perfume. Bedouin women occasionally sell their weaving or the handspun yarn itself, though most purchasing was and still is done by the man of the family – Bedouin and townsman alike.

In larger towns the markets usually open every day except Fridays. In the villages one day in the week is fixed as market day; village names often incorporate the day the market is held. For the people of neighboring villages and the nomads it is a festive and social occasion – an opportunity not only to trade but also to catch up on news, and see friends and relations. Thus the suq remains an important part of the lives of both the settled folk and the Bedouin of Saudi Arabia.

W.E. Mulligan
One of the most experienced and knowledgeable writers on Saudi Arabian culture.

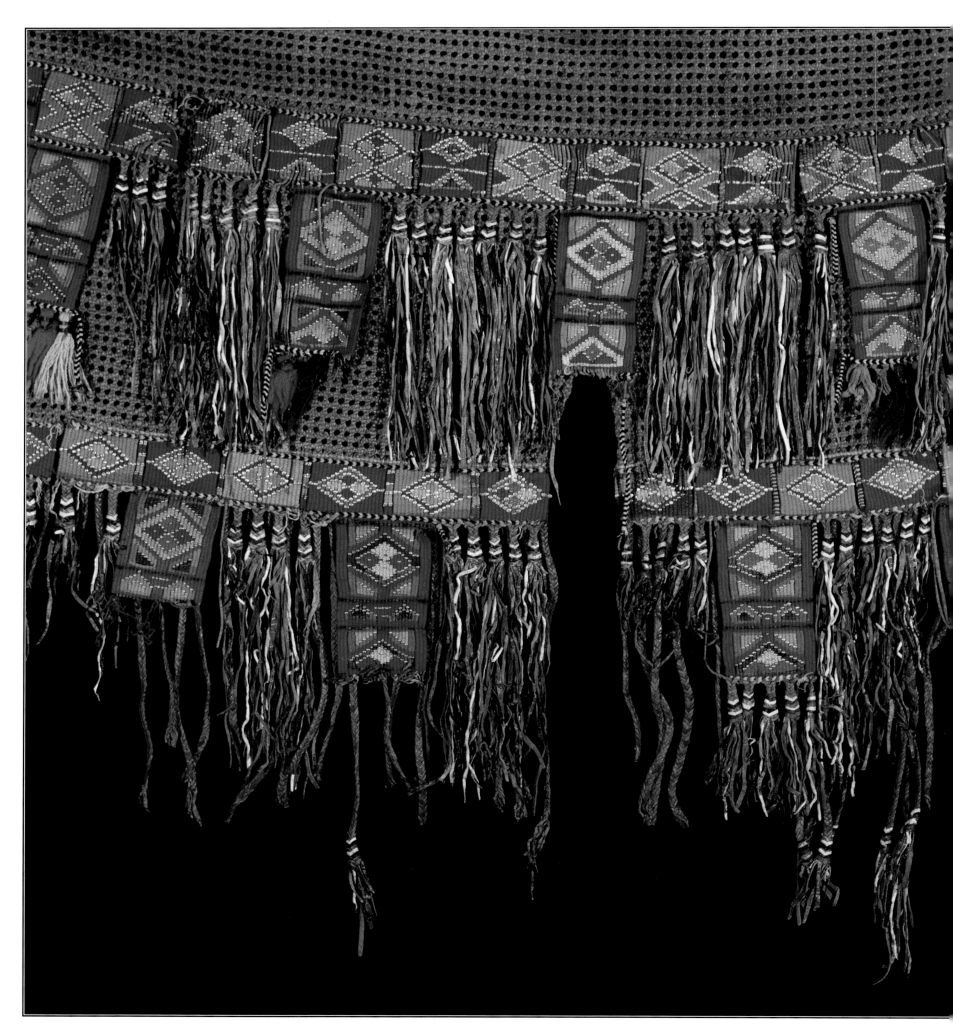

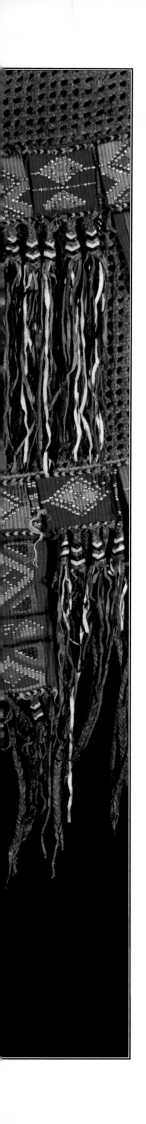

WEAVING

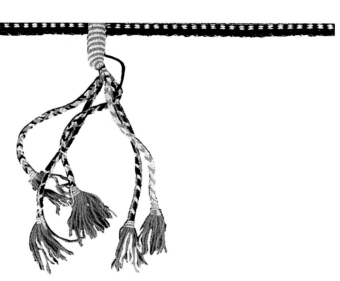

In its early history Arabia lay across the great land-sea trade route between China and India, and the West.

With the advent of Islam, Arabia became a religious and imperial centre reaching west into North Africa and Europe, and east into Persia, Khorasan and beyond. With the ascendancy of the Ottoman Empire the imperial centre shifted north to Asia Minor, and more northerly overland routes to China and the East opened. But while Arabia lost its significance in world trade, its communication with East Africa continued; and although the Caliphate shifted to Istanbul, the significance of Arabia as the centre of Islam continued unabated. The Hajj or pilgrimage to Makkah brought the faithful from the whole Muslim world to Arabia and did much to bring about the diffusion of culture there.

For centuries rugs, as well as other arts and crafts, have been brought to Makkah by pilgrims from all over Asia and Africa, and these have been used throughout Arabia. Tribal society of Arabia, however, resisted change; outside

6. Camel shoulder decoration. This finely woven miraka *from eastern Arabia falls on either side of a camel's neck. It consists of open work braided leather strips with fringes at the bottom. Small 'tags' of weft-faced twined tapestry over leather warp are attached to the leather apron; the weft twining material is mostly cotton, predominantly red and orange. Cast metal beads are threaded on to the leather warp. A highly disciplined piece of work, it was made in about 1960 and measures 31in high. A detail is shown on the preceding pages.*

Acquired in Hofuf.

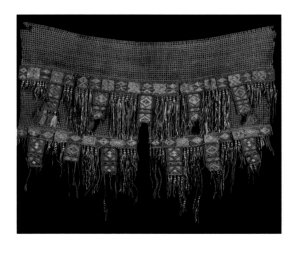

influences were, until recently, absorbed very slowly. While reflecting to some degree ideas from East and West, most rugs found even recently appear essentially to be of Arabian desert and village design and technique as practised for centuries.

The uses to which Arab tribal weavings are put revolve around daily life in the desert; they include tent walls, animal trappings, blankets and floor rugs for the tent. Textile elements are found in many objects made by Arabs for their own use; beyond village and Bedouin barter, few were for sale.

Clues to the forces at work in Arabian weaving can be found in both designs and techniques, and it is in spinning that the heterogeneity of Arab weaving can be most clearly seen. Most spinners in the rug weaving area, from Turkistan through Persia and Turkey into eastern Europe, use the cz spin for yarns. The twist of the spin yarns slants in the direction of the centre part of the letter z, from the upper right to the lower left. Plies of two or more yarns, (usually two for wool, more for cotton), are in the opposite or cs' direction. The slant of the twist of the plied yarns is in the same direction as the centre part of the letter s, from the upper left down to the lower right. By contrast, in much of the weaving of Ethiopia, Egypt and other areas of Africa adjacent to Arabia, s spun yarns are plied together, two or more, in the z direction.

Some Arabian fabrics display both s and z spinning in the same woven piece, reflecting both the Oriental and the East African techniques. In the southwestern highlands opposite Africa, we find yarns almost exclusively s spun, while in the Hijaz and further north, fabrics are mostly made using the z twist. In the central Najd and the Gulf region, both s and z spinning are found, although the z spin dominates.

Weaving techniques, too, show the same mixture of influences. The twining technique (except at the start and finish of loom-woven items and in isolated decorative rows) is seldom used in the Oriental rug area, while it predominates throughout Ethiopia and the Horn of Africa. Twined tapestry is also prevalent. Knotted pile rugs are not indigenous to Africa; the concept of the knotted rug was brought to

North Africa by the Ottomans and spread from Egypt to Morocco and even to Spain.

In Saudi Arabia, twining and twined tapestry are often mixed with other types of weaving. We also find that the rugs of al-Jawf – the only identified location where pile rugs are made in Saudi Arabia – are knotted in the so-called 'Turkish' or symmetrical knot, indicating Ottoman and Turkic tribal influences. These rugs are similar to the Qashqai in layout, with, however, important differences: instead of rows of plain weave ground weft between rows of knots, rows of weft twining are often used between rows of knots as a foundation in the Arab pieces; this appears to be an Arab innovation.

Other technical correlations also exist. Again in the Oriental rug area, most weaving,

except for a few long, narrow (often tablet woven) animal trappings and warp-faced tent bands, is weft-faced and weft patterned. The kilim, pile rug, soumak and brocaded weaving of Turkey, Persia and Turkistan are weft-oriented structures. While weft patterning is found in East African weaving, warp patterning techniques too are prevalent. In Saudi Arabian textiles both warp-faced warp patterning and weft-faced weft patterning are common, very often in the same fabric. One of the most fascinating aspects of Arabian weaving that so many different weaving structures are often found in a single example.

Along with other warp and weft pattern techniques, twined tapestry also seems prevalent throughout Saudi Arabia. Some soumak brocading is found in accessory items, but

generally little wrapping or weft float brocading occurs which is unlike the predominance of these features in the Oriental rug area. Weft-faced plain weave tapestry is found in kilims in the North, occasionally in slit and dovetailed techniques, but most frequently in interlocking or double interlocking joining. These weft-faced plain weave kilims are not so common as the twined tapestry weaving, and seem to be a modern adaptation. In some cases, as for example in some al-Jawf weavings, the knotted pile is not tied in rows as it is in Turkey, but staggered so that alternate rows of knots are on adjacent warps to create a diagonal effect.

Designs, like the weaving techniques, demonstrate a variety of influences, although their predominantly geometric character gives them a distinctly Arabian quality. These

patterns are often based on strong vertical or horizontal stripes, sometimes combined into plaids. Within the general layout of stripes and plaids are contained smaller geometric motifs: usually triangle, x and hourglass figures. Symbolic motifs such as the tribal *wasm* marks may also be woven in.

The general layout of these fabric designs shows more affinity to Africa than to the Middle East. The logic and restraint, along with the remarkable lack of stylized representational elements, while perhaps not intentional, certainly befit the strict observation of Islam in Arabia. The Oriental rugs which were traded into Arabia, plus contact in the north with such groups as the Kurds, may have influenced techniques and designs; but on the whole, Arabian weaving has maintained a native simplicity in design, with an exuberance for added ornamentation, such as appliqué, leather strips, braiding and tassels. The colours are bright, perhaps balancing the austerity of life in the desert.

The predominant weaving materials are wools from sheep, camels and goats, although cotton is quite common, especially for the white sections of designs. The yarns are still largely hand spun using drop and hand spindles.

A great many of the bright colours in the rugs appear to be synthetic, especially in the more recent pieces (fastness of dyes not being an important consideration in this arid country), but some of the softer colours in the older textiles are likely to be natural. Undyed wool is frequently employed in natural shades of brown, grey and black and is blended into the spinning. Travellers have remarked on large-scale indigo production in the early part of this century, as well as other natural plant dyes. Topham reports seeing pomegranates, onion skins and other plants sold along with European dyes. Some dyes, not notable for their fastness, are imported from India and Indonesia – a line from a Bedouin love poem describes love lasting no longer than the dyes from India. Since the 1970s natural dyes have been replaced with chemicals in most areas. Henna and onion skins are still

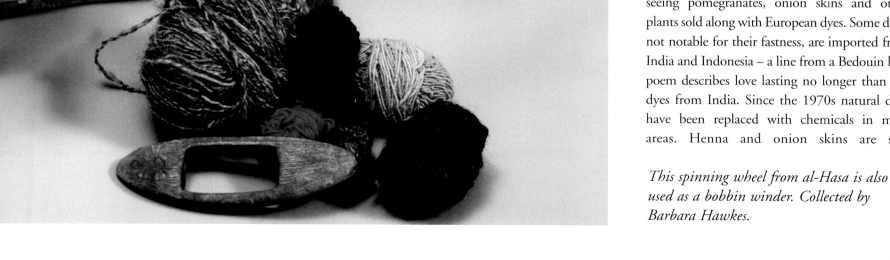

This spinning wheel from al-Hasa is also used as a bobbin winder. Collected by Barbara Hawkes.

occasionally used. Manufactured yarns, factory dyed, are in common use.

In typical Saudi Arabian tribal weaving, a simple horizontal ground stake loom is employed for the weaving of widths – from a few inches up to three feet. For large items such as tent walls, two to five widths are sewn together along the selvedges. The long warps are stretched out between long horizontal beams staked into the ground. The weaver sits on the finished cloth and moves the heddle bar away from her as the weaving progresses. The single heddle bar is elevated slightly on concrete or wooden blocks, or even oil cans, for shedding, with a heddle stick used to make the alternate shed. A flat wooden weaving sword is used to hold the shed open and for beating. Yarn is

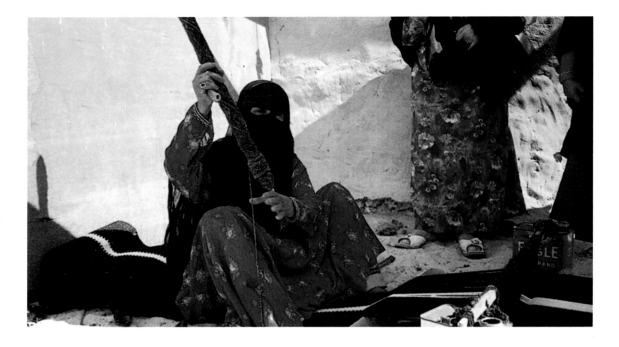

Above: An al-Hasa woman holding a shuttle stick wrapped with yarn.

Above: A ground loom in use in Sakaka, Al-Jouf.

wound on a stick used as a shuttle. The parts of the loom are in lengths not much longer than the warp width, and when necessary, the entire loom, with weaving in progress, can be rolled up and packed on a camel. Even towns and villages, where portability is not important, utilize this nomadic technology, but sometimes metal parts are now used.

In northern central Arabia, in al-Jawf, an interesting variation of the traditional ground loom adapted for modern knotted pile rugs has been introduced. Since these rugs have a twined weft ground, no shedding device is needed.

Instead, the entire warp is elevated across the centre by a beam running under it, the ends of which rest on blocks. This device serves to make the warp more accessible to the weaver, and it may also provide more tension on the warp.

In al-Hasa, weavers employ two harnesses for the making of rugs and the famous al-Hasa *bishts*. There were also four harness looms essential to the twill weaving found in some rugs and blankets from this area.

A.L.

Below: A woman weaving tent cloth in al-Hasa on a ground loom.

Below: A pit loom from al-Hasa, suspended in Pittsford, New York. The red rug shown with it was woven on this loom before it was dismantled and taken to the USA.

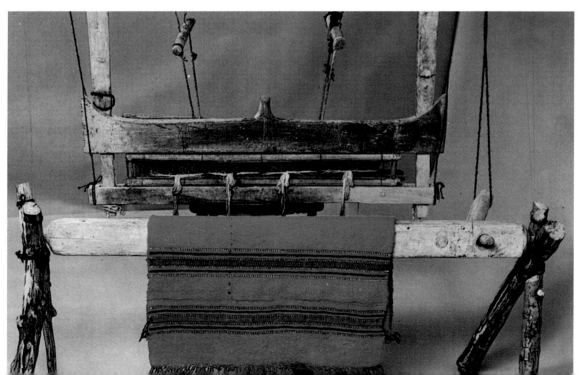

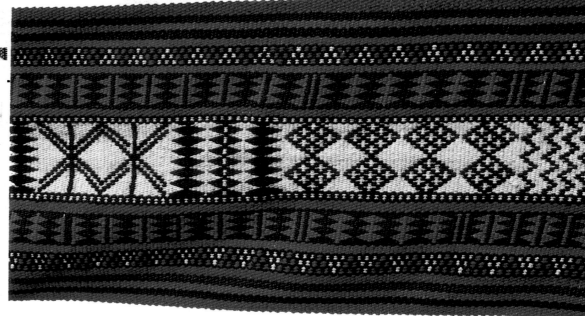

WEAVINGS FOUND IN SAUDI ARABIA

Both flat weavings and pile weavings are found in Saudi Arabia. The flat weavings fall into the following categories:

Bedouin weavings. The predominant design type found throughout the Arabian peninsula is characterized by longitudinal striping in warp-faced plain weave with complementary warp. This type of weaving is described and depicted in illustrations 5 to 24 inclusive; it includes tents, camel gear and so on. The most prevalent design motifs are to be seen in tent dividing walls (1 and 11), bags (51 and 59) and rugs (19 and 23).

The weavings of the pastoral people of the Asir and Baha. These are characterised by transverse banding in plain weave with soft wools. Descriptions and photographs of them are found in illustrations 27 to 31 inclusive.

Unidentified weavings probably of Arab origin. Probably from the east and northeast, such examples are not common; they are characterised by a twill ground with tapestry patterning and are described and pictured in illustrations 32 to 37 inclusive.

Contemporary weavings based on traditional Bedouin examples. Even though the craftsmanship is good, brilliant synthetic dyes, factory-made and metallic yarns are used in these weavings; in some cases these have been made for sale rather than for use. As a result, their similarity to traditional Bedouin weaving is obscured so they are dealt with separately – in illustrations 65 to 68 inclusive.

Pile weaving is not, in general, similar to what we term Bedouin weaving, although some symbols characteristic of Bedouin examples are used. Such weaving has probably been done at some other time in other locations in Arabia, but the author knows of only one in al-Jawf and there it was a relatively new development. *See* illustrations 69 and 70.

Bedouin design motifs

Tent walls, rugs and bags, apart from stripes, are decorated with repeat patterns of one form or another. A 'camel tooth' motif, for instance, is created by alternating yarns in two colours in a plain weave structure.

Narrow bands of a series of pyramids or triangles, on the other hand, are produced by complementary warps appearing in spots on the surface. These are generally used either side of the main design stripe, and are called *llwairijan*. The commonest colours are black and white, but red and black and other combinations are often seen. The pyramids are often interspersed with an inverted row of pyramids in a third colour. Sometimes instead of pyramids, two-colour designs forming xs, hourglasses, or combinations of such motifs are woven.

Most scope is given to the weaver by representational designs. These are almost always black on a white field and done with complementary warps. They might represent incense burners, scorpions, camel litters, *wasm* (tribal marks) – anything common to Bedouin and village life. Human or animal figures are rare. There are also checkerboard patterns, diamonds, chevrons, lightning, zigzags, stepped diagonals, combs and a great variety of other abstract patterns. The designs are arranged in self contained boxes, separate from one another. On recent pieces, images such as aeroplanes and Western numerals are found. These series are usually paralleled on both sides with pyramid stripes and are known as 'tree' pattern *(al-shajarah)*.

Rugs and tent walls often end with one or more transverse bands of weft twining with two or more usually bright weft colours. The designs remain simple, mainly triangles, crosses and diamonds. Twined bands may occur on bags. Sometimes a piece will have only narrow bands of twining at the ends, in simple stripes of one or two colours, which act as binding for the weaving. The most spectacular, however, are pieces which combine both wide and narrow bands.

Nabila Bassam Project

The enterprise in al-Khobar of Nabila Bassam, which once primarily used weaving by village and Bedouin women to make decorative hangings, pillows, and other items for everyday modern life, has developed into a large scale shop in a fine building, using not only indigenous weaving but beaded costume parts, especially from Asir, to make beautiful decorative boxes and other furnishings.

JT

A woven wall hanging, an example of work from the Nabila Bassam project in 1978.

Tent walls, bands and curtains

The Bedouin tent is usually twenty-five to forty feet by twelve to eighteen feet – varying according to the size of the family. The Bedouin describes its size by the number of poles used longitudinally to hold it up. The span between poles is ten to fifteen feet. The poles are of wood, usually from oases or mountain areas. The tent ropes, braided in the past from wool or leather but recently made of hemp (or plastic), run out fifteen feet or more to the stakes or rocks around which they are tied.

For the interior walls (*riwaq*), cloth strips are sewn together, with the strips running the length of the tent and fastened with large pins to the lowest edge of the tent roof. The bottom edges are usually buried or pegged in the sand or earth, or rocks are laid on top of them. Alternatively, the back and end walls can be raised according to the weather. Tent cloth is woven in panels twenty-five feet or more long, but the width is seldom more than three feet. The top and central strips of the tent cloth are usually renewed every year or two. The old strips are moved towards the outside, and the outer strips discarded or put to lesser use. The bottom wall strip is often of coarse plain material because it has to be replaced more frequently. Tent cloth was commonly made in the summer by the Bedouin when they settled for several months near water; most frequently it is the produce of villages and towns. In the 1990s most of it was imported from Syria, or woven by a modern factory in Riyadh.

The traditional material for nomadic tent cloth throughout the Middle East is goat hair, because of its strength, though sheep's wool or mixtures with goat hair are sometimes used. Camel hair is often used by the al-Murrah tribe who may construct the entire tent, including ropes, out of it. The tent is usually black, the colour of goat hair; occasionally, however, more prosperous Bedouin have white bands woven into it or narrow stripes added. The top strip of the back wall (*ruag*) is decorated with long series of geometric designs. Tribal or regional differences are apparent in these stripes and geometric motifs. The al-Say'ar in the far south, for instance, use black stripes alternating with narrower white stripes; by contrast, the Bani Atiyah and other northern tribes sometimes use vertical design bands as well as horizonal stripes.

At right angles to the tent cloth, and attached to it, are usually wool bands four to eight inches wide; wooden sockets are laced to the bands

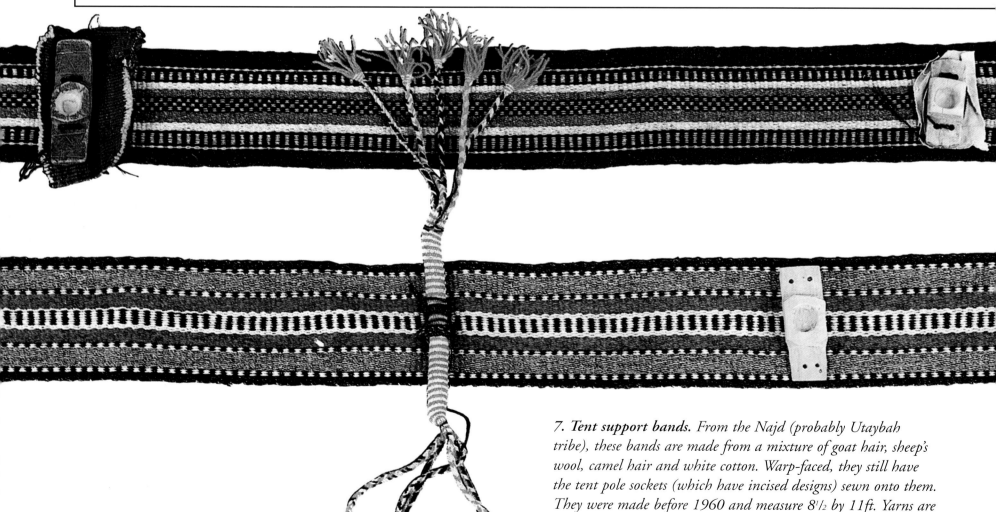

7. Tent support bands. From the Najd (probably Utaybah tribe), these bands are made from a mixture of goat hair, sheep's wool, camel hair and white cotton. Warp-faced, they still have the tent pole sockets (which have incised designs) sewn onto them. They were made before 1960 and measure 8¹/₂ by 11ft. Yarns are 2 s spun, plied z. Sewn to the tent cloth, they spread the strain from the poles.

Acquired in Ta'if, 1978.

to receive the tent poles and keep the strain off the cloth. The tent ropes are tied to these bands or to reinforced loops at the edge of the tent cloth. Wool tent bands of varying quality are usually woven in decorative patterns – from simple stripes to a series of geometric designs or symbols. Bands are usually brown or black with white stripes, or sometimes coloured, especially with reds and oranges.

Woven dividers or curtains (*qata*) are used to separate the interior of the tent into its several sections. When the tribe is frequently on the move, only part of the tent is erected, with one compartment for the women and cooking, and one for the men. When settled for longer periods or through the summer, the full three compartments are put up.

The glory of the tent is the main dividing curtain between the men's section on the right and the sleeping section in the middle. These curtains are often made of as many as six narrow strips giving a total height of five to seven feet. A great variety of materials and colours are used in them. Some have continuous rows of geometric designs, wide bands, often of white cotton, and red stripes. The curtains of the northeast and Kuwait, described by Dickson, were elaborately decorated with cross bands and patterns at one end, the horizontal stripes extending to the back of the tent. The decorated end, suspended from the tent ropes, sometimes projects far enough to be drawn across the front of the tent to close it; some examples have a profusion of sashes and tassels attached. Other curtain walls have designs vertically crossing the stripes; these are sometimes so elaborate that the stripes show only at intervals of a foot or so.

There are also examples of solid colour (except for very thin design bands), sometimes with decorative fringes along the top edge. Those from the southwest of Arabia and around the Empty Quarter are simpler because materials are scarce. The curtain erected between the sleeping and cooking sections is usually plainer than other curtains. Sometimes, however, an old curtain from the men's section is used. Curtain design motifs varied in the past between regions and tribes. Regional motifs are still distinguishable, but tribal motifs are now obscure.

Decoration within the tent is mostly limited to these woven designs. However, tufts of coloured wool, loose tassels, mirrors, and similar objects are often hung inside when the tribe is settled in one place for a long period. Saddle bags and other equipment, even decorated litters, placed inside for convenience, also give the tent a warmer and more cheerful appearance.

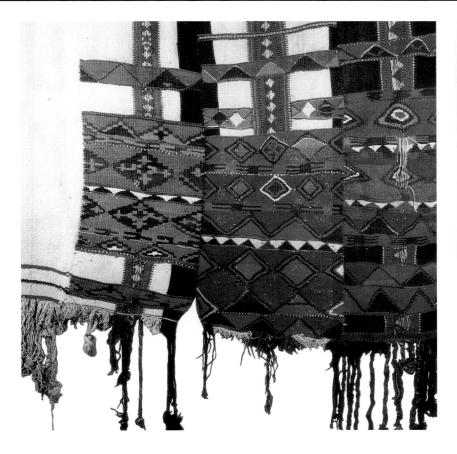

1. Tent Curtain Wall. *From the Gulf and made before 1950, this tent curtain has a striking variety of design patterns. It was probably made by the Ajman tribe and measures 6ft by over 20ft. A detail is shown here.*

Acquired in Hofuf, 1974.

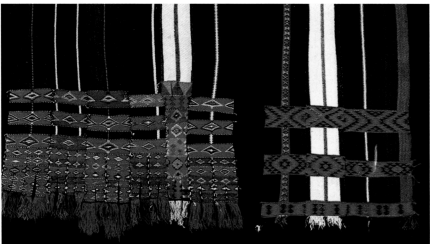

8 (above left). Tent dividing curtain. *From the northern Najd, this piece is made of six narrow panels of warp-faced plain weave with a band of twined tapestry weave at one end. It is a combination of sheep's wool and black goat hair, with some natural dyes; an added strip is chemically dyed. It was made before 1950 and measures 5ft by 16ft. Yarns are 2 x spun, plied s. Acquired in Ta'if, 1978.*

8 (above right). Tent wall. *A goat and sheep's wool tent wall, from northwestern Arabia (Bani Atiyah tribe), this peice is woven with some chemically dyed yarns. It is constructed from three woven panels of warp-faced plain weave with an additional stripe of warp-faced complementary warp pattern weave. There are thirteen bands of weft-faced twined tapestry and two narrow bands of weft-twining. In each of the two narrow bands are tufts formed from cut loops of weft. The wall has a warp fringe and it measures 3ft 4in by 29ft 6 in. Acquired in Tabuk, 1979.*

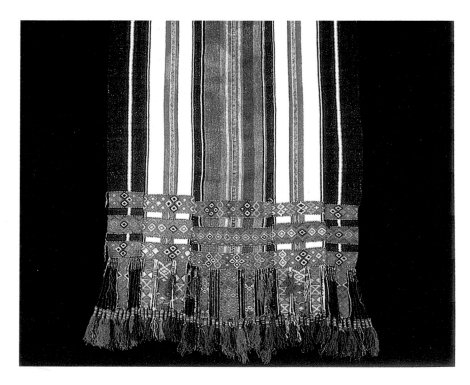

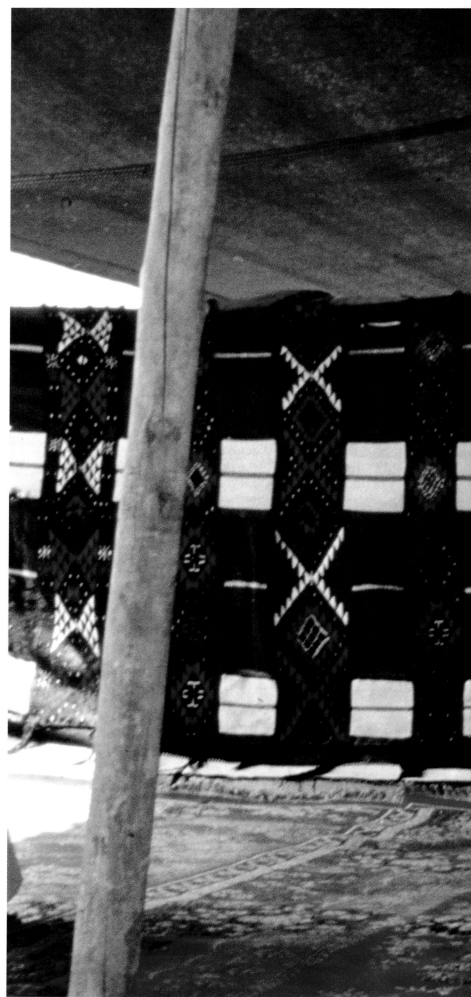

9 (above) and 10 (below). Tent dividing curtain. This example, made before 1960 in the northern Najd, is constructed of black goat hair with white cotton bands and red wool stripes (probably naturally dyed with pomegranate). The five woven panels are warp-faced plain weave with bands of weft-faced tweed tapestry. Twined tapestry woven fringe flaps alternate with a braided fringe and have wrapped warps sewn to the sides; mostly chemical dyes are used. Tassels are looped through uncut warp ends and wrapped. The curtain is 5ft by 12ft. Yarns are 2 z spun, s plied. A detail is shown in illustration 10.

Acquired in Ta'if, 1978.

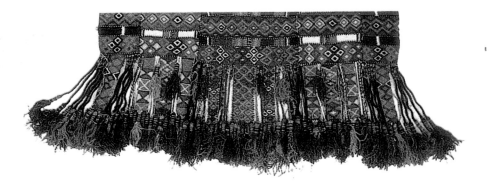

11 (right). Section of a tent dividing curtain. Made by the Shararat tribe in al-Jawf in about 1970, this curtain has a cotton, wool and goat hair weft. Regular crosswise bands in weft-faced twined tapestry appear in all four strips of the curtain. Motifs include diamonds and triangles, in reds and blues. Twined tapestry rectangles are woven in the top edge . The 14in long fringes are braided. It measures 6ft 4in by 24ft 5in.

Gift of Prince Sultan al-Sudairi to John Topham. 1981.

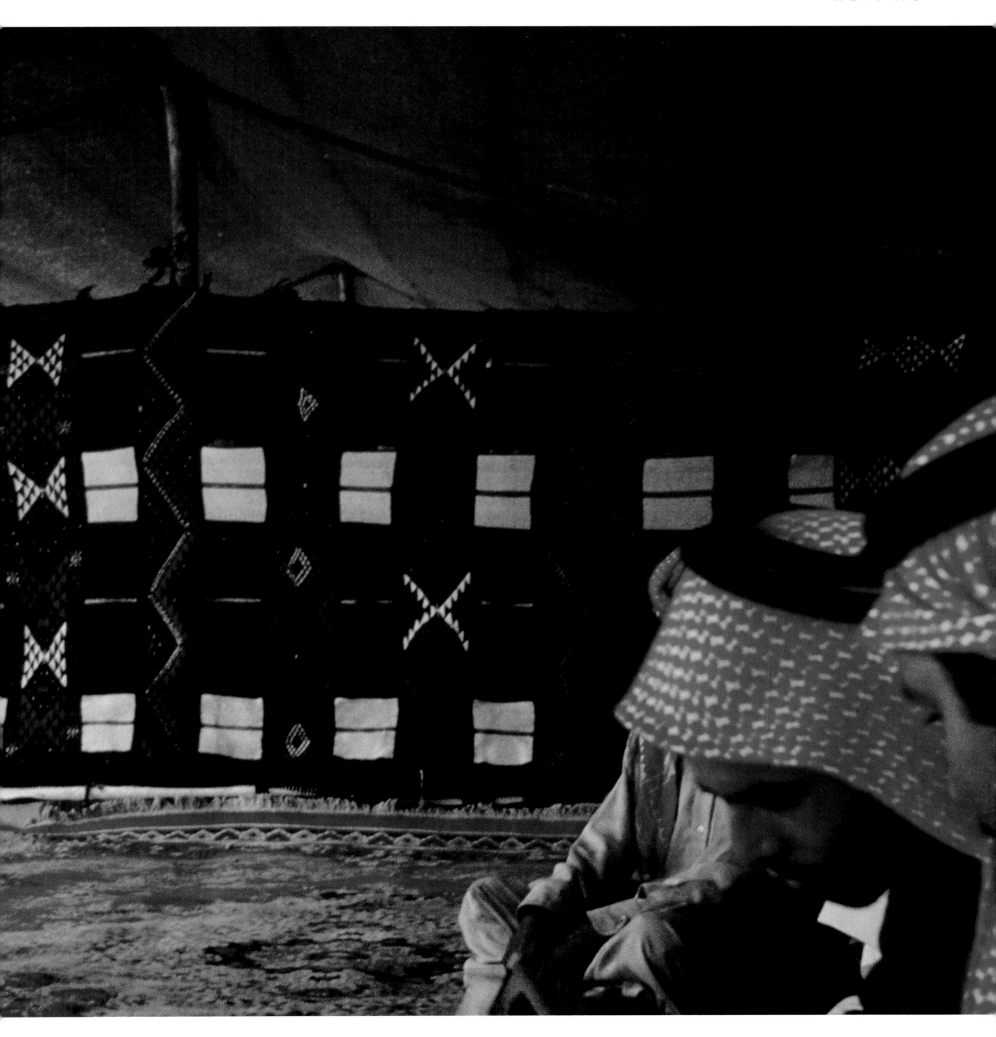

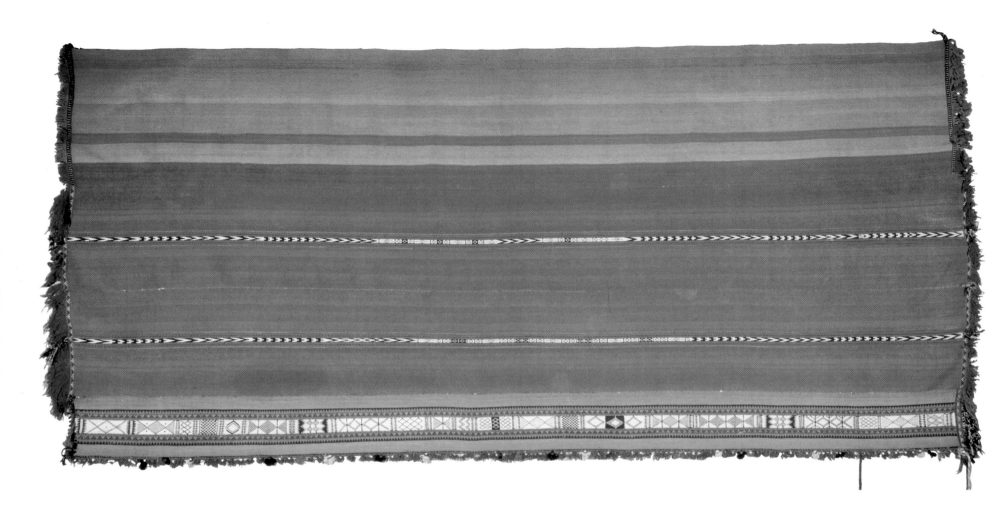

12. Tent curtain. *From the Gulf and made before 1950, this tent curtain has a striking design pattern. It was probably made by the Ajman tribe and measures 6ft by over 10ft. A detail is shown here. This weaving is notable for the subtle control of henna-dyed wool in striations the whole length of the weaving. It is probably the most sophisticated large weaving found.*

Collected in Hofuf, 1974 by Barbara Hawkes.

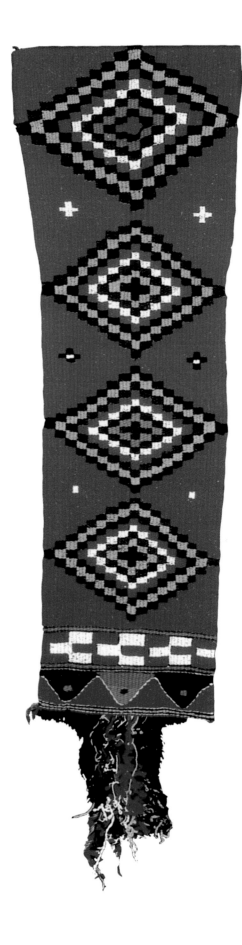

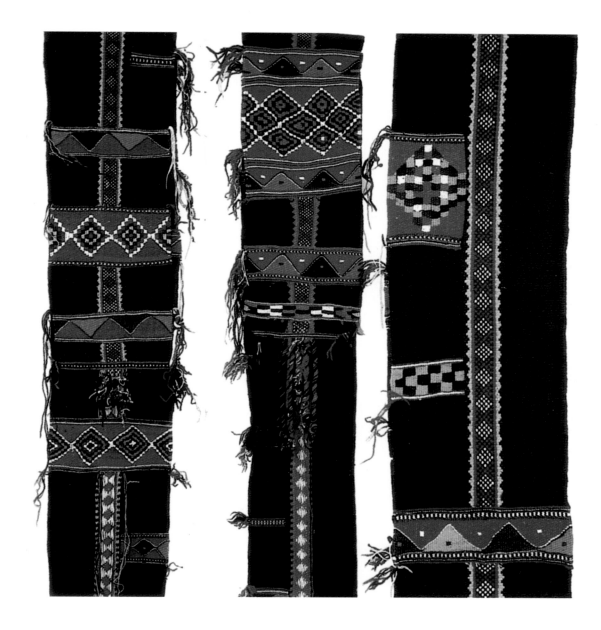

13 (left), 14 (above and above centre), and 15 (above right). Tent curtain wall strips. The pieces shown here are sections from two strips for an unfinished tent curtain wall. Made in about 1978, they come from the Eastern Province and are black goat hair with coloured wools and white cotton. Each of the two strips, is warped-faced plain weave with a centre stripe of warp-faced complementary warp patterning. Rectangles of twined tapestry of varying sizes and designs (14 and 15) appear at intervals along the strips. The longer piece has a tapered 3ft end of weft twining with stepped diamond designs (13). Goat-hair and wool yarns are 2 z spun, s plied; cotton is 3 z spun, s plied, 2 z plied. The longer strip is 11in by 19ft plus fringes.

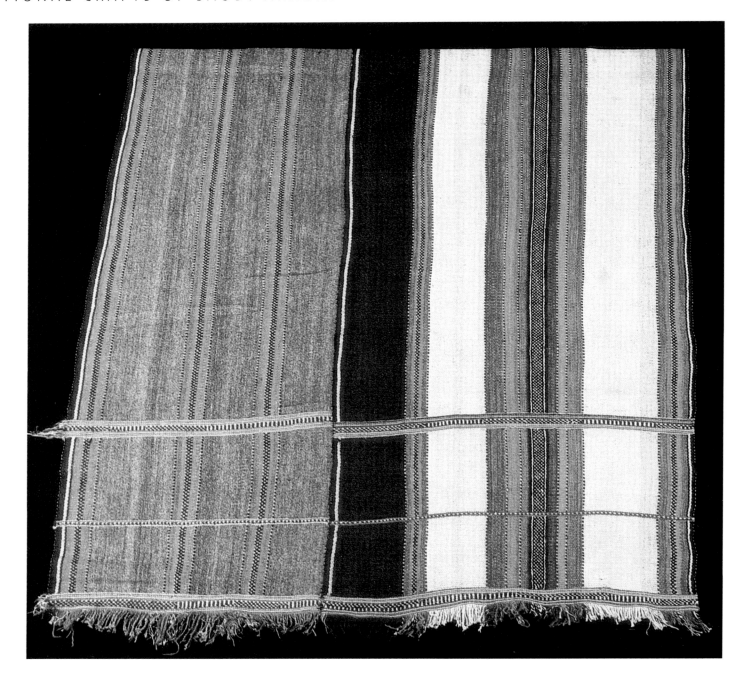

*16 (above). **Tent wall or rug.*** *From the western Najd (probably Utaybah tribe), this piece is predominantly sheep's wool dyed with natural colours and black goat hair. It consists of two woven panels sewn together; wide stripes of warp-faced plain weave alternate with narrow stripes of complementary warp pattern weave. There are three bands of weft-faced twinng at one end and one at the other, and there is a warp fringe. It measures 6ft 6in by 13ft and was made before 1960. Yarns are 2 z spun, plied s.*

Acquired in Ta'if, 1978.

18. Tent decorations. In these examples from the Najd (probably Utaybah tribe), 12in wooden sticks are covered with warp-faced plain weave cloth; the warp continues on to the braided tassels, decorated with metal and glass beads. Decorations such as these are sewn onto the tent support bands. The lengths of the pieces shown here range from 30in to 52in.

Acquired in Ta'if, 1978.

17 (right). Old wool tent or litter decoration. This piece has later cloth/machine embroidery tape sewn over a woven wool band. The original wool band dates from c.1950.

Rugs and Blankets

The nomad carries with him no more rugs than are necessary for sleeping or for sitting on. The ground area under the tent is not normally covered except in the case of the wealthier Bedouin. Men spend much of their day about the coffee hearth, sitting on rugs laid in a wide open square. A tent usually contains one or more rugs of five to seven feet wide, made of two strips of matching design sewn together. Larger pieces made from a number of strips are occasionally found; these may also be used as covers for the floor. Since houses are fast being built in the settled areas by the Bedouin, traditional weavings can be found which have obviously been woven into room sizes. Such pieces are also used in the tents of sedentary Arabs, who although they have business and own houses in the town, prefer to live in, or maintain, their tents. As well as ordinary rugs, prayer rugs, mostly imported, are found in most Bedouin tents.

The rugs of the Asir and Baha are quite different from Bedouin weavings. Simple in layout with well-balanced designs, they are used solely for the floor unlike many Bedouin examples. The majority consist of two panels with matching striped designs sewn together. The stripes run across the panels (with the weft), rather than the longitudinal Bedouin style. The fields are usually natural brown or white sheep's wool; the black goat hair used in the Najd is infrequently seen. Most dyes, except in the very recent pieces, appear to be natural. Landreau discovered that all the yarns used in the Asir and Baha were s spun, the reverse of the usual Middle Eastern spin. The width of the yarns is remarkable, as is the softness of the wool. Some of the symbols used, however, are similar to those in Bedouin weavings but this relationship has little significance, since the designs form part of the general repertoire of weaving motifs used throughout the Middle East.

Older, lightweight rugs or blankets using twill weaving, with tapestry woven cross panels generally of the same color field, are found in Jeddah, Riyadh, al-Kharj, Dammam and al-Hasa. These are unlike other Saudi Arabian weavings both in technique and design and were referred to by the Arabs as coming from the Najd or from the Iraqi Bedouin. Most have some form of crenelation like that found in some Kurdish nomadic weavings. Pieces found in Hofuf were said to have been made there. (It is known that four-harness tread looms, capable of producing twill weaving, were used in the al-Hasa area, which makes it the most probable source for rugs as varied as these.) Several Arabs identified a few of the pieces as Shammar or Mutayr, and since in past times these tribes traveled deep into Iraq and undoubtedly had contact with Kurdish nomads, such examples could indeed have been adaptations of Kurdish weaving, or bought from them or from other areas of Iraq.

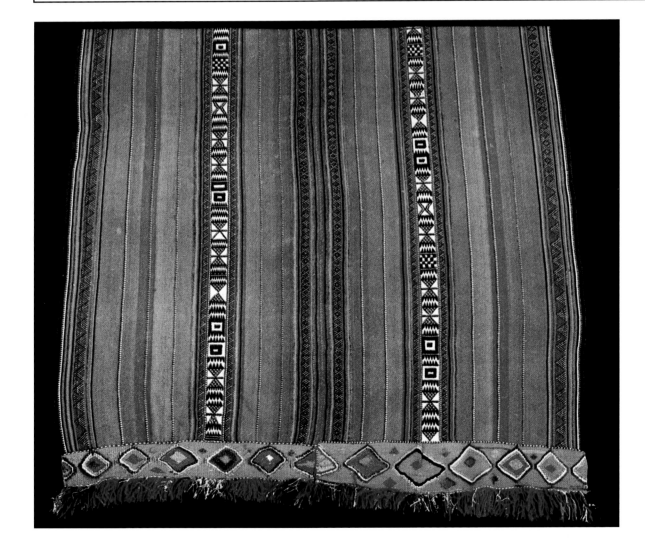

19. Rug. This traditional rug from the Najd (Utaybah tribe) consists of two panels of warp-faced plain weave alternating with narrower bands of warp-faced complementary warp pattern weave; the two bands at the end are twined tapestry. The yarn, sheep's wool and goat hair, is more tightly twisted than on later rugs. Yarns are 2 z spun, s plied. The rug is 6ft 3in by 10ft 7in.

Acquired in Riyadh, 1977.

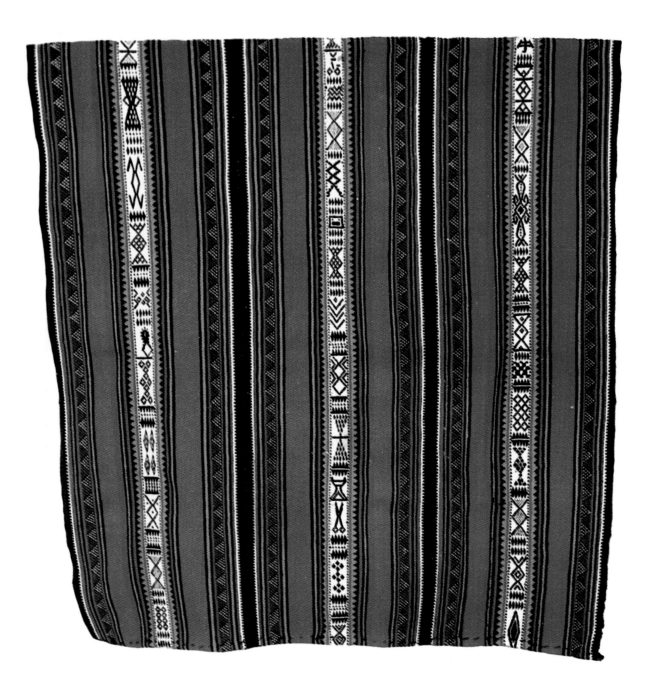

20. Rug. Made in about 1979, this rug is from the Eastern Province. It consists of three warp-faced plain weave strips with warp strips and strips of warp-faced complementary warp geometric patterning, in the typical style of the Najd (but with some modern imagery). It is made of synthetic dyed wools and cotton and measures 4ft 8in by 10ft.

21 Rug. This rug from the Ta'if area (probably Utaybah tribe) was made in about 1960, for use in a house. It is sheep's wool with black goat hair stripes. The three panels are warp-faced plain weaves; they have narrow bands of twined tapestry at one end and a twisted warp fringe. It is 12ft 2in by 8ft 1in. Yarns are 2 z spun, plied s.

Acquired in Ta'if, 1978.

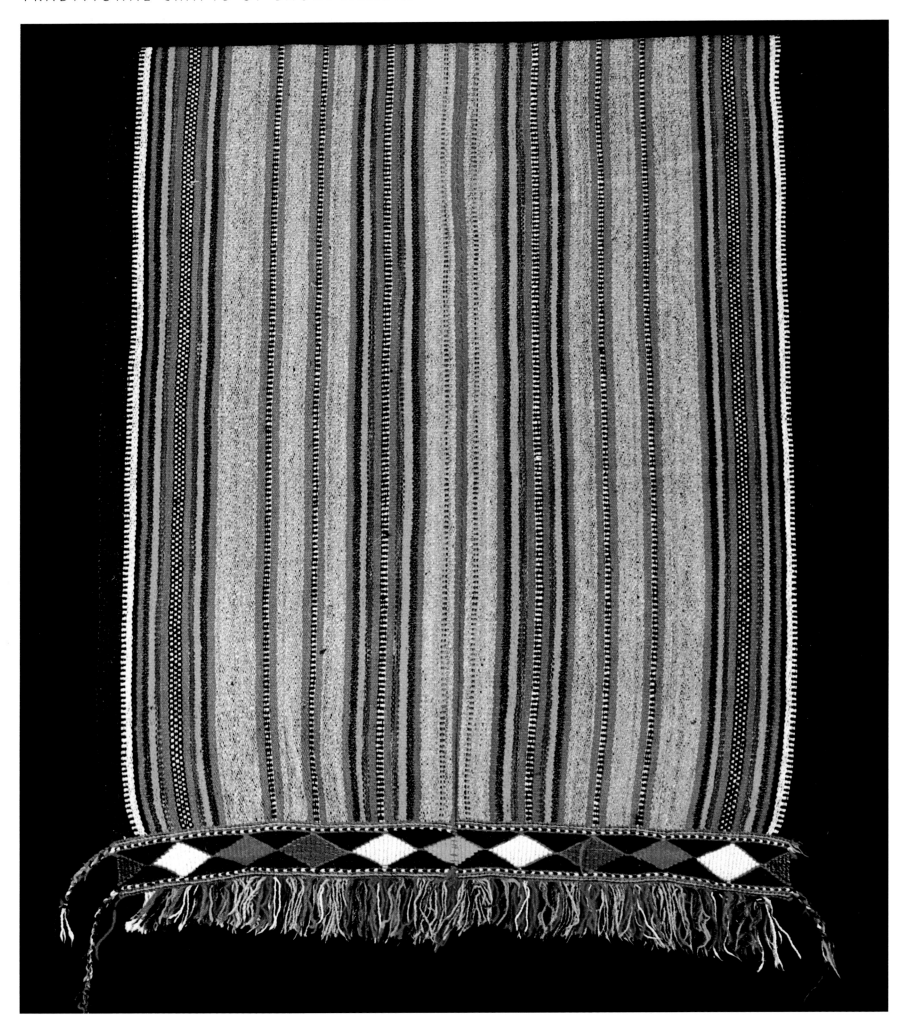

22 (right). Strip rug. This piece from southwestern Arabia (possibly Qahtan tribe) is similar to the rugs from the Asir. It consists of two camel hair, goat hair and wool panels of warp-faced plain weave with designs in weft-faced twined tapestry; there is a warp fringe at both ends. The bright colours are chemically dyed. Yarns are 2 z spun, s plied. It measures 15ft long and is said to be a wedding presentation piece.

Acquired in Jeddah, 1978. (Brought from Bishah, where it was supposedly made).

23 (left). Rug. From the Gulf (probably Ajman), this rug is a typical Bedouin or village rug made of chemically dyed sheep's wool with natural camel hair and black goat hair. It consists of two panels of warp-faced plain fabric twined tapestry bands at both ends. It is 1ft long. Yarns are 2 z spun, plied s.

Acquired in Dammam, 1977.

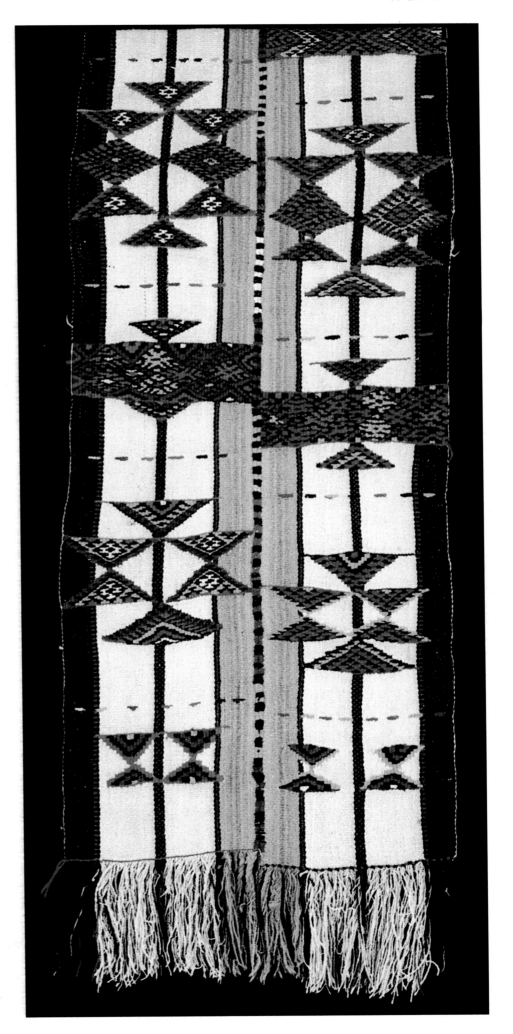

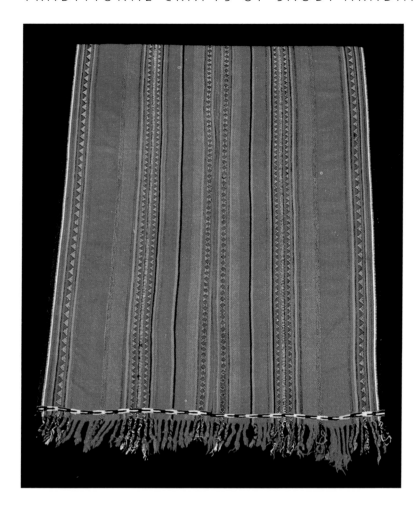

24 (above). Rug. *From the Najd and made before 1950, this piece consists of warp-faced plain weave with twined tapestry weave at the ends. The warp ends are braided. It is 5ft 4in by 8ft 8in.*

Acquired in Riyadh, 1979.

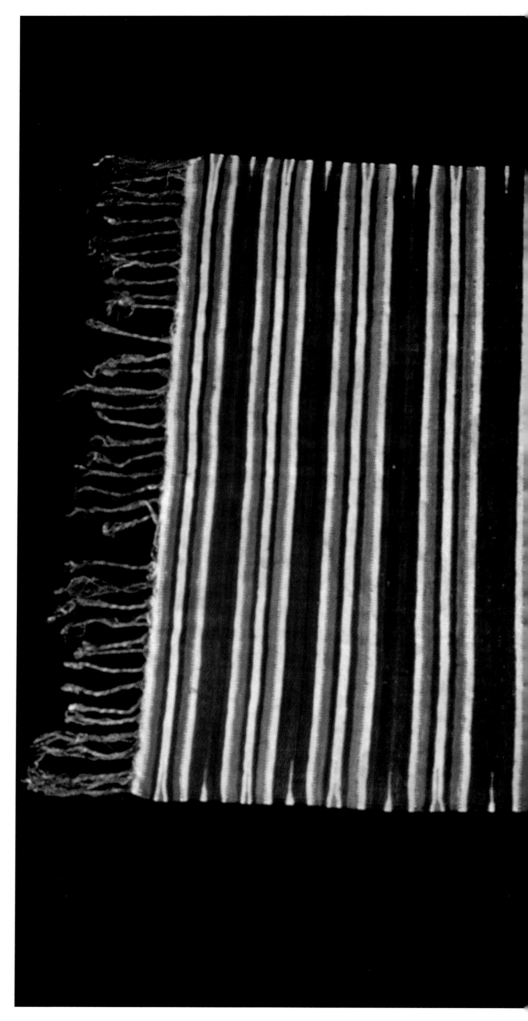

25 (right). Blanket. *This al-Hasa blanket or rug is made from sheep's wool with natural colours and finely spun yarn. It is weft-faced plain weave; with tapestry inserts at the selvedges and a knotted warp fringe at one end. It was made before 1940 and measures 5ft 8in by 6ft 10in; it is unusually wide for a single loom in Arabia.*

Acquired in Riyadh, 1979

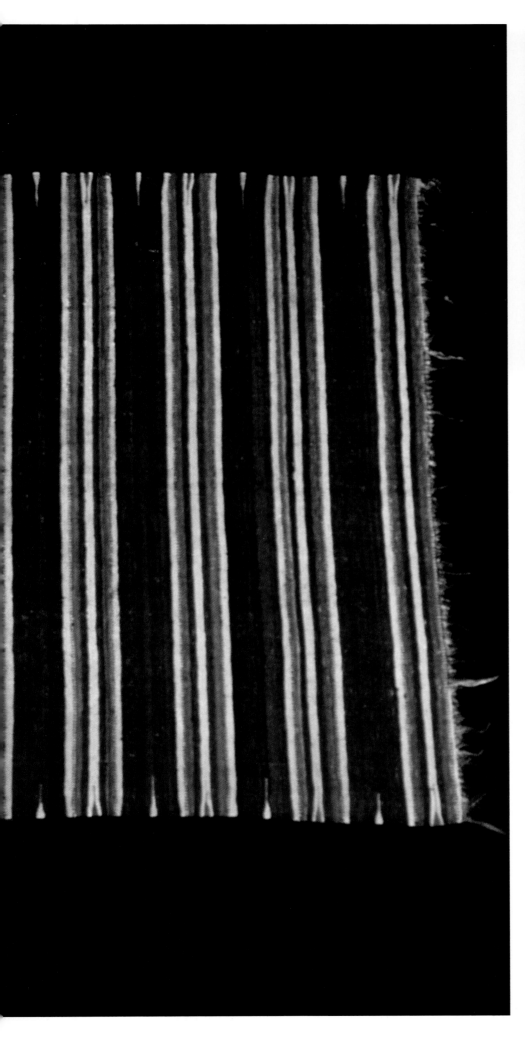

26. Rug. *This rug from the Gulf (probably al-Murrah tribe) is a typical example of a striped utility piece made about 1970.*

Acquired by F. Taylor from an al-Murrah tribesman, 1975.

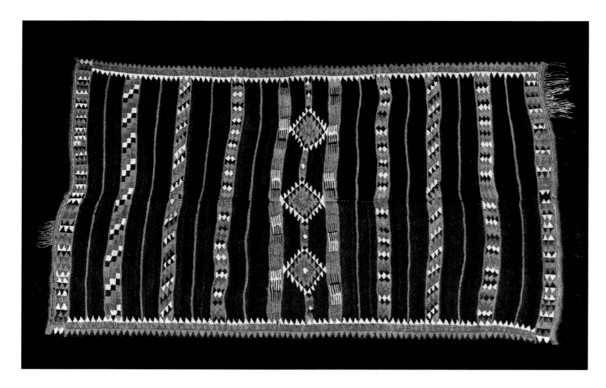

27a (above). **Rug.** *Made of soft brown and naturally dyed wools, this rug comes from the Baha (probably Zahran tribe). It consists of two loom widths, sewn together at the center, of weft-faced interlock tapestry and weft-faced palkin weave stripes. Made before 1950, it measures 4ft 11in by 8ft 2in. Warp and weft yarns are 2 s spun, z plied; 6 ½ warps by 16 wefts per square inch.*

Acquired in Ta'if, 1978.

27b (above centre). **Rug.** *This sheep's wool rug from Baha, made before 1950, is woven with naturally dyed yarns. It consists of weft-faced slit tapestry and weft-faced plain weave stripes in two loom widths sewn together. The curvilinear elements are weft inserts; the fringes are warps braided with extra yarn. It measures 3ft 9in by 6ft 9in. Warp yarn is 2 s spun, z plied; 20-22 wefts by 3 warps per square inch.*

Acquired in Ta' if, 1978.

28 (above far right). **Rug.** *From the Abha area, this sheep's wool rug is mostly dyed with natural colours. It consists of two widths of weft-faced slit tapestry (rendered curvilinear by inserts wefts) alternating with weft-faced plain weaved stripes. It was made in about 1960. Its width is 4ft 4in-4ft 8in, its length 7ft 3in-7ft 9in. Yarns are 2 s spun, plied z, warp and weft; 4 ways, 12-14 wefts per square inch.*

Acquired in Ta' if, 1978.

29 (right). **Rug.** *Probably made in Baha before 1950, this rug is sheep's wool with yarns that are probably naturally dyed. It consists of two stripes of weft-faced plain weave sewn together; it measures 7ft 10in long. Warp yarn is 2 s spun, plied z; weft yarn is s spun, and some 2 s spun, plied z; 19 wefts by 4 warps per square inch. Most of the rugs of the Asir area are made of soft wools, since it is primarily a farming area with houses that do not require the hard twisted and woven weavings necessary for nomadic life.*

Acquired in Ta' if, 1978.

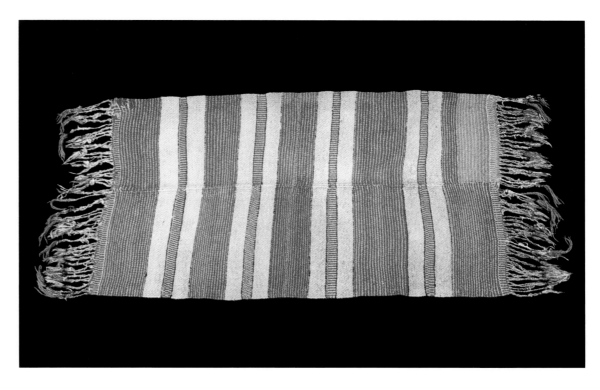

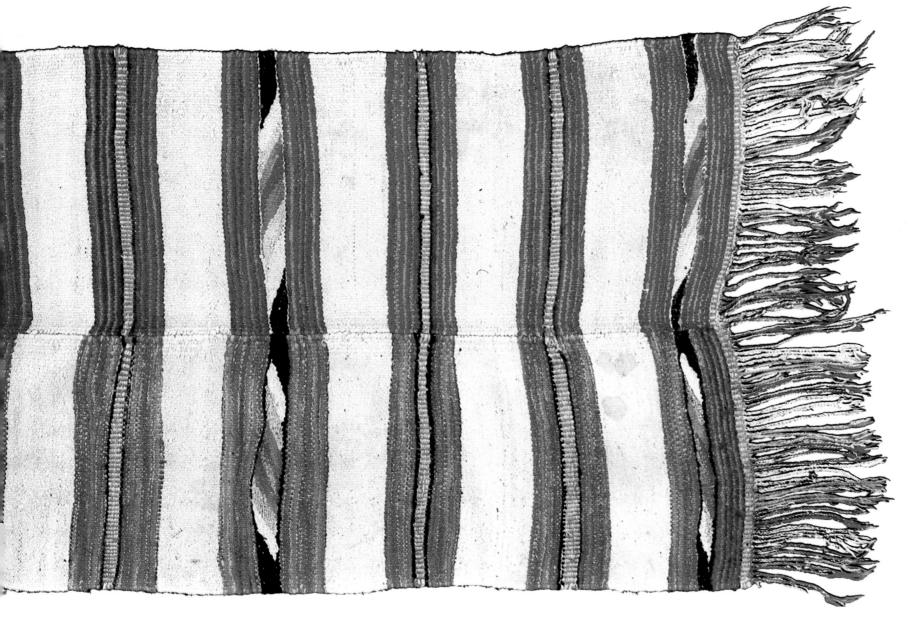

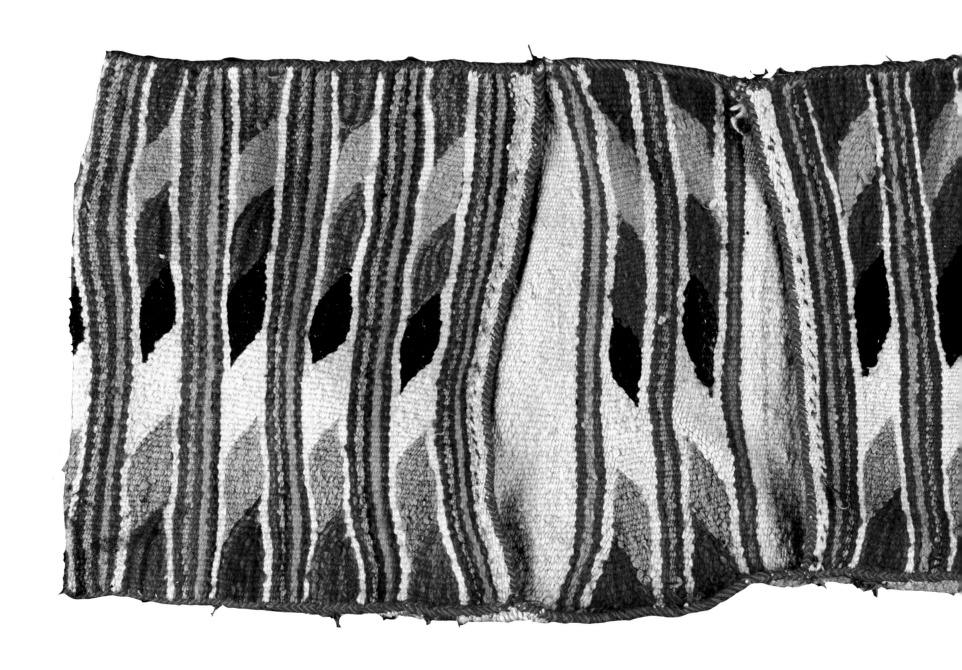

30 (above). Saddle bag. *From the Asir (Abha area) this is a donkey saddle bag made of soft sheep's wool with both natural and chemical dyes. It consists of weft-faced slit tapestry alternating with weft-faced plain weave stripes. The tapestry areas are curvilinearly shaped with insert wefts. Its edges are hemmed and overcast and it measures 26in by 54in. It is similar to the rug shown in illustration 28 and it comes from the same area.*

Acquired in Jeddah, 1978.

31 (right).Rug. *This rug from the Abha area in the Asir was made in about 1960. It consists of weft-faced tapestry, slit and dovetailed. The 'eye-dazzler' pattern, sometimes found in Iran, is unusual in Arabia. It is 3ft 6in-4ft by 9ft 4in. Warp yarn is s spun, z plied; weft yarn is s spun; 16 wefts by 4 1½ warps per square inch.*

Acquired in Ta'if, 1978.

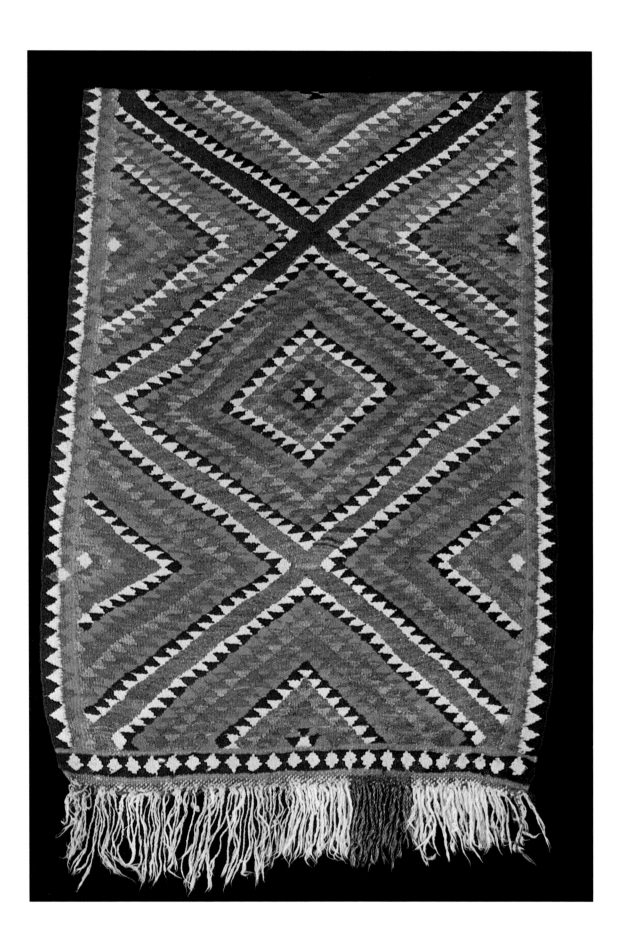

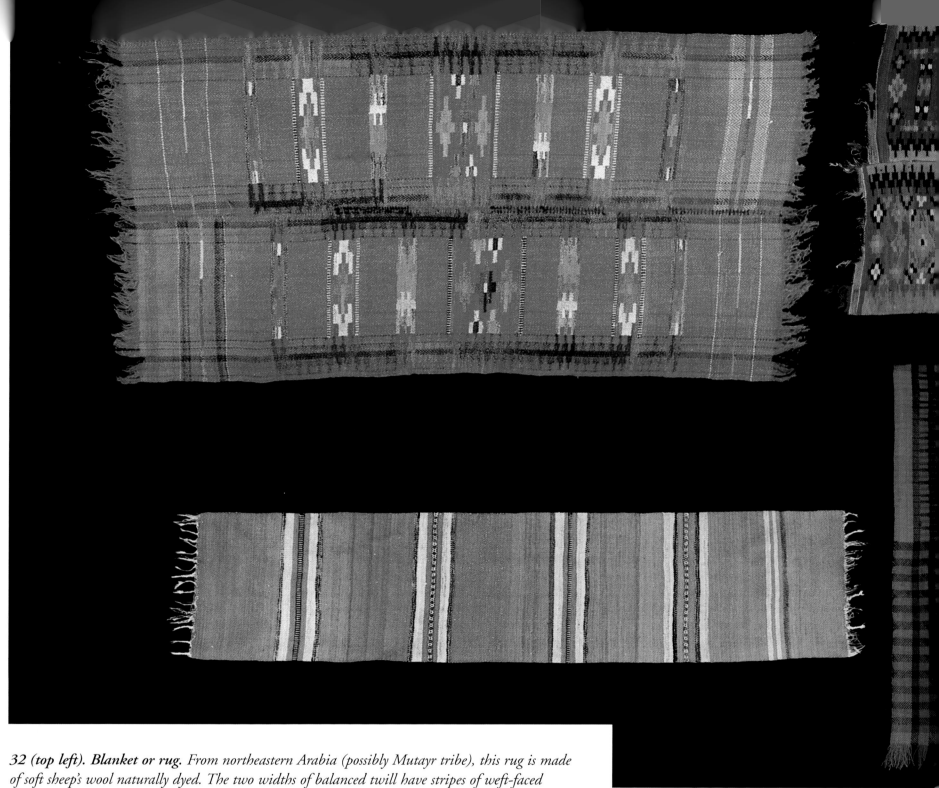

32 (top left). Blanket or rug. *From northeastern Arabia (possibly Mutayr tribe), this rug is made of soft sheep's wool naturally dyed. The two widths of balanced twill have stripes of weft-faced interlocking tapestry with some border areas in twill tapestry. It has cut warp fringes; some tassels have remnants of former braiding. Made before 1950, it is 4ft 5in by 7ft 3in. Warp and weft yarns are z spun, s plied; 10 warps by 10 wefts per square inch in tapestry parts.*

Acquired in Hofuf, 1977.

33 (bottom left). Strip rug. *This weft-faced plain weave rug from al-Hasa has three narrow strips of weft-faced, weft-pattern weave. The warp ends were originally braided but are now mostly worn away. Made before 1940, it measures 27in by 18in. Warp and weft yarns are z spun, s plied; 6 warps by 18 wefts per square inch. Of the rugs shown on these pages, this alone is not also woven in Iraq, which could be the provenance of the others illustrated here.*

Acquired in Hofuf, 1979.

34 (centre, top). Rug. *Both natural and synthetic dyes are used in this sheep's wool and goat hair rug from the northeastern Arabia. Two strips, made of weft-faced interlocking tapestry weave, are joined together to form the rug and there are warp fringes at the ends. It measures 6ft 4in long. Warp and weft yarns are z spun, s plied; 20 wefts by 6½ warps per square inch.*

Acquired in Riyadh, 1979.

44

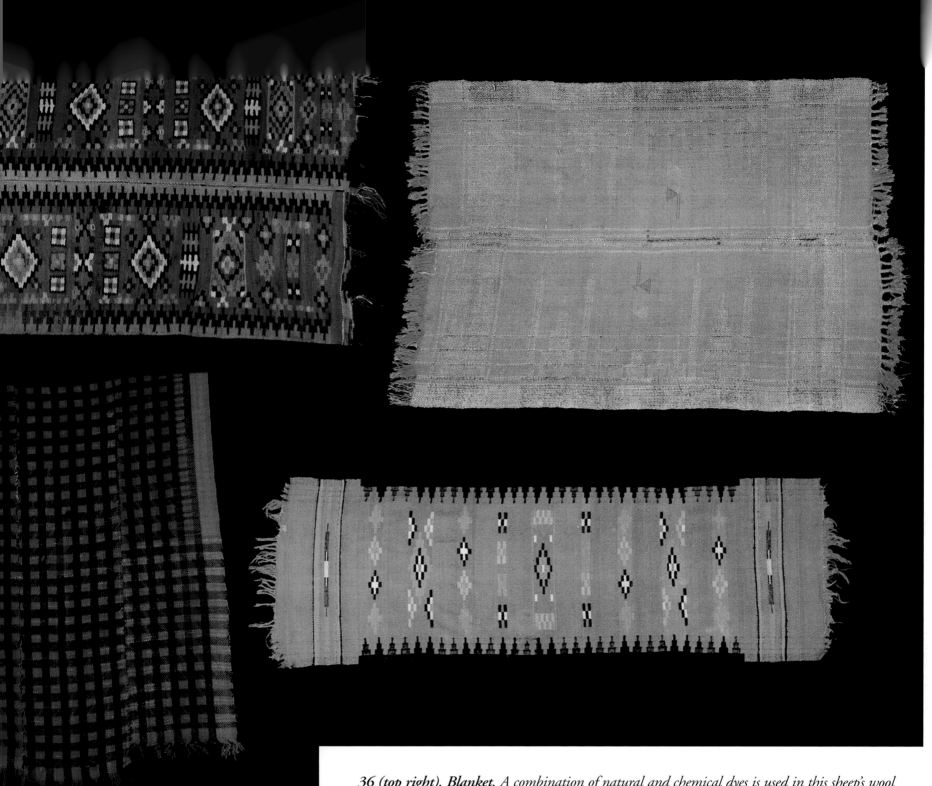

35 (centre, bottom). Blanket. *This cover (possibly for a Dhalla) from eastern Arabia has an unusual plaid design with crenelations over the edges. It is made of soft wool dyed with natural colours and consists of three loom widths of balanced twill weave and twill tapestry. It measures 4ft 6in by 9ft 8in and was said to have come from the Najd. Warp and wefts yarns are z spun, s plied; 12 warps by 12 wefts per square inch.*

Acquired Dammam, 1977.

36 (top right). Blanket. *A combination of natural and chemical dyes is used in this sheep's wool blanket from northeastern Arabia (possibly Mutayr tribe or Kurd). It consists of two loom widths of balanced twill tapestry ('herringbone' pattern) sewn together along the center selvedges. It has a braided warp fringe, knotted at the ends. It is 6ft 4in long and was probably produced on a four harness pit loom. Warp and weft yarns are 2 z spun, plied s; 11warp by 11 wefts per square inch.*

Acquired in Riyadh, 1979.

37 (bottom right). Rug. *Probably woven in Hofuf, this twill tapestry rug is made of soft sheep's wool, finely woven and naturally dyed. It is balanced twill and tapestry twill bands of weft-faced double interlocking tapestry. It measures 2ft 8in by 7ft and was probably made before 1940. Warp and weft yarns are z spun, s plied; 14 warps by 16 wefts per square inch in twill; 14 warps by 25 wefts per square inch in tapestry areas.*

Acquired in Hofuf, 1977.

Camel Gear

The camels of the Bedouin are often profusely decorated with sashes and bands in addition to their harness, which is made of woven or braided sheep's wool, goat hair and leather. The bridles are constructed of woven and braided strips or sometimes of rope. These strips are patterned and often fringed with braided or tufted tassels. Neck bands are sometimes brought together to stand upright behind the ears with an added fluff of wool to make a colourful top-knot. The chin section of the bridle is usually a metal chain slipped through a ring to a single guide or control rope, always on the camel's left.

A blanket is placed on the camel saddle; over this a sheepskin or stuffed leather cushion is normally fastened. In front of the saddle is another cushion, called a *miraka*; made of leather with tassels attached, it serves both as decoration and as a leg or knee pad. It has a loop to go over the horn of the saddle, and ties. Some examples also have finely woven fabric strips and sashes sewn to the leather and multiple rows of braided leather tassels cascading down the camel's front legs and shoulders.

The *miraka* is often combined with the saddle blanket as a continuous piece of cloth which runs from above the camel's tail, over the saddle, to the tassels falling over its shoulders. Such weavings are often elaborate with a profusion of long sashes and intricate patterning. Some incorporate thick matted wool forming the cushion in front of the saddle.

Other purely decorative items made to be suspended from the saddle are pairs of narrow woven panels, the warp of which extends into three or more long sashes and ends in tassels or tufts of wool. The warp is continuous from one panel to the other, making an unpatterned section between the pair with a slit for the rear saddle horn. This extravagant decoration, along with the cascading *miraka*, fringed halter and guide rope, and a ribboned bag in addition to the camel's top-knot, makes a glorious throne for the rider.

Camelback litters (less common in modern times) are also covered and decorated; the more ornate have numerous blankets, bands, fringes and tassels. The most spectacular litter, the winged *zetab*, seldom seen today, often had bands twenty-five feet long, festooning it from wing to wing. Litters, too, are often covered with finely woven blankets with long tassels. Examples of these are found in solid colour – a rich naturally dyed red or a bright orange. Covers which have open patterned fields also occur.

Other woven camel gear includes utilitarian items such as udder covers. Made of a coarsely woven square of camel hair with loops at its corners, the cover is fastened to a strap around the camel's loins; the strap in turn is attached to long bands which reach under the camel's tail, along its hump to its neck where they are crossed and tied. This contraption keeps the young camel from taking all of its mother's milk, once the main food of the Bedouin.

38. Camel bridle. *This piece is made from two narrow twined tapestry bands, one to go over the nose of the camel, the other over its head. A 9ft long black goat hair braided rope is tied to the bridal chain; only one rein is used on camels, which are guided on the left side. Yarns are 2 s spun, plied z.*

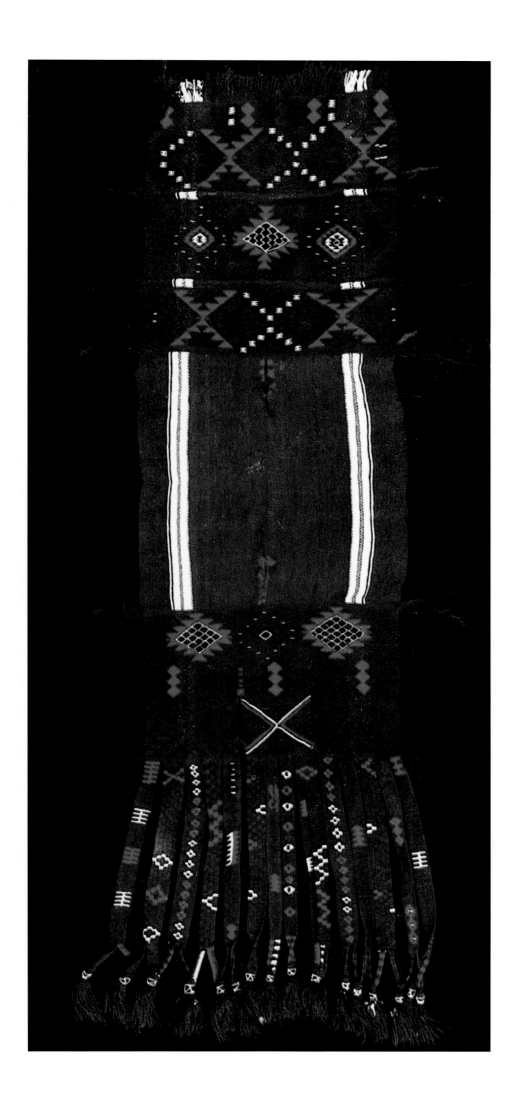

39 (left). Combined camel saddle blanket and miraka. *From the al-Dawasir tribe in central Arabia, this unusual blanket was made in about 1970. It consists of panels of tightly-woven weft-faced twined slit tapestry; twined tapestry flaps with braided tassels are at one end. It is made mostly of sheep's wool with some goat hair. Yarns are 2 z spun, s plied.*

Acquired in al-Khobar, 1977 (said to have come from al-Hawtah).

40. Camel saddle blanket. *This piece from eastern Arabia (probably Bani Khalid tribe) was made in about 1970. It consists of two widths of warp-faced plain weave in camel hair, goat hair and synthetically dyed yarn. Four bands of weft-faced twined tapestry are at the bottom, with warp fringes. (26 warps by 6½ wefts per square inch; 16 wefts alternating over 5 under 5 warps in twined tapestry areas.) It measures 39in wide. Yarns are 2 z spun, plied s.*

Acquired in Riyadh, 1979.

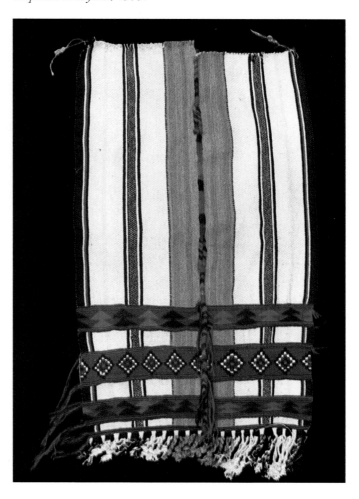

41 (below). Miraka. *This combined knee cushion and shoulder decoration from central Arabia was made before 1940. The flat area would have been stuffed with wool and fastened at the front saddle horn. Tassels fall over the camel's shoulders. It measures approximately 36in by 24in.*

Acquired in Jeddah, 1978.

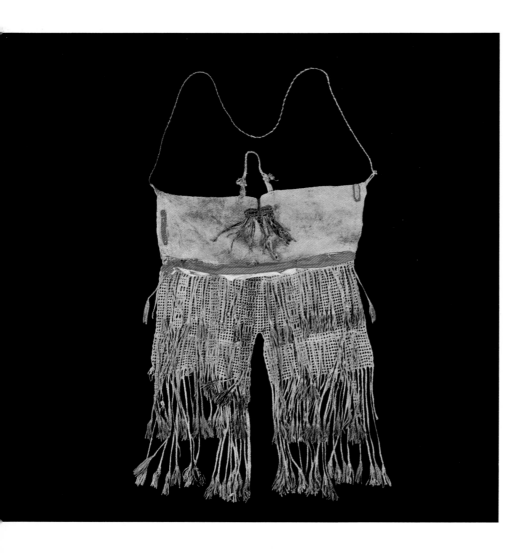

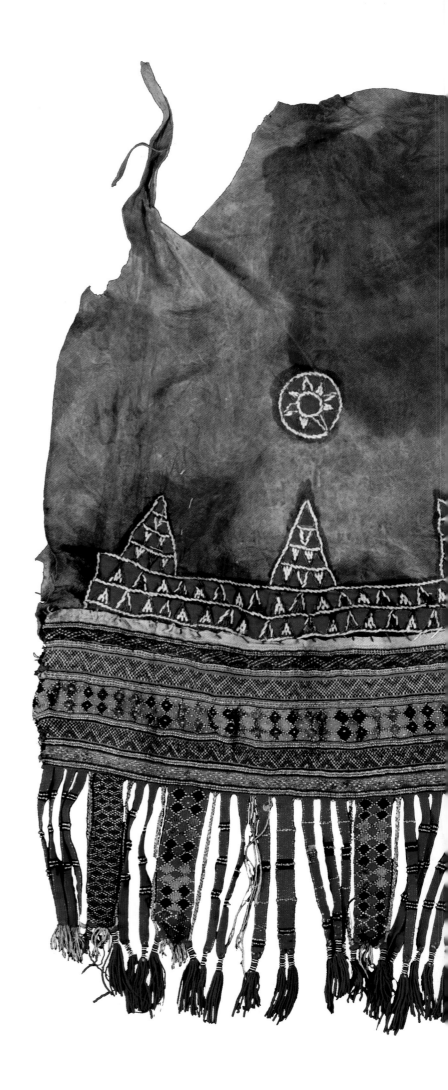

42 (centre). Miraka. *Said to be from the Harb tribe and made before 1930, this unusual piece was possibly for use on a horse. It consists of embroided leather with an apron of woven cotton with two strips of cotton warp and leather weft. Silver beads are woven in and the warp continues into the fringe. 17 warps by 30 wefts per square inch.*

Acquired in Jeddah, 1978.

43 (below). Udder cover and harness. *This harness, of warp-faced plain weave, goes round the camel's loins with a loop for the tail; the long straps are looped on each side of the hump and tied around the neck. It is sheep's wool with some goat hair and cotton. The udder cover of camel hair is plain woven with braided and twined edges.*

Acquired in al-Kharj, 1979.

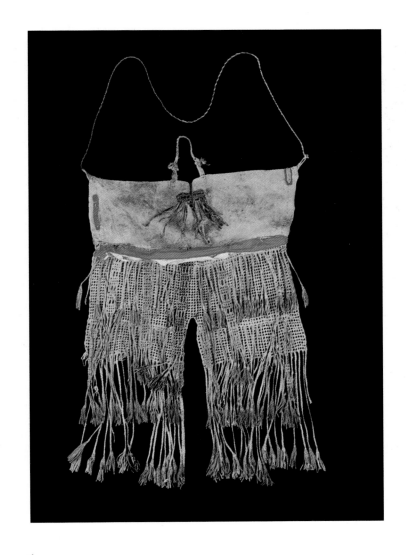

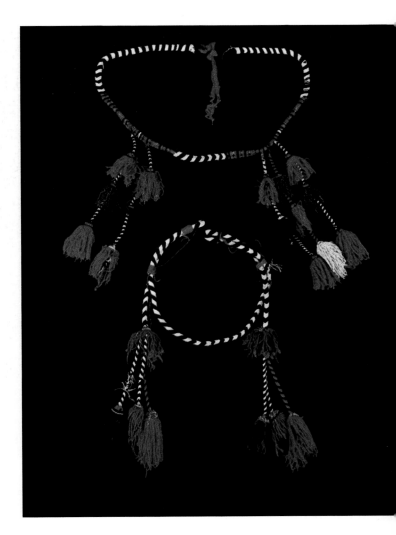

44 (above). Horse or camel decorations. *Straps such as these are placed around the animals' necks. Each of the examples shown here consists of a long rope of black goat hair braided with white wool, with smaller wrapped cords and tassels attached. Yarns are 2 s spun, plied z, except for the white which is 2 spun, plied s.*

Acquired in al-Kharj, 1979.

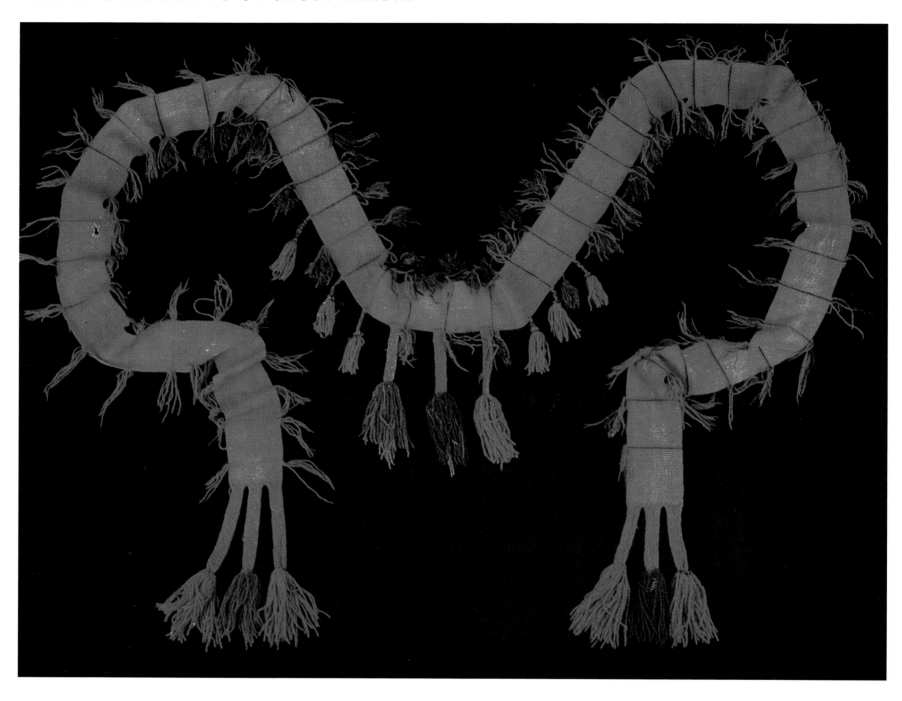

45 (above). Decorative band. *Made to decorate the* zetab, *the winged litter, this sash, now a rare item, is probably from the Ruwala tribe. It is warp-faced plain weave, with narrow weft-faced stripes with tassels at either end. Such bands are sometimes used to decorate the tent. This example is 25ft long and was probably made before 1930.*

Acquired in Sakaka, 1979.

46 (right). Camel litter decorations. *Made in the Najd before 1950, these bands are sheep's wool, with natural coloured yarns. They are made of warp-faced plain weave hemmed over sticks and have braided tassels attached. They are each about 9ft long.*

Acquired in al-Kharj and Riyadh, 1979.

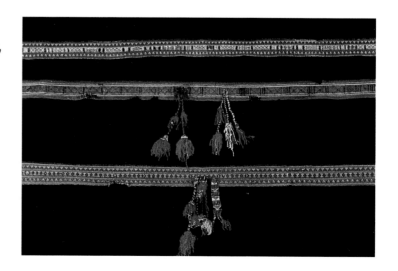

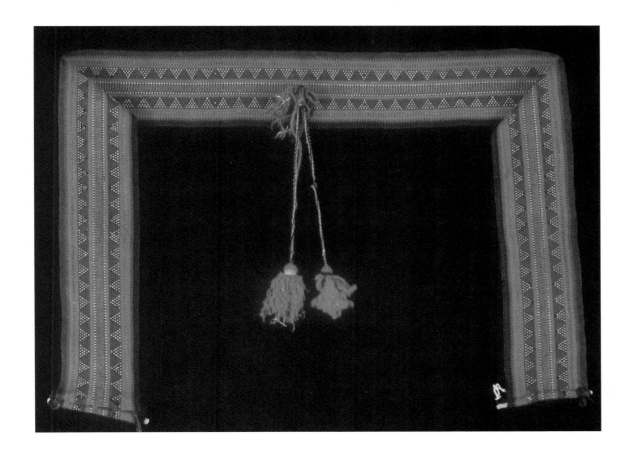

47 (left). Litter decoration. From the Najd and made before 1950, this finely woven band is sheep's wool with cotton. It is warp-faced plain weave, with two bands of warp pattern weave. The ends are hemmed over sticks and small wrapped loops are attached to each corner. A large tassel is sewn to the centre of the band. It is 8ft 1in by 6in. Yarns are 2 z spun, s plied.

Acquired in al-Kharj, 1979

48. Litter cover. *This rug consists of three panels of strongly woven warp-faced weave and it has long braided fringes. The lustrous wool is naturally dyed a vibrant red. It measures 9ft 4in by 5ft 2in and was probably made before 1940.*

Acquired in Riyadh, 1977.

49. Saddle blanket and miraka. *Probably made in northern Arabia before 1950, this piece consists of two warp-faced plain weave strips at the front end of which are three rows of regularly placed woollen tufts. These serve both as decoration and as a knee and leg cushion. The centre seam has two open slits for fitting over the saddle horns. It is 38in wide by 58in long. Yarns are 2 spun, s plied with unspun roving; 20 warps by 5 wefts per square inch.*

50. Camel saddle decoration. *A colourful woven band with tassels, this trapping hangs down from the rear saddle horn on either side of the camel. Wooden sticks are inserted between the warps at the end of each pane, to keep them flat. It is 6ft long from the end of the loop to the bottom of the tassels.*

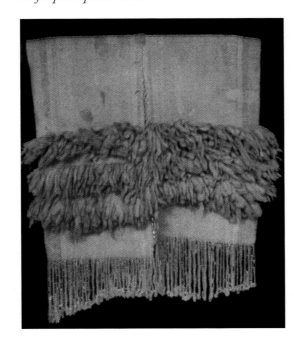

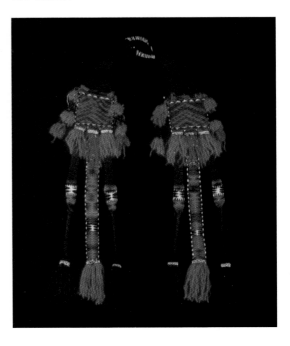

Woven Bags

Most Bedouin utility bags are made of woven wool, and range in size from about twenty by thirty inches to four by three feet. Almost all examples have stripes, or geometric designs woven in; occasionally decorative fluffs of wool or corded tassels hang from the bottom. They are constructed from two woven strips which run continuously from front edge to back edge, and are sewn together at the outer sides. At the top they are hemmed and sometimes bound with leather bands. The open corners have large loops of braided wool or braided leather to hang the bag over the camel's saddle horns. On some of the smaller bags the material extends on the back side to form a flap over the opening. To prevent the contents from falling out, bags used for personal possessions and small objects usually have a series of thongs looped one into the other and tied at the end.

A man's saddle bag, along with his weapons, is his main show piece and an object of great pride. Usually double, it is made of a continuous piece of cloth which forms the back panels, the connecting area, and the front panels. Such bags have reinforced slits to slip over the two saddle horns. As well as stripes and patterns woven into the cloth, successive tiers of elaborate sashes, ribbons and tassels are sewn onto these bags for decoration. Sometimes, especially in the north, the bottom row of sashes will reach almost to the ground. T.E. Lawrence described a saddle bag with seven rows of sashes seen on the camel of a young man from Qasim. In the south, however, sashes tend to be shorter, and the bags themselves more simply decorated, as, for instance, among the al-Murrah tribe.

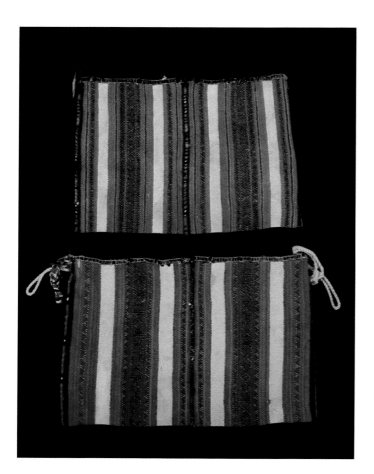

51 (left). Camel bags. *Made in western Arabia before 1950, these two bags are goat hair and sheep's wool with white cotton. Each consists of warp-faced plain weave stripes alternating with complementary warp pattern weave; the two widths are sewn together by overcasting at the selvedge. Both measure approximately 28in deep. Yarns are 2 z spun, plied s.*

Acquired in Ta'if, 1978.

52 (opposite, top left). Camel utility bag. *This large bag is made of two widths of striped warp-faced plain weave loosely basted together at the selvedge. The top of the bag is hemmed and overcast. It is natural coloured sheep's wool, black goat hair and cotton. Made before 1960, it measures 32in deep by 39in wide, and comes from western Arabia. Yarns are 2 z spun, plied s.*

Acquired in Ta'if, 1978.

53 (opposite, top right). Camel utility bag. *Made in the Najd (probably Subay tribe) before 1950, this large bag is a mixture of sheep and goat yarn and white cotton. It consists of two widths of striped warp-faced plain weave with an extra orange strip inserted into one section. The top of the bag is hemmed and overcast as are the selvedges. It is 43in wide by 31in deep. Yarns are 2 z spun, plied s.*

Acquired in Rabigh, 1978.

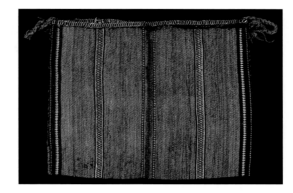

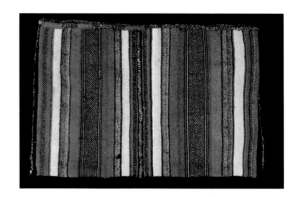

54 and 55 (right and below). Camel bag.
These bags, made before 1950 in south
eastern Arabia (probably al-Murrah tribe),
are sheep's wool and white cotton. They
consist of two woven strips of warp-faced
plain weave, overcast at the outer edges. The
centre selvedges are basted and covered
leather strips sewn on to the top. Leather
thongs pulled through holes fasten the bag.
It measures 34in by 23in. Yarns are 2 z
spun, plied s. A detail is shown in 55.

Acquired in Hofuf, 1977.

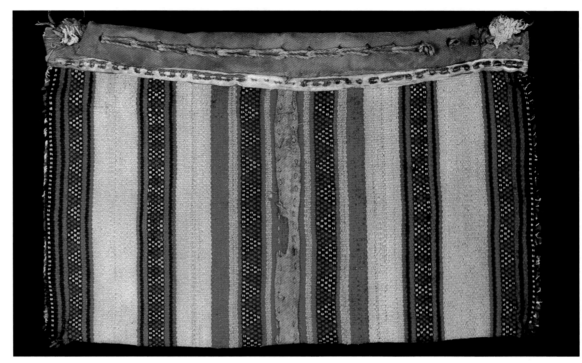

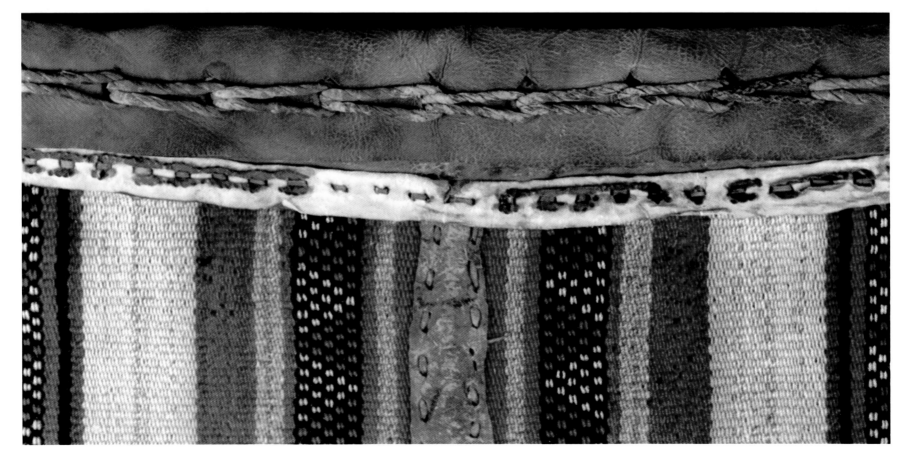

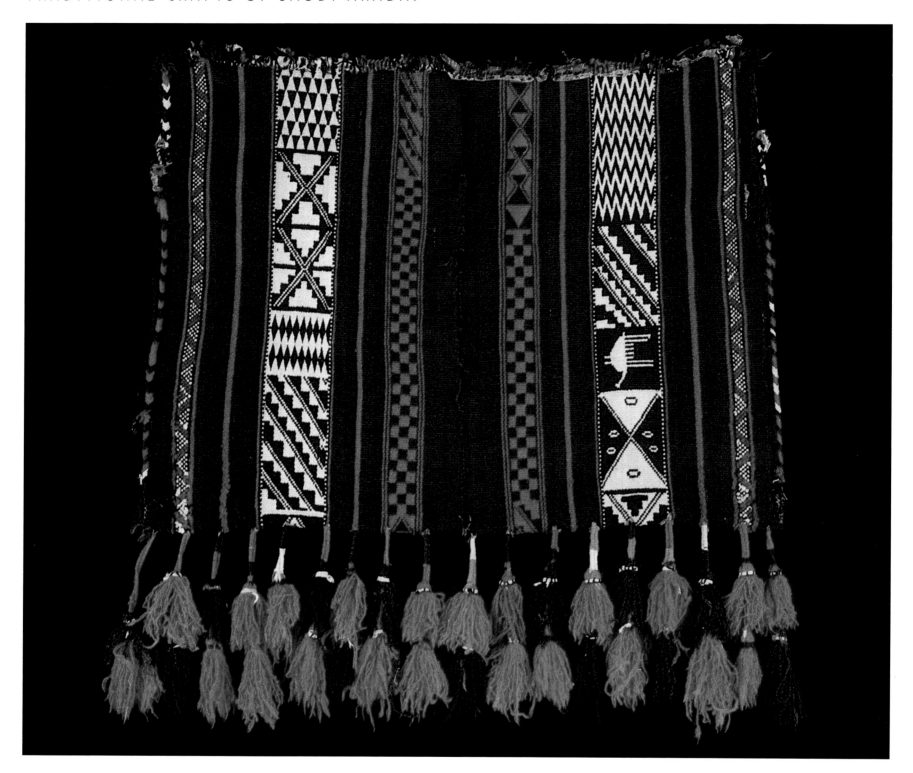

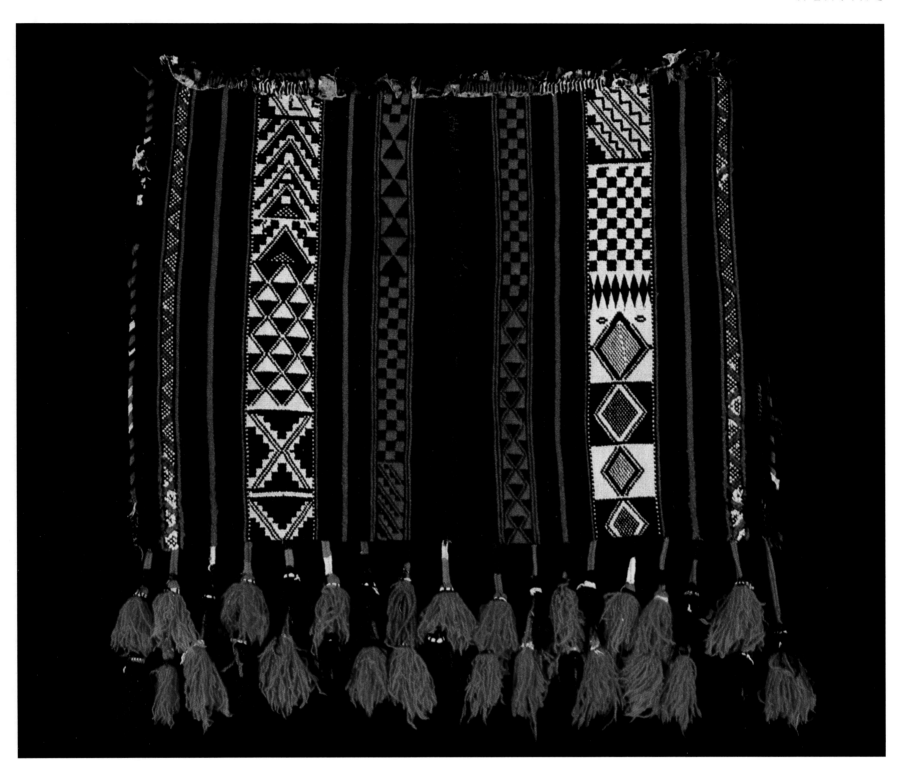

*56 (above left), 57 (below left) and 58 (above). Large utility bag. From the
northern Najd or possibly Jordan or Syria, this example is sheep's wool with natural
dyes. It consists of two woven strips of warp-faced plain weave alternating with
stripes of complementary warp pattern weave. The sides are overcast and the ends
at the top were originally reinforced with leather. Tassels are attached to the bottom.
(Body is 32 warps by 6¹/₂ wefts per square inch.) It is 36in deep. Yarns are 2 z
spun, s plied. Both sides of the bag are shown here, and a detail in 57.*

Acquired in Riyadh, 1979.

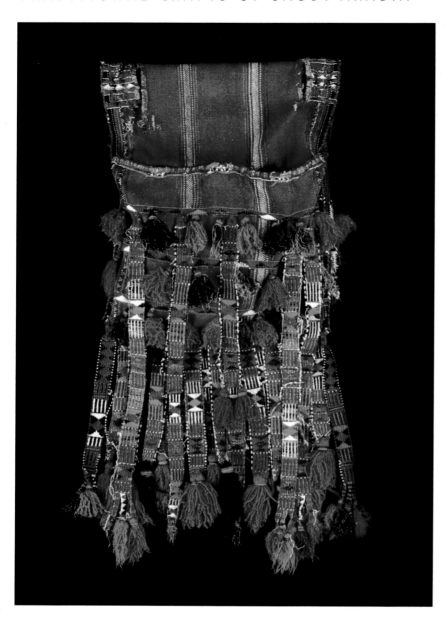

59 (above). Double camel saddle bag. *This classic man's bag from Najd (probably Utaybah tribe) is constructed from a continuous panel sewn at the edges to form a bag on each side of the camel. Made of sheep's wool, naturally dyed, and white cotton, it is striped warp-faced plain weave with two bands of complementary warp pattern weave and three bands of weft-faced twined tapestry. Two saddle horn slits are strengthened with leather strips; long colourful sashes and tassels hang from the ends. It was made befort 1950. Yarns are 2 z spun, plied s.*

Acquired in Riyadh, 1979.

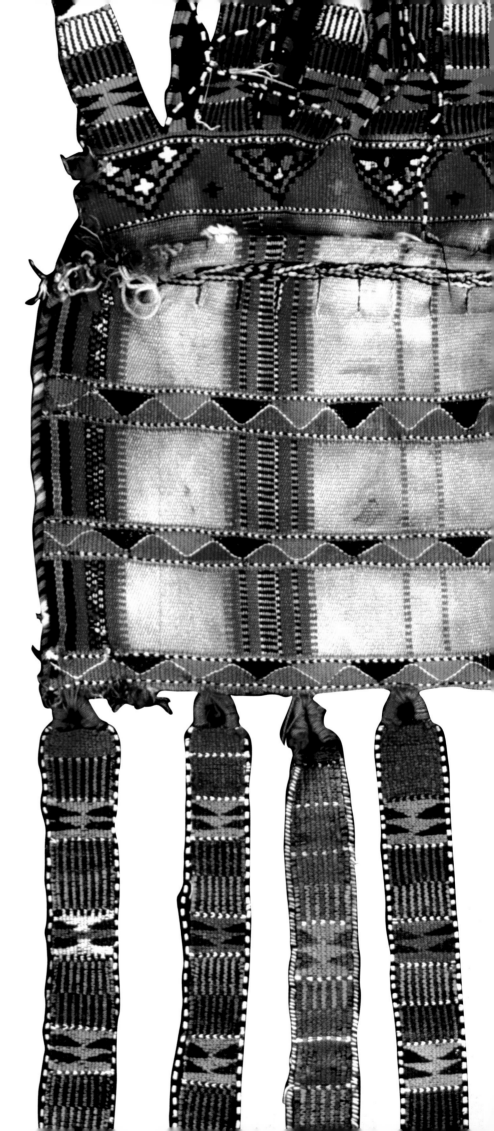

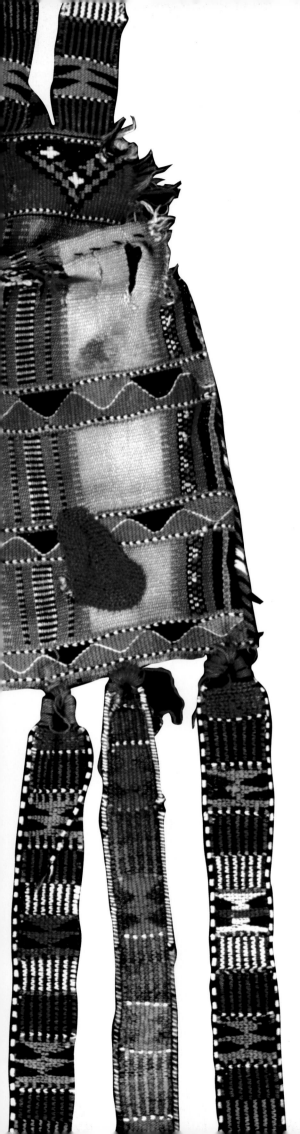

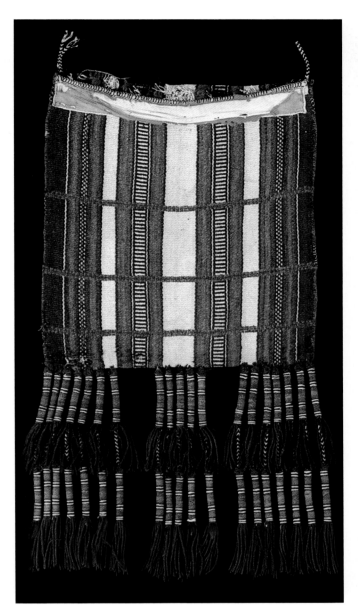

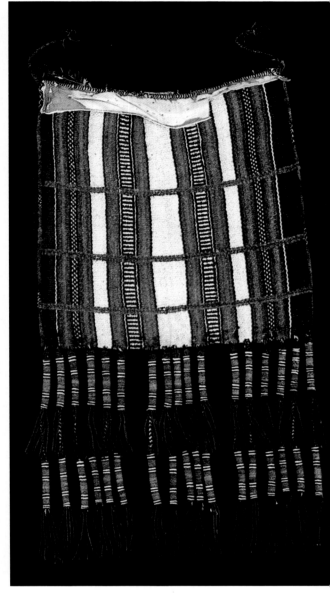

60 (left). Camel saddle bag (detail). *From the Qahtan tribe in southwestern Arabia and probably made before 1990, this bag is sheep's wool with some goat hair and white cotton. Naturally dyed, it consists of striped warp-faced plain weave with two bands of complementary warp pattern weave. Bands of weft faced twined tapestry at one end are used for the front. Sides are overcast, the front edge is hemmed and cord loops are attached to the top corners. Twined tapestry sashes and tassels hang from the flap and the bottom. In this illustration the bag is opened to show the front panel. It is 29in wide. Yarns are 2 s spun, plied z.*

Acquired in Riyadh, 1979.

61 (above). Pair of saddle bags. *These camel saddle bags from western Arabia (probably Juhaynah tribe) are in striped warp-faced plain weave in blended and naturally dyed wool with some goat hair; the white is cotton. The sides are overcast and there are bands of weft-faced twined tapestry. Openings are hemmed at the front and overcast at the back. Red cotton cloth is sewn at the top of the bag fronts and there are two-tiered wrapped fringes at the bottoms. Each bag is 22in wide.*

Acquired in Rabigh, 1978.

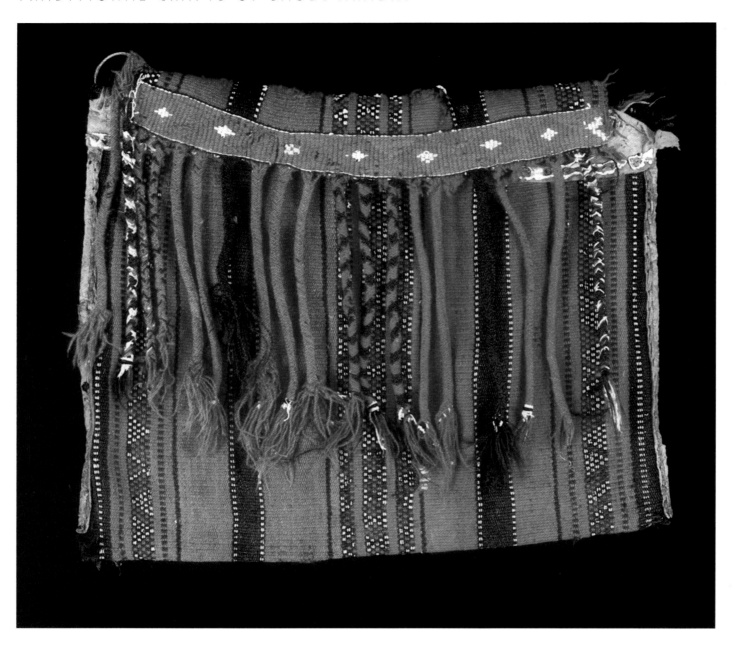

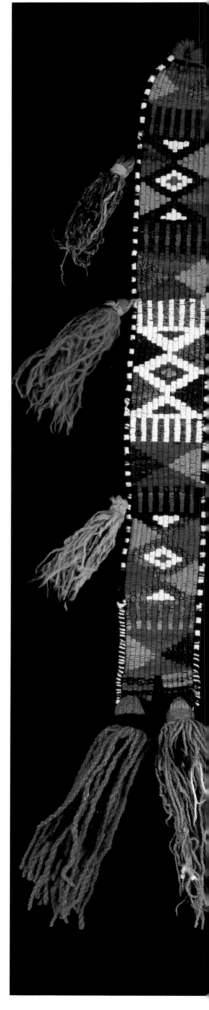

62. Camel saddle bag. *This single bag, made in the southern Najd (probably Subay tribe) before 1950, is sheep's wool with white cotton and goat hair. It consists of warp-faced plain weave with stripes of complementary warp pattern weave and leather strips sewn on to the side of the bag. The front is hemmed and faced with leather strips; the back projects above leather closure and ends in a band of twined tapestry with a fringe. It is 26in wide by 21in deep. Yarns are 2 z spun, plied s.*

Acquired in Riyadh.

63 (right). Sash. *Made in about 1960 for a saddle bag, this typical colourful sash is form the Najd. It is decorated with geometric designs and has tassles hanging off it at intervals, with wrapped warp edging.*

Acquired in Ta'if, 1978.

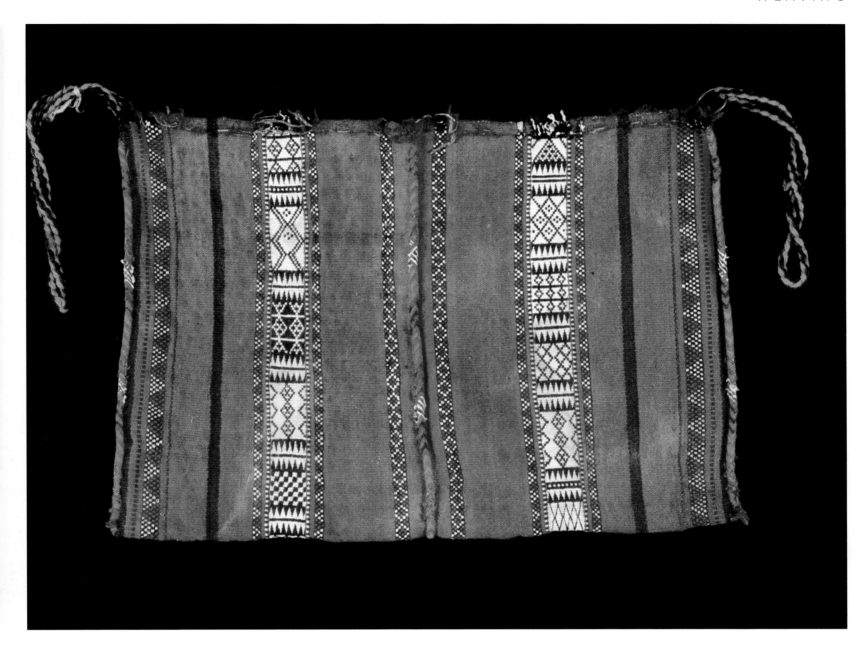

64 (above). Camel saddle bag. *This single bag, probably the oldest found, was made in the Najd before 1930. It is finely woven sheep's wool and cotton with natural dyes. It consists of warp-faced plain weave and bands of complementary warp pattern weave. The ends and centre selvedges are overcast and the top edges are hemmed. Metal rings and braided loops are sewn to the corners. It is 28in wide by 20in deep. Yarns are 2 z spun, plied s.*

Acquired in Ta'if, 1978.

Modern Weaving

Much weaving is still being done in Arabia but mostly of decorative items such as rugs, some tent walls, shoulder bags and coffee bean bags. Most of the large utility items such as tent cloth and back walls are imported, especially from Syria. Topham was told that there is a factory in Riyadh making goat hair tent cloth.

The native rugs that were once found on the streets in Dammam and other cities, being sold by the women who wove them, are now found in only a few shops. They also appear in profusion, usually of poor quality, in the flea markets at such events as the annual Janidariyyah Festival near Riyadh. Some of the Bedouin weavings seen here are possibly imported.

In al-Jawf there was an annual showing of weavings, but this custom appears to have died. There is a school in al-Jawf teaching primarily pile weaving, but in patterns and colours that are not indigenous. On a recent trip into this area, Topham did not find evidence of the relatively high level of activity in weaving that he had seen there in 1979.

Local weaving is featured less at the very refined Nabila Bassam shop in al-Khobar, but is still found there in the shape of cushions, shoulder bags and stool covers. Topham understands that there is ongoing activity, led by Aisha al-Mana, sponsored by the Ministry of Labour and Social Affairs, to reactivate traditional weaving skills, especially among the Bani Khalid women of the Eastern Province. Nearly all weavings seen recently utilize chemical dyes and synthetic yarns, also metallized yarns. Colours tend to the violent.

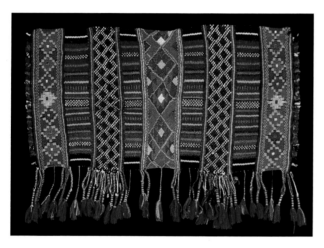

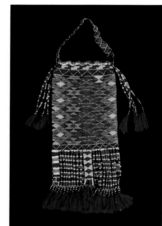

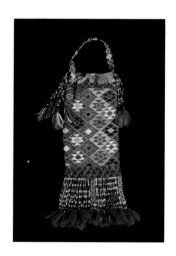

66 (left and right). Coffee bean bags. These recently made and synthetically dyed cotton bags are from Ta'if. They both consist of tubular weft-faced twined slit tapestry with tassles at the end. The bag on the left is 40 wefts by 12½ warps per square inch; yarns are 2 z spun, plied s.

Acquired in Taif, 1979.

65 (left). Decorative hanging or window cover. Made in about 1975 in western Arabia (Thaqif or Shahran tribes), this hanging is woven from sheep's wool and goat hair, using traditional designs in a variety of weaves (tapestry, plain and warp-faced weave). Yarns are both naturally dyed and handspun, and synthetically dyed and machine-made. This conformation of decoration appears to be based on the saddle bag shape.

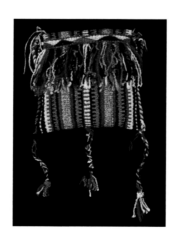

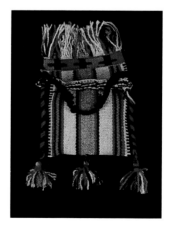

68 (left and right). Shoulder bags. Made in the Gulf (Bani Khalid or Ajman) in about 1977, these are wool and camel hair with goat hair edging. They are chemically dyed and are striped warp-faced plain weave. They are closed by braided chain loops which are twined into the back and extend to form a flap. Yarns are 2 z spun, plied s. This type of bag is one of the items made in Arabia for sale to Westerners.

Acquired in Dammam, 1977.

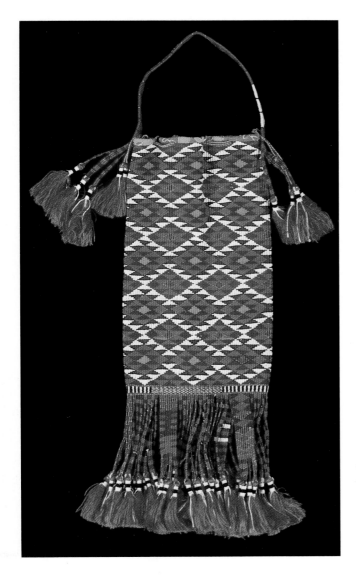

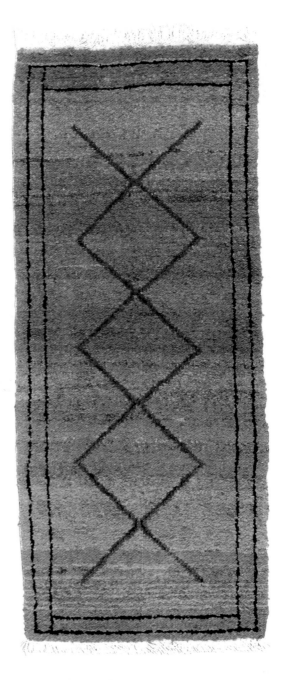

67 (left). Coffee bean bag. *This exceptionally disciplined piece of contemporary weaving is from the Ta'if area. It is tubular weft-faced twined tapestry with woven fringes and added cotton tassles. The cotton warp and weft are synthetically dyed. There is a braided drawstring and a woven band, and added tassles sewn on to the top to form a handle. It measures 7in wide.*

Acquired in Ta'if, 1978.

69 (right). Pile rug. *This modern rug was made in Sakaka in about 1977. It is camel hair with designs in chemically dyed sheep's wool using 'Turkish knots' with 'staggered crowns'; these alternate over and under one another to give a diagonal effect. One row of 2-strand twining occurs between the rows of knots which are placed over a set of 4 cotton warps. It measures 3ft 1in by 7ft 4in.*

Gift of Prince Sultan al-Sudari, 1979.

70 (right). Pillow cover. *From al-Jawf, the design of this modern weaving combines Bedouin and Middle Eastern influences. It is wool warp and weft with the pile dyed chemically. 'Turkish knots' are staggered with 'crowns' in the rows giving the weaving its diagonal effect. A row of 2-strand twining in white cotton occurs between the rows of knots.*

Gift of the weaver via her husband, Sakaka, 1977.

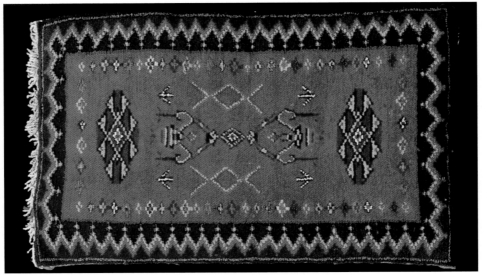

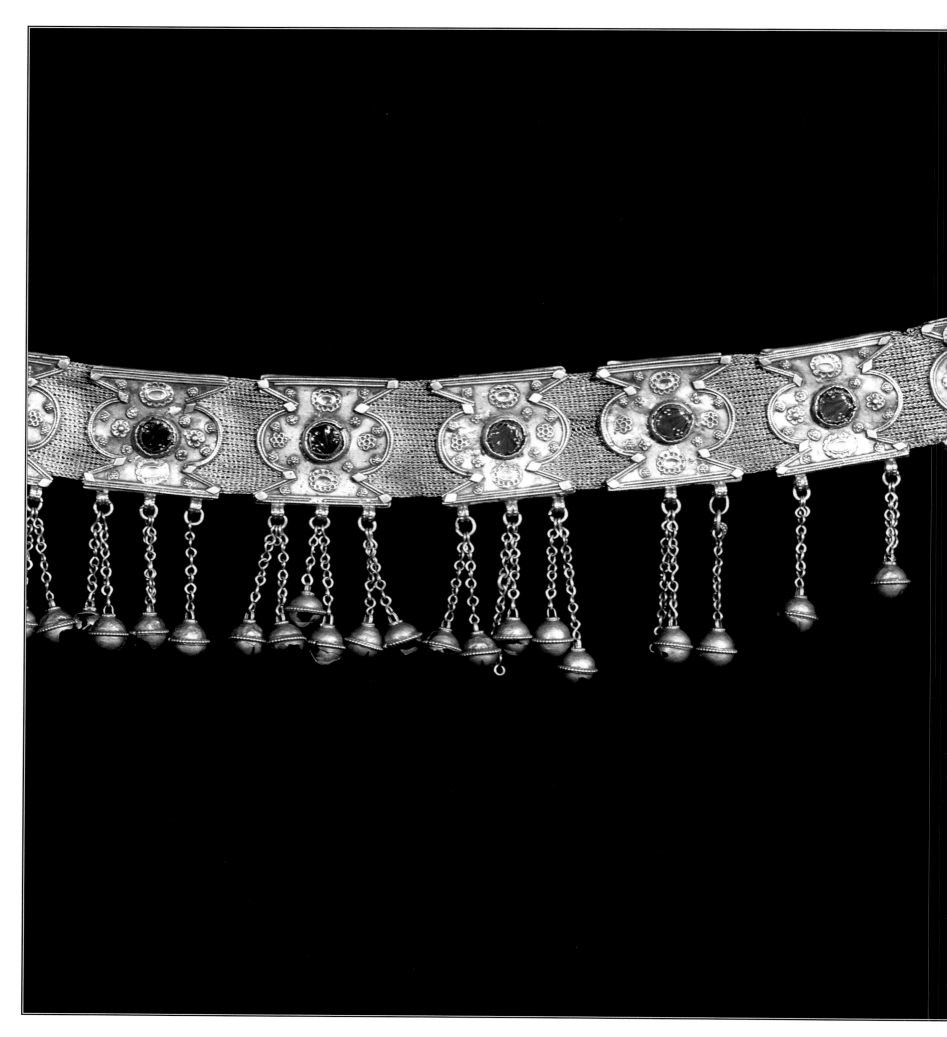

JEWELLERY

For centuries jewellery has formed an integral part of the feminine costume in Arabia. Today all women – rich and poor, old and young, urban, village and nomadic – still wear much of their jewellery, even when performing chores such as grinding flour or kneading dough, though naturally certain items like tiaras are reserved for ceremonial occasions. Men, by contrast, have tended to adorn their weapons and their camels rather than themselves.

Jewellery is of course, primarily a medium of adornment, but in Arabian society it stands for more than mere visual decoration: a woman's jewellery is regarded by men as having a sensual, perhaps seductive quality – the tinkling of coins, chains and bells, the glittering in the bright

Right: *Umm Abdullah's stall in the women's* suq *in Riyadh.*

71 (below). **Belt**. *This high quality silver belt* (hizam) *was probably made by Najrani craftsmen before 1940. Onto a knitted silver wire band are applied flat metal sections, elaborately decorated at the front with small rosettes, granulation, cast or stamped strips, applied filigree work, and inlaid glass beads. Engraved floral sprays with gold appliqué are inset on red glass which is thought to have come from Russia. Small cast bells hang off the chain along the bottom edge. The closing mechanism is a pin fastener. A detail is shown on the preceding pages.*

Acquired in Jeddah, 1978.

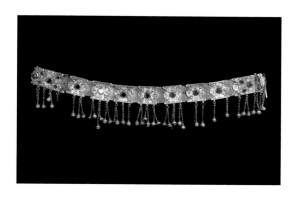

sunlight, the metallic elegance in the intense heat of the day. Women's jewellery also represents social and economic status; a portion of a woman's bridal settlement is still paid in jewellery which then becomes part of her personal wealth to keep or dispose of at her discretion. Like veils and headdresses, it is also a badge of a woman's married state and her fecundity, since it is customary to reward a woman with new pieces of jewellery when she bears a son. Finally, Middle Eastern jewellery often takes the form of amulets against the evil eye and malevolent spirits.

A Saudi woman might wear several wrist bracelets, elbow ornaments and arm bands, anklets, and rings specially designated for each finger. She might have one or more pairs of earrings, and a nose ring for each nostril; she might have several pieces of head jewellery – on top of the head, across the forehead, at the temples and at the ends of the braids. In addition, there may be belts, necklaces and chest ornaments that come to the waist. Even gold teeth in the front of the mouth are a form of adornment.

Much jewellery has its roots in history. For example the two types of twisted silver bracelets, known as *melwi*, derive from ancient Greek and Egyptian prototypes. The nose ring fashionable in the Middle Ages had its origins in Byzantine, Fatimid and more ancient models. The necklace, frequently adorned with ancient motifs including hand charms and crescents, is a romantic symbol repeatedly described or alluded to in Arabic love poetry. The medieval poet Hazim al-Qartajanni describes his beloved as;

A star in ascent who is haughty among other stars. Where necklaces and collars are made to shine. A string of pearls, as if your throat against it were a dawn against its pearly stars.

Stylistic features often reflect a woman's background. Like clothing, jewellery styles can be generally divided as between townsfolk, villagers and Bedouin, with Bedouin and village styles often overlapping. Unlike clothing, however, regional styles vary little. The differences therefore are

social rather than tribal. Even so, names vary from place to place, and the same name can designate entirely different things in different places.

Urban women have generally preferred to adorn themselves with fine confections of gold and precious stones. Their peasant and nomadic sisters in the past usually contented themselves with ornaments of silver, brass, or copper, semi-precious stones, and a great variety of beads. Not infrequently, objects made in gold for the urban elite were imitated in silver and baser metals for rural and Bedouin women.

The traditional handsome jewellery of village and tent society, mostly of silver of varying grades, was usually purchased by weight directly from the silversmiths, some of whom were itinerant. Some pieces were ready made from stock forms; others can be fashioned to order. Alternatively, village and Bedouin women often created their own necklaces after buying individual beads and charms. Until a generation ago, the most renowned craftsmen were the Najrani and Yemenite silversmiths, whose skilled work is still highly prized.

The silver jewellery found in Saudi Arabia, fine examples of which are illustrated on the following pages, range from the very plain to the highly ornate, with a wide variety of techniques and motifs. Relief decorations may incorporate granulation, filigree, repoussé, or niello work; twisted metal wires and various types of chain links are also present, the 'figure eight' being particularly popular. Geometric and other pictorial symbols, such as triangles, crescents and hands frequently found in Saudi jewellery as in much Islamic art, provide protection from the evil eye (the crescent's power is also mentioned in Isaiah 3:8).

The sign of the hand (the so-called hand of Fatima, daughter of the Prophet Muhammad) on Saudi necklaces – not usually the dominant central pendant, as in other parts of the Arab world – has been a talisman since antiquity. Some of these hand charms are highly stylised and only suggestive of their original inspiration. The

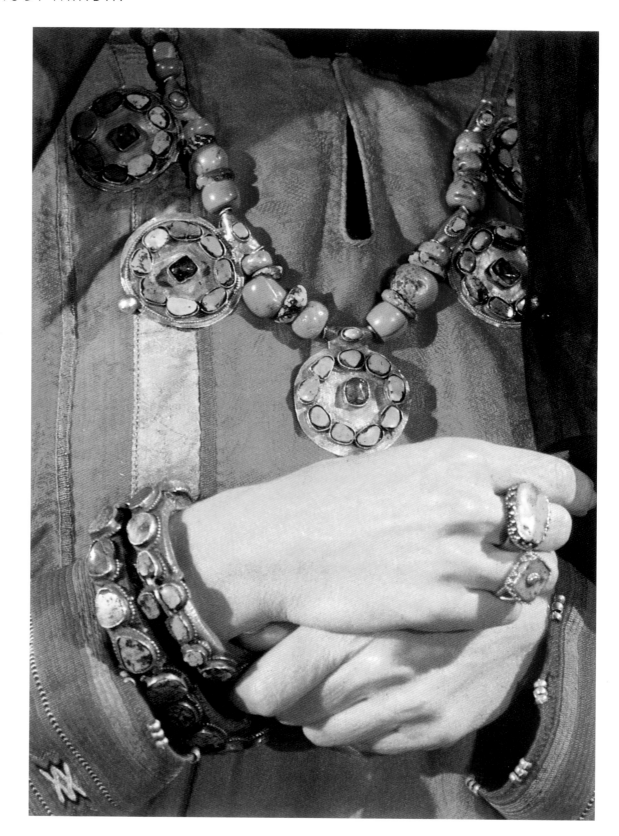

The turquoise and coral necklace (above) is also shown in illustration 83 (p.72). The dress is from the Bani Tamim tribe in the Riyadh area. The dress pictured opposite is from the Bani Malik tribe in the Asir. The belt is also shown in illustration 71 (p.64). Clothes and jewellery on these two pages are modelled by Carolyn Crouch.

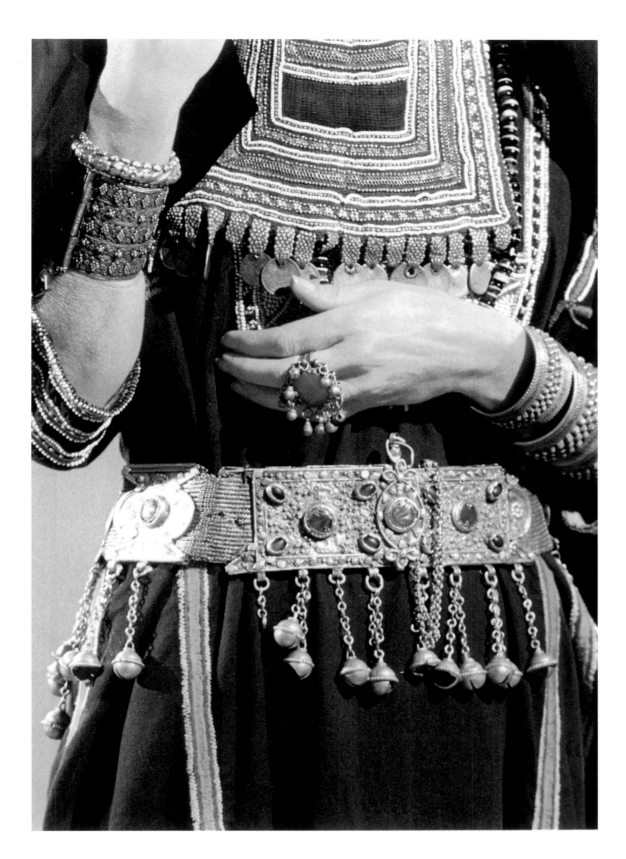

number five is the mathematical equivalent of the sign of the hand also representing the five tenets of Islam, and a combination of amulets if often worn to achieve this figure. Other numbers have symbolic significance and certain inscriptions are also considered powerful charms.

Green, blue and red are considered as protective; hence the most favoured stones are turquoise, agate, coral and glass of these colours. Amber is also much esteemed in Saudi Arabia, as throughout the Arab world. The beads usually come from Yemen and are mostly yellow; the colours yellow and brown are accorded protective properties. (Cloves also, are thought to have similar properties; Berber and Palestinian Bedouin brides frequently wear clove necklaces. The 19th-century Arabian traveller, Charles Doughty, reported that Bedouin women sometimes inserted cloves in their nostrils instead of nose rings.)

Other forms of ornament on jewellery are silver bells and different coins. The coins are usually part of the dowry money and might include Arab, Ottoman and French coins, and the ubiquitous Maria Theresa thaler. They are a major decorative element, especially on necklaces, and may appear alone or decorated with chains, soldered to the edges, from which various charms are hung. The preferred number of chains hanging from a large coin is three or five. Unfortunately these coins are only of minimal help in dating an object since they may be frequently re-used, or struck from the original dies a century or more after the date they bear, as is the case with Maria Theresas and some Ottoman coins.

Arabian jewellery, and in particular the silver jewellery that has been popular for so long with villagers and Bedouin, is now subject to new influences. The combined forces of modernity, wealth and the techniques of masss production have resulted in an increasing preference for gold jewellery and a desire to imitate urban styles. Factory-made gold, most often from Italy, for those who can afford it, and costume jewellery of all kinds, have almost completely replaced traditional craftsmanship.

Headpieces and pendants

Highly ornate, the headpieces, pendants, hair and face ornaments of the Bedouin women are usually made of silver or silver alloys. Like most Bedouin jewellery, they are decorated with soldered metal strips, delicate filigree work, glass or semi-precious stone inlays or with bells or coins or other intricate pendants.

The headpieces and pendants are suspended from a strap at the top of the headdress and arranged to hang onto the forehead or to one side of the head. Other head ornaments include bands which are worn across the forehead and tied at the back of the head. These, for greater flexibility and comfort, are sometimes made of interlocking chains of small diamond-shaped pieces linked tightly together by vertical rods.

Hairpieces are often worn in sets of five or seven; each has a loop soldered onto its back, through which the hair can be pulled. The attractive examples illustrated here have turquoises set into brass. Sometimes the nose too might be adorned. Apart from gold or silver studs for the nostrils (*see* page 84), unmarried girls may wear a pendant hung above the bridge of the nose. This is typically a flat piece of silver inlaid with glass beads with small rings and chains attached to

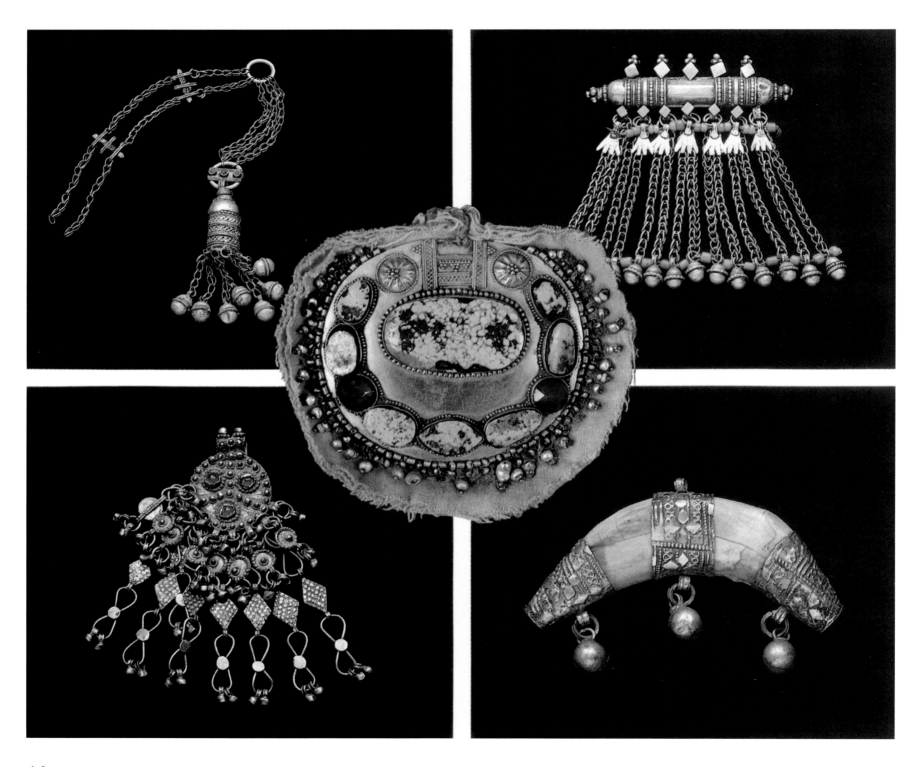

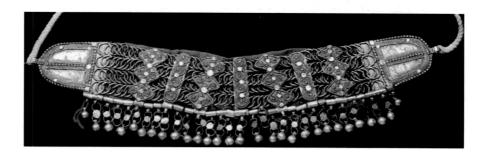

Opposite page, clockwise from top left:

72. Headpiece. *Made in Yemen before 1960, this low grade silver piece was intended to hang from a head covering. A double chain, held apart by two decorated metal strips, is attached to a ring fastened with chains which lead to another ring with a soldered strip decorated with red and black beads. The main section, covered with filigree bands, is hollow and open at the end. It is 16in long.*

Acquired in Ta'if, 1978.

73. Headpiece. *Made in Najran in about 1900, this high quality silver headpiece is decorated with coral beads on chains. Below the amulet hang small metal pieces, the shapes of which are based on Fatima's hand. This headpiece could possibly have been worn hanging from a headdress, but more probably from the neck, given its weight.*

Acquired in Jeddah, 1978.

75. Hyena tooth pendant. *From the Asir and probably made before 1940, this pendant consists of a hyena tooth encircled by three bands of high grade silver. Relief designs in applied filigree and small diamond shapes soldered on, form the decoration. A small ring is soldered to the top. Metal beads are attached to the three bands at the bottom. It measures 3in long.*

Acquired in Jeddah, 1978.

74. Pendant. *Made before 1950, this piece consists of a Maria Theresa thaler surrounded by twisted wire, red glass beads in bezel settings and layers of chains which end in bells.*

Acquired in Ta'if, 1978.

76 (centre). Forehead piece. *Worn on the forehead, this rare silver gilt piece is said to have been made in Unayzah and favoured by the al-Dawasir tribe. It is decorated with granulation and applied filigree and has two embossed cones at the top. The inlaid stones are turquoise and glass in bezel settings; pearls on short threads hang round the edge. Sewn onto a cloth backing, the piece measures 4 1/2 in by 3 1/2 in. It was bought with the necklace shown in illustration 83 (left).*

Acquired in Riyadh, 1979.

77 (above). Forehead band. *This attractive example from the Hijaz was made before 1940. It is silver with linked chainwork and a green backing cloth. The vertical sections which hold the chains in place are decorated with twisted wire and cast or stamped strips with small pieces of round flat metal soldered on. It measures 13in long.*

Acquired in Jeddah, 1978.

78 (below). Headpiece. *This exceptionally well-made Najrani headpiece (ilaqa) of about 1900 is decorated with small diamonds and circles soldered onto it. It is inlaid with red glass; chains, separated by coral beads suspended from bells, hang from it. It measures 9 1/4 in long.*

Acquired in Jeddah, 1978.

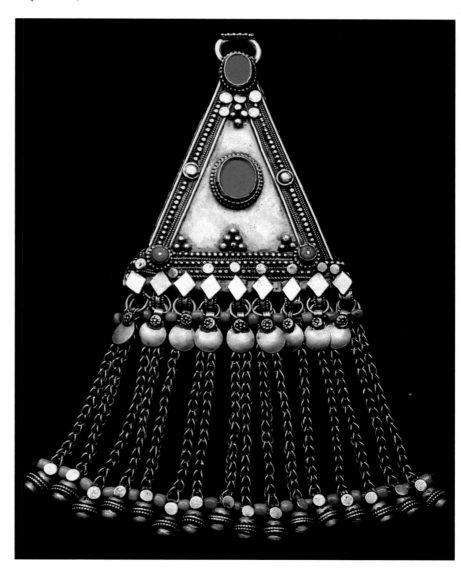

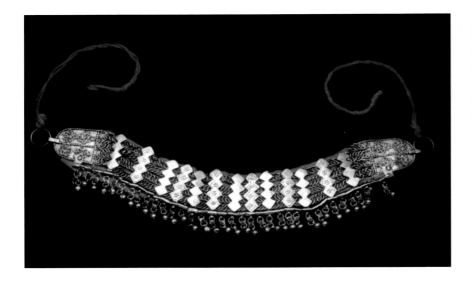

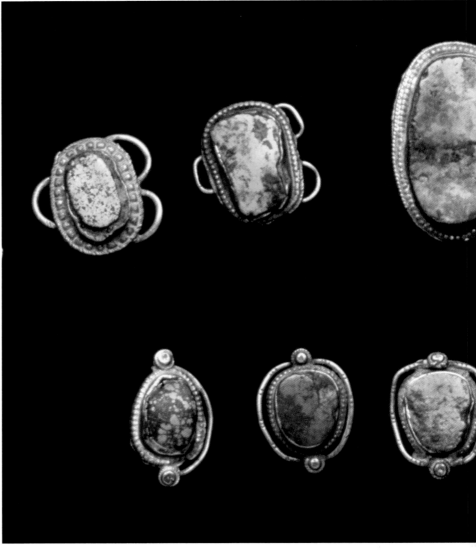

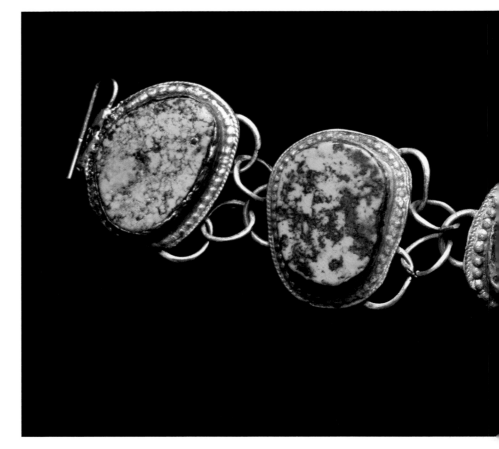

79 (above). Forehead band. *Made in the Hijaz before 1940, this silver piece consists of diamond-shaped cross sections holding rows of horizontal chains in place. It has chased designs, small circular pieces of wire soldered on at both ends, and bells hanging off the lower edge. It has a cloth backing and is 15 1/2 in long.*

Acquired in Jeddah, 1978.

80 (top right). Hair ornaments. *Used in sets of seven or five, these ornaments from the central Najd, consist of turquoise stones set in brass mounts decorated with granulated and applied filigree designs. The turquoise pieces, some of which are chipped or cracked, are fixed into their settings with a paste adhesive made from dates. Soldered to the back are rings through which the hair is pulled. The dimensions of the largest are 2 1/4 in by 1 1/4 in.*

Acquired in Riyadh, 1979.

81 (bottom right). Hair ornaments. *This set of hair decorations, made before 1950 in the Najd, has been crudely turned into a 7 1/2 in long bracelet. The turquoises are set into silver mounts – a rare occurrence. The settings have simple repeat patterns in granulation or are soldered on. Rings, through which the hair was pulled, are soldered onto the back of each piece.*

Acquired in Ta'if, 1978.

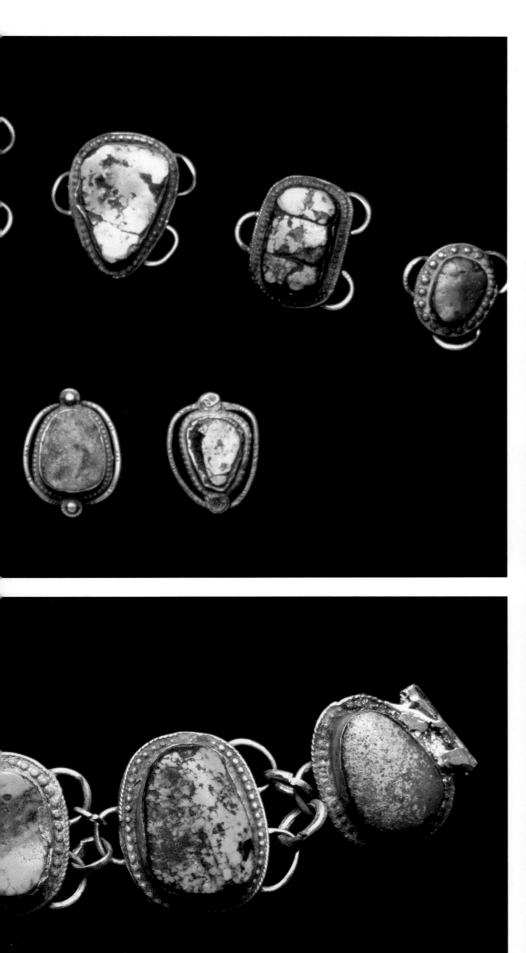

82 (below). Nose pendant. *This rare 4in long example was made in the Hijaz before 1950 and is constructed from a flat piece of silver inlaid with glass beads. Its lower end consists of a ring set with red glass. It is said to have been worn hanging above the nose bridge only by an unmarried girl.*

Acquired in Jeddah, 1978.

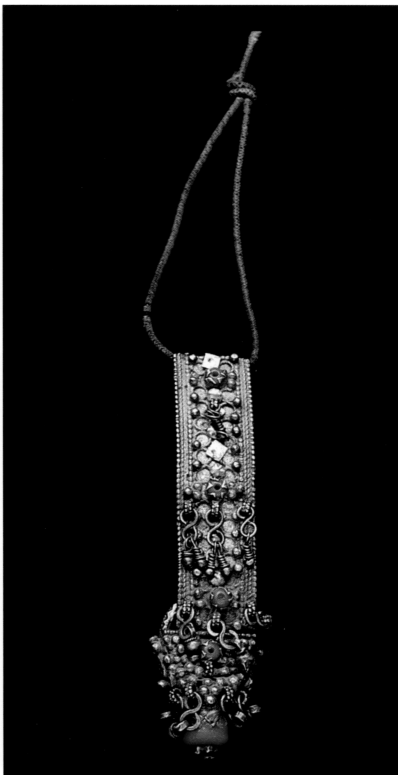

Necklaces

Bedouin necklaces commonly have amulets (hirz) attached to them, the most popular of which is a pendant of simple geometric shape (hijab): a triangle, a square, rectangle, or cylinder (khiyar or uda), worn alone or flanked by decorative beads. Sometimes five amulets are combined.

Most hirz necklaces are silver. One of the most impressive is the mirta'sha, a necklace which combines amulets of many different shapes and forms and covers the entire chest. Such neckpieces are often finely decorated with silver bells, silver or amber beads, diamond shaped pendants, filigree work, or delicate granulations. Some of the pendants, such as the khiyar or uda, are actually containers that open at one side so that a written talisman, usually containing verses from the Holy Qur'an, can be inserted.

There are, of course, other types of necklaces that are essentially decorative and not primarily charms. These include the iqd (a general word for necklace from the word meaning 'knot'), the khnaq and kirdan, (from the Persian word gardan meaning 'neck'), a choker (often backed with cloth) consisting of small silver bars with a variety of pendants. The word silsila denotes all kinds of metal chains, although in Saudi Arabian jewellery it specifically refers to the heavy silver chain which women wear over one shoulder and under the opposite arm like a bandoleer.

The term glada is the general name given to beaded necklaces, of which a simple but attractive type is the gladat ambar which is made from five amber beads. Other examples have turquoises (fayruz) and coral (marjan) strung between five pendants which are themselves studded with turquoise and blue and red glass beads. Some necklaces are made entirely of coral; these in northern Arabia are called mahnaka instead of glada.

As in other types of jewellery, coins are a major decorative element in necklaces and may appear alone or decorated with chains that are soldered to the edges and from which various charms are hung. The preferred number of chains hanging form the large coin is three or five.

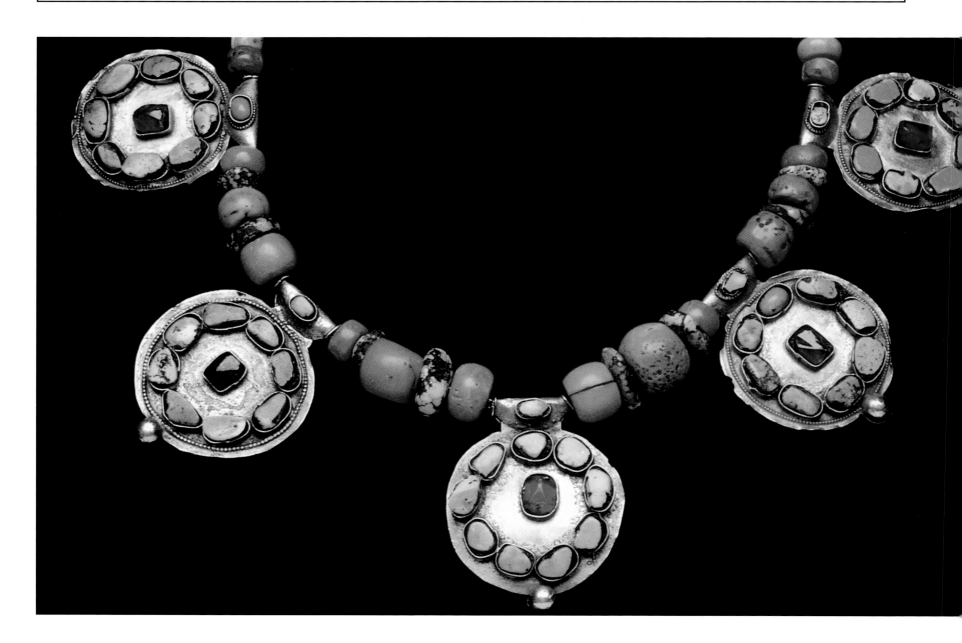

83 (left) Necklace. This 17in long necklace (glada) was made in the Najd before 1940. It consists of turquoise, coral and glass beads strung between gold plated pendants. Each pendant is made up of turquoise pieces, which surround a central piece of red glass; all are in bezel settings. Formed simply from sheet metal, the pendants have extended upper edges, folded over and soldered to attach them to the necklace itself.

83 (right). Neckpiece (loah). *This classic silver neckpiece was made before 1950. The intricate symmetrical decoration on the pendant consists of alternating bands of applied filigree and granulated or cast beads, overlaid with diamond shapes. At one side there is an opening containing verses from the Holy Qur'an; small beads on chains hang from the lower edge. The large hollow beads are decorated with repoussé and applied filigree work, a type especially used by the Bani Salem of Harb. The piece measures 35in long.*

Acquired in Ta'if, 1978.

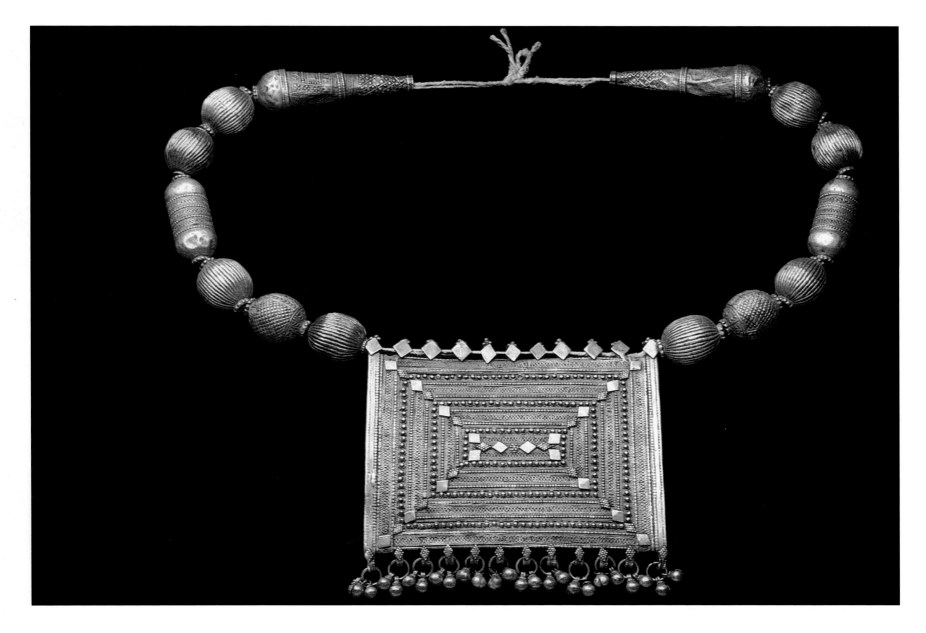

84. Neckpiece. *The intricate neckpiece (kirdan), probably made in Yemen before 1950, is 9½ in long. It is silver with cloth backing and consists at the top of a row of hollow squares; below are bands of 'figure of 8' chains alternating with sections of twisted wire, teardrop-shaped pieces and tiny hollow balls.*

Acquired in Jeddah, 1979.

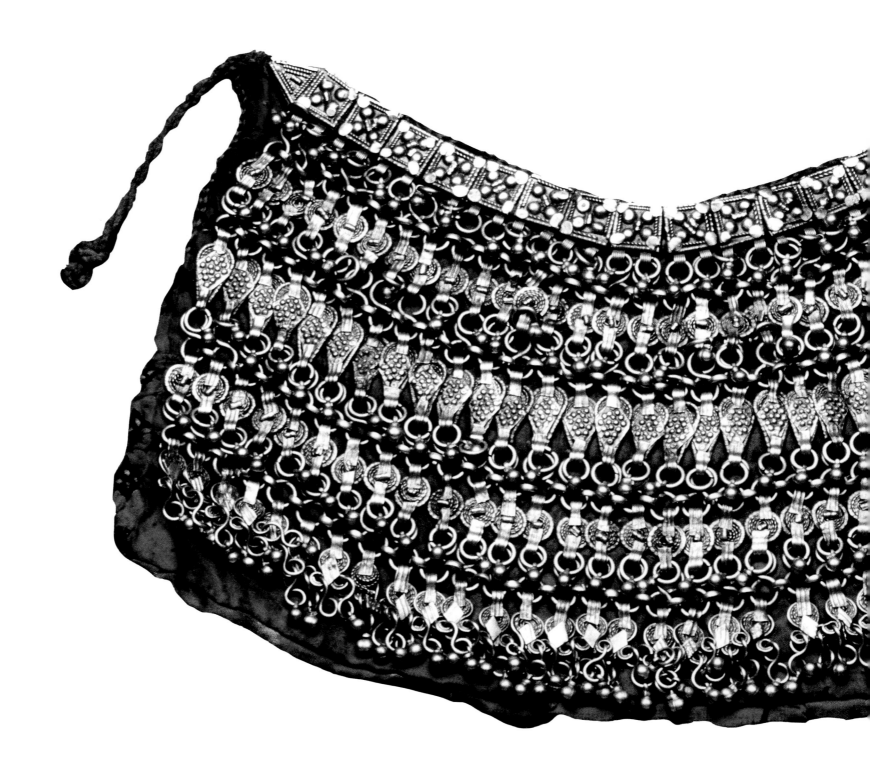

85. Neckpiece. *This silver neckpiece is an example of Arabian village craft. It consists of three rows of thin metal strips held together by small rings; nine geometric pieces decorated with embossed floral motifs hang from each row of strips. Small bells are attached to the lower pieces. It is 9¹/₂ in long.*

Acquired in Ta'if, 1979.

86 (bottom). Neckpiece. *This choker-type necklace from the Gulf (possibly made in Oman before 1960) consists of a band of metal, one inch wide, decorated with geometric cast and soldered metal pieces. It is closed at the back by a thinner metal strip that hooks through holes at both ends of the wider strip. The 'fringe' is made of simple chains alternating with 'figure of 8' loops and large hollow beads, all of which end in bells.*

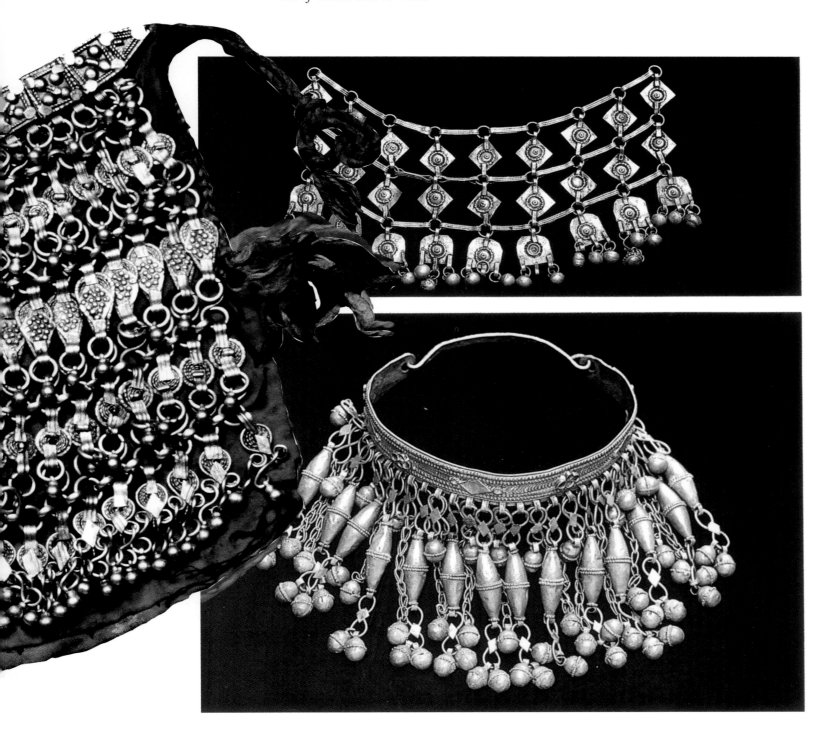

87 (above). Necklace. Made before 1950 in the Asir, this necklace consists of glass and old agate beads interspersed with later Saudi Arabian coins. Several of the beads have decorative incised holes or unusual spiral patterns. It is 15¹/₄ in long.

Acquired near Najran, 1979.

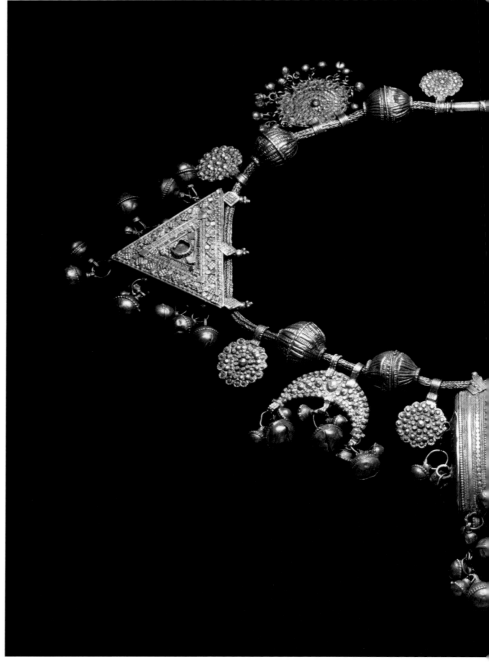

88 (below). Necklace. This contemporary necklace from Yemen consists of five large yellow and brown amber beads interspersed with smaller red glass beads. The number five is considered a charm against the evil eye. The silver linked chain on either side of the bead closes with a hook and loop. The necklace is 18in long.

Acquired in Jeddah, 1979.

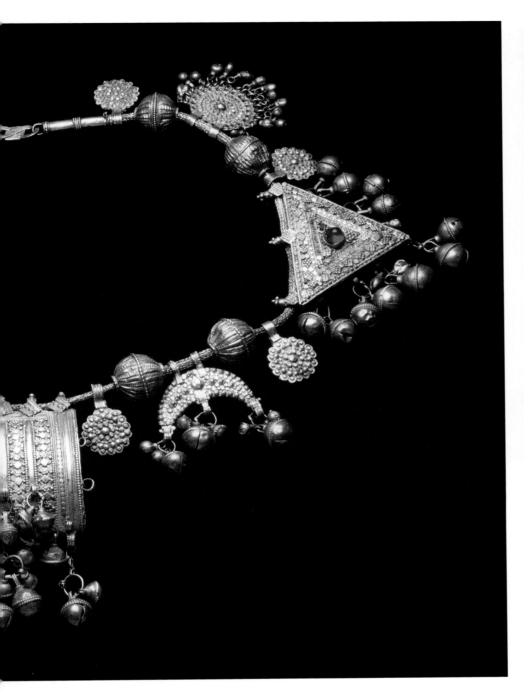

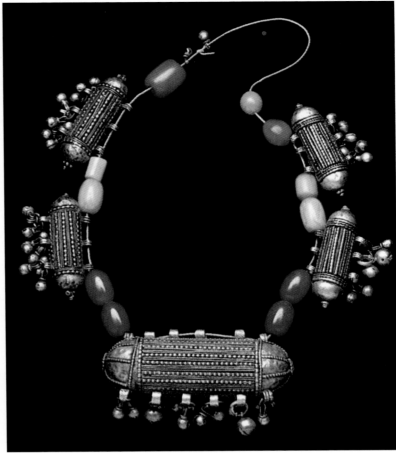

89. Necklace. *This amulet necklace (hirz) was made in Yemen before 1950. It consists of red and yellow amber beads interspersed with five hollow cylindrical low grade silver amulets (khiyar) which are decorated with overlaid wire and cast strips. The large central cylindrical piece opens at one end and could have held verses from the Holy Qur'an. Rings are soldered onto the top and bottom and hold the necklace thread and bells. It is 17in long.*

Acquired in Riyadh, 1979.

90. Necklace. *This unusual necklace of low grade silver comes from Yemen and was made before 1950. It is composed of a central rectangular hollow piece flanked by crescents (hilal), two hollow triangular pieces, and rosettes interspersed with beads, all strung on a thick chain. The triangles and the central rectangular amulet (hijab) are decorated with bands of applied filigree and soldered and cast motifs. The beads have chased patterns and the crescents and rosettes are cuttlebone cast. It is 36in long. This type of necklace is sometimes made long enough to be worn over one shoulder, extending to the waist.*

Acquired in Jiddah, 1978.

Bracelets

Bracelets, elbow bands, and anklets are similar in their general form, material, decoration, and technique, and hence are grouped together under a single heading. They are mostly silver and are usually made in pairs. While a single pair of anklets (*khilkhal* or *hijl*) and arm bands (*zand*) or elbow bands (*ma'qid*) is sufficient for most women, five or more bracelets (*siwar*) might be worn on each wrist.

As with other items of jewellery, some bracelets have special names. A bracelet consisting of a string of large amber beads is called a *khasur*, while a string of multicoloured stone, glass and metal beads is known as a *dalqa*. This last type is commonly worn by Bedouin women all over the Middle East. Fine gold bracelets studded with turquoise are called *khuwaysa* but are of course expensive and were once only worn by the wealthy.

One bracelet commonly found throughout Saudi Arabia, and much of the Mediterranean, is the *melwi* (literally 'twisted'). Made of twisted silver wires it is capped at either end with finials and often studded with stones. A variation of this bracelet is a thick piece of wrought metal (*ma'din mutarras* – literally, 'embroidered metal') around which a wire is twisted. In central Arabia this last type of bracelet is apparently called *hijl*, a word which also means anklet in other parts of the country.

Bracelets, anklets, and armlets all vary in weight and workmanship. They might be light hollow silver tubes with chased geometric or floral designs or massive pieces of solid metal (often used for trading) either chased or with extra pieces of metal soldered on. Some bracelets have magnificent granulation and filigree work, and one highly intricate bracelet (Fig. 100) is made from three bracelets joined together, each of which is decorated by three rows of pointed knobs running around the centre; it is closed by a single pin.

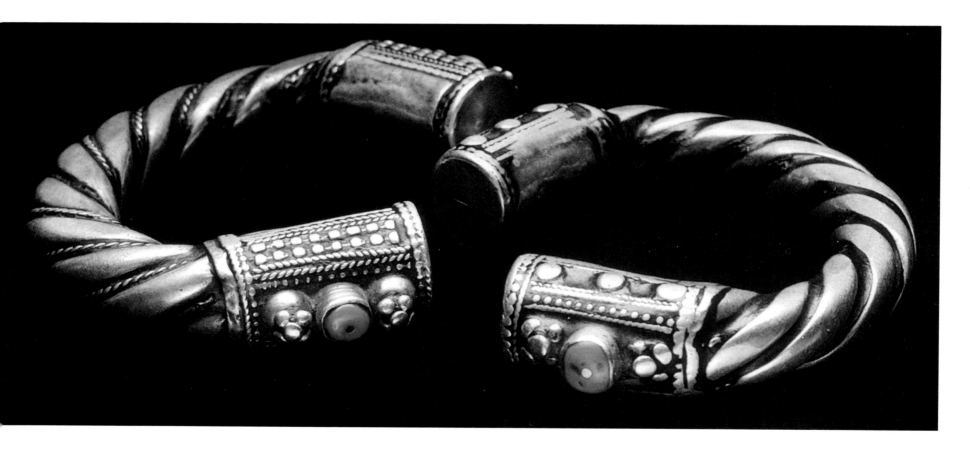

91. Pair of bracelets. *Made in Najran before 1920, these finely worked bracelets are high grade silver. Formed from twisted metal rods, their ends have granulated decoration and coral in bezel settings. The darker areas, applied for contrast, may be pitch. Both bracelets are 3¹/₄ in diameter.*

Acquired in Jeddah, 1978.

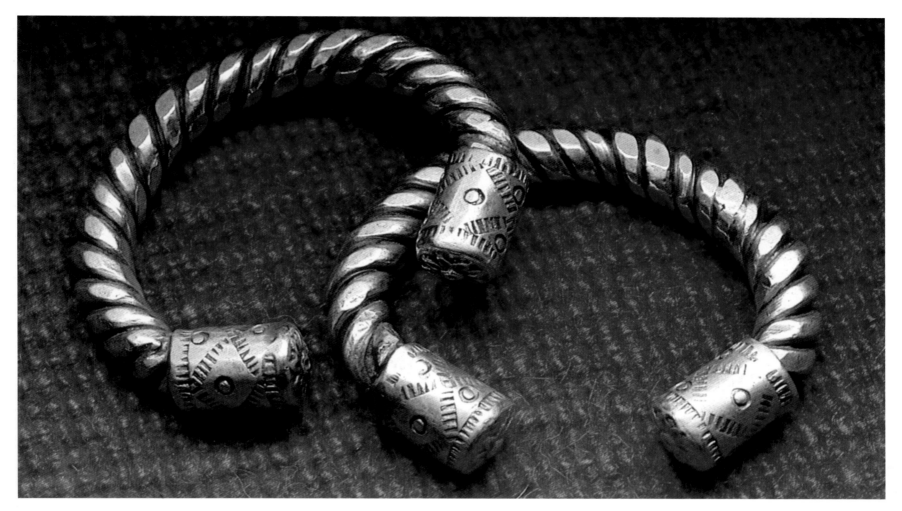

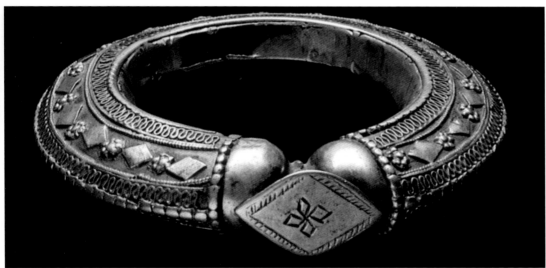

92 (above). Pair of Bracelets. These bracelets (melwi) *from Najran were made before 1940. They are constructed from three twisted strands of high grade silver, slightly flattened on each side. The caps are decorated with chased lines, circles and floral motifs. They measure 2³/₄ in diameter.*

Acquired near Najran, 1978.

93. Bracelet (said to be anklet). *Probably made in Arabia before 1950, this anklet consists of a hollow, triangular cross-sectioned tube made of three silver pieces soldered together. It is decorated with stamped and embossed pieces of metal in floral and diamond shapes with additional filigree work; the motifs are characteristic of Saudi-made jewellery. It is 4¹/₂ in in diameter at the widest point.*

Acquired in Riyadh, 1979.

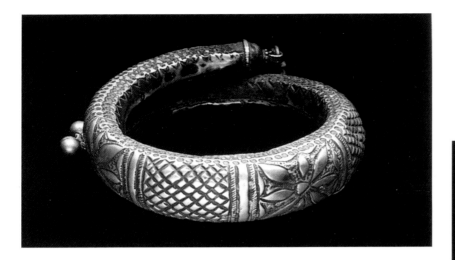

94. Bracelet. *Made before 1940 in western Arabia, this bracelet is hollow silver. Deeply chased alternating diamond and petal shaped designs with a few beads attached are its decoration. There is no clasp since the bracelet forms a loose spiral with the ends overlapping. Bracelets, such as the example shown here, are normally worn in pairs.*

Acquired in Yanbu, 1979.

95. Pair of bracelets. *These bracelets from the Najd are typical of central Arabian work. They consist of hollow sheet metal moulded around a form and then decorated with geometric chased designs. Turquoise pieces (14 per bracelet) are soldered on in high bezel settings with cast metal decoration. They are closed with a hinge and clasp mechanism and measure approximately 3in in diameter.*

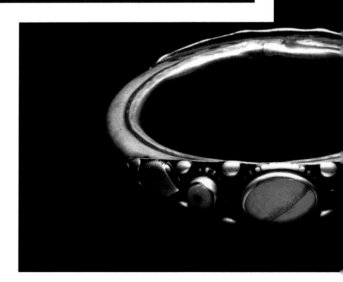

96 (below). Pair of bracelets. *These handsome bracelets from Najran are made of high grade silver. The bands at the front and back are decorated with red glass in bezel settings, coral beads and silver beads soldered on. A dark, hard material, possibly pitch, has been applied to the recessed areas for contrast. The bracelets are solid, but much worn; they have been relined inside with metal bands. Their diameter, 33/4 in – larger than that of most bracelets – suggests that they were worn around the upper arm. They were made before 1900.*

Acquired in Jeddah, 1978.

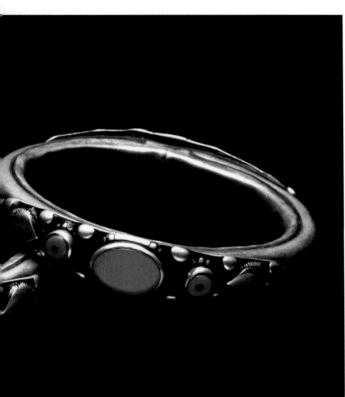

97 (below). Three bracelets. *These three examples, made before 1960, are possibly from Yemen. The bracelet on the left consists of a double row of beads strung onto wire which forms a hook and loop closing at the back. The beads are cast in rough geometric shapes; thin bands of smaller cast beads are soldered to the ends of each main bead. The bracelet in the middle is an old twisted silver example with three rows of 'droplet' clusters soldered onto the top and sides. On the right is a bracelet made of twisted silver wires braided together. Its screw fastener is covered with a decorated metal piece.*

Acquired in Ta'if, 1978.

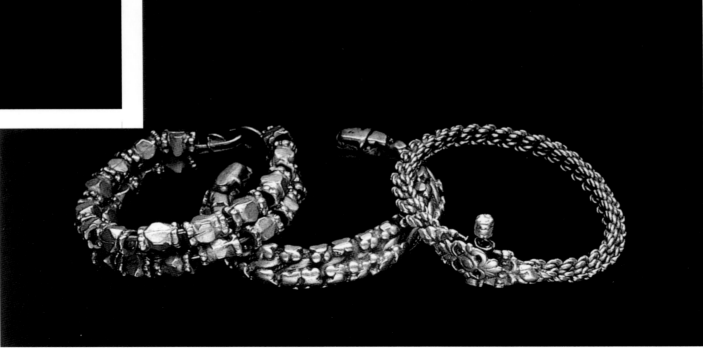

98. Bracelet. *This intricate wide silver bracelet* (iswara) *is probably from Najran and was made before 1940. Floral designs in applied filigree and granulation are repeated in strips up the bracelet. There is a hinge on one side of the piece and a removable pin fastener on the other; this is decorated with small granulated shapes. It is 2¹/₂ in long.*

Acquired in Jeddah, 1978.

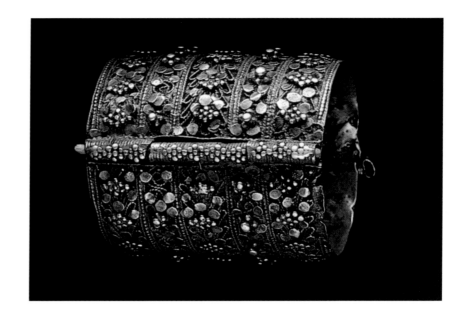

101. Bracelet. *A piece from the Asir (possibly Ghamid tribe), this bracelet consists of a leather strap decorated with two rows of stamped hemisphere silver pieces and a buckle of stamped and soldered metal with red glass in bezel settings. It is 7in long and was made before 1950.*

Acquired in Ta'if, in about 1975.

99 (right). Bracelet. *This square bracelet* (iswara) *is possibly of Yemeni manufacture and made before 1940. Constructed from tinned brass, it is formed from four hollow, rectangular sections hinged together. Beads surrounded by twisted wire are soldered to the four plates, which are edged with thin strips of tiny cast beads. The bracelet has a hinge and pin closing mechanism. Each of the four sections measures 2in by 1¹/₂ in.*

Acquired in Jeddah, 1978.

100. Bracelet. *This elaborate low grade silver* iswara *was made before 1950, possibly in Oman, and is constructed from three separate bracelets. Each is decorated with three rows of small separately cast fluted cones which are soldered on; the rows are bordered with bands of applied filigree. It is held together with a hinge and pin mechanism, one pin going through all three pieces. Said to be used by the Bani Salem, it is 4³⁄₄in long.*

Acquired in Jeddah, 1978.

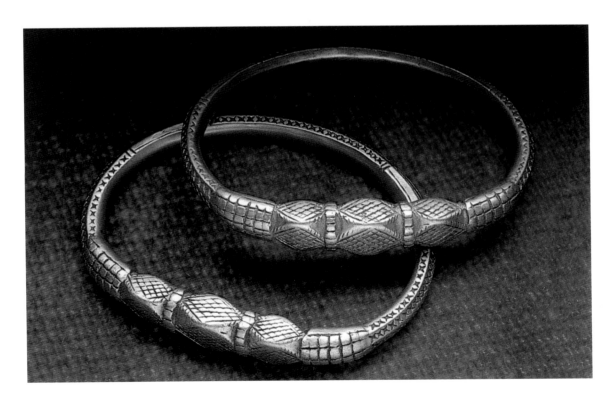

102. Pair of upper arm bracelets. *These bracelets, probably from Najran, are made of solid cast silver alloy with a high copper content; they are decorated with hatched line and check patterns. Since they are quite heavy, they may have been made for trade into the Hadhramawt where men sometimes wore bracelets on the upper arm, as did some Bedouin long ago.*

Acquired in Khamis Mushayt, 1978.

Earrings and Rings

Most little Bedouin girls have their ears pierced and frequently their nose as well by the age of one or two. Sometimes boys' ears are also pierced in order to mislead evil spirits that are thought to attack first born males in particular.

The most common name for an earring is a *khirsa* or a *halqa*. Normally made in pairs, a woman might wear up to six in each ear. The basic earring is an enormous silver ring, decorated with silver balls, that pierces the upper part of the ear. This earring varies in diameter depending upon what part of the ear is pierced. Typical of the eastern part of the peninsula are long conical or oval-shaped earrings. The cone or oval is attached to a large silver loop that pierces the ear, and is decorated at the centre, with bells and chains hanging from the end.

The classic nose ring, *shanf*, commonly worn throughout the Middle East and North Africa, is made of silver or gold; the upper half is thick wire and the lower a semicircular disc decorated with filigree work. There are also special types of nose ring. A *frayda* (literally, 'a little solitaire') is a large nose ring set with a pearl or turquoise. A nose ring worn in the right nostril is often called a *khizama*, while one worn

in the left is a *zimam* or *zmam*. In the al-Hasa oasis, the same term is used for a gold stud set into the nose, which can be either plain or inlaid.

Rings are worn on both fingers and toes. The generic term for a finger ring is *khatim*, literally meaning 'seal', although in fact, in most instances, there is no seal or insignia but simply a plain flat topped metal or stone surface sometimes engraved with geometric or floral designs. Only rarely is there an inscription.

Sometimes the shape of the surface of the ring gives it its special name: for example, a ring with a large, square surface is called *murabba* ('square'), whereas one shaped like a teardrop is known as *shahid* ('witness'). A ring with a stone setting (*fass*) usually has a special designation; an individual turquoise ring, very common in Saudi Arabia, is referred to as *khatim fayruz* or *abu fayruz* ('turquoise ring' or 'father of the turquoise'). It may also take the name of the finger on which it is worn; thus, one worn on the middle finger may be called *wasat* ('middle'). Rings set with red stones, such as carnelian, garnet or often merely glass, are usually called *fatha*, probably because they recall the red fruit of the *naba* tree. Dome shaped rings, some of which are believed to have talismanic properties, also go by various names, such as *zar*, a gold ring often set with a carnelian. Again, such rings can also take their names from the different fingers

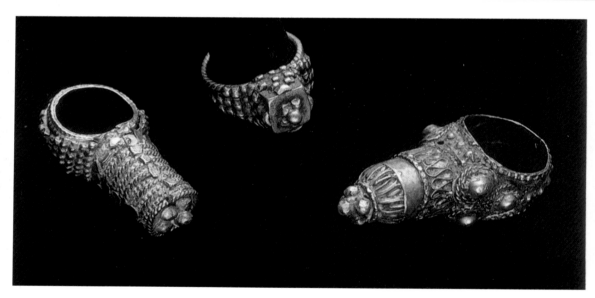

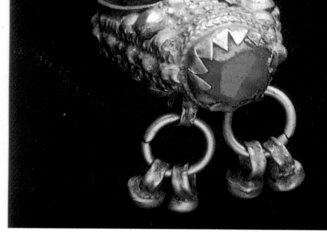

103. Three rings. *Typical of Arabian manufacture, these three dome-shaped rings are made of cast white metal, possibly low grade silver. They have applied filigree, twisted metal and granulated designs. The two larger rings are hollow with gravel inside which rattles. The small, middle ring is much heavier than the others and it appears to have a solid bezel section. The largest ring measures 2¼in from its point to the back of the band.*

Acquired in Jeddah and Ta'if, 1978.

104. Ring. *Worn on the fourth finger, this ring of typical Arabian manufacture is made of low grade silver. It is decorated with granulated and twisted metal and set with a roughly cut piece of red glass. The main sections of the ring have been soldered together after being decorated. It is 1½in in diameter.*

Acquired in Jeddah, 1978.

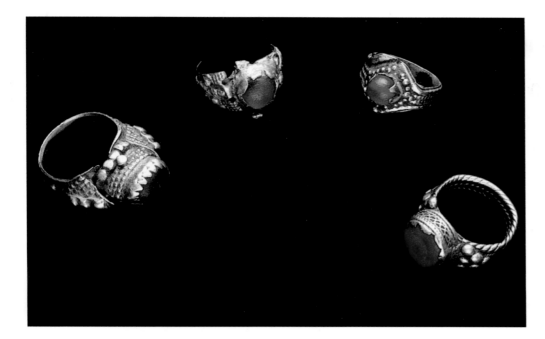

105. Four rings. *Made of low grade silver with granulated and twisted metal designs, each of these rings has a central piece of red glass in a bezel setting. The ring on the right is Arabian, the others probably Yemeni. Both the first and the third rings (from left to right) have backing strips of metal inside their bands; the band of the fourth is made of thicker sections of twisted wire.*

Acquired in Jeddah and Ta'if, 1978.

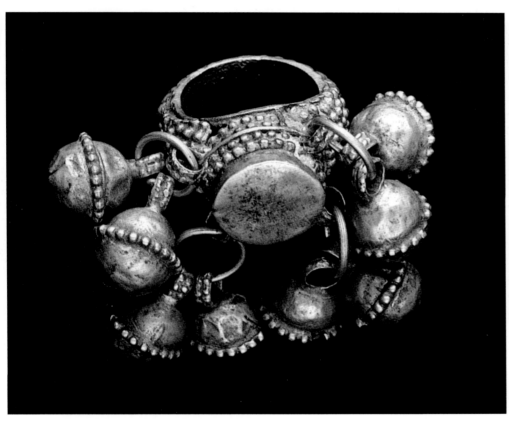

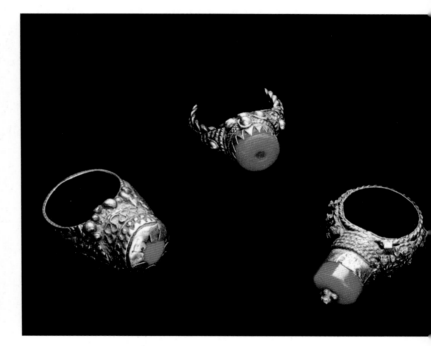

106. Ring. *This ring from central Arabia is made of low grade silver. It has a cast design, a flat centre and eight wrought bells hanging from metal loops. The decorated outside band of the ring is cast and soldered onto a backing piece of flat metal. It is probably a* wasat, *a ring worn on the middle finger. It measures 1¹/₂in in diameter.*

Acquired in Riyadh, 1979.

107. Three rings. *Possibly from Yemen, these low grade silver rings have applied filigree, granulated and twisted metal decorations; each has a projection for a red glass piece in a bezel setting. The ring on the right has a decorated pin protruding from a hole in the glass. On the example in the centre the pin is missing. The ring on the left has an unusual teardrop pattern in niello work on the sides of the band.*

Acquired in Jeddah, 1978.

108. Ring. *Possibly for a toe, this ring of cast white metal was made in the Najd before 1970. It is decorated with a simple repeat pattern and has two small bells hanging at the front. The protruding section at the top is attached to another layer of metal inside the ring. It was said to have been made in Unayzah and it measures 1¼ in in diameter.*

Acquired in Riyadh, 1979.

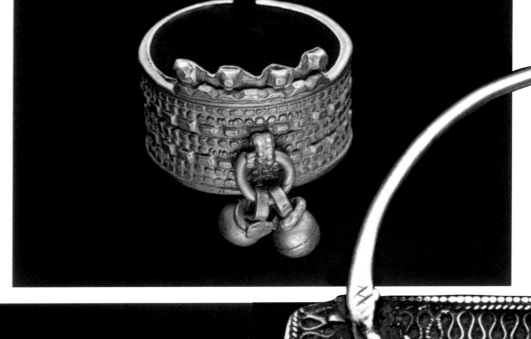

109. Three rings. *These are typical* marami – *rings worn on the middle finger of either hand. Made in the Najd about 1970, they are low grade silver. Their decoration consists of simple cast bands of repetitive designs soldered together. Each measures ³⁄₄ in in diameter.*

Acquired in Riyadh, 1979.

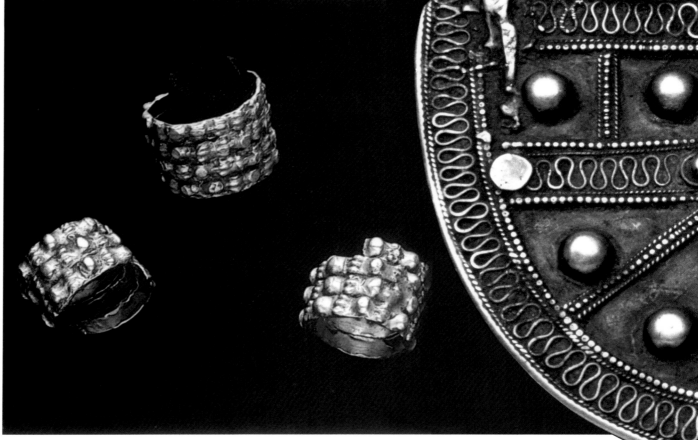

110. Ring. *This* khansar, *a ring worn on the little finger, comes from Yemen. It is made of low grade silver and has a large agate in the centre in a bezel setting surrounded by small bells. The band of the ring is soldered to the bottom of the setting; it was probably cast flat and then bent to form the ring. It was made before 1950.*

Acquired in Ta'if, 1978.

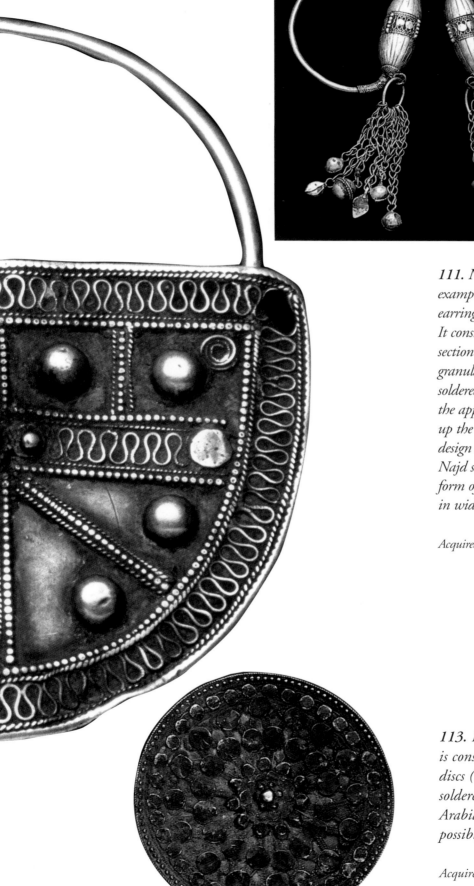

112. Earrings. *This pair of earrings possibly comes from Oman. They are made of hollow oval metal sections and are decorated with applied filigree and soldered pieces with bells hanging off chains. Twisted wire is wrapped round section ends. They measure 5¹⁄₂ in long.*

Acquired in Ta'if, 1978.

111. Nose ring. *This silver example of a nosering (or possibly earring), was made in the Najd. It consists of a semicircle metal section decorated with granulation, applied filigree and soldered pieces. A single band of the applied filigree runs vertically up the back of the piece. The design details are typical of the Najd style. The fastening, in the form of a loop, is wire. It is 2³⁄₄ in wide.*

Acquired in Riyadh, 1978.

113. Pendant. *This piece was probably made in the Hijaz before 1940. It is constructed from two silver discs soldered onto a shallow cylinder. Both the discs (1¹⁄₂ in in diameter) are decorated with granulation and additional soldered motifs. This piece is completely different in style from typical Saudi Arabian silver pendants and though it is probably a pendant, it might possibly be a bobbin for very fine thread.*

Acquired in Jeddah, 1978.

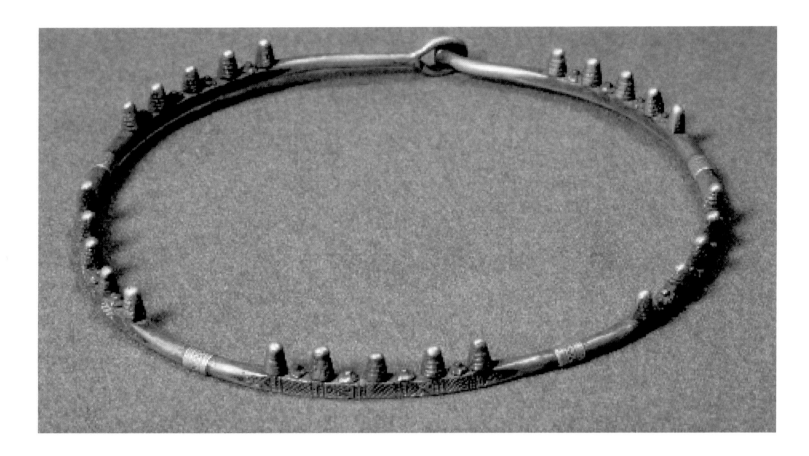

114a (above and below). Neckpiece. This is an unusual and scarce silver piece measuring over 10in in diameter. It is said to be worn by members of the Juhadlah tribe, according to the Zahrani family, the primary dealers in Arab antiquities in Jeddah. (The Juhadlah tribe, or sub-tribe, is not familiar to the author.) The detail shows the intricate design of the castellations.

Acquired in Jeddah, 1995.

Belts

Belts (*hizam*), like so much Bedouin jewellery, were in the past frequently manufactured by Najrani or Yemeni craftsmen. Often highly ornate, they were made either of silver of varying quality or silver and copper alloys, and they were usually backed by a piece of black cloth or silver mesh.

These belts are formed from square or interlocking pieces. The individual sections are often inset with coloured glass beads or stones, with small strips of metal or filigree work attached, or they may be incised with floral or geometric patterns. To complete the effect, little chains with bells or coins at the ends are sometimes added to the lower edge. Such belts are secured by hooks and loops, or by pin fasteners, fixed to one end by a short chain.

114b (below). Belt. Made in the 1950s, probably in Yemen, this belt is cast white gilded metal. It consists of elaborately decorated sections with raised areas in the form of circular, floral or star motifs linked together; coloured glass pieces are inlaid into high bezel settings. It is held together with two hooks and loops, and is backed with green and yellow cloth. It measures 32in long.

Acquired in Jeddah, 1979.

114c (bottom). Belt. This high grade silver belt is of unidentified nomadic origin, and was acquired in Saudi Arabia, though not made there; it was probably brought in by Hajj pilgrims. It is flat metal with openwork animal and plant designs; the details are executed in very fine chasing. It measures 27$^{1}/_{2}$in long.

Acquired in Jeddah, 1979.

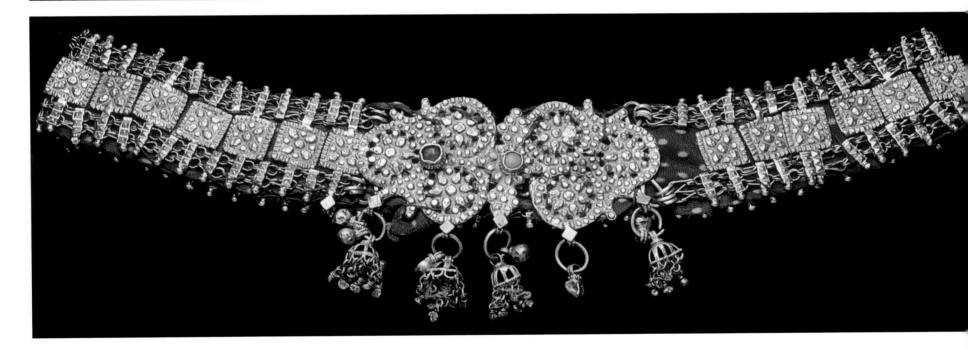

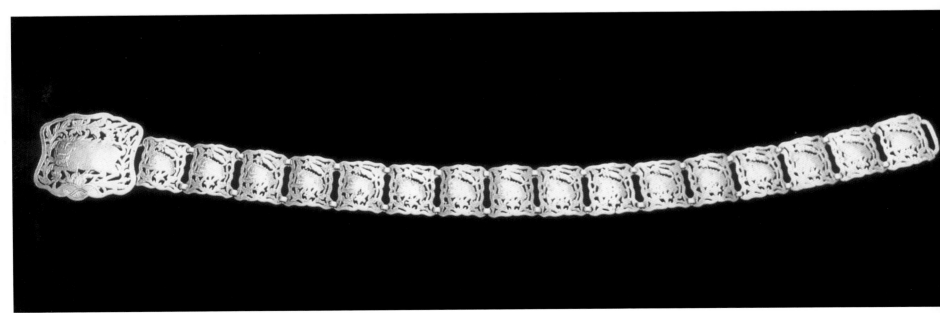

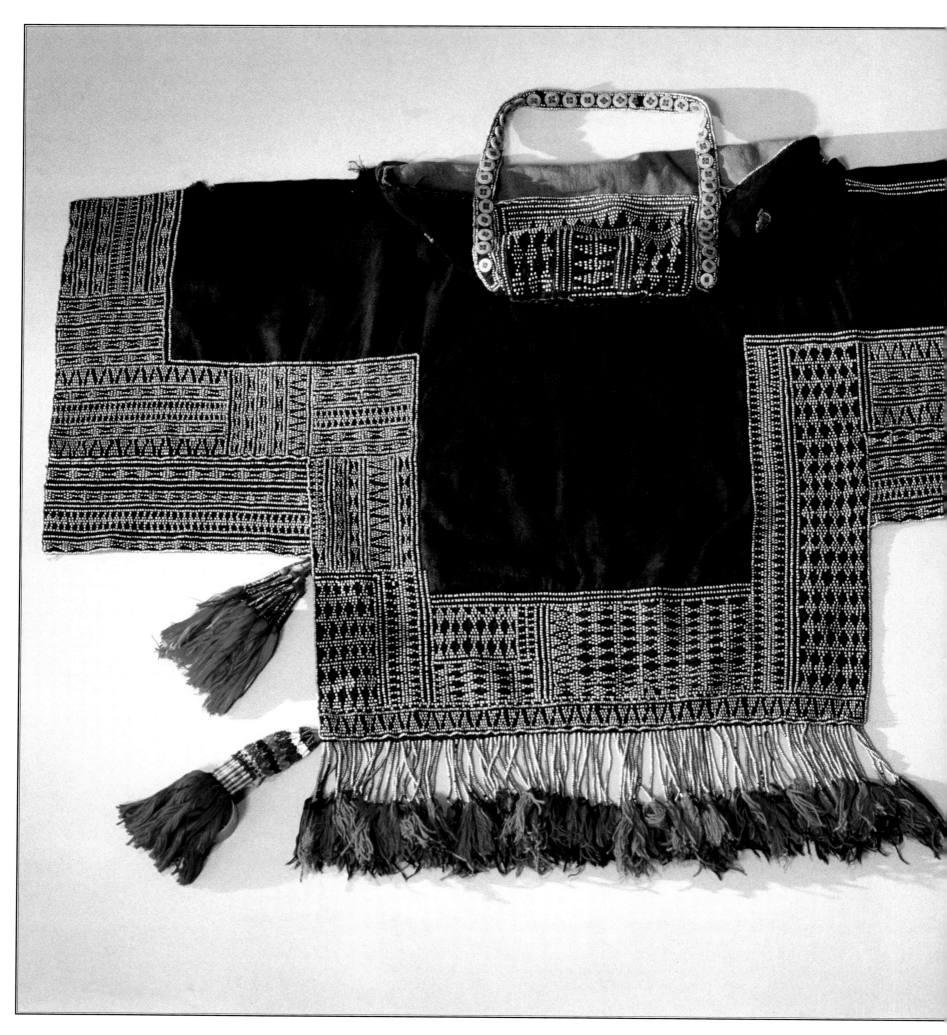

COSTUME

Traditional Arab costume has changed little since antiquity. The advent of Islam only influenced existing pre-Islamic styles of dress in so far as it brought with it requirements of modesty. As the Arabs came into contact with their conquered peoples, they were affected by new tastes and techniques but retained the traditional styles in dress. Even though there were always some regional differences, which still exist today, Arab costume has remained for the most part unified – the same types of garments being worn with little variation throughout the Muslim world.

For both sexes, the principal articles of clothing consist of an undergarment, a body shirt, a long dress, gown or tunic, a loose-sleeved mantle or wrap, shoes or sandals, and a headcloth. In the past many items worn by men and women were identical – many, indeed, were simply large pieces of fabric wrapped around the body. The number of garments worn depends on the weather, the occasion, and the economic means and social position of the wearer.

In ancient Arabia the basic undergarment (and in some places the basic garment) was the loincloth *(izar)* or sarong. The Greek historian Herodotus mentions it as the principal item of Arab clothing. The *izar* is to this day commonly worn by men in Yemen and southern Arabia. The wearing of underdrawers *(shirwal)* by both men and women became common practice after the conquest of Persia where this garment had been worn since antiquity. By later Islamic times, *shirwal* styles differed greatly from country to country and came to include all sorts of pantaloons, knee-breeches and long trousers, as well as close-fitting drawers.

The basic outer garment from early Islamic to modern times has been, and in many areas still remains, a body shirt. From the days of the Holy Prophet, these shirts have varied widely in shape, fabric and decoration; hence their many names in classical and colloquial Arabic: *qamis, thawb, jubba, ghilala* and *dishdasha,* for example.

Previous page: *A woman's blouse of the Juhadlah tribe, made of cotton, silk, white meatl beads and ceramic muttons.*

Acquired in Jeddah, 1995.

Over these basic items a person might wear a long flowing cloak not dissimilar to an academic gown in the West. Old Arabian custom required both men and women to wear a mantle of some sort over everything else when going out in public. The same cut of mantle might be worn by members of either sex, although a woman's was usually more enveloping than a man's. Some mantles in early Islamic Arabia were, however, associated with one sex or the other. The *rida*, for example, was a man's cloak *par excellence*, gold braided for men of distinction, whereas the *jilbab, khimar,* and *mirt* were worn primarily by women. Then, as now, there were many names for cloaks and gowns (such as *abaya, mishla* and *bisht*), often synonymous; they probably reflected earlier usages or regional dialects. Other mantles were known by the material from which they were made: the *burda*, a mantle of striped wool (called *burd*) produced in Yemen, was a garment worn according to tradition by the Holy Prophet himself and preserved among the relics

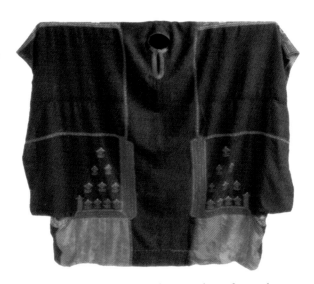

115. Dress. *This elaborate dress from the Bani Tamim tribe was made before 1960. The material is uncut balanced black cotton twill, with imported silk brocade strips in vivid colours sewn together. There is silk and rayon embroidery in fishbone and chain stiches at the seams, lower front side panels, upper back panels, and collar. Under the arms are triangular cotton inserts outlined with embroidered floral patterns. It measures 5ft 5in across.*

Acquired in Riyadh, 1978.

of the Caliphs of Baghdad. The *namira*, on the other hand, was an old Arabian wrap for men with stripes on it which resembled those of a tiger. Its name comes from *nimr,* the Arabic for tiger or leopard.

Already at the time of the Holy Prophet, the Ancient Near Eastern convention of covering the head out of modesty and respect was the practice for both men and women. The great majority of adults still appear in public with some form of head covering, be it for men a *kaffiya* or *ghutra*, or simply the *abaya* to cover the head as well as the body. From an early age, girls cover their heads with a small bonnet or scarf. Veiling for women, which in its simplest form used to consist merely of drawing part of the large outer wrap over the head and face so as to leave one eye free, remains common throughout the Muslim world. Elderly women, however, have the perogative of covering their chin, neck and head, but not the main part of their faces, and village women wear a veil only when they are in town, since it is an encumbrance in their manual work. The two most common forms of face veil in early Islamic Arabia, the mask-like *burqah* and the rectangular *litham* that covers the nose and lower half of the face, are still worn today: the *burqah* as found all over the Middle East, the *litham* largely confined to North Africa (though it is sometimes worn in Saudi Arabia).

No symbol is more striking to the Western eye and none more concretely representative of the position of the woman in traditional Middle Eastern society than the veil. It remains the mark of a woman's honoured and protected status, a status enhanced by marriage, since her primary role is that of a wife and bearer of children. Furthermore, a married woman is considered in traditional Arab circles her husband's *ird* or 'honour'.

A woman's costume is distinguished from a man's by its use of brightly coloured embroidery and appliqué, the preponderance of elaborately ornamented veils and headdresses, and by the fact that it exhibits wide regional differences.

(Opposite) The typical costume of a modern Saudi man – photographed as he serves coffee at a desert feast. (Taken by the author in 1979.)

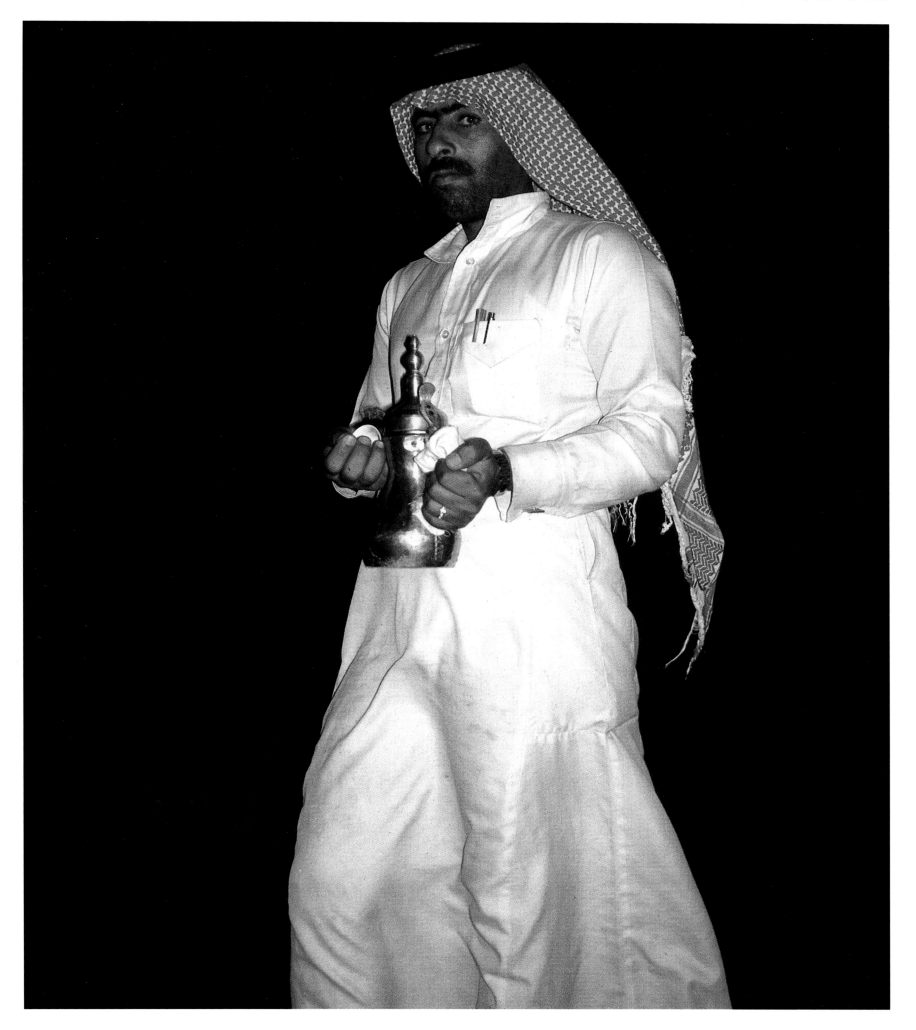

The costume decoration of the Saudi Bedouin women appears to be sparser than that of their village and urban sisters; this is no doubt due to the structure of Saudi tribal society where the women have little leisure and therefore less time for elaborate embroidery. A man's costume, by contrast, tends to be uniform throughout the Arab world and more simply decorated, with no counterpart of the bright glittering veils and headpieces of his womenfolk.

The Bedouin buy their mantles and other garments in the *suq*. Doughty, the late 19th-century traveller, describes the nomads exchanging their precious clarified butter for silver, in order to be able to buy a new cloak. Although *abayas* and *bishts* of Syrian or Iraqi origin were bought when the Hajj caravan passed through the towns, these garments were also made in the Saudi Arabian centre of al-Hasa. The oasis of al-Hasa at Hofuf produced a wide range of *abayas* of different weights and fabrics for both men and women. The most commonly worn were made of sheep's wool, but the finest and most expensive were of camel hair. The classic and most sought-after *bishts*, owned only by the prosperous, were also made in Hofuf which was famed for the quality of its embroidery. The Hofuf clothing industry declined in the 19th century, but it has been revived in recent years.

From the late 11th century until the end of the First World War, much of the Arab world came under the control of the various military dynasties: the Seljuqs, the Ayyubids, the Mamluks, and finally the Ottomans. These brought with them central Asian styles, particularly in ceremonial and military dress such as hats and long cross-over coats. The native Arab population was not affected much at first since this garb was the uniform of the foreign ruling class. But some influence did seep into the indigenous Arab community, especially among the élite of the great urban centres of the Arab world. Central Arabia remained largely free of such influences.

As in so many aspects of life, more changes have taken place in Arab dress in recent times than have occurred in the past fourteen hundred years. Machine stitching has now replaced traditional embroidery; standardization of styles and decoration has come to override regional differences. The economic, political and cultural influence of the West has increased from the second half of the 19th century. But while throughout most of the Arab world there has been a gradual abandoning of traditional garments for Western clothes (more so among the men than women, and in cities rather than among villagers and Bedouin), the Arabian peninsula has held out against this trend, and native-born Saudis and members of the neighbouring states southwards and eastwards almost invariably wear traditional clothes when not abroad.

This very old piece (below), a girl's bukhnuq, *comes from the Harb tribe.*

(Opposite) Carolyn Crouch dressed in the costume of the Harb tribe in the Hijaz.

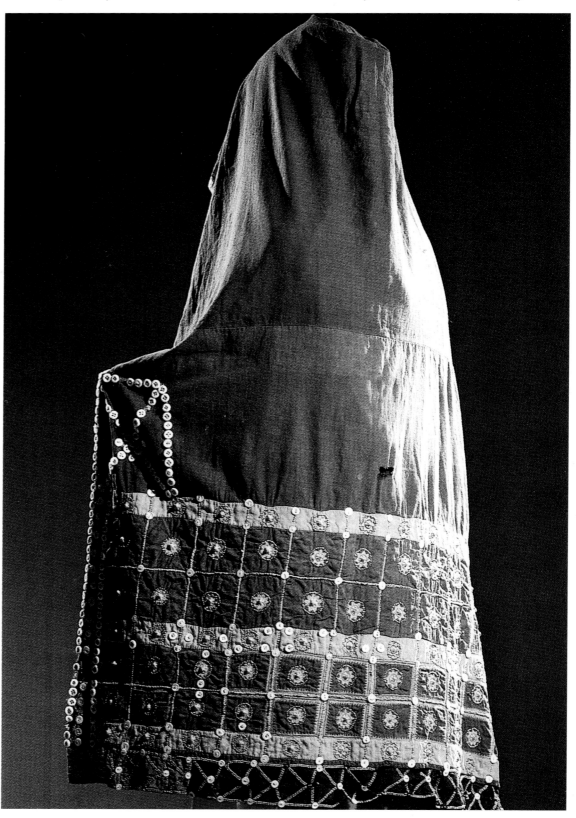

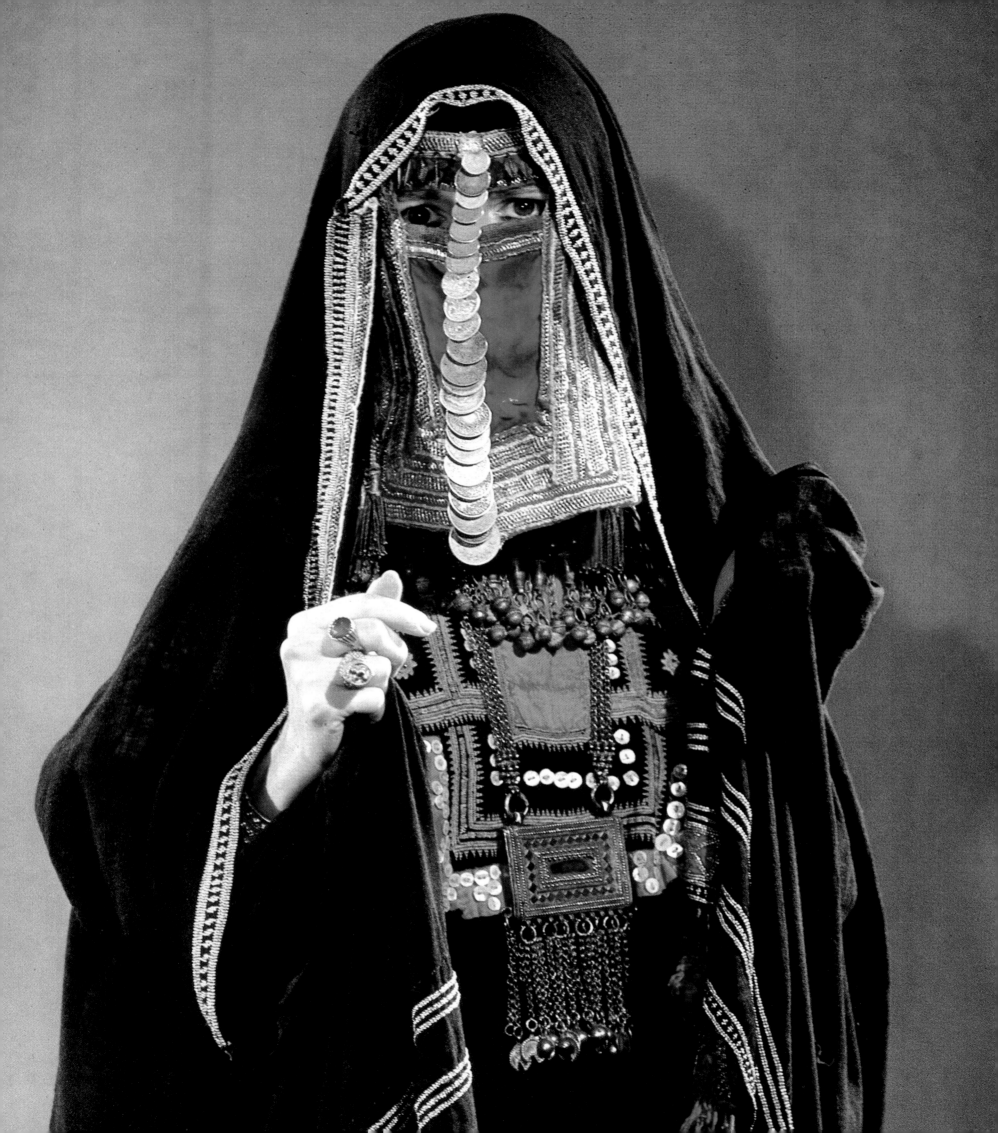

Women's Garments

The standard floor-length dress, the shape of which varies little throughout Arabia, is the *thawb* (or *dishdasha*). The *durra'a* (or *maqta*) is also worn. Traditionally both were indigo coloured but they now tend to be mostly black, dark green or burgundy.

The loose *thawb* is worn either directly over the body or over a long plain shift (*qamis* or *badan*). Underneath, a woman usually wears underdrawers (*shirwal*): baggy pants with narrow cuffs decorated with embroidery and gathered at the waist by a drawstring (*tikka* or *dikky*).

The *thawb* is constructed from several pieces of fabric with openings under the arms and down the sides. Necklines are simple, consisting of a small round hole and a narrow slit down the front. Sleeves are either long and narrow or wide-winged. This last type of sleeve is also found in Palestine, Syria and Iraq, but the Arabian versions worn in Ta'if and the Asir have square rather than sharply pointed ends, hanging down to the hem of the dress. When working, the women draw up these sleeves and tie them behind the neck.

While Syrian and Palestinian dresses are decorated primarily with embroidery, Saudi costume is embellished with a wealth of different materials, textures and techniques. Dresses from the Hijaz, for instance, are appliquéd with strips of multicoloured material. Other dresses are decorated with coloured glass beads, silver balls on the cuffs, mother-of-pearl buttons and all sorts of coins – Ottoman, Saudi and French, and Maria Theresa thalers. All this is enhanced by embroidery in metallic silk or rayon thread, usually at the seams, side panels and shoulders. The stitches used are chain, stem, flat, cross or half-cross, couching and button hole.

In public, a woman wears over the *thawb,* and over the head an *abaya* or *aba*, a coat-like mantle without sleeves but with small hand openings in the upper corners. It is approximately four feet in length and five feet in width and consists of two pieces of fabric seamed together horizontally at the hipline, with no side seams. The selvedges are sewn together to form a shoulder seam. Because of its almost square shape, the shoulders of the abaya hang down over the arms, giving it its coat-like effect. The shoulder seam and the border at the neck and front are decorated with braid or cord of the same colour as the cloth. Around the neck and front opening, the braiding is wider, and decorative knotted buttons are sewn on either side.

The abaya comes in two varieties: a simple one for every day, and a more elaborate one with gold embroidery for festive occasions. It also comes in two weights: heavier for winter, lighter for summer. Both weights are made out of various animal fibres such as sheep's wool (*suff al-aghnam*), goat and camel hair (*wabar*), or out of sackcloth (*khaysh*). Nowadays, the woman's abaya is invariably black, although travellers in the last century report other colours such as white and

*116 (above). Dress. This deep red dress (*durra'a*), measuring 52 in from neck to hem, is made of loosely hand-woven cotton, lined on the interior of the bodice. Attractive floral and geometric designs are created by chain and fishbone stitch in green, red and yellow cotton; the bottoms of the sleeves are outlined in metal beads. It comes from the Bani Tamim tribe and was made before 1970.*

Acquired in the women's suq, *Riyadh, 1978.*

116 (above). Dress. This cotton dress, c.1940, in red clay earthen colour is typical of Juhadlah. The embroidered pattern is made up of metal beads. A cape is attached to the shoulders as a continuation of the dress. The back of the dress is open from the waist up.

Acquired in Jeddah, 1995.

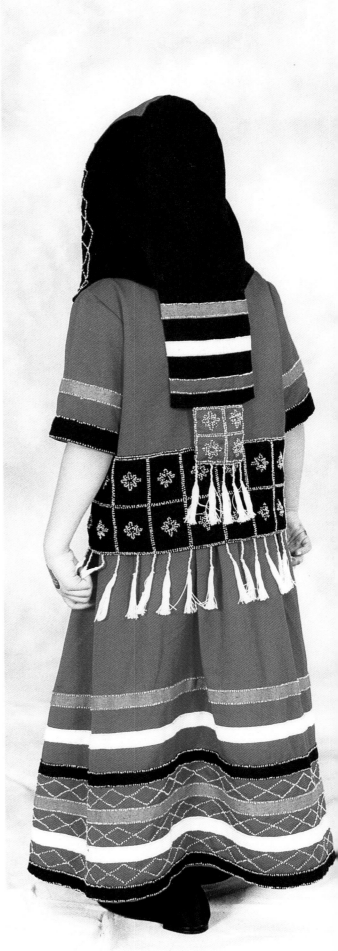

117 (right). Dress. This replica of a Hijazi thawb was made in 1997 for a children's show. The workmanship is known as Sadiyat *and uses lead beading from the Tihama Valley.*

117 (above and (detail) below). Blouse and skirt. These are said to be Juhadlah, a small tribe in the south west, and are made of cotton and silk heavily embroidered with many metal beads. The whole outfit weighs over nine pounds and dates from c.1940.

Acquired in Jeddah, 1995.

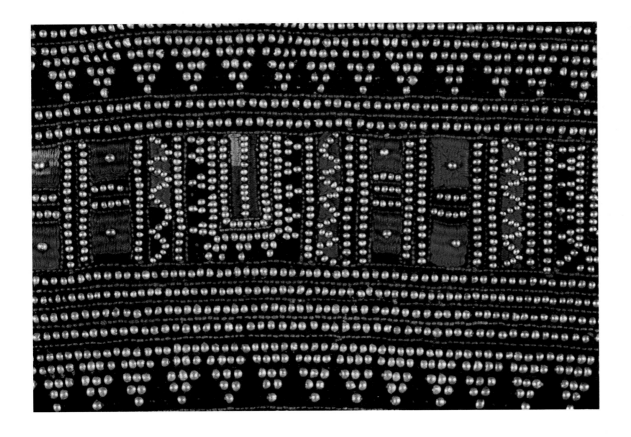

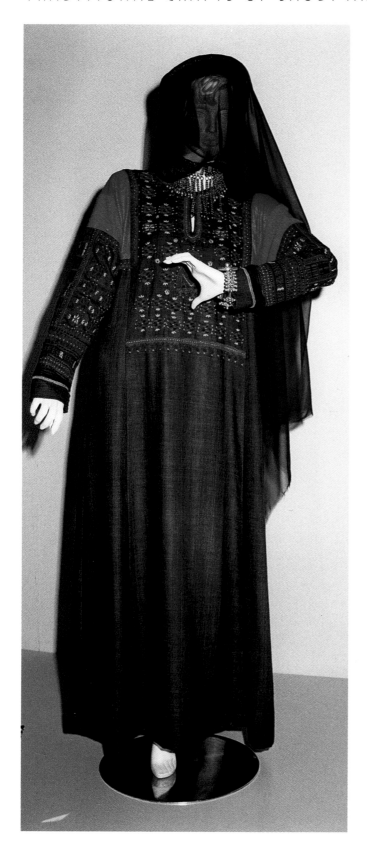

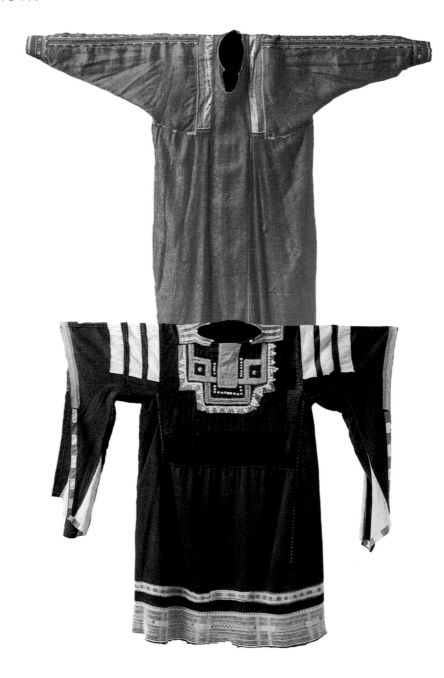

119 (above top). Dress. *From Riyadh, this brightly-coloured dress* (durra‘a) *is made from vivid orange silk with strips of green and purple at the shoulders. The diamond-shaped inserts under each arm are bright green cotton; around the sleeve seams and cuffs are floral and geometric motifs with metal beads sewn to the sleeve ends. It was made c.1970 and measures 49in from collar to hem.*

Acquired in Riyadh, 1979.

120 (above bottom). Dress. *From the Hijaz (Bani Salim tribe), this dress is made of heavy black cotton twill – probably Manchester cloth from England and once sought after by the Bedouin because of its durability. The front panel is decorated with mother-of-pearl buttons and red and yellow embroidery; three cloth strips are appliquéd to the upper part of each sleeve. The hem is embroidered with yellow and orange strips of rolled cloth and bands of appliqué. It was made before 1940 and is 48in long.*

Acquired in Jiddah, 1977.

118 (above). Dress. *This* durra‘a *from the Najd is made of cool wool, with pomegranate motifs embroidered in silken threads. The stitches used are known as* silsala maaftoha, nashal *and* tair *– all traditional Saudi Arabian stitches. It was made before 1960.*

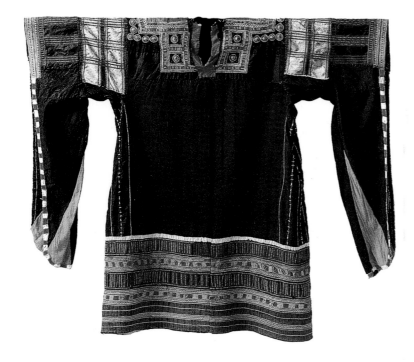

121. Dress. *This elaborately decorated dress from the Harb tribe is made of black cotton cloth embroidered with red cotton and silver wire threads. It has embroidery over appliqué on the skirt and sleeves. It was made before 1950 and is 46in long.*

Acquired in Jeddah, 1977.

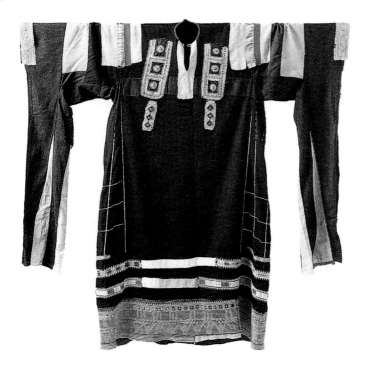

122. Dress. *From the Hijaz (Harb, Bani Salim tribe), this dress is constructed of black cotton twill, with a v shaped neck and appliquéd strips of coloured cloth on the shoulders and yoke. Ornamental rectangular panels on either side of the neck are outlined in metal beads and mulitcoloured embroidery. The intricate hem decoration is rolled cloth overcast with two strips of appliqué decoration; three yellow triangular inserts are sewn to the wing sleeve ends. It was made before 1940 and is 53in long.*

123. Dress. *This full dress made of dark fabric is appliquéd with bands of lighter material and pieces of embroidery. Made before 1960, it comes from the Hijaz (probably Harb tribe).*

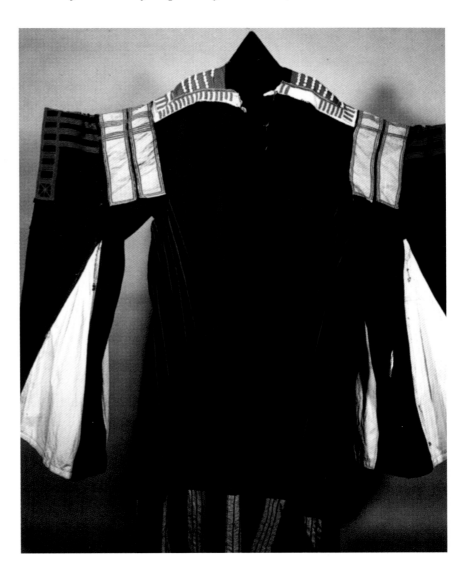

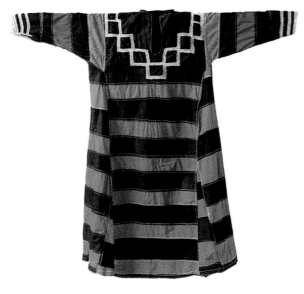

124 (above). Dress. *This embroidered patchwork dress from the Ta'if region was made in about 1975. It is constructed of horizontal strips of alternating black and blue cotton cloth, with machined top-stitching in yellow and red thread. The sleeves and collar are embroidered in red, white and gold metallic thread. Triangular-shaped inserts placed inside the seams augment the fullness of the garment. It is 49½in long.*

Acquired in Ta'if, 1979.

125 (below). Dress. *From the Asir (Bani Malik tribe), this dress is of black cotton twill. The interior is reinforced with cotton grain sacking and the side panels and lower edge consist of coloured cotton embroidered strips. The front is appliqué, typical of Bani Malik work. Beads are also sewn onto the top sleeve seams and cuffs. The shoulders and upper back are red cotton. It is 46in long and was made in about 1960.*

Acquired in Ta'if, 1978.

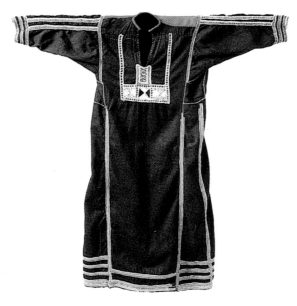

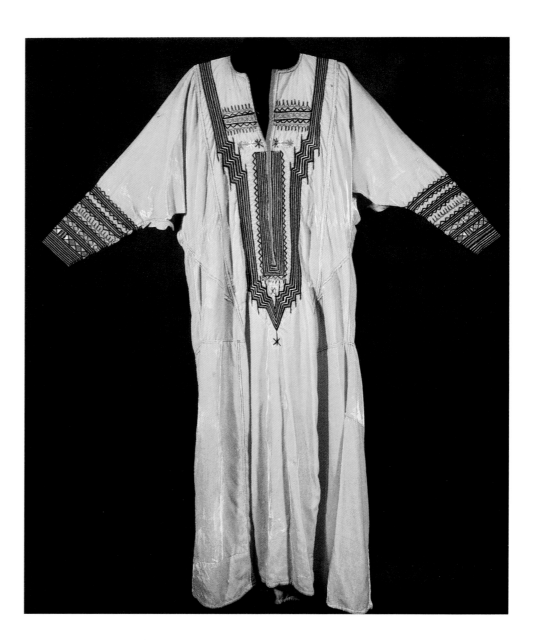

126. Dress. *Recently manufactured in the Asir, this dress is made of bright material with contrasting machine embroidery on the sleeves and in a panel down the front. The pattern is typical of the Khamis Mushayt area; similar dresses with other geometric designs are found in Abha and Ta'if, usually on black cotton or cotton velvet cloth.*

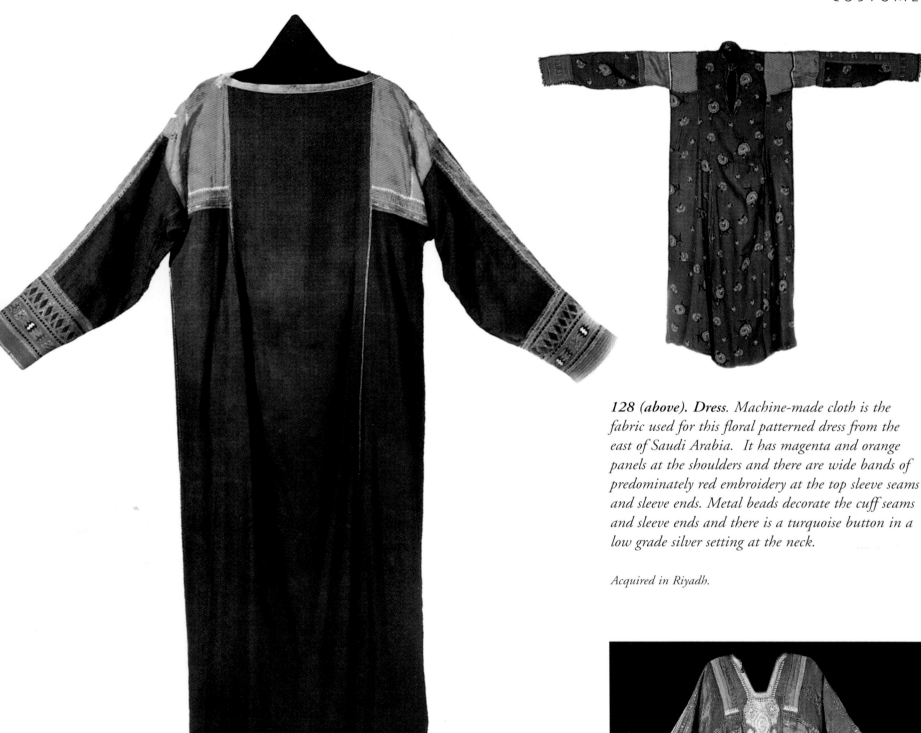

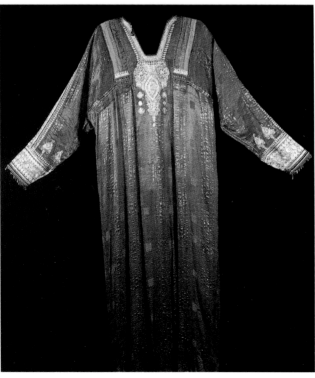

128 (above). Dress. Machine-made cloth is the fabric used for this floral patterned dress from the east of Saudi Arabia. It has magenta and orange panels at the shoulders and there are wide bands of predominately red embroidery at the top sleeve seams and sleeve ends. Metal beads decorate the cuff seams and sleeve ends and there is a turquoise button in a low grade silver setting at the neck.

Acquired in Riyadh.

127 (above). Dress. Made before 1960 in the central Najd, this fine dress is of dark material with purple and orange bands appliquéd onto the shoulders. Embroidery of geometric designs decorates the shoulders and wide cuffs and is also used along the sleeves.

129 (right). Dress. Made before 1950, this dress comes from Riyadh. Metal thread embroidery decorates the patterned material at the neck, sleeves and cuffs.

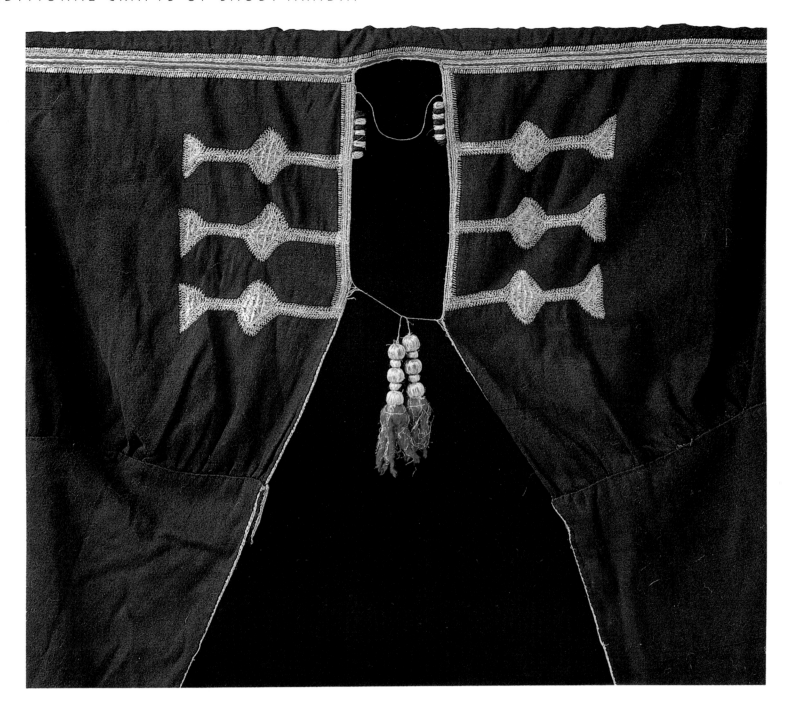

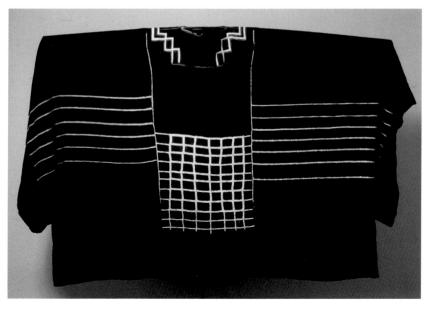

130 (above). Abaya. *This garment covers the head when worn in public. It is 6ft 6in wide at the sleeves and is constructed from two rectangles of fabric seamed at the shoulders and slightly gathered at the waist. The heavy black wool is embroidered at the front and along the shoulder seams in rayon and gold metal thread on a cotton core. On either side of the neck opening are fabric buttons covered with metal thread; below is a tie of round buttons ending in tassels.*

Acquired in Dammam, 1977.

130 (left). Abaya. *This example is said to be Juhadlah but is similar to others from the Asir area. Made of cotton with embroidery and fringed with metal beads, it dates from before 1950.*

Acquired in Jeddah, 1993.

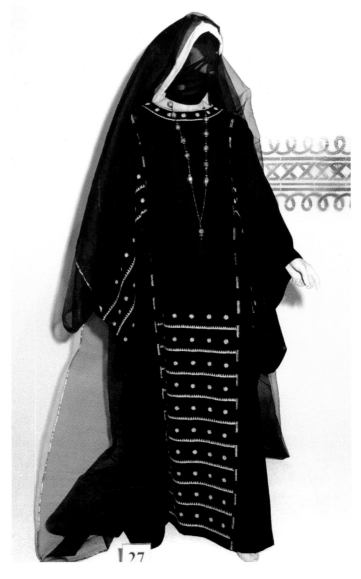

131 (above). Cloak (mikhtam). *Made in the Asir (Abha area), this cloak is goat skin sewn together with leather stitching. It has red leather trimming and the leather work around the collar and edges is skillfully and stoutly done. The cloak, which opens out flat, is worn in cold weather in the moutainous regions of the Asir, and probably also in the Hijaz, by both men and women. It is 41in long and was made c.1960.*

Acquired in Abha, 1978.

132 (above right). **Women's** *abaya. This simple contemporary black cloak is worn as a shawl over the head or on the shoulders by most women in public in Arabia. It is constructed of several panels of machine woven synthetic silk cloth. The front hand openings and top shoulder seams are overcast. It is 52in long.*

132a (right). **Women's thawb.** *This copy of a Hejazi* thawb *is decorated* **with lead beading.**

Women's Headgear

Married women in Saudi Arabia wear one of several different types of veil. That most commonly worn by nomads and village women when they come town is the *burqah*. Worn like a harness, it consists of a piece of fabric suspended from the front of the woman's headband (*isaba*). Its lower corners are attached on the front of the *isaba* by strings, creating a mask-like effect. While some *burqahs* are relatively short, others are waist length. The other common face veil is the *niqab* which consists of a rectangular piece of cloth with two holes for eyes, attached to the head by two strings tied at the back. Both the *burqah* and the *niqab* may be heavily decorated with beads, embroidery or silver coins from the bride's dowry. Some tribal *niqabs* are made of stiff heavy leather and are stained with ground henna which sometimes comes off on the skin giving it a reddish hue. Others may be cut from heavy paper. Different tribes can be distinguished by the style of their *niqabs*.

City women wear a much simpler face veil, called a *milfa* or *shella*, which is made of a long black rectangular piece of sheet chiffon or muslin placed over the head and reaching some way down the front. It is kept in position by the *abaya* which is placed over it.

From childhood, long before they take up the veil, girls nearly always wear a head covering. Their first bonnet-like hat is the *quba'a*, the most elaborate of which are beaded all over and come from Asir. At eight or nine, a girl will exchange the *quba'a* for the *bukhnuq* (also sometimes worn by married women), a rectangular piece of cloth, often a cotton twill. Folded over to form a hat, it once again resembles a bonnet, but with flowing ends that hang down from the back and sides so as to cover the hair which is worn long.

Like the *quba'a*, the *bukhnuq* may also be elaborately decorated; among the Harb it is often embellished with mother-of-pearl or with cowrie shells.

Some Bedouin women wear flamboyant headdresses consisting of a cap (*araqiyya* or *ma'raqa*) or a head scarf (*shutfa*) around which a piece of cloth is tightly twisted into folds. Strings of tassles or flat pieces of metal might be tied around it, with tassles hanging down the sides, and the whole secured by a silver tiara.

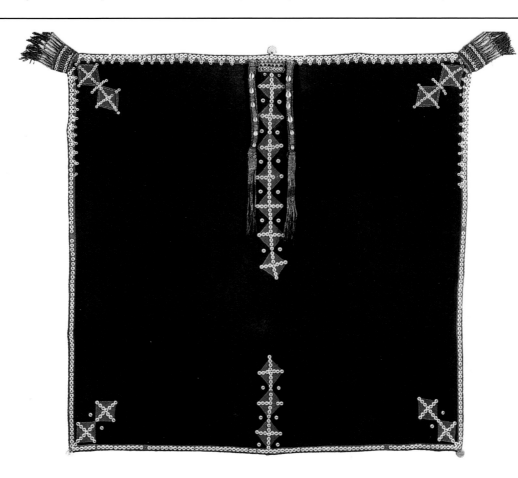

*133. Headdress. This head shawl (*milfa*) from the Harb region in the Hijaz (Bani Salim tribe) is plain black cotton with appliquéd brown and red cloth. Mother-of-pearl, glass buttons and metal beads are used for decoration of the cloth and leather tabs. On either side of the top of the head are attached two tubes of twined leather and metal bands with cowrie shells. A coin hangs from the centre over the forehead. It measures 41in by 43in. This is perhaps the the best designed item of costume found by the author, and in his eyes the most beautiful.*

Gift of Abdullah and Ali al-Zahrani, Jiddah, to John Topham.

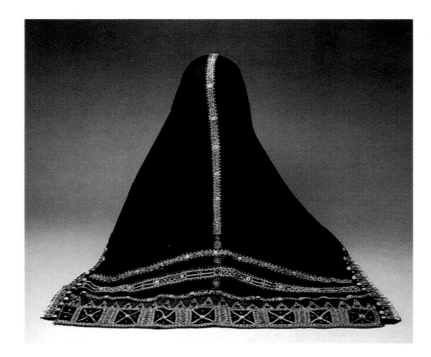

134. Headdress. *From the Hijaz (Harb tribe) and made before 1940, this elaborate* milfa *consists of a rectangular piece of balanced twill cloth, heavily embroidered with metal beads and buttons. It is 32in wide by 42in long.*

Acquired in Jeddah, 1978.

135. Headdress. *This fine shawl from the Hijaz consists of a rectangular piece of cloth, lined and decorated on the lower half with strips of rolled red cloth, metal beads and buttons. The plain sides are trimmed with an appliquéd red strip. It was made before 1950 and measures 47in by 32in.*

Acquired in Jeddah, 1979.

136. Headdress. *Made before 1940 in the Hijaz, this headdress (*milfa*) consists of a rectangular piece of cloth folded over and sewn at the top edge. It is decorated with appliqué, metal beads and buttons, and measures 31in wide by 44in long.*

Acquired in Jeddah, 1978.

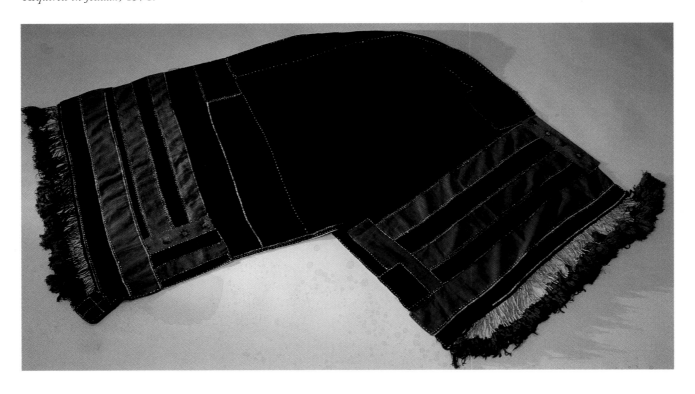

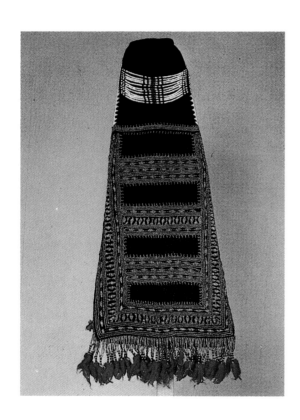

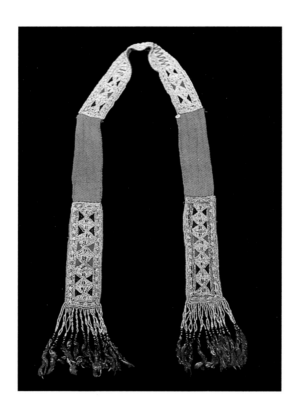

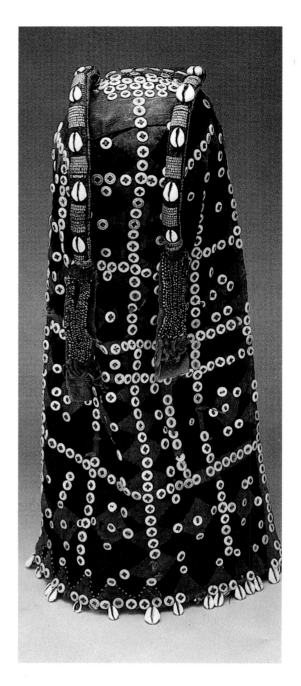

137. Headdress. *From the Asir or the Hijaz, this headdress is made of black cloth. It is decorated at the top with glass beads and strands of beads with leather cross strips which hold the piece secure across the front. The rest of the piece is similarly decorated, with metal beads running down the sides and across the back in wide bands. It is lined with a faded red printed fabric. It is 30in long and was made before 1960.*

Acquired in Ta'if, in about 1977.

138. Headband. *From the Hijaz or the Asir, this headband consists of several layers of red cotton cloth, decorated with metal beads and buttons on an appliquéd background. The band ends in beaded and wrapped fringes. It was possibly part of a larger headdress and is 5ft 5in long.*

Acquired in Ta'if in about 1975.

139. Headgear. *This elaborate girl's quba'a from the Hijaz (Bani Salim tribe) was made in about 1900. It is hand woven, lined plain weave with black and brown cotton appliqué decorated with glass buttons, coins and cowrie shells. A strap with metal pieces, beads and bells hangs over the forehead, flanked by coins. Attached on either side of the head are tubes of twined leather decorated with metal beads and cowrie shells and ending in tassels. It is 20in high.*

Acquired in Jiddah, 1978.

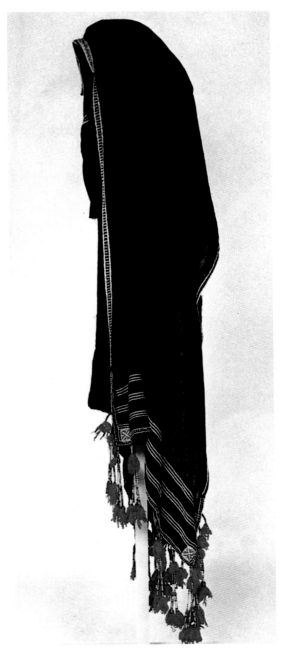

140 (left). Shawl. *From the Hijaz, this headcovering is made of a long rectangular black piece of machine-woven gauze, partially lined. A band of geometric patterned beadwork runs along the side and lower edges with the three bands of double stranded metal beads near the bottom. Intricate tassels of red rayon, beaded and wrapped in metallic thread, are at the bottom and lower side edges. It was made before 1960 and is 7ft 3in long.*

Acquired in Ta'if, in about 1975.

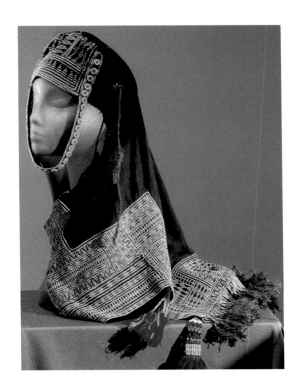

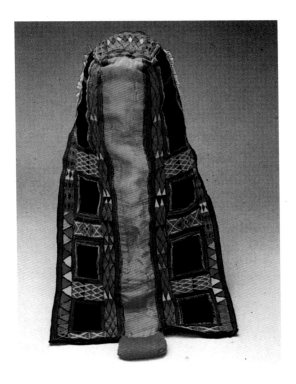

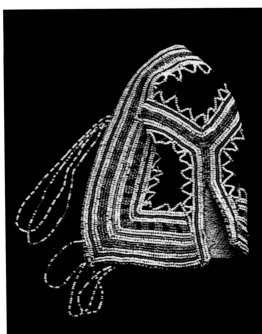

143 (above) Headcloth. *This Juhadlah girl's headcloth (bukhnuq) is a glorious and rare piece. Made of cotton, it is heavily patterned with metal beads, buttons and silk tassels and dates from c.1940.*

Acquired in Jeddah, 1995.

141 (left). Child's cap. *This headdress, worn by a child from the Asir (Bani Malik tribe), was made before 1970 of black cotton cloth. It is edged with rows of white and coloured glass beads and beaded chin and neck strands. It is 9in long.*

Acquired in Ta'if, 1978.

142. Girl's headgear. *This girl's bukhnuq is embroidered with multicoloured geometric designs. It has a large strip of coloured beads to secure the headpiece, and a narrower strip which goes under the chin. A small pocket sewn to the centre bottom is filled with cloves and other spices. From the Asir, it was made in about 1960 and measures 24in by 13in.*

Acquired in Ta'if, 1978.

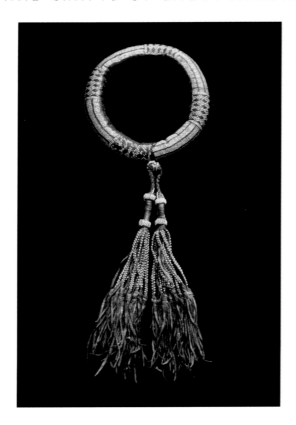

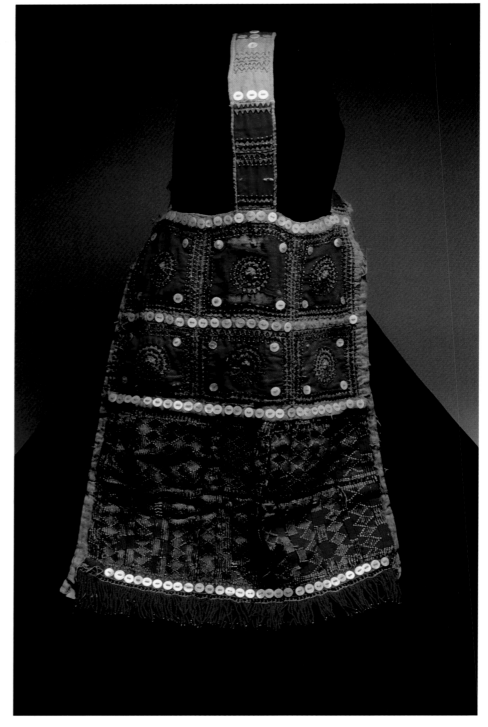

144 (top left). Headpiece. *This rare headpiece* (agal) *from the Hijaz (Bani Salim tribe) is said to have been worn by women for dance. It is made of thin leather strands, plain weave and weft twining, with woven-in cast metal beads. The leather is woven in a tube around a core of wool covered with cotton cloth; leather tassels with clamped metal decoration hang from the back. Made before 1930, it measures 8¹/₂in in diameter.*

Acquired in Jeddah, 1978.

145 (left). Headpiece. *This* agal *is from the Harb and consist of metal and glass beads and buttons braided onto leather. It was made before 1950.*

Acquired in Jiddah, before 1950.

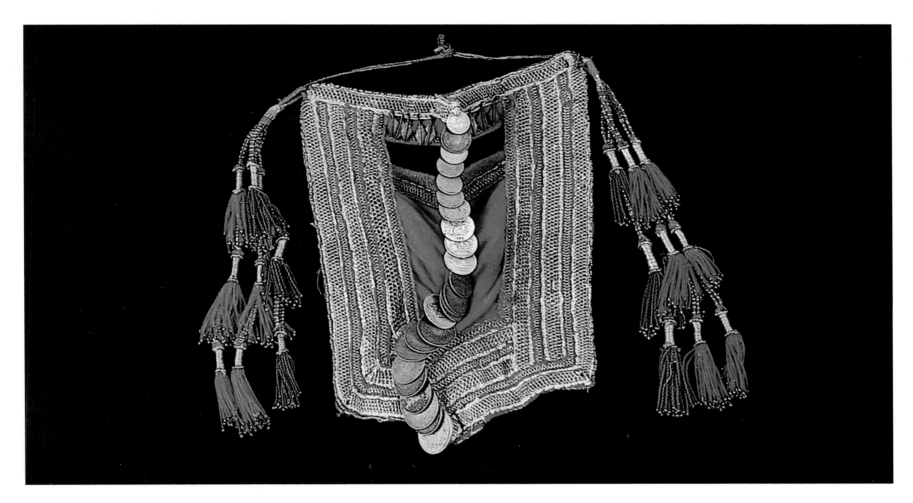

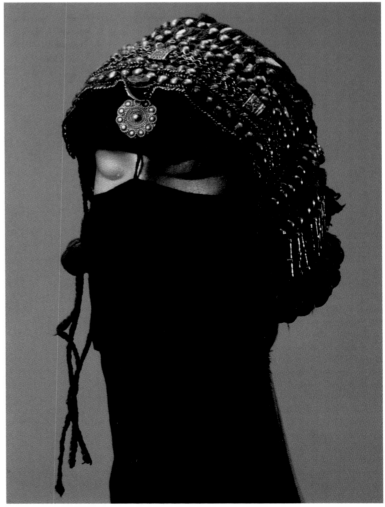

145a (left) Headdress. *This rare piece from the Hijaz consists of a central band which lies across the top of the head. Its upper half is in red cotton patchwork with mother-of-pearl buttons and soft metal beads. Alternating red and green diamonds, tapestry-woven and attached to the background, are at the bottom. Mother-of-pearl buttons and tassels decorate the lower edge. Made in before 1930, it measures 14in by 17in.*

146 (above). Face mask. *This typical Arabian mask* (burqah) *from the Hijaz has appliquéd braids which outline its sides and the eye openings. A pleat of fabric running down the centre of the mask is decorated with coins while four metal tubes over the bridge of the nose separate the eye holes; mother-of-pearl buttons are sewn on either side. It is tied with two leather strips. Made in about 1950, it is 9in long.*

Acquired near Rabigh, 1978.

147 (right). Cap. *Juhadlah woman's cap, made of intricately braided leather with metal decorations.*

Acquired in Jeddah, 1995.

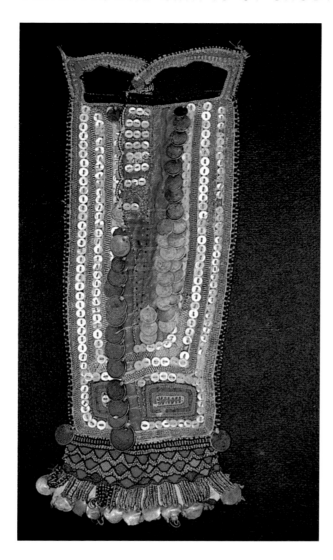

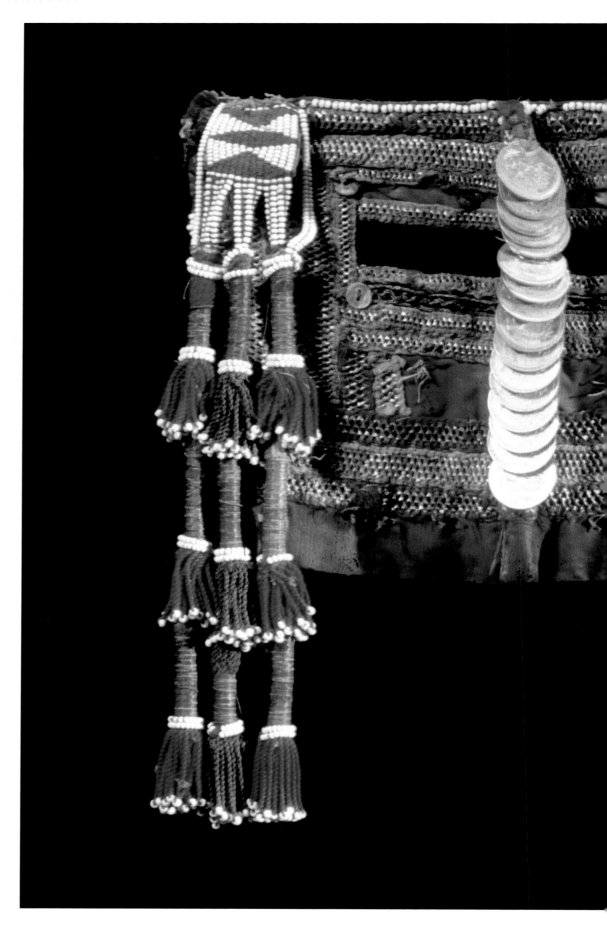

148. Face mask. *This mask from the Gulf is made of red fabric and is almost entirely covered with rows of metal and glass beads, buttons, and embroidery. Rows of coins are attached down the centre fold and at each side of it. The fringe at the bottom consists of metal beads. It is 18in long and was made in about 1960.*

(Property of S. Mulligan.)

149. Face mask. *This is a typical face mask from the Hijaz. A row of coins is sewn along the nose, followed by rows of glass beads and tassles the outer edges. It was made c.1950.*

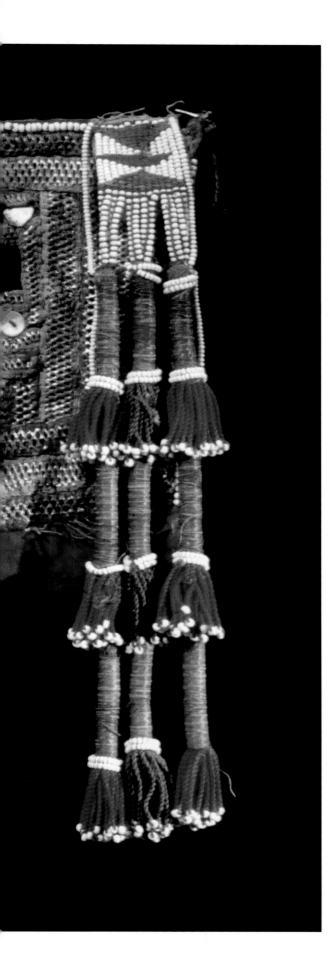

150. Face mask. This example of an everyday mask from the Gulf is the type worn by Bedouin women in many parts of Arabia. It is made of black cotton or rayon gauze, folded under the eye slits to make a double layer over the face. The band above the eyes is rayon satin. It is 24in long and was made in about 1977.

Women's Accessories

Apart from her jewellery (*see* pages 62-89), a woman's accessories might include belts, pouches and cosmetic containers. Belts are either woven and backed with leather or with goat hair (*shywayhiyya*), or made of gold or silver (*hagab* or *hizam*).

Pouches come in various forms, usually about eighteen inches deep, with braided shoulder cords. They are made so that the upper part of the bag can be folded over to close it, or left upright when the bag is very full. The same type of bag is also used by men, but the women's are more elaborate: these are decorated with an applied woven band and fringes or tassels, usually wrapped in brightly coloured cloth. Both sides of such bags are usually decorated, often with symmetrical patterns.

Until the advent of modern make-up, henna and kohl were the common forms of cosmetic known to Bedouin women. Hands and feet, as well as hair, were (and still are) treated with henna which was usually kept in round wooden boxes with domed lids, imported mostly from India. Kohl, used for the eyes (for supposedly medicinal as well as decorative purposes), was variously preserved in glass, metal, leather or wooden tubes with rolled leather stoppers. Along with a stick for application, these tubes were sometimes placed between leather pads decorated with cowrie shells. These were made in Jizan. Other cosmetic containers included hand-shaped cushions, with the kohl placed in the middle 'finger', and more ornate examples with beads and ribbons attached from the Hadhramawt. Nowadays elaborate cosmetic containers of modern manufacture are popular throughout Arabia.

Village women, and the more prosperous Bedouin women, owned small chests in which they kept their jewellery and the other accessories just described. These chests were usually compartmented and the exterior decoration often consisted of simple patterns made by scorching wood, or brass inlay.

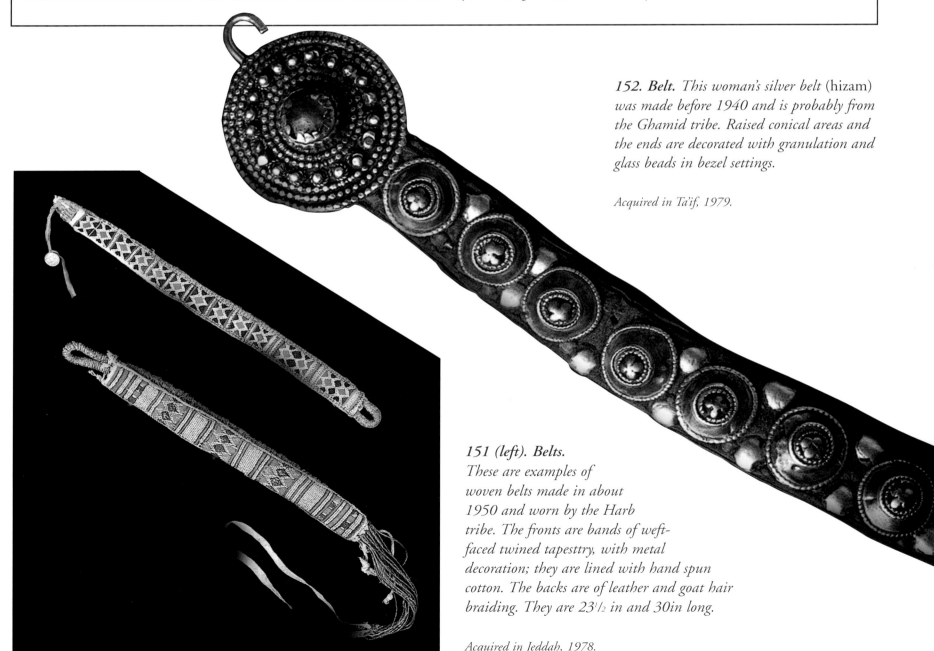

152. Belt. This woman's silver belt (hizam) *was made before 1940 and is probably from the Ghamid tribe. Raised conical areas and the ends are decorated with granulation and glass beads in bezel settings.*

Acquired in Ta'if, 1979.

151 (left). Belts.
These are examples of woven belts made in about 1950 and worn by the Harb tribe. The fronts are bands of weft-faced twined tapesttry, with metal decoration; they are lined with hand spun cotton. The backs are of leather and goat hair braiding. They are 23¹/₂ in and 30in long.

Acquired in Jeddah, 1978.

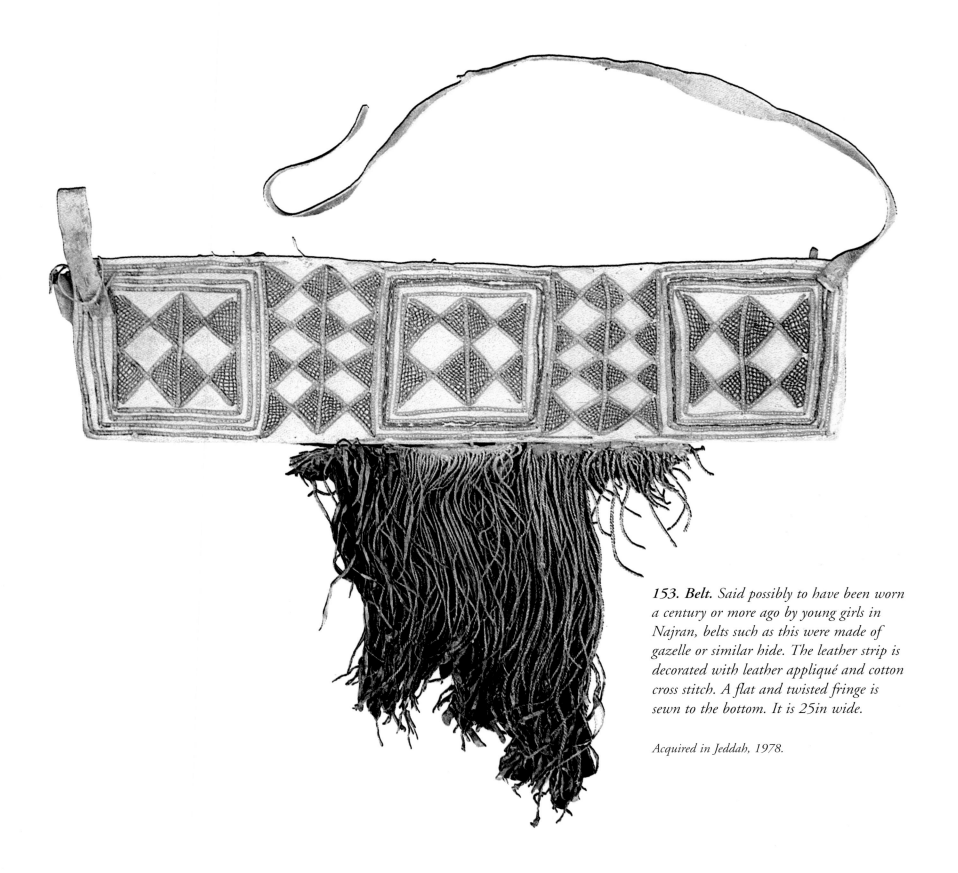

153. Belt. *Said possibly to have been worn a century or more ago by young girls in Najran, belts such as this were made of gazelle or similar hide. The leather strip is decorated with leather appliqué and cotton cross stitch. A flat and twisted fringe is sewn to the bottom. It is 25in wide.*

Acquired in Jeddah, 1978.

154 (above). Kohl holder. *From the Hijaz, this interesting kohl holder was made before 1960. It is woven over a matted cotton form suggesting a lizard shape and is made of twined leather with cast metal beads. Braided tassels on the lower edge are decorated with cloth and cowrie shells. It is 8½ in long.*

Acquired in Jeddah, 1978.

155 (right). Kohl holder, mikhakh. *This kohl container is from the Bani Salim tribe in the Hijaz. It is made of twined cotton on leather warp, decorated with cast metal beads, and stuffed with cotton fibre. The braided leather tassels are decorated with plastic, cowrie shells, buttons and metal beads. A small plastic bottle with a screw cap (probably a later addition) is inserted into the neck for holding the kohl. It is 6¼ in long.*

Acquired in Jeddah, 1978.

156 (above centre). Henna box. *Imported from India, henna containers of the type shown here are made of wood and painted red. This example is 5¼ in in diameter.*

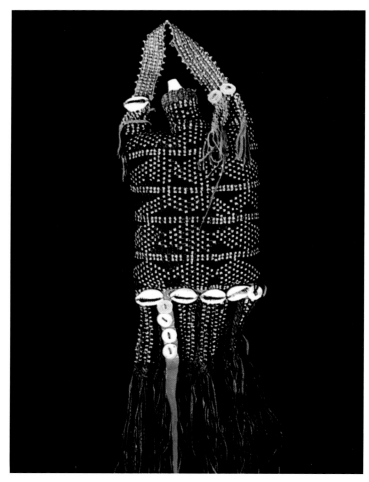

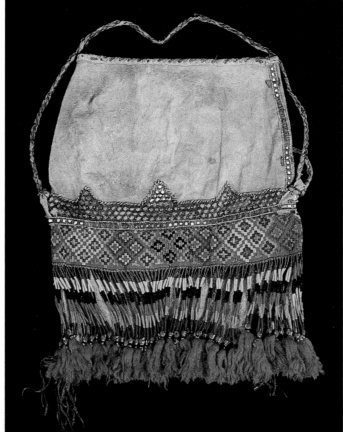

157 (bottom left). Kohl holder. *From Jizan, this kohl container is made of braided and sewn leather, decorated with cowrie shells. The tubes on each side have stoppers held by straps; the long strap at the top is for hanging the container. It was made before 1940.*

Acquired in Abha, 1978.

158 (left). Pouch. *This woman's leather pouch* (alaqa) *made before 1960 is decorated with appliquéd cloth and cast metal beads. On the front is sewn a weft-faced twined tapestry band; a wrapped weft fringe at the bottom terminates in tassels. A braided leather strap is attached to the sides. It is 18in high.*

Acquired in Dammam, 1977.

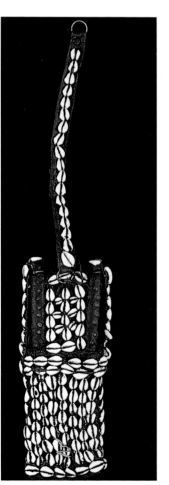

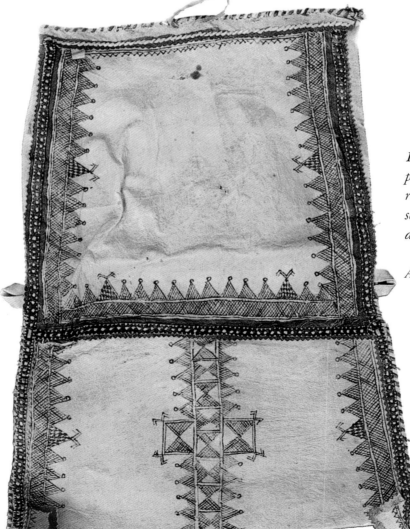

159 (left). Pouch. *From the Najd, this pouch* (alaqa) *is made of leather and reinforced with leather lacing at the seams and edges. It is decorated with designs in ink and measures 20in long.*

Acquired in Riyadh, 1977.

115

Men's Garments

The *thawb* or *jubba*, worn by all males irrespecive of age, resembles a long shirt. Though loose-fitting, it is much less ample than the woman's *thawb*. Of ankle length, it is made of white or pale grey light cotton for summer, or white, grey or fawn heavy cotton or light wool for winter. The sleeves are long and narrow, sometimes with an even narrower cuff. Until recently a wing-sleeved gown for men called a *thawb shillahat* was common in eastern Arabia but is now rarely seen. The *thawb* has a mandarin collar (though Western shirt collars also occur) and may have a pocket at the side or on the chest. This pocket was traditionally the space between the overlapping ends of a robe across the breast.

Over the *thawb* is worn an *abaya, mishla,* or *bisht* – a kind of light gown open at the front and reaching almost to the ankles. These, until recently, were not owned by the majority of Bedouin; much sought after, they were often kept by sheikhs and travellers to give as gifts to men who may have performed some service for them. Less full and elaborate than women's, they are normally worn draped over the shoulders. Of black, brown or white cotton, they are often hemmed in silk or gold thread across the back of the neck and down the front, with small gold tassels at the waist. Although Western jackets worn over the *thawb* are seen throughout Arabia and in other parts of the Middle East, many older and upper class men still wear the bisht in public.

Some peasants wear a sleeveless *abaya* that reaches only as far as the waist, called an *aba*. Villagers and Bedouin sometimes wear a *taqsiyya*, a coarse waistcoat or sleeveless jacket, or a *damir*, a jacket with sleeves. In northern and upland Arabia during winter, mean wear thick sheepskin coats, with the fleece on the inside, simply referred to as *farwa* (fur). A knee-length coat (*zabun*) may be worn between the *thawb* and the *abaya* and is fastened by a leather belt at the waist.

Other garments based on the *abaya* shape include a heavy sheep's wool cloak (*bidi*) with embroidery in dyed rust red and orange along the shoulders and neck and tassels at the small hand openings. These are said to be made by the Ghamid tribe in the Asir who are known for their soft, coarsely woven yarns. A shorter waist-length version of the *bidi* is also made, usually brown with similar embroidery, on which the yarn has been brushed to give a nap.

Also worn by the Bedouin are large cloth-covered cloaks lined with sheepskin; nowadays these are mostly imports with simulated fur. Leather capes, usually made of goat hair with the fur left on the inside, were also traditionally used and are still found in the Asir. The al-Sulabah tribesmen, reputedly great hunters, were known in the past to dress mostly in gazelle skins.

160. Thawb. This is the basic garment of the Arabian man. Of superior quality, this thawb is made of white silk and has pockets at the chest and side with a button to close the front. It is 5ft 1in long and was a gift of Abdul Aziz al-Sheikh to the author.

161 (below). Cloak. *This recently made heavy* bidi *is weft-faced plain weave sheep's wool. It is decorated with chemically dyed wool yarns and the embroidery is in couching and chain stitch with braided wool tassels. Worn over men's shoulders in winter in the desert and mountains,* bidis *such as this are usually made by the Ghamid tribe in the Asir for sale throughout Arabia. It measures 51in long.*

Acquired in Ta'if, 1978.

162 (below). Jacket. *This short version of an* aba *is worn in central Arabia and the Hijaz by both men and women. Made in about 1960, it is sheep's wool with loose camel hair woven in and brushed downwards to give a nap. The front decoration consists of coloured embroidery worked mostly in couching stitch. The armholes, shoulder line and back are also embroidered and the sleeves are finished off with braided and wrapped tassels. It measures 30in wide.*

Acquired in Ta'if, 1978.

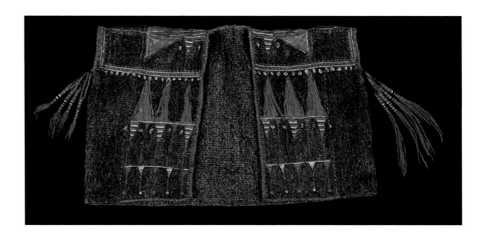

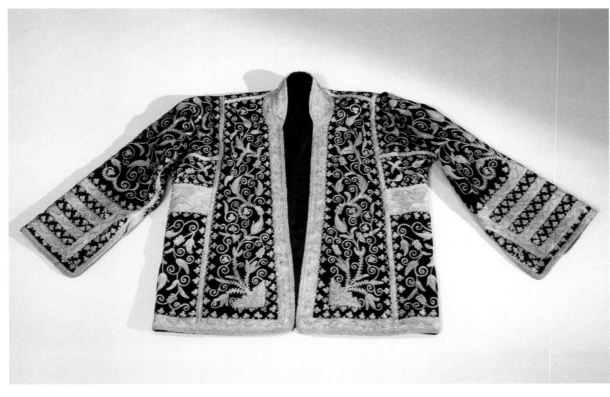

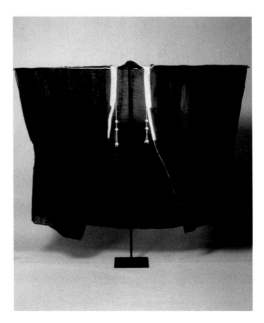

163a (above). Man's jacket. *Gold embroidery on silk and cotton. This garment would be worn by members of the hierarchy and retinue, and was probably made in Syria before 1940.*

163b (above). Mantle. *This ultra-lightweight* bisht *is finely woven, using camel hair said to be taken from the belly of young camels. The yarn or thread is very fine and difficult to handle. This now-vanished craft used to be carried out by men on pit looms in Hofuf, where the hair was woven to a cobweb-like density and embroidered with real gold.*

Men's Headgear

On the head is worn the *ghutra*, synonymous with the *kaffiya* or *hatta* of the rest of the Middle East. It consists of a large, square piece of plain white or red-and-white checked cloth with warp skull cap (*taqiyya*). During work, the sides of the *ghutra*, which normally fall onto the shoulders, are sometimes placed over the head, one on top of the other. For protection in the desert, the sides may also be criss-crossed under the chin or over the lower part of the face.

The *ghutra* is secured by an *agal*, a doubled coil of heavy black cord wrapping over a cotton core, about half an inch in diameter. The cording is just coarse enough to give it some hold on the cloth, which is essential since the doubled coil is smaller than the head. In Saudi Arabia the *agal* is usually worn centred on the top of the head but occasionally to one side or slightly forward. In the past *agals* were made of braided loops of wool, though in the Hijaz and the Asir they were often of braided leather, sometimes with inconspicuous metal beading. Others were made of short lengths of fine wire, wrapped individually over a core of leather strips.

The crown-like *agal* which used to be made of two sets of double thick gold-wrapped cords, forming a square, with black cloth medallions as the corners, seen in pictures of Ibn Saud, is now seldom worn, though small boys wear replicas on festive occasions.

164. Headgear. *This red and white headcloth* (ghutra) *is an example of the kind typically worn in Saudi Arabia. It has a fringe of small white cotton tassels on the edges; other* ghutras *of the same design are left unfringed. The black headband* (agal) *is also typical.*

165. Headgear. *Here the standard black* agal *of black cord wrapped over a cotton core is worn over a plain white* ghutra.

166. Skull caps. *White skull caps are often worn under men's* ghutras. *Usually made of cotton, they can be quilted and embroidered, like the example at the top, or crocheted, like the other two caps shown here.*

Men's Accessories

The modern urban Arab seldom wears a belt over his *thawb*. These are more often worn by men in the smaller towns and isolated areas. They might be knife or cartridge belts, or purely decorative. In the past, dagger belts were often worn. Made of goat skin with an outer panel of white or another light colour, designs employing leather lacing might be cut into them. The dagger sheath was fixed permanently to the belt. Shoulder straps running diagonally across the chest were formerly cartridge belts, but are still found as simple straps, sometimes crossing from both shoulders. More common now in the mountainous and rural areas are belts with numerous pockets decorated with cylindrical rivets and braided edges. These are made in a number of shops in Ta'if.

Shoulder pouches used to be commonly carried by villagers and agricultural people and sometimes by the Bedouin, male and female.

A pouch for men which has now practically disappeared is made from almost an entire skin, curved to fit the side of the body. Its drawstrings and openings are reinforced by leather, and its shoulder straps decorated with soft metal beads. Square pouches with flaps and braided leather shoulder straps were in use until recently, as were bags for carrying dates or grain made out of small goat skins (sometimes painted with simple designs) with leather handles – usually continuations of the same skin, with laced edges. The former leg openings of the skin were sewn up and sometimes decorated.

The most commonly worn shoes for both men and women are still the traditional sandals (*na'l*). These have flat soles and bands for the big toes, wide, flat panel straps over the insteps, and open heels. The soles are made of cow or camel hide, and the top straps and panels are usually green coloured leather. In weather too cold for sandals, a man might wear rounded, loose shoes with leather soles sewn onto heavy woollen stockings reaching about halfway up the legs.

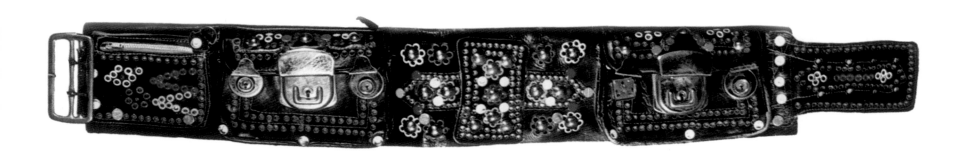

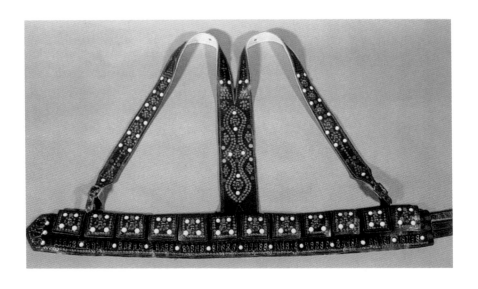

167 (above). Leather belt. Three pouches are attached to this contemporary black leather belt; one has a zipper fastening. The entire belt is decorated with patterns of mulitcoulored metal studs and punched designs.

168 (left). Belt with shoulder straps. Adjustable shoulder straps are attached to this contemporary brown leather belt. Both straps and belt are decorated with punched designs and coloured studs. A row of twelve small functional pouches runs the length of the belt.

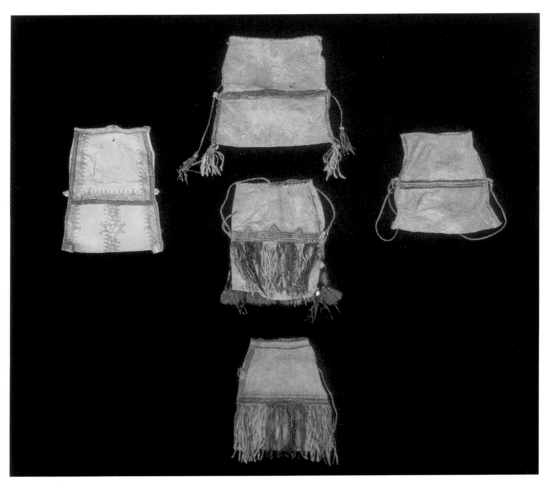

169 (above). Pouches. *These five leather pouches are decorated with coloured leather lacing or ink designs. Some are further embellished by fringes; these examples may in fact be for use by women.*

Acquired in al-Khobar, Ta'if and Jeddah.

170 (right). Pouch. *Used by the Bedouin throughout Arabia, this type of man's shoulder pouch* (alaqa) *is apparently no longer made. Constructed of goat skin, it has a drawstring closure and a shoulder strap crudely decorated in metal beads. It is 18in long.*

Acquired near Rabigh, 1978.

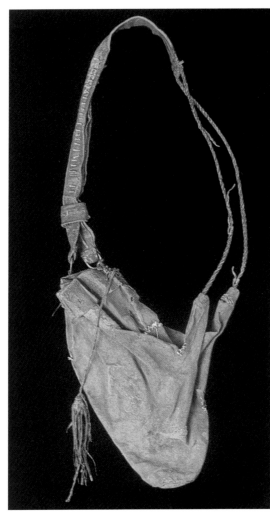

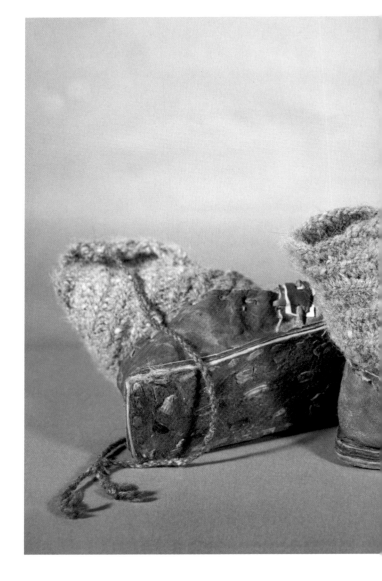

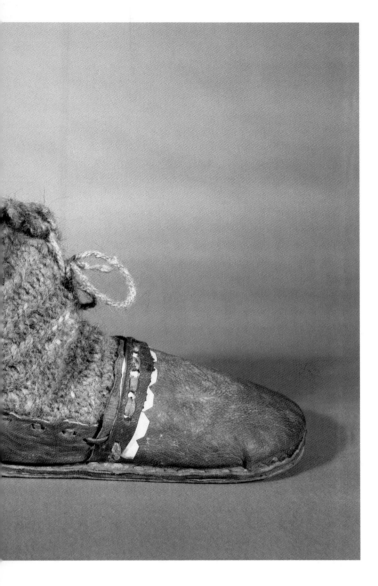

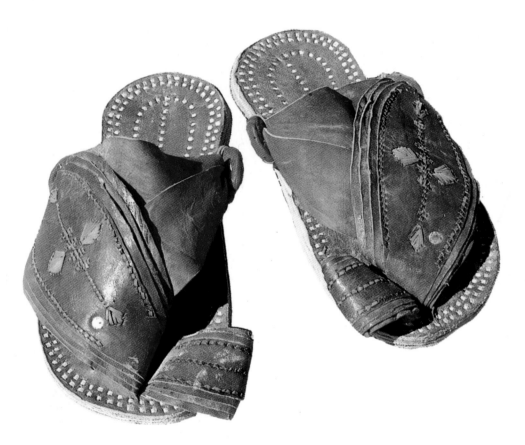

171 (above). Boots. *Crocheted camel hair stockings are stitched into soft leather shoes to form this pair of winter boots.*

Acquired in Hofuf, 1974.

172 (above). Sandals. *This pair of sandals* (na'l) *is of a type worn throughout Arabia by both men and women. They are made of leather and have embroidered designs on them.*

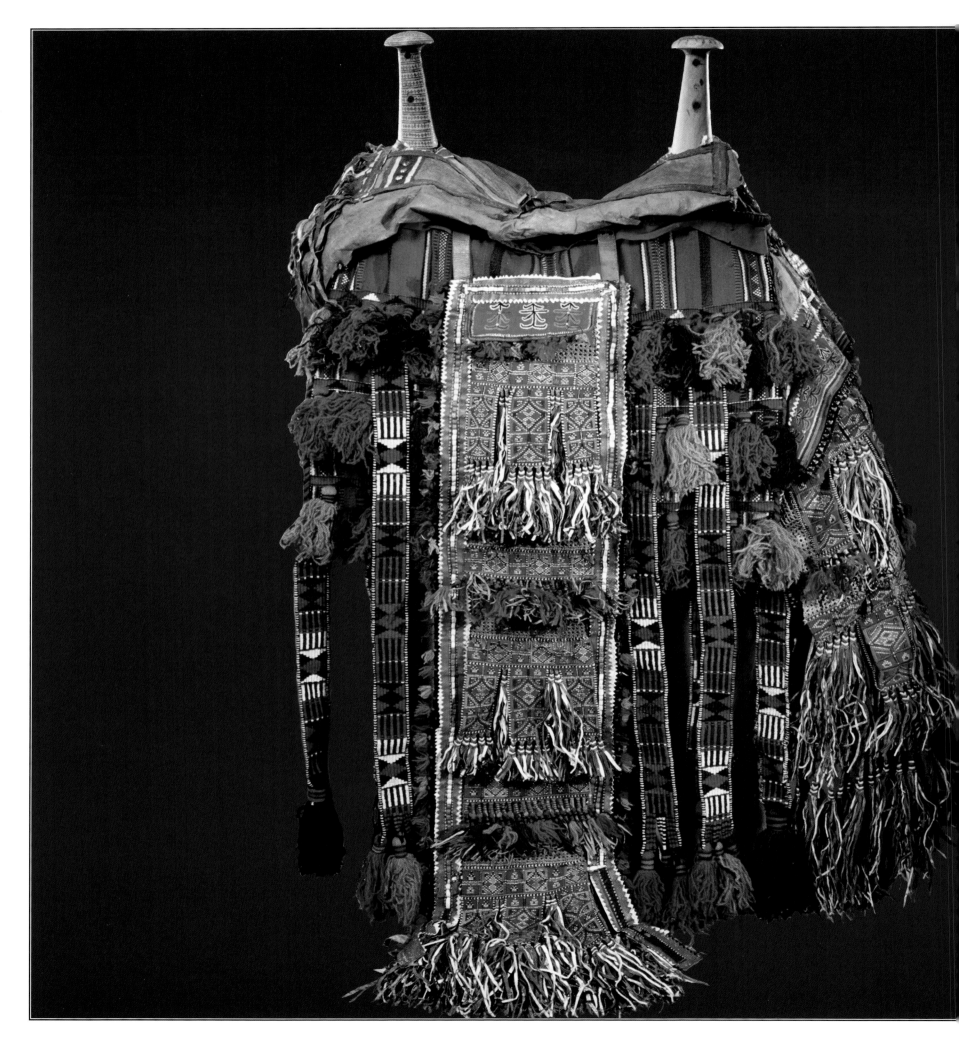

NOMADIC
EQUIPMENT

The removing of the camp of the Arab, and driving the cattle with them from one to another pasture ground, is called *ráhla*. In their yesterday's mejlis they have determined whither and how early; or it was left in the sheykh's hand, those in the neighbour booths watch when the day is light, to see if the sheykh's hareem yet strike his tent; and, seeing this, it is the rahla. The Beduish housewives hasten then to pluck up the tent-pegs, and their booths fall; the tent-cloth is rolled up, the tent-poles are gathered together and bound in a faggot: so they drag out the household stuff, (bestowed in worsted sacks of their own weaving,) to load upon the burden camels. As neighbours see them and the next neighbours see those, all booths are presently cast in the wide dispersed menzil. The herdsmen now drive forward; the hareem . . . mount with their baggage; the men, with only their arms, sword or matchlock, hanging at the saddle-tree behind them, and the long lances in their hands, ride forth upon thir thelúls, they follow with the sheyk: – and this is the march of the nomad village.

The Bedouin, always on the move, as Doughty describes above, have to travel as lightly and as compactly as possible. Apart from the tent, their luggage consists of personal possessions, coffee and cooking utensils, and woven furnishings and equipment, such as the rugs, blankets and gaily coloured utility bags described in Chapter 1. It also includes more durable items made of leather and wood used for the drawing and storage of water and for transport.

Whether on horse or camel, the Bedouin men traditionally ride without stirrups on bent wood saddles with pads for cushioning. Unlike the townsfolk, they do not use bits or reins, only a halter, and they ride with one or both

173 (preceding page). Camel saddle with full saddle decoration. The wooden frame of the saddle, with its basic paddings and seat and knee cushions, is covered with a double camel bag, including matching miraka *and rifle sling. This fine example was given to Floyd Ohlinger by Ibn Saud in the 1940s.*

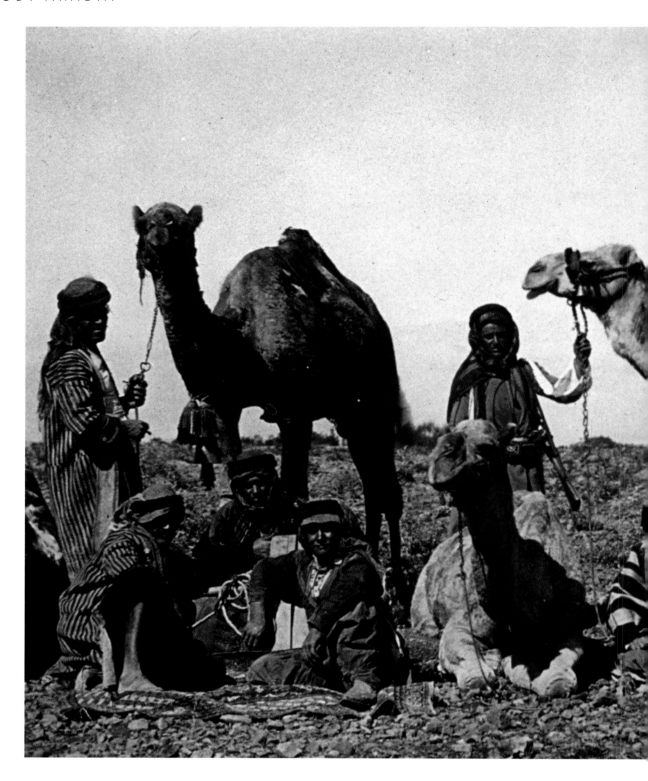

knees on the saddlebag or *miraka* cushion.

The saddles are usually decorated in some way, often with geometric incisions and metal pegs and bands. Packsaddles are used for carrying, amongst other things, tent poles and utility bags. The womenfolk and younger children used to ride in a litter, described by Doughty as a 'bedstead with an awning'. Musil in *Manners and Customs of The Rwala Bedouins* recounts the effect the sight of the *zetab*, the most extravagant of the litters, had on him:

The appearance of a number of these litters during a march is impressive. If they are seen in the distance on a pink sand drift surrounded by a blue transparent atmospheric haze, they resemble huge butterflies swaying freely to and fro in the air. In the almost entirely flat, greyish-white desert of al-Hamad, a greyish-white camel bearing the *zetab* and covered with various gaudy decorations fades from sight, while the magnificent litters project above the horizon and glide along as if upon bright and regularly rising waves.

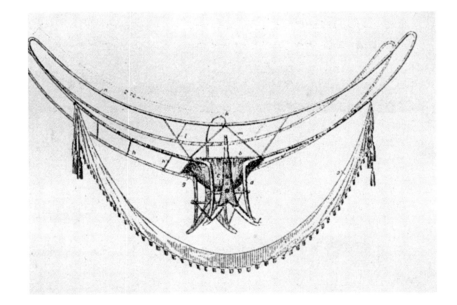

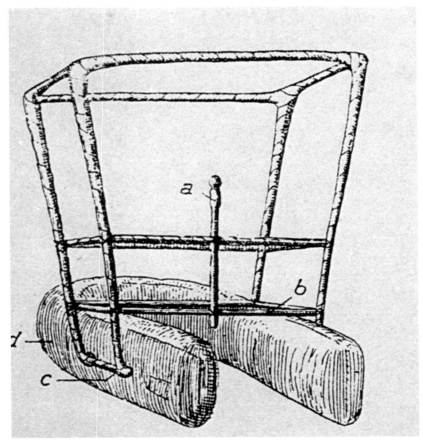

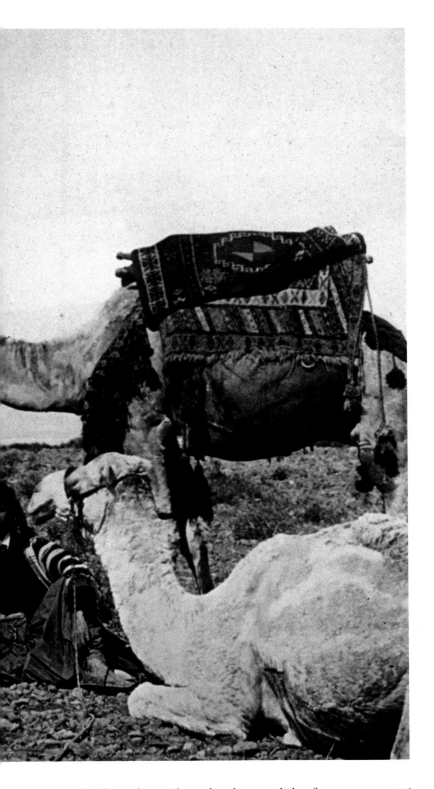

Halted on the trail, *a glass lanternslide of Bedouin taken by Bonfils in about 1870.*

Carrying the litters, tents and luggage was traditionally the role of the male so-called 'burden camels'.

The drawing of water, on the other hand, was undertaken by special 'well camels', usually the females, since they were normally less difficult to handle than the males, highly prized and preferred for riding.

Well pullies and other well equipment are essential possessions for the Bedouin, as are water carriers of all kinds. The large drinking troughs for camels have a wooden frame and leather basins; individual water bags for camels and horses are also made of leather, as are vessels and bottles. The methods used for shaping leather into efficient durable objects are remarkable and display the Bedouin skill in tanning and fabrication. Stylistically, however, most leather items of nomadic equipment are comparatively simple, their functional purpose being of prime importance.

(Above, top) A sketch of a zetab *litter from* Musil's Manners and Customs of the Rwala Bedouin.

(Above, bottom) A sketch of a ginn *litter from* Musil's Manners and Customs of the Rwala Bedouin.

Saddles

Camel saddle frames are usually made of tamarisk wood. They are constructed simply and durably from two split pommels or horns extending into splayed paddles forming a v shape to fit the hump. The pommels are joined by crossed sticks fastened on each side, the upper ends of which are held against a projecting piece of wood crossing through the horn. Rope or woven girths are fastened both from the front of the saddle around the camel's chest and from the rear around the loins. Padding or a small blanket is used under the saddle.

Pack saddles for carrying utility bags usually have horns over which the loops of the bags can be slipped. These saddles have extra cross pieces for this purpose. Pack saddles are also occasionally made with arches of bent wood to receive tent poles, though these are more often carried in slings attached to the horns.

Men's riding saddles are of the same basic structure as pack saddles but have one or both of the crossed sticks cut flat to reduce pressure on the legs. They are usually decorated with geometric patterns made by simple slashes in the wood, or with hammered-in soft metal pegs or brass tacks and metal bands. The horns often have wrapping of rawhide or gazelle skin, with the saddle covered with blankets and cushions.

In southern Arabia and Oman, the rider often sat behind the hump on an elongated cushion which bent around it. The cushion was fastened by thongs to a saddle arch in front of the hump. This in turn, was held in position by a girth around the chest of the camel.

In the past, donkeys were used for transportation and carting. Their saddles were also usually constructed from tamarisk wood and were fastened together with sinew. The fibre girths too were covered with sinew or yarn.

173. Baby's cradle. Used throughout Arabia, this type of carrying cradle can be hung over the shoulder or in the tent by its braided leather straps. It is made of leather with two pieces of wood to give it shape. The panel at the decorated end prevents the cradle from closing over the baby's head.

Acquired in Hofuf, 1972 by Ann Rhea.

174. Donkey pack saddle. Made of tamarisk wood fastened with sinew, this donkey's saddle is of the type used throughout Arabia. It was made in about 1940.

Acquired in Riyadh, 1979.

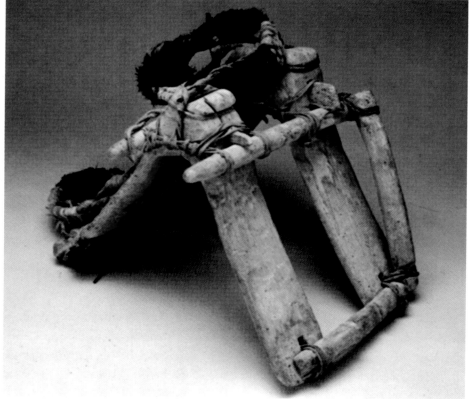

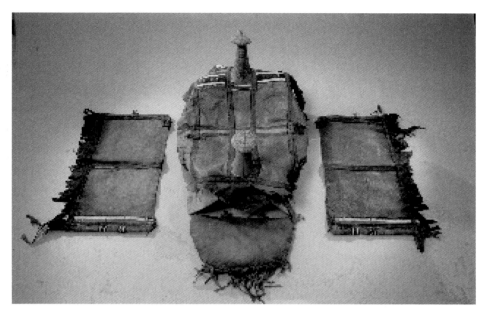

175a (top left). Camel riding saddle. The saddle (in the centre of the picture) is probably tamarisk (ithil) wood, the cushioned padding (either side of the saddle) are goat or camel leather stuffed with wool.

175b (middle left) Saddle frame.

176a (bottom left). This matching miraka *and rifle sling are braided leather with cotton decorative wefts on the tabs, and represent probably the finest craftsmanship that the author has found. The warps on the tabs are leather (bottom left).*

176b (below). The decorative tabs at the top of the miraka *and rifle slings are cotton appliqué.*

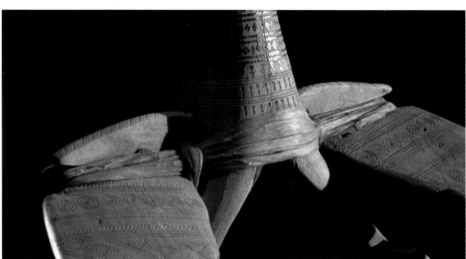

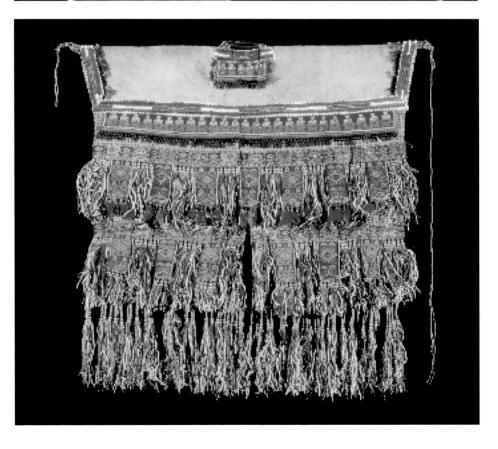

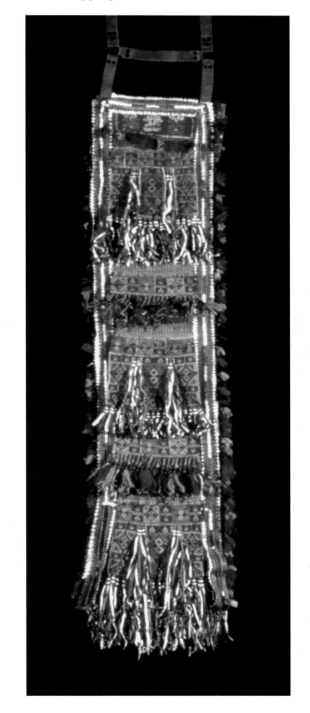

Litters

In the past, women and young children, when riding, usually sat in a covered litter built onto a basic saddle frame, the horns of which were much higher than those on men's saddles. A bent wood frame was fastened by rawhide or cord to the basic saddle and its extended horns. This frame was covered with woven cloth, leather panels or a blanket sometimes decorated with bands and tassels. The simplest and probably the commonest form of litter, called a *ginn*, had a rectangular top, held up by vertical sticks at the corners. These in turn were supported by structured padding around the hump.

Other litters, called *maksar* or *hawdaj*, were formed from four curved arches with back panels usually made of leather. Either of these litters would make an imposing sight moving across the desert. The Ruwala Bedouin and perhaps others in the north, as well as the *ginn*, used the *zetab*, a frame with great wings extending as much as eight feet on either side. This magnificent and extravagant litter covered in colourful sashes and tassels, had enormous horns and a suspended leather cradle in which a woman could carry her children.

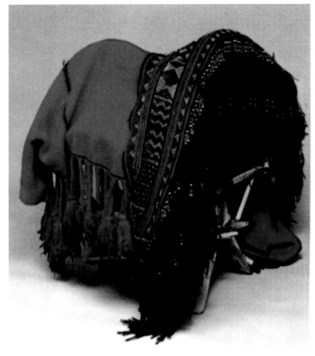

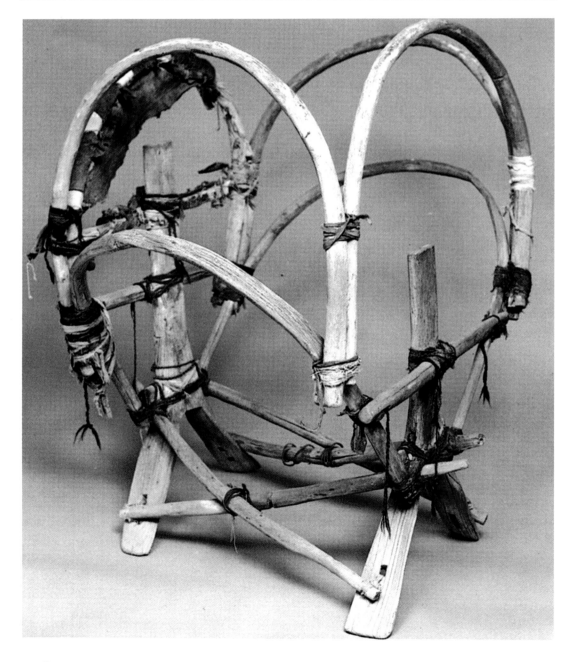

177 (above) and 178 (left). Riding litter. This woman's maksar (or hawdaj) *is constructed from a saddle frame of bent wood with elongated horns. Most of its leather back panel is missing. A blanket cover and a decorative fringed piece are shown above; folded blankets or sheepskin would have formed its seat. It is 45in high.*

Cover acquired in Hofuf by the author, in about 1975. Frame acquired by Grace Burkholder in about1970.

179 (right). Camel watering trough. Used throughout Arabia, this type of hawdh *has a bent wood frame and a basin, usually made of leather. The original leather on this example has, however, been replaced with rubber sheeting from a large truck's inner tube. It was made before 1950 and measures 40in in diameter.*

Acquired by Grace Burkholder in about 1970.

Leather Carriers and Well Pullies

Another large frame commonly carried by the Bedouin is the watering trough for the camels. This is a large circle of bent wood with arc-shaped supports lashed with rawhide at the crossings. A large leather hide is attached to the circular frame to make a receptacle, onto which water from wells would be poured for the beasts.

For drawing the water from the wells, which are often very deep, the Bedouin usually carries with him his own well equipment which includes wooden sheaves cleverly made out of small pieces of wood laced together. These are valuable objects and are normally carried with the mounting apparatus and well ropes. Such ropes were in the past made of leather, but are now of hemp or plastic. Larger and more elaborate well pullies are used in the oases.

Water is carried in skins of varying sizes; the leg openings are closed and the neck, used as a funnel for filling, is then lapped over and tied. The projecting legs are reinforced with sewn-on tabs used for fastening the skin to the pack saddle. Most water skins are made of goat hide, though a few larger ones are of camel. Sheepskins make poor water bags, but are normal for making buttermilk (*leban*).

A man on his own carried his water in a small skin or sometimes a bottle made from leather. Camels and horses also have individual leather water and feed bags with braided leather straps, fastened over their heads. Sometimes these are decorated with tassels, cowrie shells, and metal or glass beads. Leather was also used for other types of bag: for carrying dates and such like, and for children's cradles. These had panels at the head and were decorated with long leather ribbons. Braided leather straps enabled the cradle to be hung over the shoulder or in the tent.

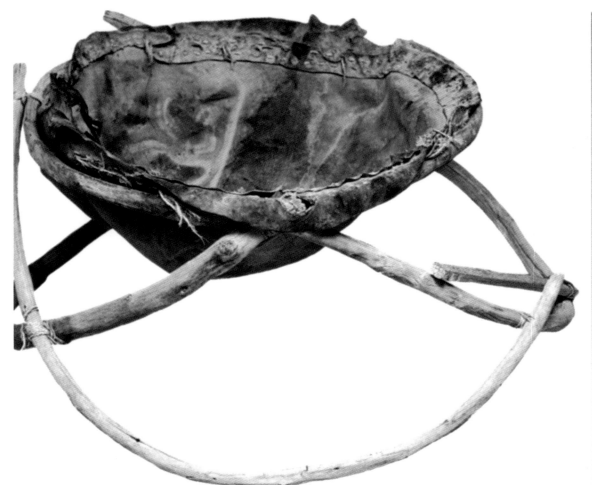

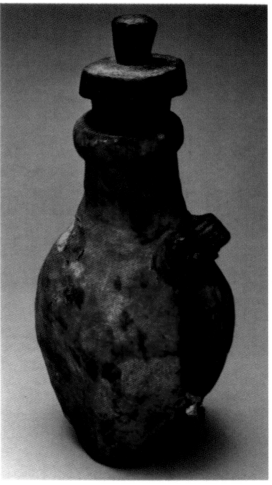

180. Leather bottle. This skilfully made water container is constructed from animal skins stretched over a frame; no stitching is visible. It has a wooden stopper. Its origins are obscure but it possibly comes from the al-Murrah tribe. It stands 14½ in high.

Acquired in Riyadh, 1979.

181 (above). Feed bag. *Made in the Najd, this bag is leather and decorated with glass beads and cowrie shells. Metal rings and leather straps are attached to the top. It is 10in in diameter, similar to a water pail for drawing water.*

Acquired in Ta'if, 1978.

182. Camel bag. *This leather camel bag is an example of a type used throughout Arabia. It was made in about 1960 and is decorated with leather and cloth appliqué and a leather fringe. It is 23in high.*

Acquired in Dammam, 1977.

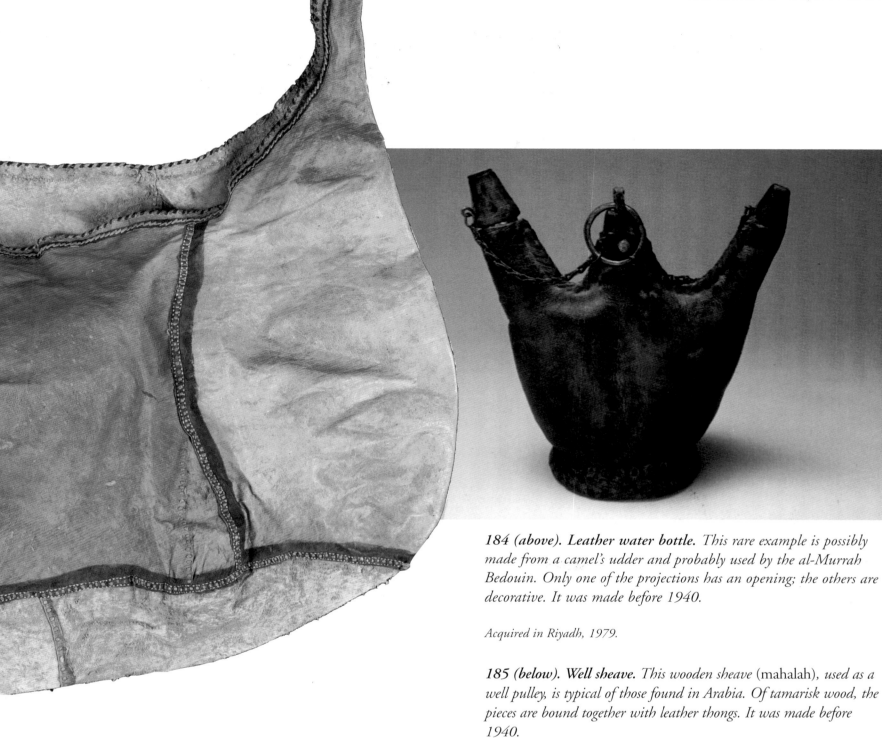

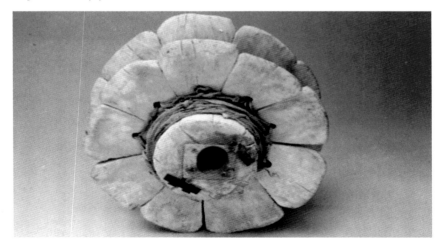

184 (above). Leather water bottle. *This rare example is possibly made from a camel's udder and probably used by the al-Murrah Bedouin. Only one of the projections has an opening; the others are decorative. It was made before 1940.*

Acquired in Riyadh, 1979.

185 (below). Well sheave. *This wooden sheave (mahalah), used as a well pulley, is typical of those found in Arabia. Of tamarisk wood, the pieces are bound together with leather thongs. It was made before 1940.*

Acquired in Hofuf, 1977.

183 (above). Leather camel bag (roahwah). *This large, plain utility camel bag is open at the top. It is constructed entirely of leather and the joins are of leather lacing. Made in about 1960, it measures 26in by 44in.*

Acquired in Dammam, 1977.

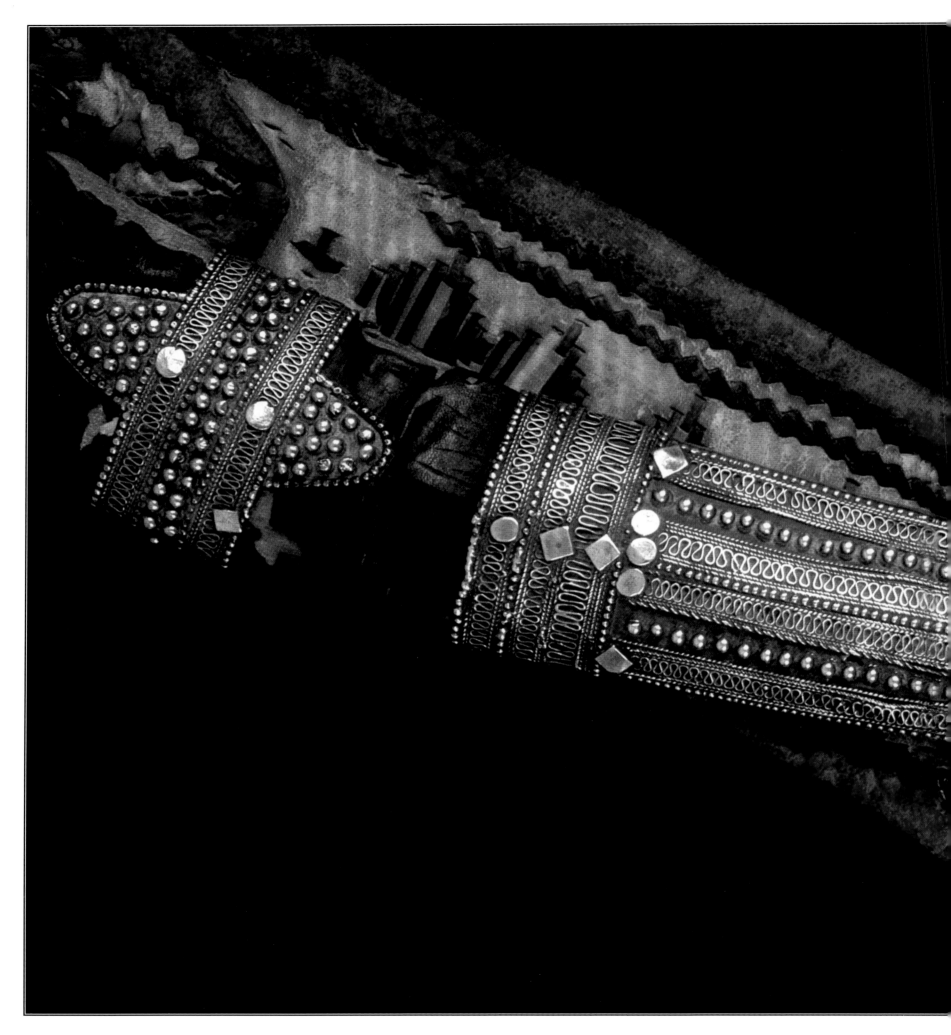

WEAPONS

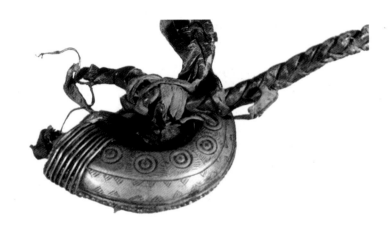

It is a brave sight, as they come on with a song, bowing in the tall saddles, upon the necks of their gaunt stalking beasts, with a martial shining of arms. The foemen in sight, the sheukh descend with the long lances upon their led horses; and every sheykh's backrider, *radif*, who is also his gun-bearer, now rides in the thelûl saddle. Those thelûl riders, upon the slower sheep-like beasts, are in comparison of their few light horsemen, like a kind of heavy infantry of matchlock men. The nomad cavalier, sitting loosely upon a pad without stirrups, can carry no long and heavy firearm, which he could not reload. Only few amongst these southern sheyks are possessors of some old flint horse-pistols, which abandoned in our grandsires' time, have been sold away from Europe. Their hope is in the romhh or shelfa, the Beduin lance: the beam, made of a light reed of the rivers of Mesopotamia, is nearly two of their short horse-lengths; they charge them above their heads.

The spear *(romh or shelfa)* described above by the 19th-century traveller, Charles Doughty, in his account of a battle between warring tribesmen, was for centuries the traditional weapon of the Bedouin. Known as the horseman's lance, it was sharply pointed at one end and had an iron spike at the other for standing in the ground. As the description shows, the lances were sometimes used alongside the more 'modern' rifles but they are no longer a part of the weaponry of the Bedouin today and are rarely found.

Long daggers and short knives on the other

186 (preceding pages). Dagger sheath.
Probably made in Saudi Arabia before 1940, this impressive dagger sheath is attached to a leather belt, decorated with dyed, laced and braided leather strips. The sheath itself is built over a wooden core, and silver filigree and soldered silver pieces (in patterns usual in the Najd) decorate its leather exterior. It is 16in long.

Acquired in Jeddah, 1978.

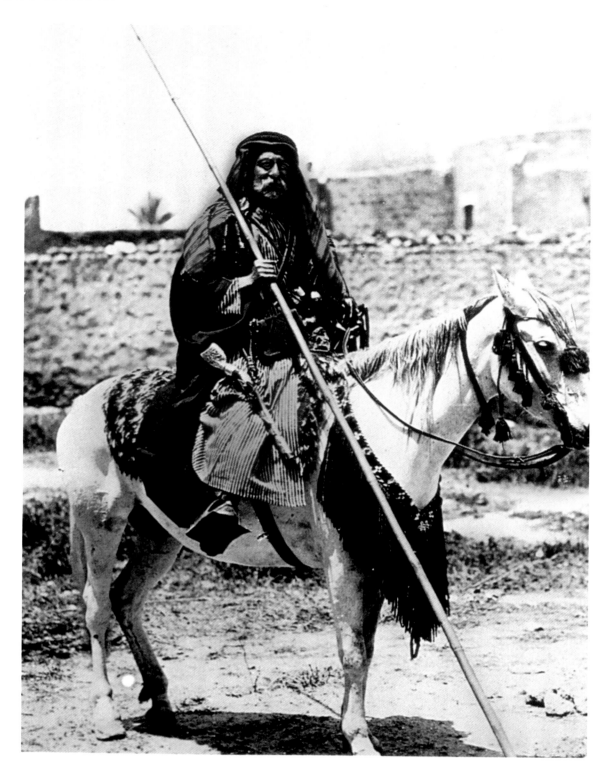

Above: A glass lantern slide of a Bedouin sheikh taken by Bonfils in about 1870.

hand, are still commonly worn by Bedouin in the remoter areas and appear throughout Arabia on ceremonial occasions. The long curved dagger of the Bedouin was fastened almost horizontally onto the belt, with the handle to the wearer's left; it was drawn with the right hand in a sweeping upward motion. These double-edged daggers, called *khanjar*, were used more like swords than daggers. In some areas, especially in

Opposite: A Bedouin with his sword on horseback, photographed in Hofuf by 'Ilo the Pirate' in about 1950.

the Hijaz and Asir, double-edged curved Yemeni daggers of about ten inches long were favoured. These were fastened vertically rather than horizontally to the belt, their sheaths curving far beyond the point of the blade, up towards the belt. The points were finished off with a round, heavily ornamented cap. All dagger handles and sheaths of this type were decorated: while the

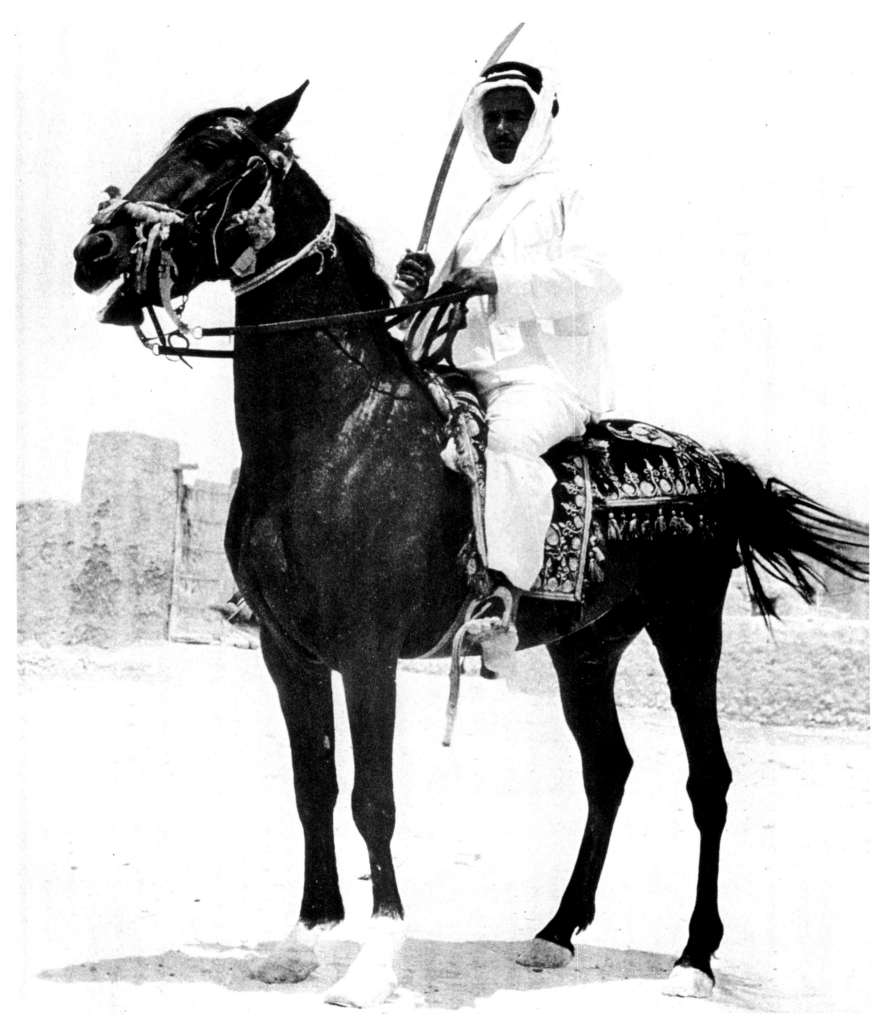

more ordinary examples were made partially of leather with brass bands at the openings and tips, and chased brass decoration often on the hilt, the more elaborate types used silver instead of brass, with some leather showing through the more intricate decoration on the metalwork. Others were embellished with glass and semi-precious stones, their sheaths covered in metal. The sheaths themselves were built over a two-piece wooden core, which fitted on either side of the blade. While the sheaths and hilts were often made by local craftsmen, the blades were usually imported from Damascus or Yemen, and were usually engraved with geometric designs down both sides.

In the past, long curved swords, resembling cavalry swords, were also used. Now seldom found, these swords were normally carried only by leaders and their guards. The sheaths were made of leather and decorated with brass or silver bands both at the tip and the hilt, which was itself simple and often without a hand guard. As well as being used for defence, these swords also fulfilled a ceremonial function: they were given as presents, gold-handled sheathed pieces being a favoured gift, and were (and still are) used in the traditional sword dances.

The manufacture of these weapons is remarked on by Doughty in his *Travels in Arabia Deserta*. He recounts a visit to Hail in the western Najd, one of the locations at which metalworkers were found during the 1880s:

> They were rich men, of the smith's caste formerly of Jauf, where are some of the best sânies, for their work in metal, wood and stone, in nomad Arabia. Aheyd at the taking of the place found these men the best of their craft, and he brought them perforce to Hâyil. They are continually busied to labour for the princes, in the making and embellishing of sword-hilts with silver and gold wire, and the inlaying of gun-stocks with glittering scales of the same. All the best sword-blades and matchlocks, taken (from the Beduw) in Ibn Rashîd's forays, are sent to them to be remounted, and are then laid up in the castle armoury.

As can be seen from Doughty's evocative descriptions, rifles were being used alongside the more traditional weapons by almost all of

the Bedouin tribes – though they appear to have had more faith in their lances than in the guns, which were impractical in the kind of warfare they were used to. Most battles were fought on horseback and the guns were difficult to reload, often being discharged only once in the course of a battle. Even so, by the middle of the 19th century, a rifle of some sort had come into the possession of most Bedouin, the commonest being the matchlock, a gun

A glass lantern slide of a Bedouin encampment taken by Bonfils in about 1870.

with a lock in which a fuse-wick was placed to ignite the powder. This kind of gun could be made by almost any Arabian metalworker.

Flintlocks, discharged by the spark from a flint, were used into modern times, as were percussion caps, devices containing explosive powder, exploded by the fall of a hammer.

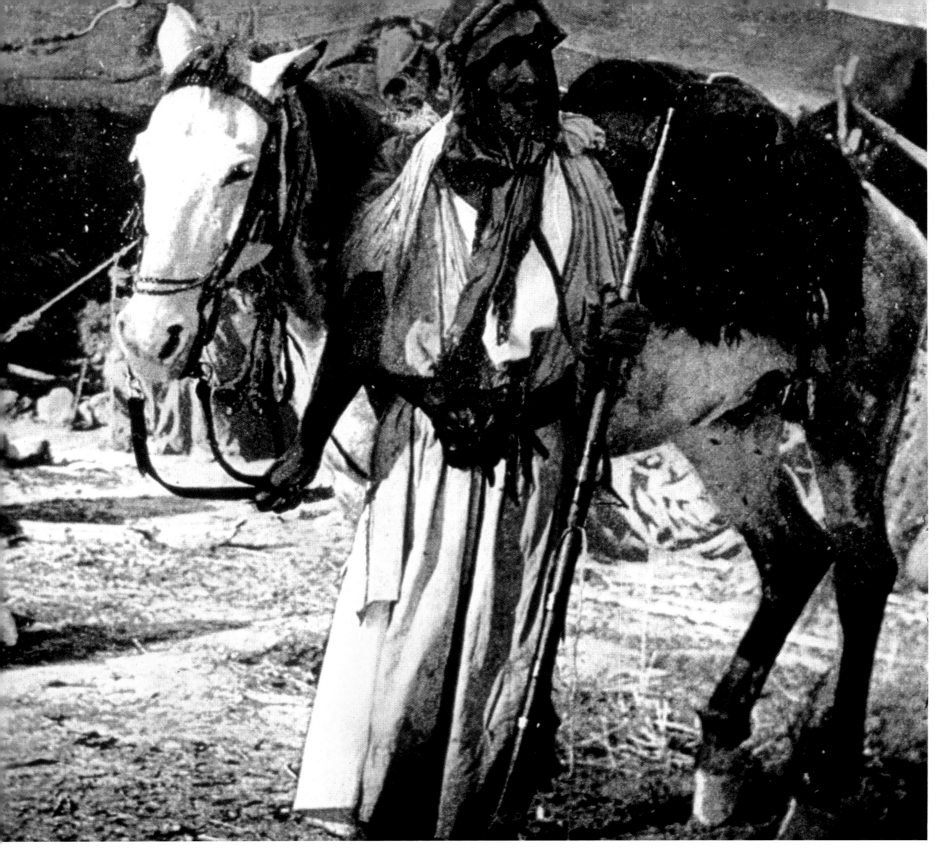

These were not replaced by European breech-loading guns until after the First World War.

In Doughty's time, the most highly esteemed guns were the oldest. The three most popular types were apparently *el-lazzary* (so called because of the marque *Lazzarino Cominazzi* inscribed upon it), *el-majar* ('the Hungarian'), brought probably by the Turks to the border cities, and *el-englysy* ('the English'). While the wealthier Bedouin might have owned one of these, the poorer nomad would have had to make do with imitations made locally and bearing false European marks. Other guns, such as the bolt-action European rifle, shown in illustration 198 (Page 143), were also imported from abroad, but were decorated locally by Arabian craftsmen.

Bullets were made from lead purchased in the local towns. However, as lead was a scarce commodity, a small pebble covered with a coating of lead might have been used instead, or in the case of real poverty, limestone balls gathered from the river bed.

Nowadays, with a strong concern for the preservation of the wildlife of the peninsula, the weapons of the Bedouin are little in daily evidence, but produced on occasions of ceremony, in remembrance of their past.

J.T.

Swords and Daggers

Until the advent of firearms in Arabia, daggers, swords and lances were the weapons of the Bedouin. Typical of Saudi Arabian manufacture are the daggers and swords (*khanjars* and *seyf*) shown here. The daggers are highly ornate: they have applied filigree decoration and small pieces of round or lozenge-shaped silver soldered onto the hilt and scabbard. On some, small pieces of glass have been inserted as additional ornamentation. Daggers in use today on ceremonial occasions are attached to attractive belts, which are decorated with plaited and dyed leather strips. Sword designs are much simpler; the most usual decoration being marks which are pricked in the steel of the sheath tip.

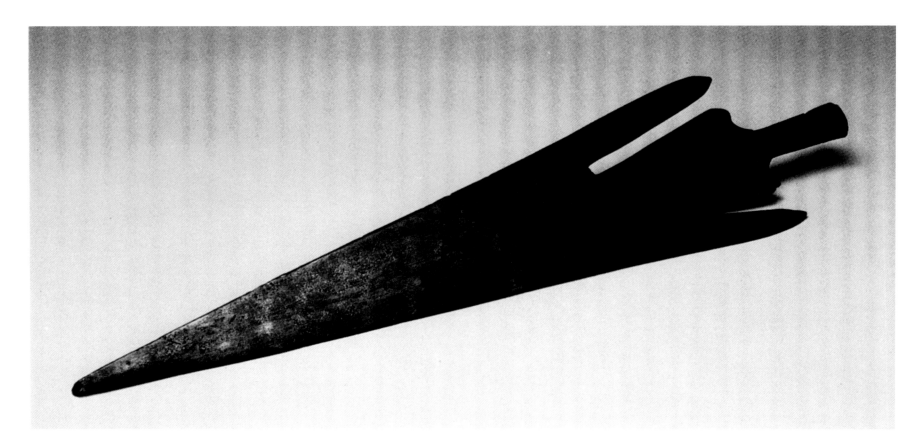

187. Spear point. Made of steel, this spear head, the traditional weapon of the Bedouin, is decorated with chased patterns worked into the metal. The shape of this example is not, however, typical; most spear points are more conical and elongated in form.

Acquired in Jeddah, 1978.

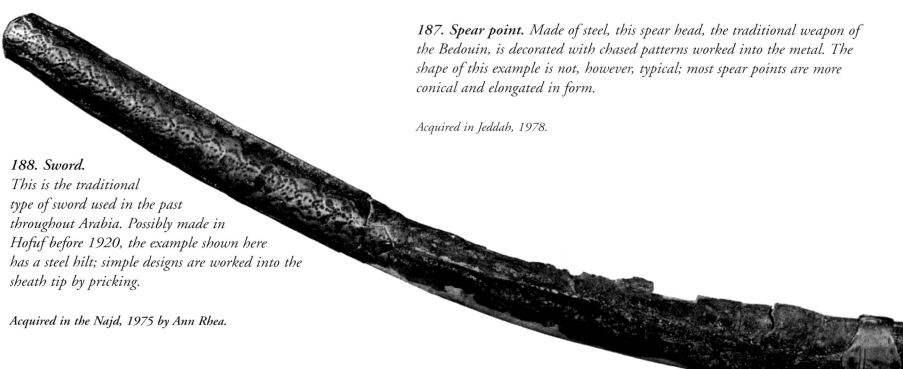

188. Sword.
This is the traditional type of sword used in the past throughout Arabia. Possibly made in Hofuf before 1920, the example shown here has a steel hilt; simple designs are worked into the sheath tip by pricking.

Acquired in the Najd, 1975 by Ann Rhea.

190 (right). Knife sheath. *A modern sheath for a short knife, this example is made of leather and decorated with lead beads.*

Acquired in Ta'if, 1978.

191 (above). Spears. *Typical of Bedouin spears, this range of examples displays the conical and elongated form of the head and the blunted shape of the spike, for sticking into the ground, at the other end.*

189 (below). Sword. *This is an example of the type of sword commonly used by the Bedouin until recent times and still used ceremonially and in dance.*

192. Dagger and sheath. *Probably from the Gulf area, this metal dagger was made before 1950. Its bone handle has granulated designs on it; its leather sheath is embossed and decorated with round-headed metal studs. The sheath tip is engraved metal.*

Acquired in Abha, in about 1975.

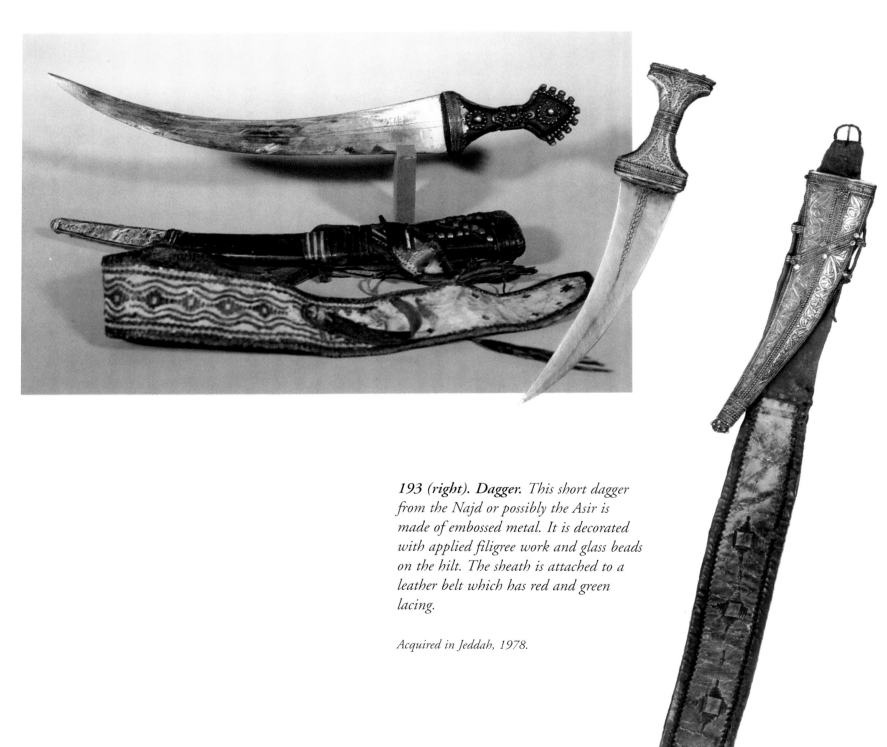

193 (right). Dagger. *This short dagger from the Najd or possibly the Asir is made of embossed metal. It is decorated with applied filigree work and glass beads on the hilt. The sheath is attached to a leather belt which has red and green lacing.*

Acquired in Jeddah, 1978.

Guns

As soon as they were available, guns overtook the more traditional weapons of the Bedouin. The oldest of these rifles dates from the early 19th century – it is a flintlock made in the Middle East. Other firearms shown in this chapter include a pistol with chased metal decoration, a bolt action European rifle modified and decorated by Arabian craftsmen, and a matchlock – the commonest and most popular of the older guns.

When not in use, a man would carry his gun in a bag usually made of leather. He would also wear a cartridge belt, either with a powder horn or small brass powder containers attached to it.

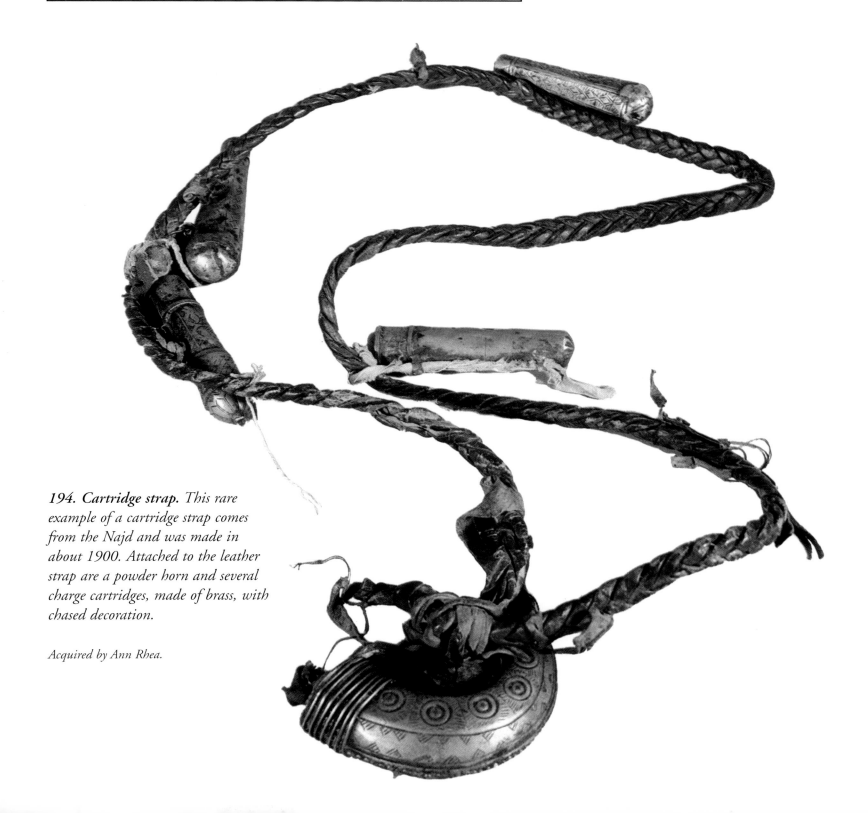

194. Cartridge strap. This rare example of a cartridge strap comes from the Najd and was made in about 1900. Attached to the leather strap are a powder horn and several charge cartridges, made of brass, with chased decoration.

Acquired by Ann Rhea.

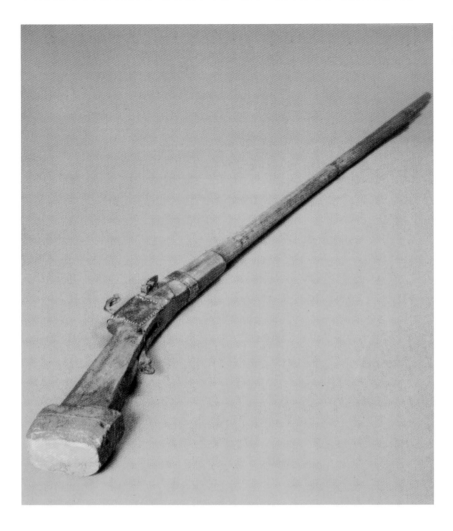

195. Matchlock rifle. *The most commonly used gun in Saudi Arabia, this undecorated example was made in the Middle East in about 1850.*

Acquired in the Eastern Province, in about 1970.

197. Flintlock pistol. *Made in about 1810, this is a French flintlock pistol. Along its barrel is an inscription which reads: 'made by Muhamand Ali al-Shagawi'; this is presumably the name of the man who decorated the pistol. Both the inscribed plate and the chased metal bands around the handle are later additions. The hammer is now missing. It measures 12¹/₂in long.*

Gift to John Topham, Jeddah, 1978.

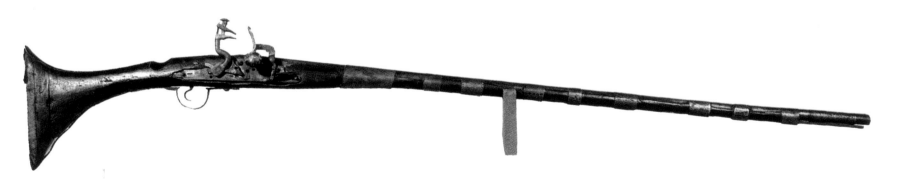

196. Flintlock rifle. *Of Middle Eastern manufacture, this flintlock rifle was made in about 1800. It is unusual in that it has a wide butt not ordinarily seen on guns in Saudi Arabia. Plain metal bands form its simple decoration. (See pages 6 and 7.)*

Acquired in Riyadh, 1970 by Ann Rhea.

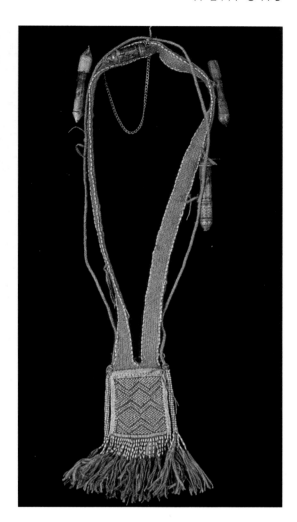

199. Gun bag. *This* jirab, *or gun bag, from the Najd was made in about 1940. It is constructed from leather and decorated with brass rivets and fringing.*

Acquired in Riyadh, 1979.

200. Catridge strap. *Probably from the Harb or Bani Salim tribe, this example has a braided leather strap which ends in a* soumak *wrapped flap with braided fringes. A second flap is sewn at the front and is embroidered with lead and brass beads. Attached to the strap are four chased brass powder containers. The strap is 24in long.*

Acquired in Ta'if. 1978.

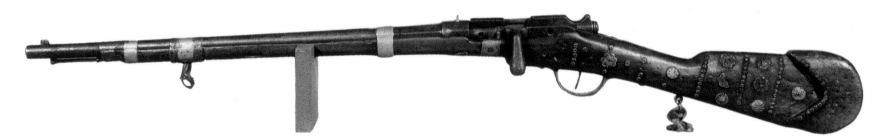

198. Bolt action rifle. *The stock of this modified bolt action rifle is decorated with metal tacks and applied rosettes. It was made in about 1910.*

Acquired in the Najd, 1970.

HOUSEHOLD CRAFTS

Although fast being overtaken by the concrete block, in villages and small towns in Arabia, adobe is still the commonest building material and usually covered with mud plaster. Sometimes whitewashed, these adobe houses occasionally have crenelated parapets and their windows ofter consist of triangular openings in the walls. Both windows and doors are decorated; the wood is incised and painted with geometric designs, and the surrounds too are painted.

In some towns in the Asir or in the Hijaz, where stone is plentiful, it is used for houses with a layer of smooth plaster on top. Houses in these regions would in the past have been built in walled compounds with watchtowers for defence purposes. In the southern Asir and the Najran area, the mud brick towers have rows of projecting stone

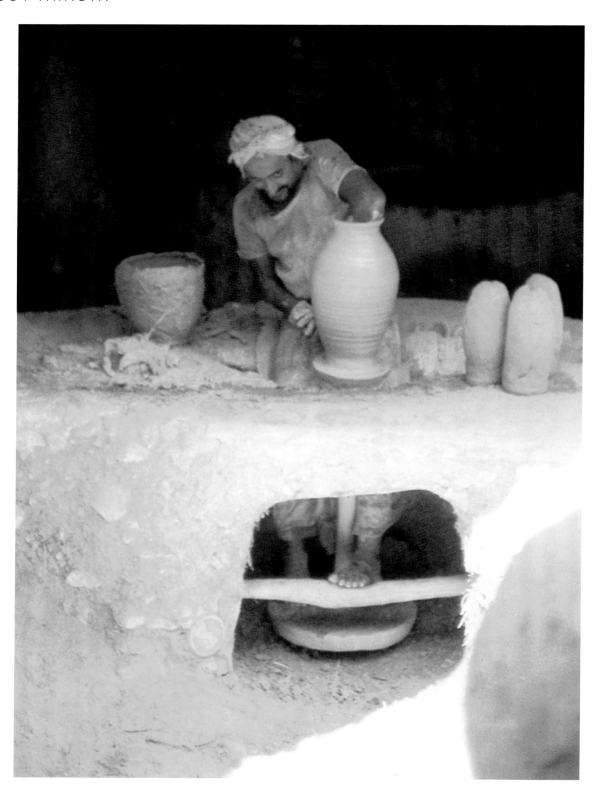

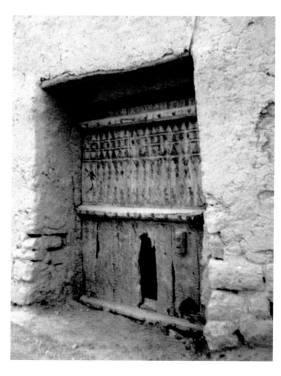

An old door in Riyadh bears traditional painted decorations.

201 (preceding pages). Container. *Made from a gourd, this vessel has a coiled fibre neck and is carried by means of cotton and fibre ropes. It is 18in in diameter.*

Acquired in Abha.

shingles placed at frequent intervals around them to prevent the rain from washing away the mud. The buildings in this region are distinguished by their elaborately painted parapets and interiors. Philby, visiting Bishah, describes in *Arabian Highlands* the art of wall decoration – a skill practised by the women of Abha.

Incidentally he had allowed me the luxury of a bath in his personal bath-room adjoining his private sitting-room,

A potter at his wheel in caves near Hofuf.

luxuriously furnished with rugs very attractively decorated with geometrical designs in various coloured inks all round the walls. This sort of domestic decoration is typical of the country around Abha and is a speciality of the women of those parts, some of whom must be real artists. This room had been beautified by a slave-girl imported from Abha...

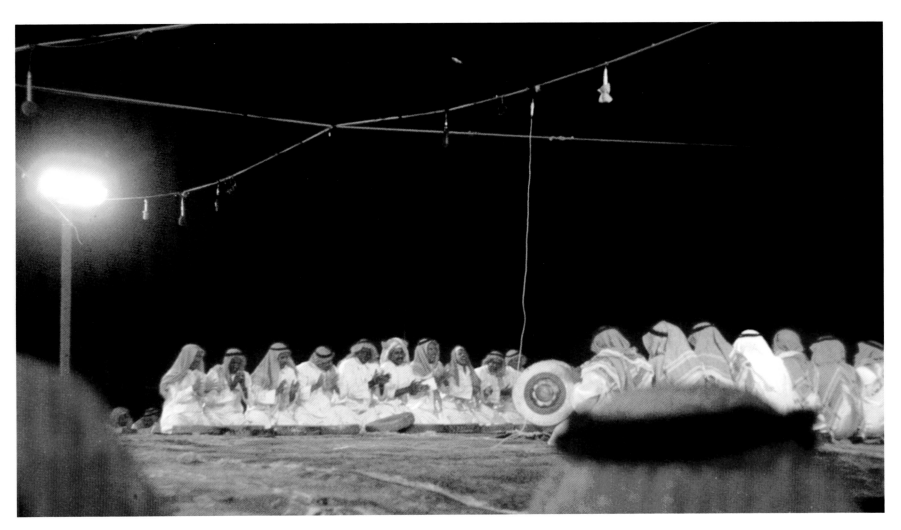

Above: men playing drums at a folklore festival in Riyadh in 1979.

Below: Nargilas *(hookahs) being repaired in a shop in Ta'if.*

Like the Bedouin tent, the interiors of houses are sparsely furnished; bedding is rolled up during the day and a few rugs and cushions are scattered over the floor. Among the wealthier families there might be a chest of carved wood, often with polished brass tacks, made in Medina or Makkah or imported from Kuwait. Such chests are only rarely owned by Bedouin.

General household objects include a variety of items made from wood, metal, clay and basketwork. Most non-woven objects used by the nomads are manufactured in the towns and villages and are generally similar to objects used by the villagers themselves. The Bedouin are obviously governed by what is practical to carry, and thus would not transport trivets or bases for their cooking pots for instance; rods or hollows in the earth are used instead. By the same token, they are unlikely to carry much pottery; this in the villages tends to consist of functional objects such as storage jars and jugs, often in forms and shapes unchanged for centuries. Metalwork also tends to be functional: cooking vessels of various types and sizes, usually large metal pots, brass coffee pots and items such as scales or measuring

cups. In the towns, however, most households might have a decorated tray, or other piece of elaborate metalwork of modern manufacture. Other accoutrements of the house, and to some extent of the tent, might be woodware (now rarely found and highly valued as it was made from imported wood or tamarisk), or basketry. Commonly produced in most oases of palm leaves or grasses, the most popular basket work objects are decorative and colourful mats, and baskets for winnowing, or for holding dates or grain.

Finally, mention must be made of musical instruments. Arab music today has preserved its traditional sounds, using traditional instruments. Drums three to five inches deep and about eighteen inches in diameter, are often painted with geometric patterns and have coloured strips of cloth attached to them. One of the most commonly played instruments is the *rubaba*, an open-bottomed skin-covered sound box with a single string reaching from the neck. It is played with a bow.

J.T.

Basketry

Basketry is worked in most of the oases in Arabia. The most common fibre is the date palm leaf, but grasses are also used in the larger oases and in the Tihama and the mountains of the southwest. The most popular products are circular mats which are used under eating trays, for seats, and for displaying merchandise. Though such items usually retain their natural fibre colour, in the east coloured fibres are woven in, while in central Arabia and the west, wool embroidery in simple patterns is used. Most baskets seen in the Gulf are of durable construction and used for winnowing, and containing grain, dates and other products. Some are reinforced at the bottom and upper edges with leather and have decorated leather ribbons hanging from the rim. Those of current manufacture usually replace leather with plastic. Hand fans with handles of reed or split palm stem, and rectangular fan mats, are also common products, and some heavy baskets made of date palm stem fibre can still be found.

It is in the Asir, especially in the Abha area, that the most decorative baskets can be found. There are two basic shapes: a pot with a lid, and an open conical shape supported on a short conical rim. Both consist of a fibre core wrapped with grass, and sewn in a spiral to form the basket. The pot-shaped baskets usually have bands dyed in blue or purple, while the open baskets have star and zig-zag patterns on the inside walls of the bowl and are usually very colourful. Grass or palm frond hats, often with extremely wide brims, are also woven in the Asir and Tihama, and usually worn by the women.

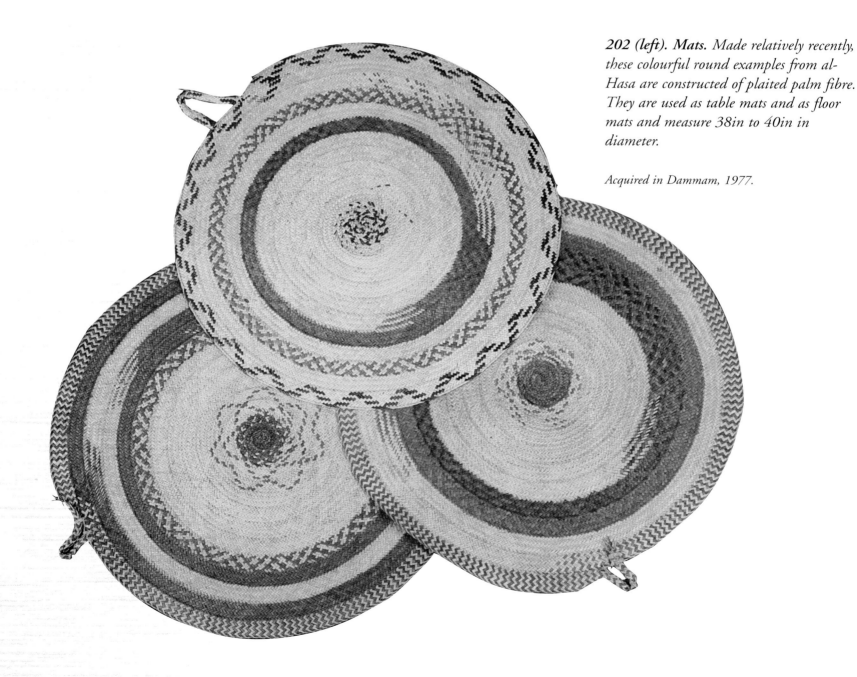

202 (left). Mats. Made relatively recently, these colourful round examples from al-Hasa are constructed of plaited palm fibre. They are used as table mats and as floor mats and measure 38in to 40in in diameter.

Acquired in Dammam, 1977.

203. Basket. *Shown here filled with wool from Ta'if, this basket is made of palm fibre with leather reinforcements. It was made recently and measures 20in in diameter.*

Acquired in Dammam, 1977.

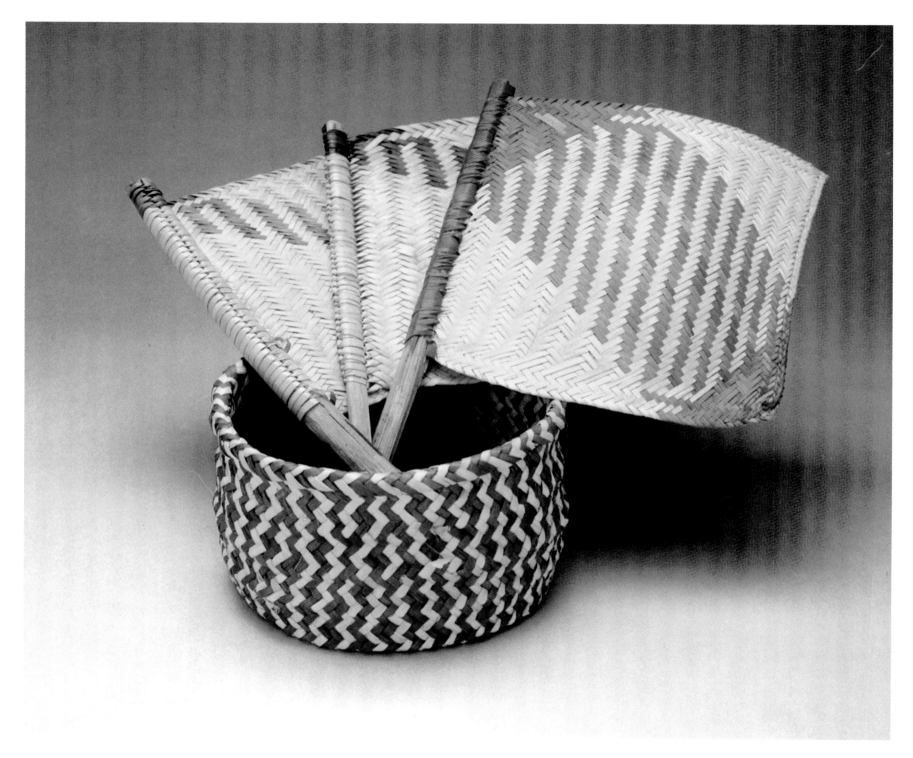

204 (above). Fans and basket. *These attractive examples of basketry are found in oases throughout Arabia.*

Acquired in Hofuf and Ta'if, 1977 and 1978.

205 (right). Dowry basket. *Used by a bride to transport her dowry to her husband's home, this object is constructed from two baskets; the smaller is placed at the bottom, the larger forms the cover. Sewn together and carried on the head, this item is probably peculiar to the Qatif area.*

Acquired in Qatif, in about 1975.

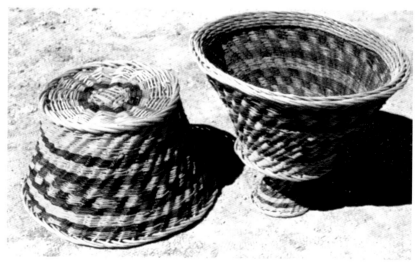

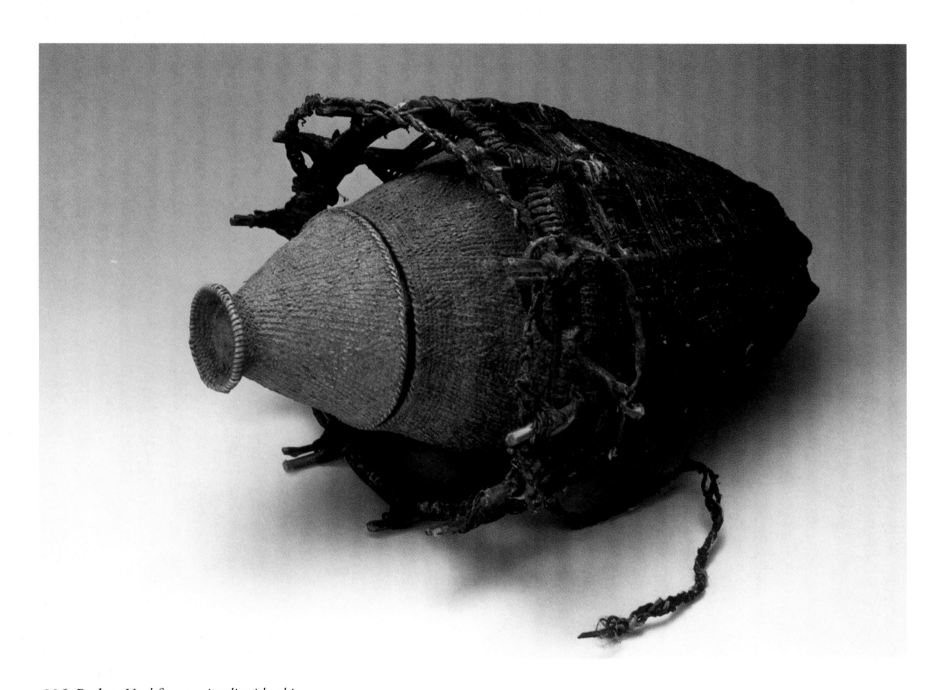

206. Basket. *Used for carrying liquids, this example is from Jizan. It is made of tightly coiled grass fibres with a leather outer basket woven onto wooden ribs. The interior is caulked with clay. It is 22in high and is similar to examples from the Sudan.*

Acquired in Jeddah, 1978.

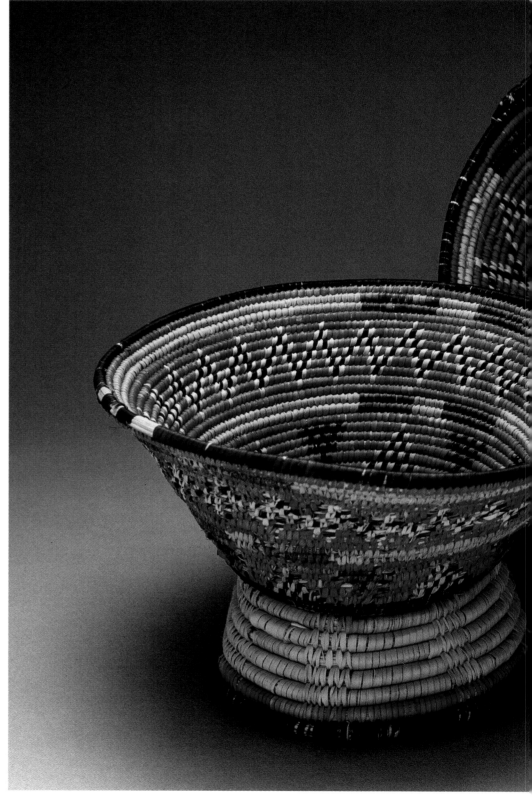

207 (above). Whisk broom. *Made of date palm stalk fibre, this broom comes from Qatif.*

Acquired in Qatif, 1975.

208 (right). Baskets. *From the Abha area in the Asir, these baskets are made of grass wrapped around a thin reed core. They are 11in and 13in in diameter.*

Acquired in Abha, 1978.

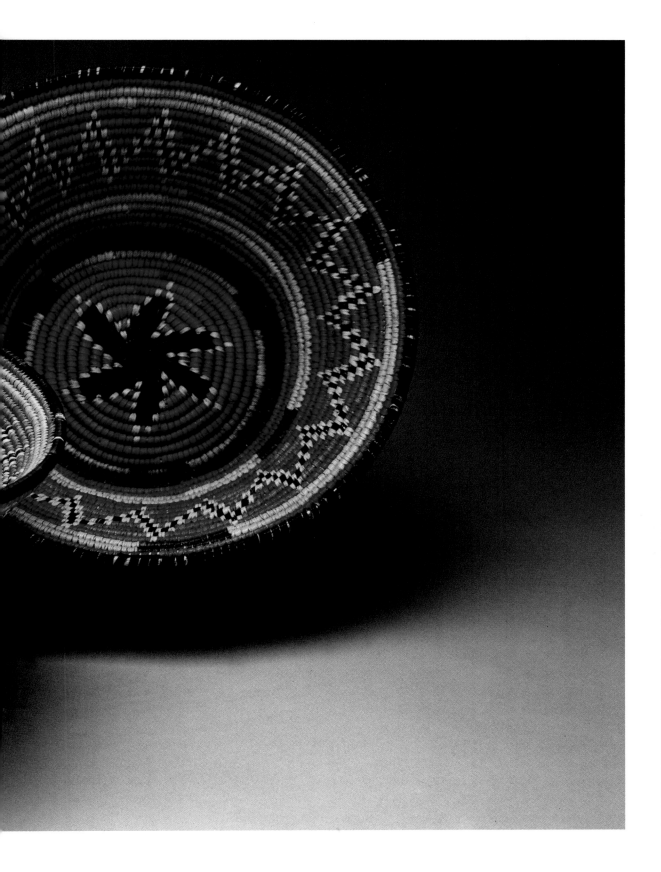

209. Container. *This carrier, made out of a gourd, has a basketwork cover and carrying handle.*

Woodware

In the past, and still to a certain extent today, large wooden vessels were traded from the coastal towns where wood came in from Yemen, Africa or India. Many smaller wooden objects were made in the oases from tamarisk and acacia and other trees, while elaborate ones came from the Asir and Yemen.

Almost no shape, including funnels for pouring, needed in the preparation of food (except for the actual cooking) is too complex for the woodworker. The wooden bowls are highly valued, as can be seen from the careful repair of the cracks in many. Some bowls are fined down to a thin cross section and decorated with pegs in soft metal in simple rows. These are now among the scarcest of Arab artifacts. More ordinary thick walled bowls and dishes are often decorated with pegs and brass tacks, and wooden mortars with wooden or stone pestles for grinding grain are still sometimes used.

The advent of aluminium and plastic has condemned much woodware to the cooking fire.

214 (above). Wooden vessel. This shallow wooden bowl with a lip was probably used for pouring milk.

210 (left). Wooden bowls. Covered with fibre and grass woven lids, these two bowls would be used for butter, stews and so on. Leather and cotton loops are attached to the lid tops, and both bowls can be hung in the tent from holes in projections at the sides. The larger bowl is 9½ in high.

Acquired in Ta'if and Riyadh, 1978.

211 (below left). Wooden bowl and spoon. A good example of the type used throughout Arabia, this bowl is made from imported wood. The cracks have been carefully repaired with rawhide lacing. It is 15in in diameter.

Acquired in Riyadh, 1979.

213 (below centre). Funnel. From the Eastern Province and made in about 1960, this wooden funnel is an example of the type used throughout Arabia for filling water and milk skins.

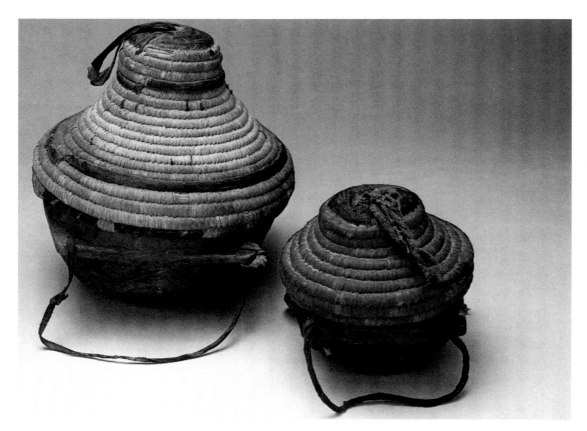

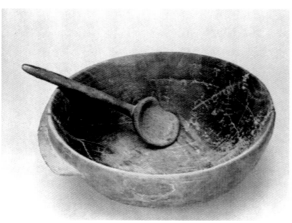

Pottery

The pottery shown here is from al-Hasa, Qatif and the Asir. Pots are made and used throughout Arabia; modern pots differ little from ancient pots. All are thrown on the wheel and none are much decorated.

There are potteries near Hofuf located in caves where the craft has been passed down within the same families for centuries. The pots made there dry in the sun for two weeks, and accumulate until there are enough to fill the kiln. Kiln firing usually takes place in the winter with palm frond being the main fuel. When dug into the ground, the heavy fired jars preserve food against the heat. Unglazed porous jars are used to cool water; the water seeps to the outisde where it evaporates and cools the contents.Also made of clay are incense burners; some are quite plain but others, found in the Asir, are painted in simple patterns.

215 (above) and 216 (below). Pottery. These examples of a wheel-thrown glazed bowl and a jar are typical of the pottery used throughout Arabia.

Acquired in Qatif and Tayma.

217 (left). Pottery. This unglazed modern storage jar was wheel-thrown in Hofuf.

Acquired in Hofuf, in about 1975.

218 (right). Hookah. This modern nargila *consists of an unglazed wheel-thrown bottle, a smoking bowl and a reed. Such hookahs used by women are called* gadow *in the Eastern Province.*

212 (left). Shallow bowls. One of these bowls is decorated with metal tacks; the other example has had wax spotted on it and the surrounding area scorched.

Metalware

Cooking vessels are usually made of tinned copper manufactured in a number of places in Arabia, notably al-Hasa. Some large vessels have probably been imported from cities such as Baghdad and Damascus. The most spectacular are those in which a whole sheep or a large section of a camel may be cooked. These in turn – and sometimes two or three sheep together – are laid upon massive eating trays. Such huge trays are for the sheikh or the rich who have cause to entertain large numbers. Arabs also use trays or large bowls for main courses; all eat from these with the fingers of their right hands, seldom employing knives or other implements. These trays sometimes had hourglass-shaped sheet metal pedestals, as described by Musil.

219. Metal vessels. Cooking pots of tinned copper, like those shown here, are commonly found all over Arabia. The piece on the left is decorated with embossed designs, while that on the right is plain and made of beaten pieces of copper soldered together. They are 9in and 8in respectively in diameter.

Acquired in Dammam and Riyadh, 1977 and 1979.

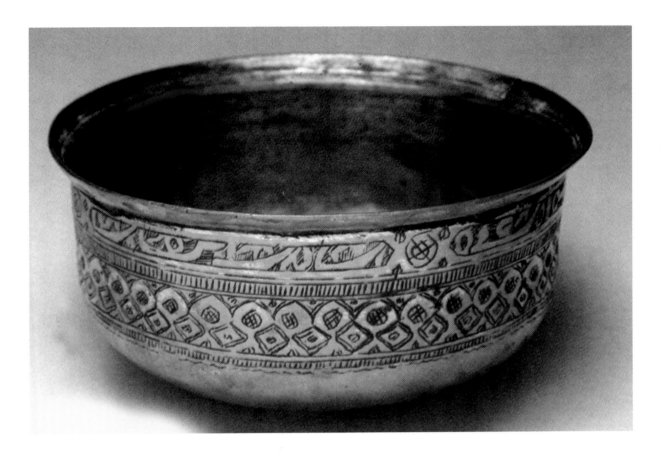

220. Copper bowl. *Made before 1940, and probably in Makkah, since this type of work was formerly done there, this decorated bowl is particularly striking. Its upper band features incised Arabic script while the lower bears a repeating design around it. It measures 3 ³/₄ in by 7in.*

Acquired in Ta'if, 1979.

221. Tray. *From Hofuf, this tinned copper tray has wrought iron handles. It is 20in in diameter. The very large trays, used for a whole sheep for instance, are made in the same way as this example.*

Acquired in Hofuf, 1978.

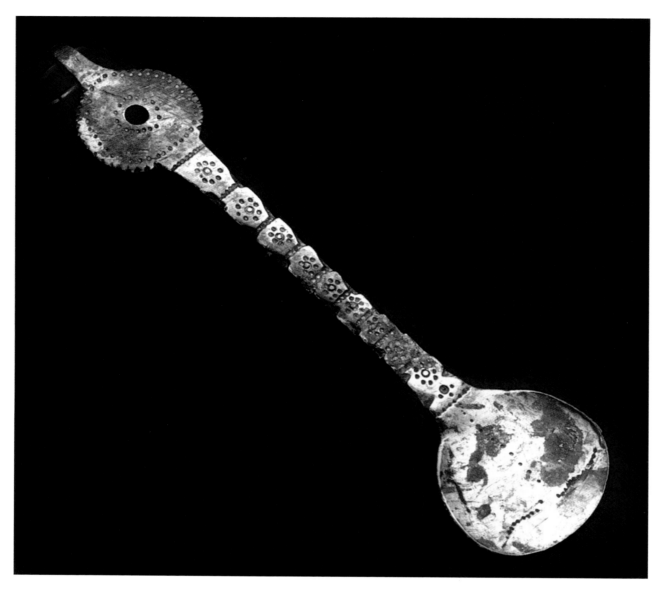

222. Spoon. *This decorated brass spoon with a long handle is said to have been used for stirring buttermilk. It is 7in long.*

Acquired in Riyadh, 1979.

223 (below). Tray. *From Makkah, this copper tray is decorated with concentric patterns typical of Arabian crafts. It is 31in in diameter.*

224 (above). Hookah mouthpiece. *Made in the Hijaz before 1940, this mouthpiece for a hookah is silver with embossed designs. It measures 2 ¹/₂ in long.*

Acquired in Jeddah, 1978.

Scales and Measuring Cups

Locally-made scales are composed of simple balances made of a wooden stick with baskets at each end, one for produce and the other for the weight. Balances are also made with a hook at one end and a rock or metal weight at the other, with several slotted positions on the shaft. These are common to most households.

Until recently, cups and larger vessels for measuring grain were made in a variety of regulated sizes. The smaller are usually single pieces of wood, often worn to a fine patina from many years of use, and the larger are usually constructed from banded straight staves. These devices have now been mostly ousted by factory-made and aluminium vessels.

225 (left). Scales. These are examples of typical scales (mizan) *once used throughout Arabia; the wood is decorated with simple designs.*

Acquired in Riyadh, 1979.

227. Scale (below). This simple scale is constructed from a piece of wood with metal support rings and a hook; it is missing its weight. It is 12in long.

Acquired in Ta'if, 1978.

226. Measuring cup (right). From the Najd, this simple wooden container (mikyal) *is used for measuring grain and such like. It was made before 1940.*

Acquired in Riyadh, 1979.

Chests

A town-dwelling family's precious possesions are often kept in large locked wooden chests made in Kuwait, Makkah, or Medina. These chests are usually impressively decorated. Those made in Makkah are characterised by carved reliefs, a brass lock and decorated brass reinforcements at the corners. Those referred to as from Kuwait are typical of chests found throughout Arabia. Their decoration includes brass tacks arranged in patterns and brass plates applied symmetrically. Sometimes chased or indented designs appear on the brasswork.

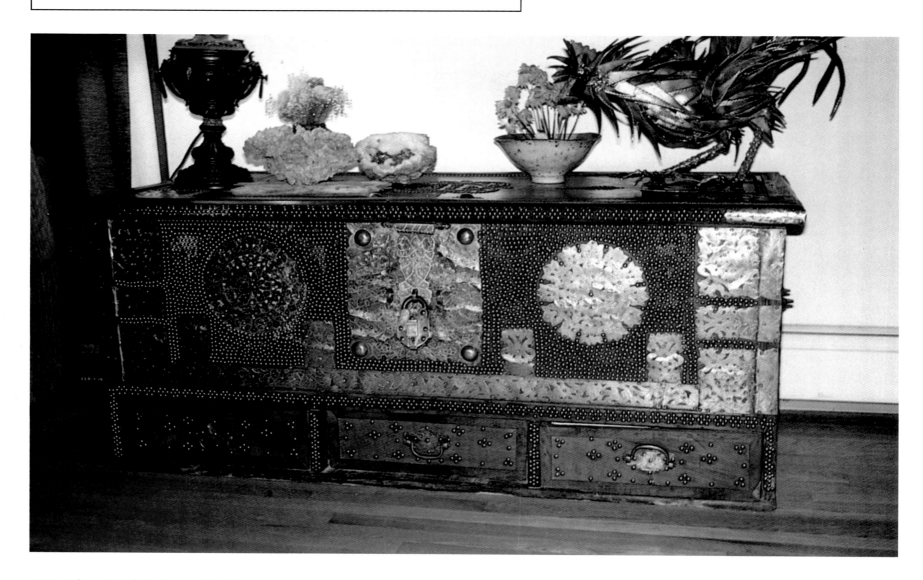

228. Chest. *Made before 1940, this is a typical example of the Kuwaiti chests that are found in most cities and towns in Arabia. Brass plates with chased or incised patterns are attached to the wood. (It was photographed in W.E. Tewell's house in Vermont.)*

Acquired in al-Khobar, in about 1970 by Tewell.

228. Chest. *This large chest, made in Makkah before 1950, is carved in relief. It has brass reinforcements at the corners. Two modern but traditionally-shaped incense burners stand on the chest (Photographed by W.E. Tewell's house in Vermont.)*

Acquired in al-Khobar, in about 1970 by Tewell.

Doors, Windows and Locks

Throughout Arabia, doors and window shutters, and their locks, are usually decorated. The doors and window shutters are normally made of thin, narrow strips of wood nailed to a semicircular wooden fastening structure. The flat face (and sometimes both faces) of the planks are incised with geometric patterns, and painted in green, yellow, red and blue. An alternative method of decoration is to scorch designs into the surfaces with a hot iron.

The older wooden door locks had sets of vertical pegs which, when slotted into holes in varying combinations, locked the door. The pegs were lifted with a key, to which were fastened pegs in the same combination. These locks were also incised in patterns and coloured, or scorched with a hot iron.

231. Window (right). From the Gulf, this wooden window is elaborately carved and painted on both sides. It was made before 1940 and is 31in high by 18in wide.

Acquired in al-Khobar, in about 1970.

230. Storeroom door and frame with latch. Doors and windows of this type are used thoughout Arabia. Geometric patterns are incised into the wood and then brightly painted. This example from Unayzah in Gasim is said to be mid 19th-century; it is 31in high.

Gift of Abdullah al-Zamil to John Topham, Riyadh, 1979.

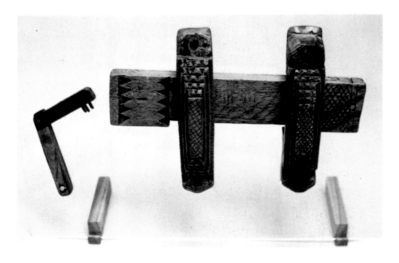

232. Wooden latch with key. *This lock was made before 1940 in the Gulf; it was originally painted and it has incised designs. It is displayed here on a clear plastic and wooden stand, with its wooden pegged key which matches the pegs in the lock. It is 10in high.*

Acquired in al-Khubar, 1975 by B. Hawke.

233 (right). Latch. *This elaborately decorated wooden latch is both carved and painted. 6in high, it is from the window shown in illustration 231 (previous page).*

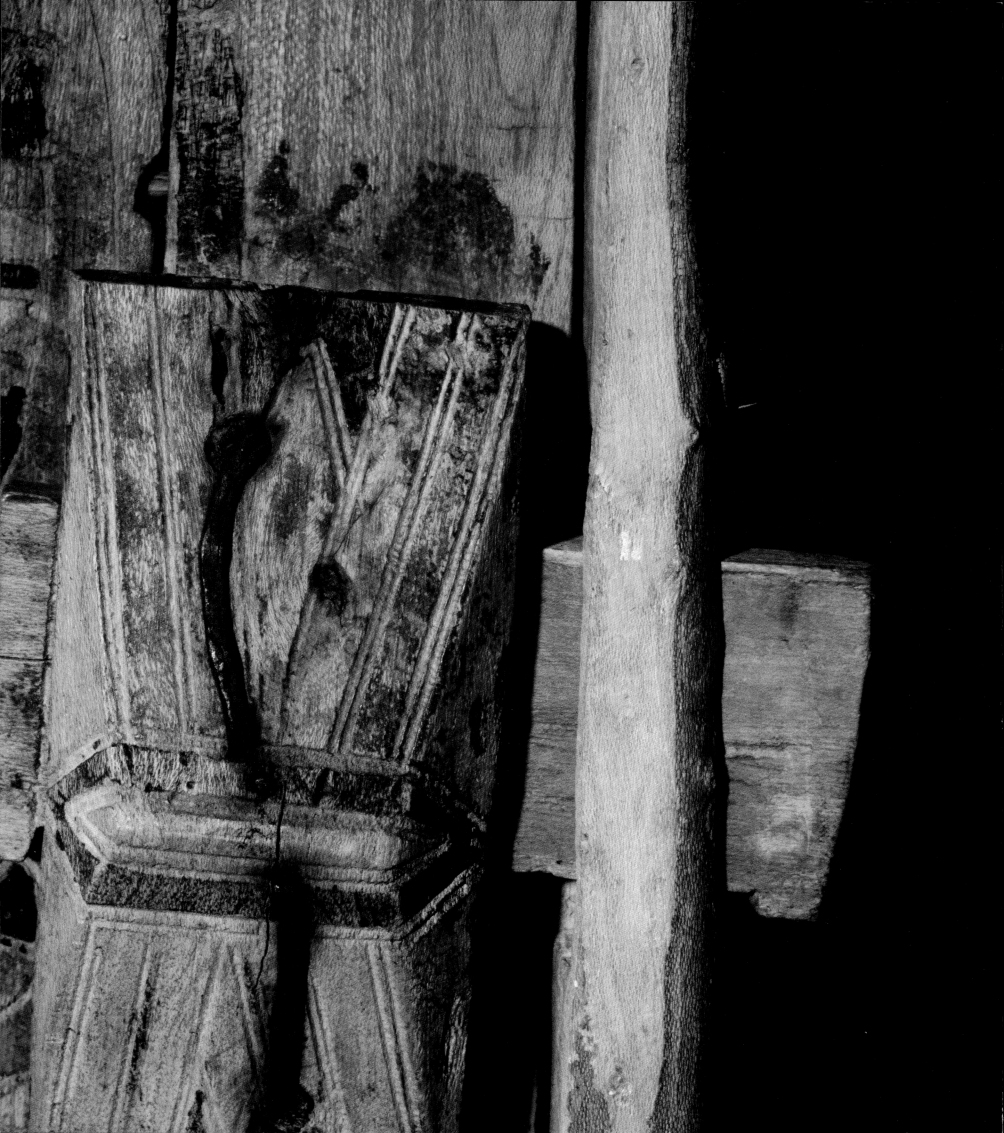

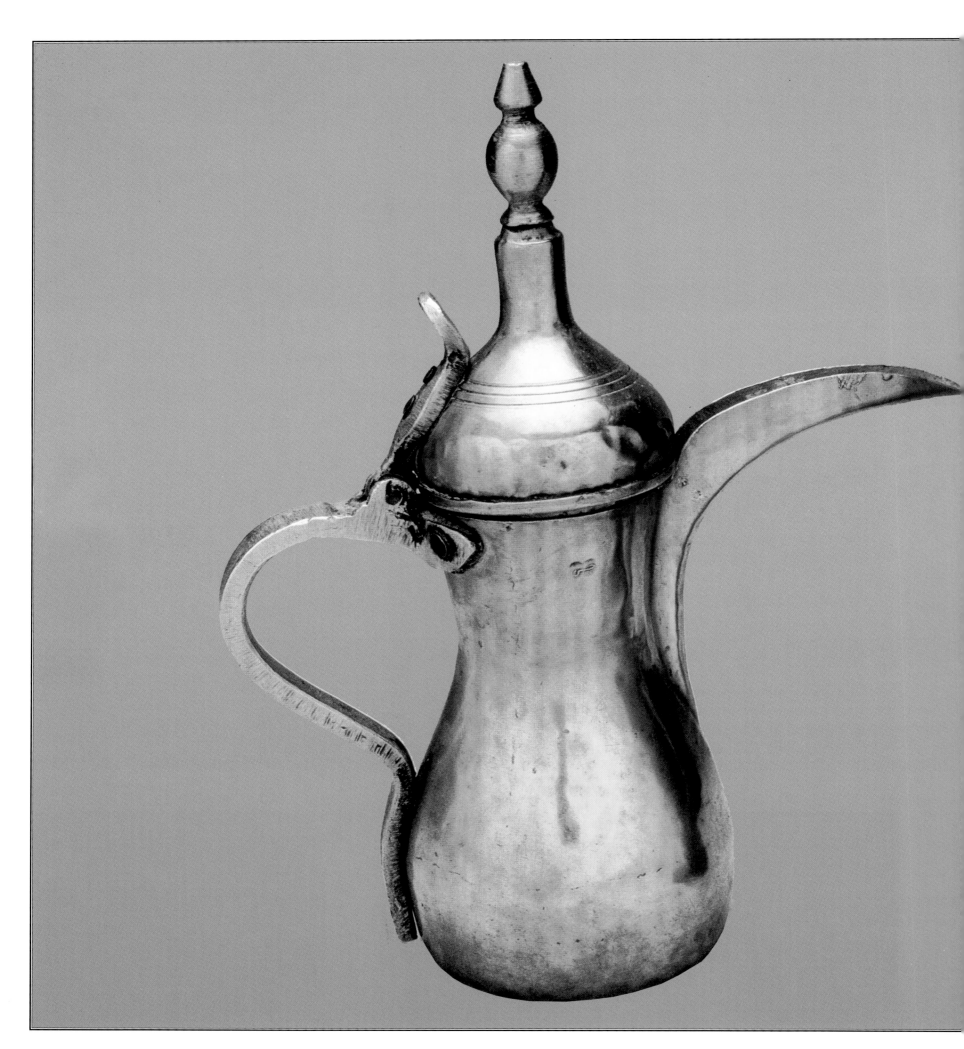

COFFEE AND INCENSE

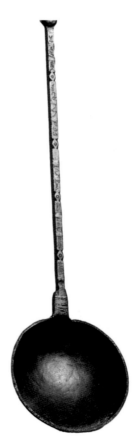

Afavourite pastime of the Bedouin, and indeed of most Arabs, is the preparation and drinking of coffee, whether a host or a guest. Methods of preparation, and the implements used, are traditional; each step is an almost ritually observed process. Coffee may be made any number of times in a day, and however poor the host, it is always produced when a guest arrives. Kept in small decorative bags (*kis*) the precious beans and cardamom or other spices are entrusted to the women. When it is time for the coffee to be made, the host obtains the necessary quantity of beans from his wife and roasts them carefully in a long-handled pan *(mihmas)*, some examples of which, along with the accompanying stirrers, are elaborately decorated. The roasted beans are transferred to a shallow wooden tray *(mubarrad)* which has a small opening at one end. The tray is used for cooling the hot beans, and the opening for obtaining the correct amount of coffee beans to be emptied into the mortar *(yad al-hamam)*, and this inviting sound announces to his fellow Bedouin that they are welcome to join in.

Meanwhile, a pot (*dallah*, the correct name for a coffee pot) of water comes to boil on the fire. This, in the desert, is commonly fuelled with camel dung or twigs if available. In the villages it is a charcoal brazier. The boiling water is poured into a second *dallah* containing the ground coffee, and as it comes to the boil again, the coffee maker grinds the cardamom seed. This second pot is set aside for the coffee to settle and the ground cardamom added, after which the pot is briefly brought to the boil again. Date palm or other fibres are usually placed in the spout to filter grounds which have not settled. A third brightly polished decorated *dallah* is used for serving the coffee into small cups without handles which the Bedouin traditionally keep in a special cup box (*gutia*). It is the custom to drink three of these small cups of coffee, each of which contains four sips, and then to decline more. Sometimes a pot

234 (preceding pages). *Coffee pot. Made in the Najd before 1950, this small coffee pot is of brass, with tinned interior and open spout. It stands 10in high.*

Acquired in Riyadh, 1979.

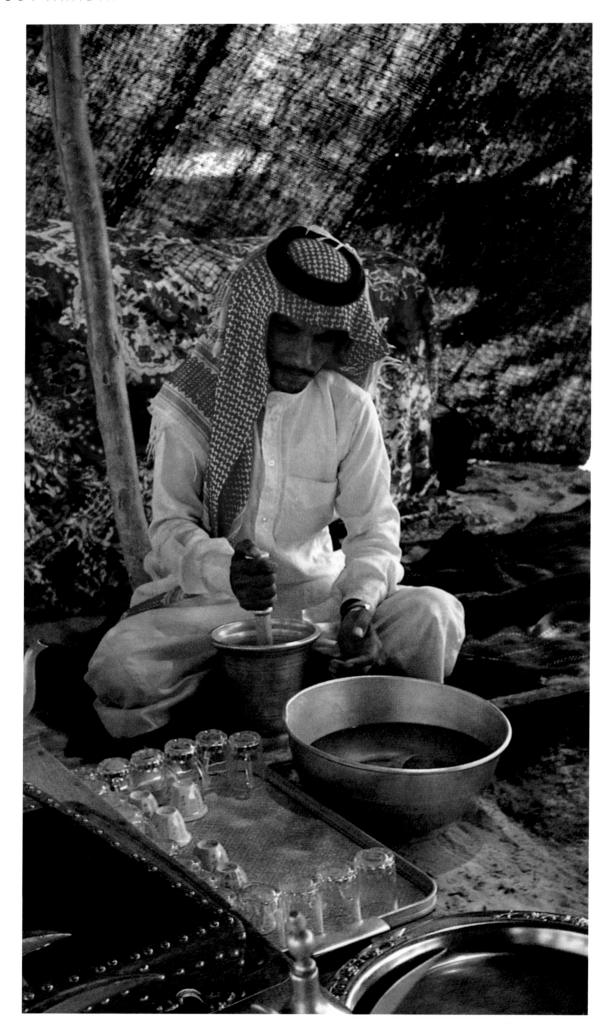

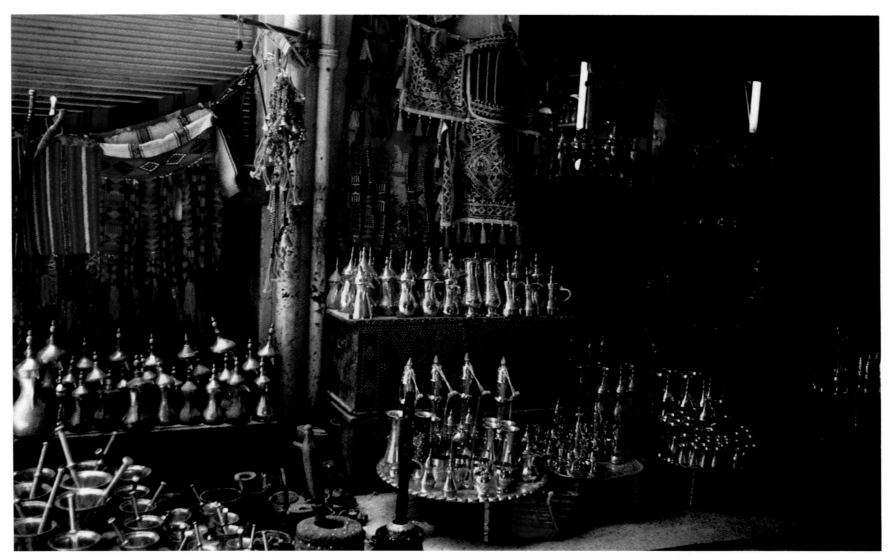

Suliman's shop in Riyadh showing his stock of coffee pots.

containing grounds from a previous coffee making may have water added to it and be used at the beginning of the process.

Doughty, during his stay among the Fukara Bedouin in the late 19th century, described the importance attached to the ritual of coffee drinking:

The *fenjeyn kahwa* is but four sips: to fill it up to a guest, as in a northern towns, were among Beduins an injury, and of such bitter meaning, 'This drink thou and depart.' Then is often seen a contention in courtesy amongst them, especially in any greater assemblies, who shall drink first. Some man that receive the *fenjeyn* in his turn, will not drink yet, – he proffers it to one sitting in order under him, as to the more honourable: but the other putting off with his hand will answer *ebbeden*, 'nay, it shall never be, by Ullah! but do thou drink!' Thus licensed, the humble man is dispatched in three sips, and hands up his empty *fenjeyn*.

But if he have much insisted, by this he opens his willingness to be reconciled with one not his friend. That neighbour, seeing the company of coffee-drinkers watching him, may with an honest grace receive the cup, and let it seem not willingly; but a hard man will sometimes rebut the other's gentle proffer.

Like coffee, incense has long been enjoyed throughout the Middle East and the Arabian peninsula, and it is still part of the way of life across the peninsula. Those who can afford it will pay over a thousand riyals a pound for some of the fine bark that comes from India. It is used traditionally both as a charm to ward off evil spirits, and as a perfume for the house and clothing. It is most commonly used after a meal, especially when there are guests. A member of the family or a servant will carry the incense burner to each visitor, who, leaning over it, will enclose it with his *ghutra* and fan the scent into his beard and clothing.

J.T.

Dallah-making in Hofuf, photographed by 'Ilo the Pirate' in 1950.

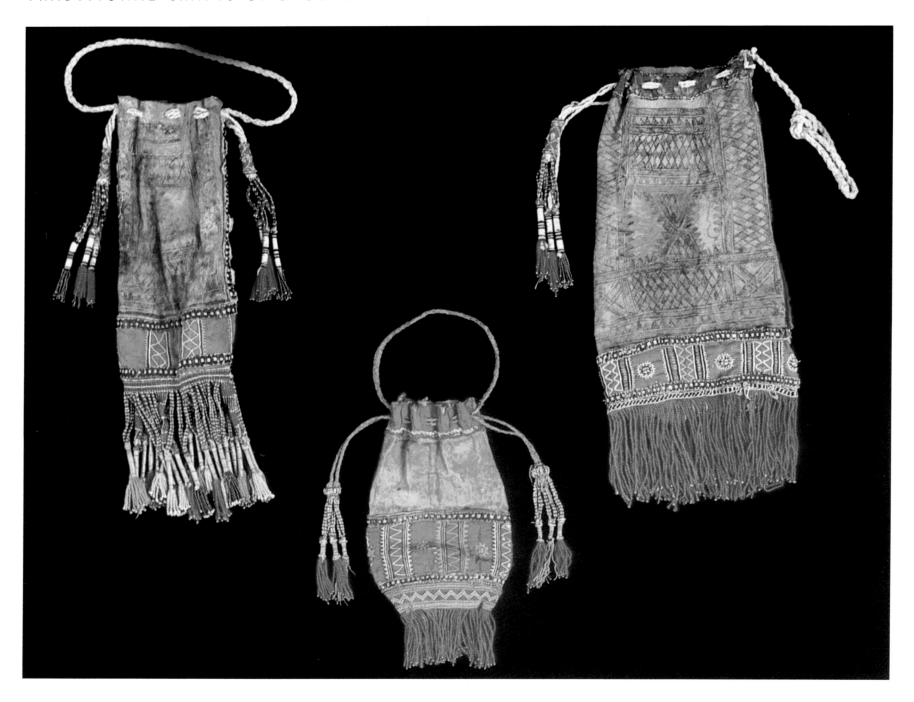

235. Leather coffee bean bags. These coffee bean bags from the Hijaz and western Arabia were made in about 1960. They are constructed of leather, appliquéd with cloth and elaborately embroidered with woven fringes at the bottom. Their lengths are from left to right: 7¼in, 13¾in and 12 in.

Acquired in Jeddah, 1978.

Coffee Bean Bags

The traditional coffee bean bags are made of cloth and leather with leather drawstrings. They usually have an apron of embroidered material which is sewn onto a band with woven or plaited tassels. A few bags are made of loosely woven leather strips. Others are entirely leather with embroidered or appliqué decoration. The bags illustrated here display some of the finest workmanship to be found in Saudi Arabia; most were made in the Hijaz and the Najd.

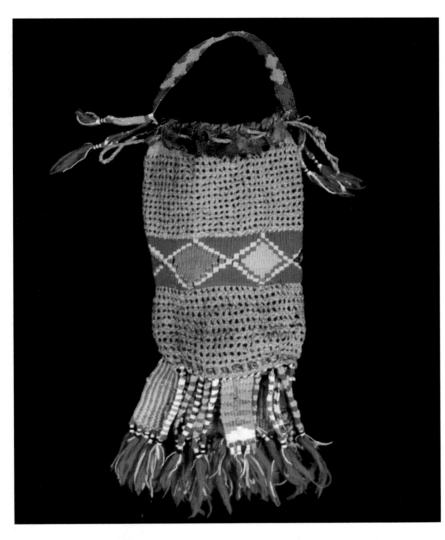

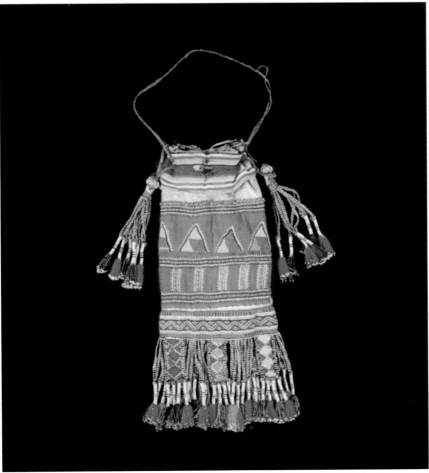

236 (left). Braided coffee bean bag. *An openwork leather bag made before 1960 probably from the Harb tribe, this piece is constructed from two separate sections joined to a central band of tubular weft-faced slit tapestry. There are woven tapestry fringes at the botton and on the handle. The top of the bag is a solid leather piece, from which are cut the strips that the body is braided from. It has a leather drawstring and is 16in long, including the attached wool tassles.*

Acquired in Ta'if, 1978.

238 (below). Pair of small bags. *These leather bags from the Hijaz, made in about 1970, are painted and decorated with geometric designs. They have leather appliqué at the edges and leather fringes and are joined by a braided cord. Probably used for carrying tea and sugar, they measure 9$\frac{1}{2}$ and 10$\frac{1}{2}$ in long.*

Acquired in Ta'if, 1978.

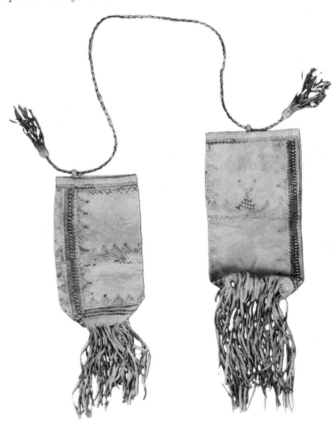

237 (left). Coffee bean bag. *This exceptionally fine bag, made in the Najd in about 1950, is constructed of leather and covered with appliquéd cloth. It is decorated with embroidery and metal and glass beads. At the bottom is a soumak woven band with fringes. It is 11$\frac{1}{2}$ in high. The solid coloured triangles are tiny embroidery knots so compact that they look like cloth.*

Acquired in Dammam, 1978.

Roasting Pans and Bellows

Every Bedouin and village household has a long-handled iron pan for roasting the green coffee beans and a long iron stirrer consisting of a round rod and a flat disk at one end. The pans range from small curved-bottom examples with simple flat bar handles and matching stirrers, to magnificent pans with handles six feet long, decorated with brass and copper inlay. Occasionally the latter are mounted on a pair of iron wheels fastened to the handle of the pan.

Although many old roasting pans in Saudi Arabia are undoubtedly imports, many were made locally. They were manufactured by blacksmiths, and those with motifs common to jewellery and architecture were probably made in Hofuf, Unayzah, Makkah or Medina.

Bellows of wood and leather with air outlets of metal are used. One side is usually decorated with strips of shining metal, brass tacks and fragments of broken mirrors.

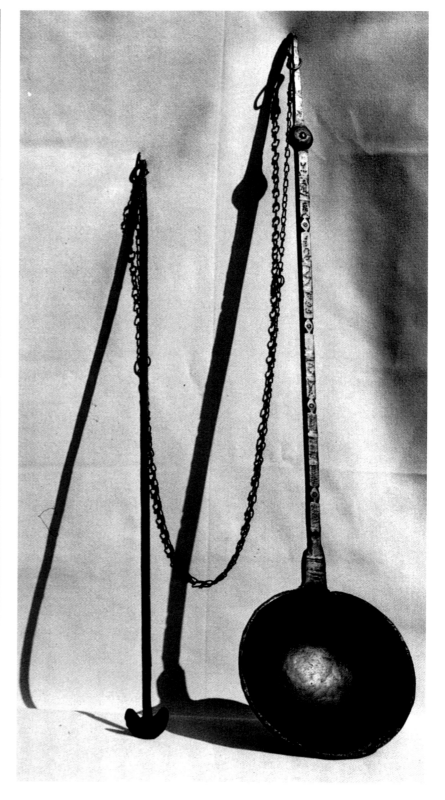

239 and 240 (right). Roasting pan and stirrer. Made in the Najd before 1940, this is a fine old decorated iron roasting pan (mihmas) *with its stirrer. The patterns worked into the shaft with brass and copper inlay are particularly noteworthy. The pan is 45in long and the stirrer 36in. Illustration 239 shows a detail of the decorative work.*

Acquired in al-Khobar, 1965.

241 (opposite). Bellows and roasting pan. These bellows (minfakh) *from the Najd are used throughout the Arabian penninsula. Made before 1950 of leather with wooden sides, they are decorated with tin mounted trading mirrors. Also shown here is a plain coffee bean roasting pan with its stirrer.*

Acquired in Riyadh and Ta'if, 1978.

Coffee Boxes

Another item of the coffee making 'ceremony' is the wooden box or tray (*mubarrad*) with an open end. The hot roasted beans are placed in it to cool before being poured into the mortar for grinding. Usually made of a single piece of wood, these boxes are often decorated either with single cut patterns or with brass headed tacks; sometimes rings are fastened to the box. Occasionally the *mubarrad* has additional decorations of mirrors or beads. Old examples sometimes have hinged lids with a projection or gate at one end so that the beans can be closed in the box or their flow controlled when pouring.

242. Coffee box. A mubarrad *from southwestern Arabia, this fine example has an unusual hinged lid and two compartments – the second for cardamom seed or other flavouring for coffee. The body is made from a single piece of wood and is decorated with brass tacks and rings. It was made before 1920 and is 10in long.*

Acquired in the southeastern area, 1978.

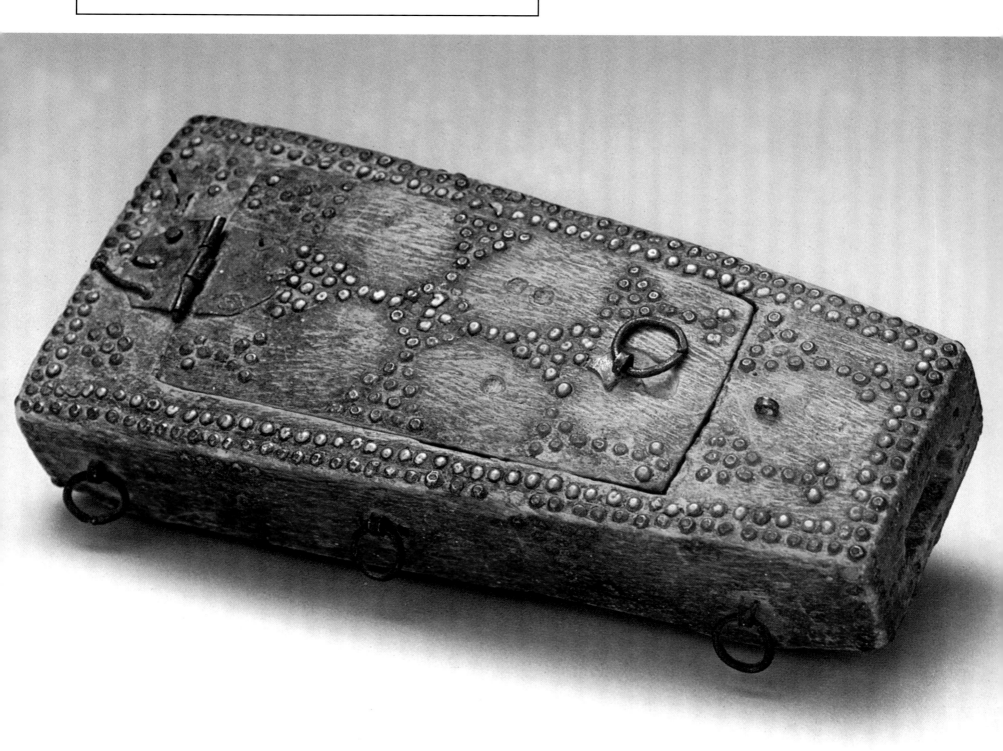

245. Coffee or spice box. *Regarded in Arabia as a rare item, this conical wooden box was probably made in the Hijaz before 1920 and used as a coffee bean or spice container. Decorated with steel studs and brass rings, it has chased metal strips which act as a hinge on one side and a fastener on the other. It is 10in high.*

Acquired in Jeddah, 1978 (from a man who came from Yanbu al-Nakhl).

243 (above). Coffee box. *Probably made in the Najd before 1950, this typical coffee tray (mubarrad) is wooden with brass tacks and ring decorations. It is 8½in long.*

Acquired in Riyadh, 1979.

244 (below). Wooden mortars and coffee boxes. *From the Najd, these are typical examples of wooden mortars and mubarrads made before 1950. They are simply decorated with brass tacks or incised designs. The mortars are 5in and 6in wide (at the base), the mubarrads 7½ in and 6½ in long.*

Acquired in Riyadh, 1979.

Mortars and Pestles

The mortar and pestle are other essential items in coffee making. The earliest, made of stone were primarily used in villages because of their weight. Wooden mortars with stone pestles were also much used; wooden mortars are still found but the stone pestles are seldom seen. Since the last century the most commonly used mortars and pestles have been made of cast brass. In the past most were imported from Syria and Baghdad, but many now come from Pakistan. A type with a series of vertical projections around the lower half of the mortar, found in Ta'if and Jeddah, is claimed to have been made between Medina and Tabuk. These mortars occur in many sizes, between two and twelve inches in diameter. The smallest was probably used for grinding medicine and kohl. Large wooden mortars, broad in diameter and eighteen inches high, with relatively shallow grinding basins, decorated with incised patterns and sometimes mother-of-pearl and brass inlays, are the product of Jordan and Syria. Their wooden pestles are two feet long.

The coffee grinder takes pride in his ability to work out rhythms when pounding the coffee, and the noise of the pounding alternates with the bell-like sounds when the side of a brass mortar are struck. These are the sounds of a hospitable and generous host.

246 (left). Finned pestles and mortars. These mortars (yad al-haswan) *with small projections or fins, were said in Jeddah to have been made somewhere between Medina and Tabuk, but they are probably from Syria. The fins are both decorative and functional: they prevent the mortar from turning during pounding. The smaller example appears to be unique and may have been used either by men on their own or for grinding cardamom or other spices, or possibly kohl. They were made before 1930.*

Acquired in Jeddah, 1978.

247 (below). Pestle and mortar. This brass pestle and mortar (yad al-hamam) *is an old example of the typical shape used throughout Arabia. It was made before 1950.*

Acquired in Jeddah, 1977.

Coffee Pots

The most commonly shaped coffee pot used in Saudi Arabia is the hourglass, in which the curve of the upper part of the pot continues into the domed lid. The lids are hollow and invariably have a welcoming rattle. This type of pot is usually brass, with a brass handle and finial, and a long spout, usually open. Older pots commonly have the maker's name stamped in a circular device on the upper part of the body by which dealers can identify its provenance.

Another typical form retains the hourglass shape body, but has an almost flat lid rising to the finial. These pots often have a ring of simple stamped designs around the upper body and are usually identified as of Makkan or Medinan manufacture.

The major manufacturing area for coffee pots was al-Hasa. Pots were made here to suit the tastes of other parts of Arabia but the typical al-Hasa pot had a large, deep and sharply pointed beak-shaped spout, with small hinged flaps at the very end, curved in a small circle to hold a dangling metal decoration. Such pots were decorated with a multitude of designs – sometimes quite elaborate – made by hammering a series of fine dots into metal. The handles were also decorated, and tall elaborate finials often projected above the lids. Occasionally the bodies of the pots were brass, but more often copper and tinned on the interior; handles and lids were normally brass.

249 (above). Coffee pot. Made in Hofuf in before 1940, this small brass coffee pot is heavily decorated with incised patterns.

Acquired in Hofuf.

248. Coffee pot. Made in Hofuf, this classic coffee pot (dallah) has the profile and decoration of the typical al-Hasa pot: a copper body, tinned on the interior, a brass handle and a tall finial on the lid. It was made before 1960.

Acquired in Hofuf, in about 1965.

250 (right). Decorated coffee pot. *This fine dallah from Hofuf is decorated with applied cut brass and copper and has incised geometric patterns. The body is tinned copper and it has a brass handle, lid and finial.*

Acquired in al-Khobar, 1977.

251. Coffee pot. *This old coffee pot is from Unayzah and was made before 1900. It is copper with a brass handle, lid and spout cover. The latter is decorated with incised floral designs. The body has two raised double rings at the waist with an incised zig-zag pattern between them. It is 10½ in high.*

Acquired in Riyadh, 1978.

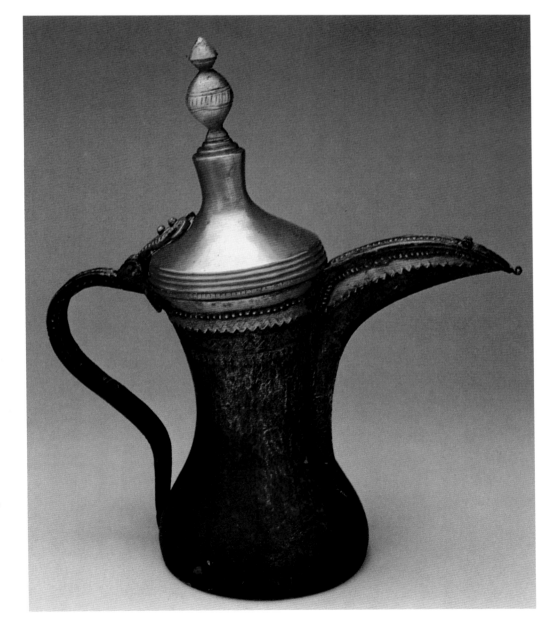

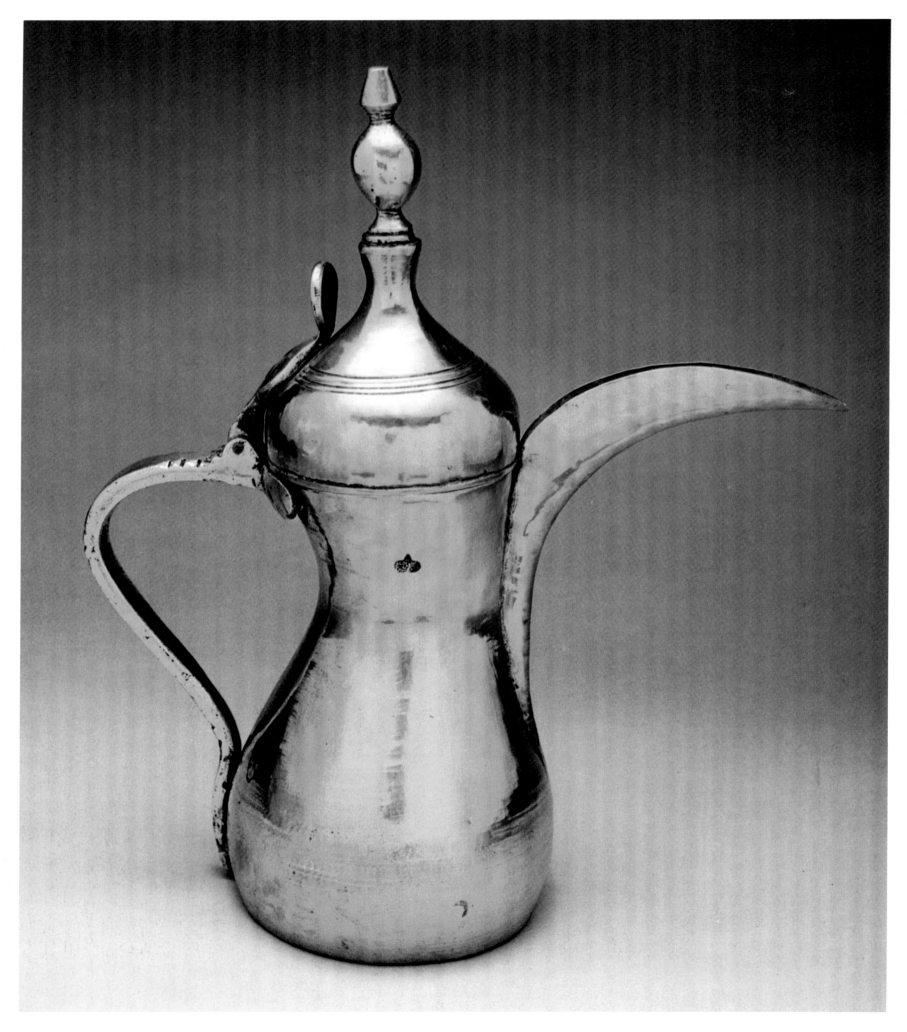

252 (left). Coffee pot. *Probably from Hofuf, this coffee pot is made in the typical shape of pots in use in Saudi Arabia today. Its place of manufacture has been identified from the maker's mark on it, though it is not the traditional Hofuf shape. It stands 18in high and was made before 1950.*

Acquired in Ta'if, 1978.

253 (right). Cup and spice containers. *Clay coffee or tea cups were traditionally kept in containers such as this tall copper example from Hofuf. In the smaller containers might be kept spices used for flavouring the coffee.*

Acquired in Riyadh and Dammam, 1978.

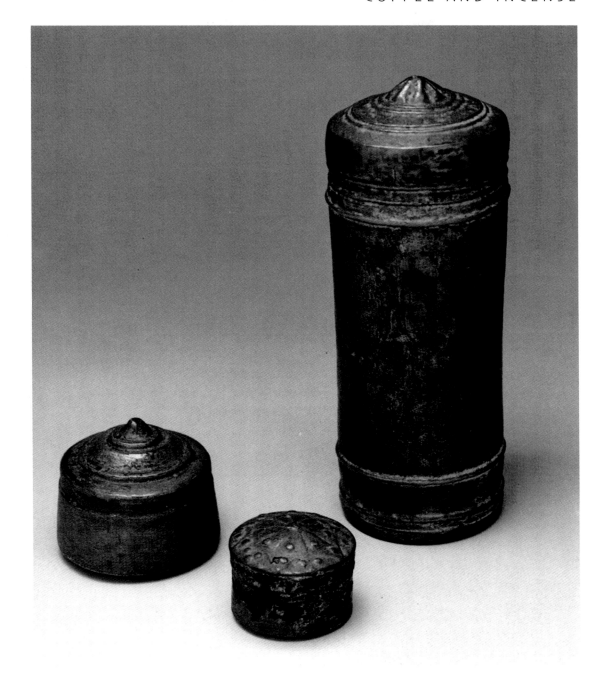

254. Coffee pot (right). *Made of tinned copper in about 1940, this* dallah *comes from the Najd. It has a brass lid, finial and handle and stands 5½in high.*

Acquired in Dammam, 1977.

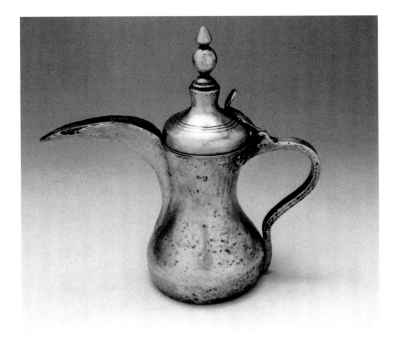

Incense Burners

Incense is commonly used in all households in Arabia and is normally burned on top of charcoal or wood embers. Clay or ceramic burners have long been used and are still made in Hofuf and Qatif. Others, for example those found in al-Jawf, are cut from soft stone. In the Abha area, some burners are shaped like egg cups and painted with red and blue designs.

Most incense burners have a square pedestal base with inward sloping sides. The wooden base is often carved out to form legs. The vessel itself is lined with sheet metal. Older burners were decorated with patterned combinations of soft metal pegs and brass tacks, often with mirrors in the panels of the upper part. The legs were ordinarily covered with sheet metal. Sometimes the soft metal pegs were driven deeply into the walls of the vessel so that they could be burnished to give a metal-plated appearance. These older burners are now hard to find and are rarely in good condition.

Modern incense burners keep the traditional shape but are made of shiny plated sheet metal. They are decorated with mirrors, plastic and coloured metals, mostly tin, and are made in many sizes, including showpieces up to three feet high.

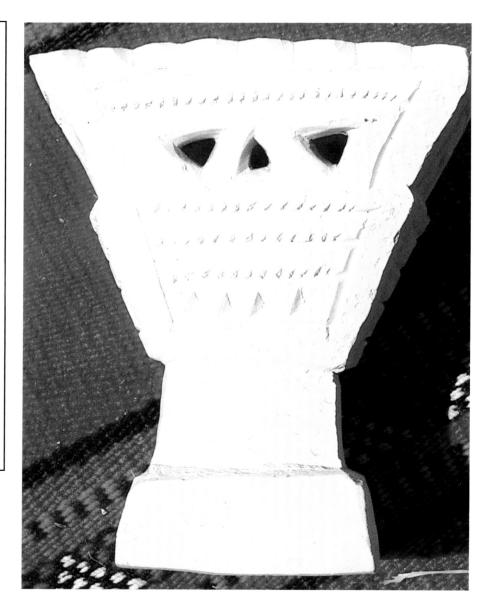

255 (above). Incense burner. *This traditional example comes from Qatif. It is made of clay and decorated in basic central Arabian style. It is 7in high.*

256 (left). Incense burner. *This tinned copper incense burner (mabkhara) was made in Makkah. Its shape is traditionally Islamic as are its attractive incised designs.*

Acquired in Jeddah, 1979.

258 (left). Incense burners. *From the Abha area in the Asir, these pottery incense burners are painted with simple designs.*

Acquired in Abha, 1978.

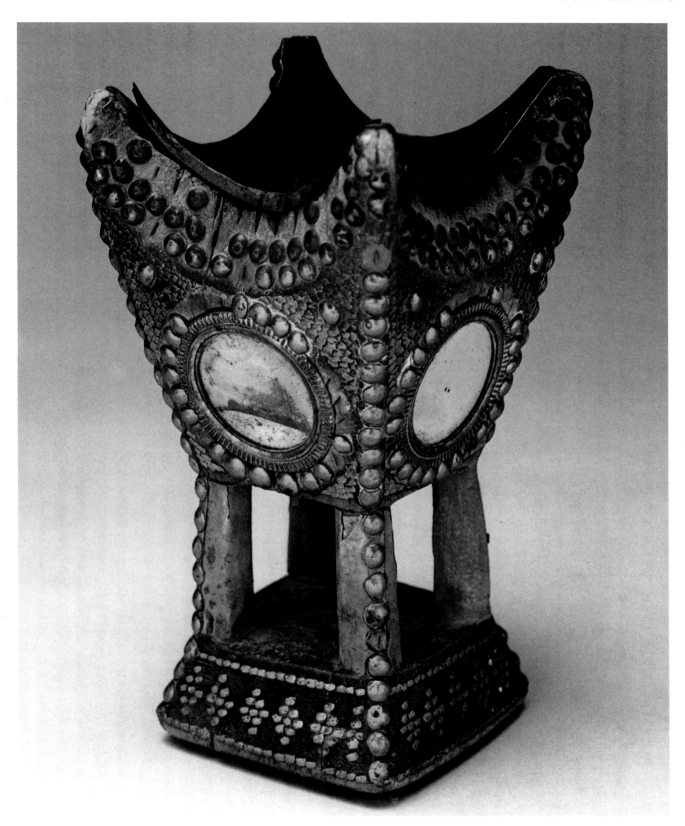

157. Incense burner. *This is the traditional conformation of incense burner (mabkhara) still used throughout Arabia. Glowing charcoal is placed in the container and the incense put over it. The last hospitable act after a feast is the passing by the host or member of his entourage of an incense burner from guest to guest. This is a signal for people to depart. As this example is relatively old (made before 1940), it is wood with columns covered in lead and decorated with brass tacks and trade mirrors. More recent ones, however, are shiny colored metal often decorated with plastic; they are usually imported from Pakistan and range in size from 6in to monumental, but averaging about 16in.*

Acquired in Riyadh, 1979.

TRADITIONAL MATERIALS AND TECHNIQUES

MATERIALS

ANIMAL FIBRES

Camel hair. Used for cloaks and other garments, camel hair also appears mixed into wools to give texture and colour. The al-Murrah tribe often use it for their tents and other types of utility items.

Goat hair. Used in the construction of the tent, goat hair is also found in other types of weaving when a dense black colour is required; also for selvedge durability.

Sheep's wool. This is the basic material for most utility items including cloaks and some clothing; it tends to be harsh and wiry in most areas of the peninsula apart from the mountainous regions.

CLAYS

Pottery continues to be made in the traditional clay centres of al-Hasa, Qatif and the Asir, though it was once made in other locations.

DYES

Until the early part of the 20th century many dyes came from India and Indonesia. Indigo was grown in a number of locations in Arabia but primarily in the Hadhramawt, Yemen and Oman; in the past it was used extensively throughout Arabia. Other dyes include henna, madder, cochineal, kermes, fermented lemons, pomegranate, safflower, saffron, onion skins and many mosses and lichens. Doughty mentions the use of tall white toadstools which grew in the northwest:

Some of our fellowship gathered them, and these, being boiled with alum in the urine of camels that have fed of the bush al-humth, yield they told me the gay scarlet dye of the Beduin wool-wives.

LEATHERS

Camel skin. Utility bags of all types, including water bags, are made of camel skin, as are sandals.

Gazelle and other wild animal skins. Used decoratively with some hair left on, these skins were worn as garments, especially by the al-Sulabah tribesmen, before about 1940.

Goat skin. Utility bags, water bags, garments (sometimes with the fur left on) and pouches are all made of goatskin. Fine braiding and lacing found on small bags, *agals* and other decorative items are usually goatskin.

Sheep skin. This is used for utility bags and milk bags and, with wool left on, for saddle seats, rugs, mattresses, jackets and cloak linings.

METALS

Although there are some metal deposits in Arabia, most metals are imported, sometimes in their finished form – steel dagger blades, for example. Iron and lead are still mined in the southern Hijaz and the Asir. Precious metals such as gold and silver were mined in ancient times; a common source of supply recently has been melted down coins.

PLANT FIBRES

Palm leaves are still used to make mats, baskets, fans and such like; palm fibre of the stem is also employed in basket making and is used as a filtering medium for coffee. Cotton has traditionally been grown in Arabia in small quantities.

SHRUBS AND TREES

Various types of shrubs are used for bent wood frames and tent poles. Unidentified larger trees were available in the past in some areas, particularly in the southwest, from which bowls and other woodware was made. Most large diameter bowls were imported or made from teak and other woods brought in from India and Indonesia.

Acacia. Poles and other small diameter work, such as bent wood frames are made out of acacia wood.

Palm (including leaves). Minor handles, temporary frames, and shelters are usually made of palm.

Tamarisk. A strong fibred wood, tamarisk is used mainly for camel saddles and well pullies; small wooden items are also constructed from it.

TECHNIQUES

Some metalwork and jewellery techniques:

Bezel setting. A setting consisting of a rim of metal hammered over the edge of a stone to hold it in position.

Casting. The use of a mould to shape molten metals.

Cuttlebone-casting. A method of casting using cuttlefish as a mould. Frequently used in silver casting.

Filigree. Tracery of fine wires.

Granulation. Granules of precious metal applied to metal for decorative purposes.

Hatching. Lines, usually parallel, etched into a metal surface.

Solder. Fusible alloys used to join less fusible metals, wires and so on.

Some weaving terms and techniques:

Couching stitch. Embroidery made by laying one thread flat on a surface and fastening it down with a second thread with short stitches at regular intervals.

Curved weft-faced tapestry. Wefts, instead of being inserted horizontally, are bent in a curve; successive wefts follow one another to build up the curve.

Dovetailing. A small number of wefts from each of the adjoining colour zones are grouped together and share one or more common warps.

Kilim. A weft-faced flat woven tapestry weave.

Llwairijan. A narrow band of geometric patterns used in weaving on either side of the main design.

Slit tapestry. A weaving technique where wefts are returned around warps where two colours meet forming a slit.

Soumak. Called after Caucasian rugs of the same name, this term is used to describe weft-faced brocade which often has a herringbone-like appearance; designs are carried on the weft.

S spin. Two or more yarns slated in the s direction from upper left to lower right.

Twining. A single row of twining consists of two wefts; one starts from the back, the other from the front of the warps. They twist around each other as they meet between the warps. This technique strengthens the structure.

Warp. Yarns stretched between the horizontal end supports of a loom which lie parallel to one another and run the full length of the piece.

Warp-faced. A weaving in which the warps carry the design, partially or completely covering the wefts.

Weft. Horizontal yarns passing over and under the warps.

Weft-float brocading. A method used for brocading small infill designs. The wefts pass over and under the surface of the rug forming a design on the front and floating loosely at the back in the spaces between the outlines of the design.

Z spin. The twist of the yarn slants in the direction of the centre part of the letter x from upper right to lower left.

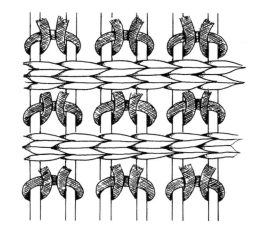

Turkish knots, shown here with a double row of countered weft twining between the rows of knots.

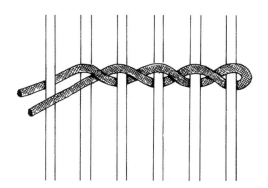

Weft twining.

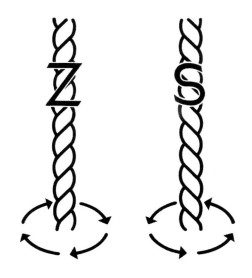

Detail of s and z spin yarns (*see also* pages 22-5)

This weaving detail is warp-faced plain weave with braided tassels.

GLOSSARY

Transliteration

The system of transliteration has been kept as simple as possible. Thus, differences between the hard and soft letters (such as H, S and T, which have both hard and soft forms in Arabic), have not been shown. The *hamza* and *ayn* are denoted by ' and ' only when they occur in the middle of a word, but not at the beginning or end. Arabic words in the main text are mostly given in their singular form; those within quotations are left in their original form.

The Arabic terms for several articles in daily use vary from region to region.

A

aba	short mantle worn by men and women
abaya	mantle worn by men and women
agal	doubled coil of heavy cord worn over a headpiece
alaqa	leather pouch
anbar	amber
araqiyya	small cap
ardah	traditional sword and drum dance

B

badan	shift or slip
Badawi (pl. Bedu)	Bedouin
barasti	palm leaf shelter
bayt	tent or house
bidi	heavy wool cloak
bisht	man's mantle
bukhnuq	girl's head covering
burd	wool used to make the *burda*
burda	mantle or cloak
burqah	face mask or veil

D

dallah	coffee pot
dalqa	bracelet consisting of a string of beads
damir	man's jacket with sleeves
dhalla	camel riding litter

dikky	cord of a *shirwal*
dirah	range of a tribe
dishdasha	woman's dress or long shift worn by men
durr'a	woman's dress

F

farwa	fur
fass	ring set with a stone
fatha	ring set with a red stone
fayruz	turquoise
frada	nose ring

G

ghilala	shift
ghutra	man's head covering
ginn	square-framed camel riding litter
glada	beaded necklace
gutia	box for coffee cups

H

hagab	belt
hajj	pilgrimage to Makkah
hajji	pilgrim
halqa	earring

hatta	man's head covering
hawdaj	riding litter
hawdh	camel watering trough
haysa	thumb ring
hays masbukat	thumb ring
hijab	amulet, a hollow container to hold a charm, usually triangular but sometimes rectangular
hijl	bracelet or anklet
hilal	crescent
hirz	amulet
hizam	belt

I

ilaqa	jewellery headpiece which hangs to the side of the face
iqd	necklace
isaba	woman's headband
iswara	bracelet
iswara habbayat	granulated bracelet
ithil	tamarisk
izar	loincloth

J

jilbab	woman's cloak
jirab	sheath or bag
jubba	shift or slip

K

kaffat	jewellery headpiece
kaffiya	man's head covering
khanjar	double-edged dagger
khansar	ring worn on little finger
khasur	amber bracelet
khatim	ring
khaysh	sackcloth
khilkhal	anklet

khimar	woman's cloak
khirsa	earring
khiyar	cylindrical amulet
khizama	nose ring (right nostril)
khnaq	necklace
khulas	dates grown in al-Hasa
khuwaysa	gold and turquoise bracelet
kirdan	choker
kis	bag
kohl	antimony, applied around the eyes as cosmetic and medicine

L

leban	buttermilk
litham	face mask

M

mabkhara	incense burner
ma'din mutarraz	bracelet (lit. 'embroidered metal')
mahalah	wooden well sheave
maknaka	coral necklace
maksar	bent wood riding litter
ma'qid	elbow band
maqta	appliquéd and embroidered dress
marami	rings worn on middle finger
ma'raqa	small cap
marjan	coral
markab	litter
maska	amulet
melwi	bracelet made of twisted metal (lit. 'twisted')
mihmas	coffee roasting pan
mikyal	measuring cup
milfa	face veil or shawl worn by city women
minfakh	bellows
miraka	a woven cushion, woollen or leather, hung in front of the saddle for the rider to rest his knee on
mirt	woman's cloak
mirta'sha	necklace

mishla	mantle
mizan	scale
mubarrad	box or tray for cooling and apportioning coffee
murabba	ring with square surface (lit. 'square')

N

na'l	shoe or sandal
namira	striped cloak
nargila	hookah
nimr	leopard or tiger
niqab	face mask or veil

Q

qadah	wooden jar
qamis	shift
qata	curtains used to divide the tent interior

R

rababa	stringed instrument
rida	man's cloak
riwaq	tent flap or wall
riyal	a standard coin of Saudi Arabia
romh	spear

S

salib	cross
sawmn	clarified butter
seyf	sword
shadda	man's leather belt
shahid	ring (lit. 'witness')
shanf	nose ring or earring
shaykh or *sheikh*	tribal chief
shelfa	spear
shella	veil worn by city women
shirwal	underdrawers of pantaloons
shutfa	Bedouin woman's scarf

shywayhiyya	woven belt
silsila	chain
siwar	bracelet
suff	wool
suff al-aghnam	sheep's wool
suq	market

T

taqiyya	small cap
taqsiyya	man's sleeveless jacket
thawb	woman's dress or long shift worn by men
thawb shillahat	wing-sleeved gown for men
tikka	cord of a *shirwal*

U

uda	cylindrical amulet

W

wabar	camel hair
wadi	dry river bed
wasat	ring worn on middle finger
wasm	tribal possession mark

Y

yad al-hamam or *yad al-haswan*	pestle and mortar
yamama	oval gold and turquoise piece worn on the forehead

Z

zand	arm band
zar	gold dome-shaped ring, often set with a carnelian
zetab	riding litter
zimam	nose ring (left nostril)

BIBLIOGRAPHY

Barthes, R., 'Histoire et sociologie du vêtement' (1957, *Annales: Economies – Sociétés – Civilisations* 3, pp 430-41)

Besancenot, J., *Bijoux arabes et berbères du Maroc* (1953, Edition de la Cigogne, Casablanca)

Bindagji, H.H., *Atlas of Saudi Arabia* (1978, Oxford University Press, Oxford)

Binzagr, S., *Saudi Arabia: an Artist's View of the Past* (1979, Three Continents Publishers, Lausanne)

Blunt, A., *A Pilgrimage to Nejd*, 2 vols (1881, John Murray, London)

Burckhardt, J.L., *Notes on the Bedouins and Wahabys* (1831, Colburn & Bentley, London)

Burckhardt, J.L., *Travels in Arabia* (reprinted 1968, Frank Cass & Co, London)

Cole, D.P., *Nomads of the Nomads: the Al Murrah Bedouin of the Empty Quarter* (1975, Aldine Publishing Co, Chicago)

Coon, C.S., *Caravan: The Story of the Middle East* (1976, Robert E. Krieger Publishing Co, New York)

Dickson, H.R.P., *The Arab of the Desert, a Glimpse into Bedouin Life in Kuwait and Sau'di Arabia* (1949, George Allen & Unwin, London)

Dickson, H.R.P., *Kuwait and Her Neighbours* (1956, George Allen & Unwin, London)

Doughty, C.M., *Travels in Arabia Deserta* 2 vols (1921, Jonathan Cape/ Medici Society, London; 1979, Dover Publications, New York)

Eudel, P., *Dictionaire des bijoux de l'Afrique du Nord: Maroc, Algérie, Tunisie, Tripolitaine* (1906, Ernest Laroux, Paris)

Fairservis, W.A. Jnr., *Costumes of the East* (1971, American Museum of Natural History/Chatham Press, Riverside, Conn)

Fayein, C., 'La vie pastorale au Dhofar' (1971, *Objects et Mondes* 1, pp 321-32)

Fayein, C., 'Al Zohrah : village de la Tihama' (1973, *Objets et Mondes* 13, pp 161-72)

Flugel, J.C., *The Psychology of Clothes* (1950, Hogarth Press, London)

Forder, A., 'Arabia, the Desert of the Sea' (1909, *National Geographic Magazine* 20, pp 1039-62)

Guarmani, C., *Northern Najd* (1938, Argonaut Press, London)

Hansen, T., *Arabia Felix* (1964, Harper & Row, New York)

Hawley, R., *Omani Silver* (1978, Longman Group, London)

Jaussen, A., *Coutumes des Arabes au pays de Moab* (1948, Adrien-Maisonneuve, Paris)

Jenkins, M., and Keane, E., 'Djawhar' *Encyclopedia of Islam Supplement* (E.J. Brill, Leiden)

Jewellery from Persia: The Collection of Patti Birch (n.d., Schmuckmuseum Pforzheim, Pforzheim)

Katakura, M., *Bedouin Village: A Study of a Saudi Arabian People in Transition* (1977, University of Tokyo Press, Tokyo)

Keatinge, M.C., *Costumes of the Levant* (1955, Khayat's College Book Cooperative Beirut)

Kawar, W. C., *Memoire de Soie-Costumes et parures de Palestine et de Jordanie* (1988, Institut Du Monde Arabe)

The Kingdom of Saudi Arabia (2002, Stacey International Publishers, London)

Kuwaiti Portfolio on Bedouin Weavings Al Sadu Project (1979, Kuwaiti Museum)

Mousally, E.J., 'Traditional Instruments of Arab Music' (1980, *Jordan* vol 5 no3, pp20-21)

Musil, A., *Arabia Petraea* 3 vols (1908, Vienna)

Musil, A., *The Northern Hegaz - a Topographical Itinerary* (1926, American Geographical Society, New York)

Musil, A., *Arabia Deserta: a Topographical Itinerary* (1927, American Geographical Society, New York)

Musil, A., *Manners and Customs of the Rwala Bedouins* (1928, American Geographical Society, New York)

Musil, A., *Northern Negd: a Topographical Itinerary* (1928, American Geographical Society, New York)

Musil, A., *Palmyrena: a Topographical Itinerary* (1928, American Geographical Society, New York)

Nancz, P., *A Journey into Traditional Saudi Arabia* (pp194, The Nancz Museum)

Niebuhr, C., *Description de l'Arabie, faite sur des observations propres et des avis recueillis dans les lieux mêmes* (1774, S.J., Baalde, Amsterdam)

Niebuhr, C., *Travels through Arabia* 2 vols (1792 Libraire du Liban, Beirut)

Palgrave, W.G., *Personal Narrative of a Year's Journey through Central and Eastern Arabia* 2 vols (1865, Macmillan & Co, London)

Philby, H. St. J.B., *The Heart of Arabia: A Record of Travel and Exploration* 2 vols (1922, Constable & Co, London)

Philby, H. St. J.B., *Arabia of the Wahhabis* (1928, Frank Cass & Co, London)

Philby, H. St. J.B., *Sheba's Daughters, Being a Record of Travel in Southern Arabia* (1939, Methuen & Co, London)

Philby, H. St. J.B., *The Land of Midian* (1957, Ernest Benn, London)

Philby, H. St. J.B., *Arabian Highlands* (1976, Da Capo Press, New York)

Raswan, C.R., *The Black Tents of Arabia (My Life Among the Bedouins)* (1935, Hutchinson Publishing Group, London; Farrar, Straus & Giroux, New York)

Ross, H.C., *Bedouin Jewellery* (1978, Stacey International, London)

Stein, L., *Abdallah bei den Beduinen* (1964, F.A. Brickhaus, Leipzig)

Stillman, Y.K., 'Libas' *Encylopedia of Islam* V (1960-, E.J. Brill, Leiden)

Stillman, Y.K., 'The Middle Eastern Amulet as Folk Art' (*Dov Noy Festschrift*, Ed: B.Z. Fischler)

Thesiger, W., *Arabian Sands* (1959, Longman Group, London; E.P. Dutton & Co, New York)

Thomas, B., *Alarms and Excursions in Arabia* (1931, Bobbs-Merrill Co, Indianapolis)

Thomas, B., *The Arabs* (1937, Doubleday, Doran & Co, Garden City)

Thomas, B., *Arabia Felix* (1932, Jonathan Cape, London; Scribners, New York)

Tilke, M., *Kostümschnitte und Gewandformen* (1948, Ernest Wasmuth, Tübingen)

Tilke, M., *Oriental Costumes* (1922, Kegan Paul Trench, Trubner & Co, London)

Verbrugge, A.R., 'La main: ses figurations au Maghreb et au Levant' (1965, Catalogues du Musée de l'Homme, Série B: *Afrique Blanche et Levant* I, Musée de l'Homme, Paris)

Weir, S., *The Bedouin: Aspects of the Material Culture of the Bedouin of Jordan* (1976, World of Islam Festival Publishing Co, London)

Western Arabia and the Red Sea (1946, Naval Intelligence Division, British Navy)

Winder, R.B., *Saudi Arabia in the Nineteenth Century* (1980, Octagon Books, New York)

INDEX

For clarity of reference, most transliterated Arabic words in the Index are given their singular form. Entries in italics refer to illustrations.